# How to Do Everything

# Digital Photography

## Jason R. Rich

Mc
Graw
Hill

New York   Chicago   San Francisco   Lisbon
London   Madrid   Mexico City   Milan   New Delhi
San Juan   Seoul   Singapore   Sydney   Toronto

The McGraw·Hill Companies

Cataloging-in-Publication Data is on file with the Library of Congress

McGraw-Hill books are available at special quantity discounts to use as premiums and sales promotions, or for use in corporate training programs. To contact a representative, please e-mail us at bulksales@mcgraw-hill.com.

### How to Do Everything™: Digital Photography

Product images are used with permission from:

| | | |
|---|---|---|
| CEIVA Logic, Inc. | Lowepro® | Tarmac® |
| Corel® | Nikon, Inc., Melville New York | Vortex Media |
| Eastman Kodak Company | Sonic Solutions® | Western Digital Corp. |
| Epson America, Inc. | | |

1234567890   DOC DOC   10987654321

ISBN    978-0-07-175471-2
MHID    0-07-175471-7

| | | |
|---|---|---|
| **Sponsoring Editor** Megg Morin | **Copy Editor** LeeAnn Pickrell | **Illustration** Glyph International |
| **Editorial Supervisor** Janet Walden | **Proofreader** Paul Tyler | **Art Director, Cover** Jeff Weeks |
| **Project Editor** LeeAnn Pickrell | **Indexer** Karin Arrigoni | **Cover Photographs** Jason R. Rich |
| **Acquisitions Coordinator** Stephanie Evans | **Production Supervisor** Jean Bodeaux | |
| **Technical Editor** Bill Bruns | **Composition** Glyph International | |

*To my family for all of their love and support, and to my dog Rusty.*

## About the Author

**Jason R. Rich** (www.JasonRich.com) is the bestselling author of more than 42 books covering a wide range of topics. He also contributes articles on a regular basis to a handful of national magazines, major daily newspapers, and popular websites, including the *New York Daily News* newspaper.

As a photographer (www.JasonRichPhotography.com), his work often appears in conjunction with his articles and in his books, which include over a dozen full-length travel guides. You can access his travel blog at www.JasonRichTravel.com and follow his travel adventures on Twitter (www.Twitter.com/JasonRich7).

Jason has a passion for travel photography and for photographing animals; however, he continues to help up-and-coming professional models and actors create and expand their portfolios and get signed with major agencies in cities like New York, Los Angeles, Boston, and Miami.

Throughout the year, he teaches photography workshops and classes through various adult education programs, aboard cruise ships, and at resorts. He lives in Foxboro, Massachusetts.

## About the Technical Editor

**Bill Bruns** is the Deputy Director of the Student Center at Southern Illinois University Carbondale. He has been a technical editor for fourteen years, working on more than 130 books related to digital imaging, database systems, the Internet, web servers, HTML, operating systems, and Office applications. Originally planning to work in television production, his interest turned to computers while working on an undergraduate internship at *Square One TV*, a children's mathematics show produced by the Children's Television Workshop in New York City.

Bill holds bachelors' degrees in Telecommunications and English Literature from Indiana University and a master's in Public Administration from New York University. Bill and his family currently reside on the edge of the Shawnee National Forest in Carbondale, Illinois.

# Contents at a Glance

# Contents

# Acknowledgments

First and foremost, I'd like to thank Megg Morin and Stephanie Evans at McGraw-Hill who invited me to work on this project and who worked hard to bring it to print and make it a reality.

I'd also like to thank my friends (the professional models who appear throughout this book), including Kiel James Patrick, Sarah Vickers, Neal Gibeau, Connor Jon Kuchenmeister, Eric Stevens, Hanna Lawson, Michael Jade Paquette, and my Yorkshire Terrier Rusty (who loves having his picture taken, as you'll see throughout this book, and if you visit his website at www.MyPalRusty.com).

# Introduction

Taking pictures is a fun and rewarding hobby. It's also a wonderful way to chronicle important moments in your life and capture fun, exciting, interesting, and entertaining events you, your loved ones, and your friends experience—those cherished memories that you can later reminisce about for many years to come.

Digital photographs are also easy to share with friends and family in a variety of ways. You can display them in your home or office, showcase them in a photo album, distribute them online, or simply view them on your computer screen. The many ways you can later enjoy and share your photos is limited only by your own creativity.

Thanks to recent and ongoing advances in digital camera technology, taking professional-quality photos has never been easier. With your camera set to full Auto mode when shooting, you can take excellent photos in most situations, without needing to fumble with buttons, dials, menu options, or settings on your camera. And the prices of digital cameras continue to drop, making them affordable for virtually everyone.

Instead of focusing on the technical aspects of photography, *How to Do Everything*™*: Digital Photography* teaches you how to use any digital camera and immediately begin taking better pictures by implementing a handful of shooting techniques and strategies by considering photo composition, lighting, and creativity, among other things. So, whether you're planning to snap candid photos of your kids, chronicle your next vacation, photograph happenings in your everyday life, shoot professional-quality images of your favorite pet, take pictures of your friends at parties and social gatherings, or transform your interest in photography into a serious hobby and create photographic art, you'll find information and resources in this book that will help you vastly improve your photography skills quickly and easily.

Contrary to popular belief, you do not need to invest thousands of dollars in a high-end Digital SLR camera with a bunch of costly lenses and optional accessories in order to take amazing pictures. In fact, you can begin taking eye-catching photos using any point-and-shoot digital camera, or even the digital camera built into your cell phone or smartphone (such as the Apple iPhone 4).

This book helps you find and purchase an ideal digital camera based on your needs and budget and choose the best accessories and optional equipment for your camera; then it teaches you how to take eye-catching photos in a wide range of situations. You'll also learn how to avoid many of the common mistakes made by amateur photographers that result in out-of-focus, overexposed, underexposed, or poor-quality images.

After reading this book, and with a bit of practice, you will see vast improvements in the photos you take, regardless of the subject or the location where the picture is shot. As you become better at taking photos, you'll learn more advanced techniques for using your digital camera and begin to see professional-quality results in no time, especially if you also invest some time in learning how to use photo-editing software on your computer (a subject that is also covered later in this book).

Finally, as you begin taking more and more photos that you're truly proud of, you'll want to share them with friends and family. Digital images can easily be distributed and shared online, transformed into prints, or even imprinted onto gift products (like coffee mugs, holiday cards, mouse pads, and T-shirts). You'll soon discover that sharing photos is a great way to reconnect with and bond with people and share important moments and events in your life.

By taking better and more visually impressive photos, you'll have more images to look at and more memories to look back on. Yes, taking pictures is fun and a great way to express your creativity. However, it's also a wonderful way to freeze time and capture those important moments you don't want to forget or that you want to share with others. And it all starts by looking through your camera's viewfinder and clicking the shutter button.

## About This Book

After learning about digital cameras in general and how to choose the best camera equipment to meet your unique needs and budget, throughout this book, you will discover quick and easy-to-learn techniques for taking better photos using any digital camera. You'll also learn many shooting techniques that the pros use, plus discover ways of tapping your camera's features and capabilities to shoot clear, vivid, in-focus, and eye-catching photos in almost any situation. Once you've shot your digital images, you'll discover how to edit and enhance your photos after the fact using photo-editing software on your computer, and you'll learn about many of the ways you can share your photos with friends, family, and others.

From this book, you'll get a preview of what's possible with digital photography and improve your picture-taking skills, without having to learn too much about the technical aspects of photography.

# Assumptions

*How to Do Everything™: Digital Photography* begins with the assumption that you want to buy a new digital camera, or you already have a digital camera and you want to start taking better-quality photos with it. For example, if you enjoy chronicling the lives of your kids in photos, but all too often your pictures turn out blurry, too light, too dark, or have some other problem, you'll discover quick and easy photographic techniques and strategies you can utilize to improve the overall quality and composition of your photos.

Best of all, to improve your photography skills, you don't need to know anything about digital photography or taking pictures. Plus, you'll benefit from the information in this book, regardless of what type of digital camera you are using.

## What You Should Know About Digital Photography

As you start reading this book the only thing you need to know is that you want to begin taking better photos using any point-and-shoot or Digital SLR camera. No previous skill or knowledge is required. However, if you ultimately want to edit and share your photos, a basic knowledge of how to use a computer and the Internet is useful.

As you're about to discover, photography is both a skill and an art form. As you take pictures, you'll want to tap your own creativity in order to capture unique, thought-provoking, artistic, or eye-catching images. This book teaches you the basic photography skills you need to know, and it helps you develop and utilize your own creativity. However, don't be afraid to experiment with your camera and look at everyday life through what will soon be your newly developed "photographer's eye," as you begin acquiring the knowledge and skills necessary to improve your picture-taking abilities. Be sure to practice using your newly acquired photography skills by continuing to take pictures in a variety of different situations.

# Organization

Now here's a brief summary of the book's organization and contents.

## Part I: Get to Know Your Digital Camera

Learn the basics behind digital photography technology, and discover how and where to buy the right camera and accessories to meet your unique needs and that fit within your budget in Chapters 1–3.

## Part II: Tips and Strategies for Taking Professional-Quality Photos in Any Situation

Learn basic digital photography shooting techniques and skills for taking better-quality photos in a wide range of situations. In Chapters 4–10, you'll learn the fundamentals on how to take the best possible pictures in any situation based on the capabilities of your digital camera, the available lighting, and the scenario in which you're shooting. For example, you'll discover how to take crystal-clear pictures when shooting indoors, at night, with or without a flash, or while on vacation. You'll also learn the best ways to photograph people and pets and how to capture motion for taking sports shots, for example.

### Part III: Edit and Digitally Enhance Your Photos

Learn how to use photo-editing software on your PC or Mac-based computer in order to edit, enhance, print, archive, and share your digital photos. In Chapters 11–13, discover how to improve the look of your photos dramatically and fix minor problems, after you've shot them, using a variety of different software packages and techniques.

### Part IV: Showcase, Share, Present, and Store Your Photos

In Chapter 14, discover some of the many ways you can showcase and share your digital photos with friends, family, and even total strangers, and in Chapter 15, learn the importance of organizing and backing up all of your digital images.

## Color Photographs As Examples

Throughout *How to Do Everything™: Digital Photography*, you'll see literally hundreds of full-color sample photographs. Each has been included to showcase a specific photographic technique or strategy or to show you a common photography mistake or mishap that you want to avoid. In many cases, a "before" and "after" photo is displayed, allowing you to see exactly how you can utilize specific shooting techniques to improve your photography skills.

Keep in mind that the photos in this book are just a small sampling of what's possible when using a digital camera and should be used for reference and to help you develop your own creative ideas when taking pictures. Don't try to replicate what you see in these sample photos exactly. Instead, use them as a guide for what's possible, and then adapt your shooting technique based on your subject, background, available lighting, and the situation or scenario that you're photographing.

# PART I

## Get to Know
## Your Digital Camera

# 1

# Digital Camera Basics: What You Should Know to Get Started

## How to...

- Learn digital camera basics
- Take photos without using traditional film
- Understand the latest digital camera features and functions
- Differentiate among the different types and styles of digital cameras

Have you tried taking photos with a digital camera in the past, only to wind up with a handful of blurry images or photos in which your subjects suffered from bad cases of red eye? The last time you were on vacation, did you accidently place your finger over the camera's lens and wind up with a great photo of your index finger, instead of a popular tourist attraction or historical site? Or maybe you forgot to consider the lighting when shooting a photo and wound up with silhouettes of your subjects, instead of clearly visible smiling faces?

Problems with blurriness, red eye (shown in Figure 1-1), holding your camera incorrectly and ending up with shots of your finger (shown in Figure 1-2), and not understanding how the position of natural or artificial lighting will impact your photos (shown in Figure 1-3) are among the most common problems amateur photographers face—yet they're also some of the easiest problems to overcome!

 These common problems—red eye, blurriness, and poorly lit (overexposed or underexposed) subjects—will soon be a thing of the past as you discover how to take better digital photos. And if you aren't able to fix these problems when you shoot your photos, because they're digital, you can easily fix them after-the-fact using photo-editing software. How to do this is explored in Chapter 12.

These are just a few of the common problems that amateur photographers encounter when using any type of digital camera. The good news is that by the time you're done reading this

book, not only will you know how to avoid all of these common problems and mistakes, but also you'll possess the core skills needed to start taking professional-quality photos using just about any digital camera.

So do you want to start taking better photos using a digital camera? Or are you about to purchase a new digital camera and want to make the right decision before investing a lot of money in a camera and related equipment that's too complicated to figure out, or that doesn't meet your needs?

Well, just about anything and everything you'll want and need to know about digital photography, and how to improve your picture-taking abilities quickly, is covered in this book—using easy-to-understand English, so you don't have to weed through a lot of technical jargon. The goal of this book is to help you develop and fine-tune your "photographer's eye" (more on this shortly), understand the basic principles of digital photography, and allow you to take the very best pictures possible when shooting with whatever digital camera you'll be using. You'll discover how to maximize the technology built into your camera and combine it with your own creativity.

You'll learn how to overcome common digital photography mistakes, and, if necessary, compensate for them after-the-fact

**FIGURE 1-1**  When shooting photos with a flash, red eye will detract from your images.

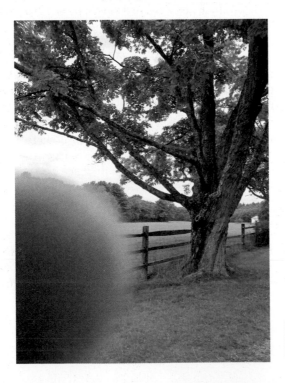

**FIGURE 1-2**  Watch the placement of your fingers when shooting!

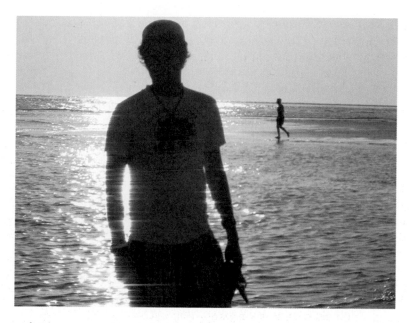

**FIGURE 1-3** Bad lighting position will cause shadows and silhouettes.

using photo-editing software. You'll also discover secrets and photography techniques that'll help you consistently take crystal-clear, visually interesting, and artistic photos in almost any situation.

Whether your plan is learn how to take better photos of your kids, preserve vacation memories with visually stunning images, or capture spontaneous moments spent with friends or loved ones so you have better photos to post on Facebook, the photographic knowledge you need is contained within this book, starting in this chapter, which offers a basic introduction to what digital photography is all about and the different types of digital cameras available.

# Digital Camera Basics: No Film Required

There are many differences between a traditional film camera and a state-of-the-art digital camera, the most obvious of which is that digital cameras require no film, and the photos you take don't need to be developed after they're shot. Instead, digital images are captured by the camera using digital imaging technology and saved almost instantly onto memory cards.

The images you take can then be viewed immediately on the camera's LCD display, transferred to a computer for

editing, storage, or sharing, copied to a digital photo frame to be displayed, printed using a home photo printer, or dropped off at a one hour or professional photo lab to have professional prints created. The images can also easily be shared online.

While in their digital form, you have the ability to crop, edit, enhance, and manipulate your images quickly using specialized photo-editing software. With a few clicks of the mouse, you can fix imperfections (such as red eye), adjust an image's contrast or color, improve an image's clarity, or add visual effects.

Thus, the digital photo-taking process really has three distinct phases—shooting, editing, and sharing—each of which will be explored in detail throughout this book. Because you don't have to wait for film to develop or be processed, you can preview your digital images seconds after you've taken them and see right away if you've captured the image(s) you intended. This capability takes a tremendous amount of guesswork out of the picture-taking process.

Also, unlike with film cameras, instead of being limited to 12, 24, or 36 exposures per roll of film, you have the ability to shoot an unlimited number of images, providing you carry around an ample supply of memory cards and extra batteries for your digital camera. A typical memory card will hold hundreds or even thousands of images at once, however, and a camera battery should last between 100 and 550 images per charge.

Another wonderful aspect to digital photography is that your personal photographic skills (even if they're limited) are enhanced by the technology and artificial intelligence built into all of the latest digital cameras, allowing the camera to compensate for shacking (when the camera moves while you're pressing the shutter button), your subject(s) moving, poor lighting, shadows, and a wide range of other challenges that, in the past, would have ruined your photos. Some of the latest cameras will even detect when your subject(s) are smiling and looking at the camera, insuring you capture the perfect image.

# You, Too, Can Develop a Photographer's Eye

Digital photography has made it so almost anyone can easily take professional-quality photos with minimal practice and training, especially if you're using a digital point-and-shoot camera that's set on Auto or Program mode.

## How to. . .   Utilize Your Photographer's Eye

Having a *photographer's eye* means understanding what your camera is capable of shooting, knowing how to operate your digital camera, and then looking at the world in a way that allows you to visualize interesting, beautiful, funny, or thought-provoking photos in your mind's eye, and then capturing what you see in the real world using your camera.

Utilizing your photographer's eye means combining your photographic knowledge with your camera's capabilities and your own creativity. It requires you to not just focus on your main subject, but also consider the lighting, shadows, foreground, background, use of color, and other aspects of the scene you're shooting.

Your goal—with each and every picture you shoot, whether it's of a person, place, or thing—is to convey a message, emotion, or somehow showcase the beauty captured within the image in a way that is visually appealing and interesting. Doing this means knowing what camera features and functions to use and what optional photographic equipment to take advantage of, and then properly visualizing your image, while taking advantage of light, color, and your surroundings.

So yes, digital photography gives you, the photographer, an incredible amount of leeway when shooting. However, it's not foolproof, and no matter how expensive and technologically advanced your digital camera is, it can't replace a human's creativity and artistic eye. Thus, in addition to learning basic photography fundamentals, which are taught in this book, you'll also discover how to develop your "photographer's eye," as well as fine-tune and channel your creativity. Ultimately, you'll combine these skills with the technology built into your camera. The result will be visually stunning images that you'll be proud to share with friends and loved ones.

While there are shooting strategies you can employ to better utilize your photographer's eye and take more visually interesting photos, there are no actual rules to follow. As that age-old saying goes, "Beauty is in the eye of the beholder." Understanding the principles of digital photography will help you take crystal-clear images. How you use your creativity, however, will determine how visually interesting your photos are.

 Throughout Chapters 4 through 9, you'll discover how to use your photographer's eye, in conjunction with your digital camera's capabilities and features, to shoot professional-quality images in a wide range of situations.

To accomplish the objective of taking professional-quality digital photos, you don't need to memorize a lot of technical information or even understand too much about things like aperture, white balance, shutter speed, ISO settings, lens focal lengths, or a wide range of other photography-related principles and theories that photographers using film-based cameras typically need to contend with.

Everyone has the ability to be creative and a basic, inherent understanding of what looks visually appealing. Once you understand how and why you want to tap into your creativity when taking pictures, and start practicing using your photographer's eye in conjunction with your digital camera's built-in capabilities and features, you'll notice a dramatic improvement in your photographic abilities.

The photograph shown in Figure 1-4 was shot using a basic knowledge of digital photography in order to take a photo that is crystal clear and free of any common photography problems. However, absolutely no creativity was used when taking this photo. No consideration whatsoever was given to the visual framing of the image, the available lighting, the foreground, or the background. The result is an image that's good, but not one that makes someone viewing the photo exclaim, "Wow!"

**FIGURE 1-4** A photo shot without using any creativity

**Tip** Part of using your photographer's eye means visually framing each image before you take it. This requires determining how you want it to look in advance and taking full advantage of your surroundings, including the available light and other factors, as you position your main subject in the viewfinder of your camera.

Now, let's take a look at another photo (Figure 1-5), which was taken in the same location as Figure 1-4. For this photo, the photographer utilized his photographer's eye, tapped into his creativity, and took advantage of his surroundings to create a more interesting and visually impressive image.

When you compare Figure 1-4 and Figure 1-5, you can see that the same basic knowledge of photography was used. However, in Figure 1-5, the additional creativity paid off with significant results.

 If you're thinking to yourself, "I'm just not a creative person. I can't do this!," you're 100 percent wrong! It may take a bit of practice, but once you start paying attention to your surroundings, and incorporating what you see into your images (and not just focusing on your main subject), your photos will improve.

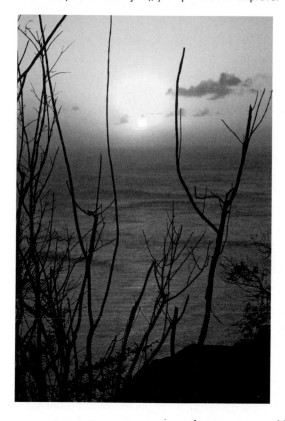

One of the biggest things that hold amateur photographers back from taking amazing photos is a fear of tapping into their own creativity, expressing themselves visually, and fully utilizing their surroundings. As you practice taking photos, your confidence, knowledge, and experience will improve, which will reflect positively in your work as a photographer.

## Memory Cards Have Replaced Film

Instead of film, all digital cameras utilize some type of flash memory card. Think of a memory card as a tiny data storage device that will hold your image data from the time you take a photo until you transfer that digital image to your computer. When inserted into a camera, a memory card will store your image data as you take pictures. However, in between photo shoots or when

**FIGURE 1-5** A photo that makes better use of the photographer's surroundings

the memory card becomes full, you'll need to transfer your image data from the memory card to a computer's hard drive or another data storage device.

 Memory cards are *not* meant for storing your image files permanently. Don't keep buying new memory cards every time you fill one up. Instead, transfer the images to a computer (for viewing, editing, storage, printing, and sharing), reformat the memory card, and reuse it over and over again. Make sure you first create a backup of your images before deleting them from the memory card, however!

Chapter 3 offers all of the information you'll need to know about choosing memory cards, in terms of the different types and formats of memory cards available. At the same time you purchase a new digital camera, you'll need to purchase at least one or two compatible memory cards for that camera.

For a camera that boasts a high resolution, such as 10 to 12 megapixels (MP), you'll want your memory card to hold at least 2GB to 4GB of image data and have a fast read/write speed. The larger the memory card's capacity, the more images it'll be able to hold at once.

**Note** Higher-resolution cameras take better quality pictures. Thus, each image will require more storage space on your memory card. For example, the file size of a single image shot at maximum resolution using a 12 or 14 megapixel camera will be much larger than the same shot taken using a 5 megapixel camera. As a result, you'll need a larger capacity memory card to hold a lot of images when using a high-resolution camera.

When you start shopping for memory cards, focus only on the card format that's compatible with your particular make and model of digital camera. There are about a dozen different memory card formats, but you only need to concern yourself with one format. What you need to take into account is the memory capacity of the card, as well as its read/write speed, which will directly impact its price.

As you've probably guessed, larger capacity memory cards cost more money (although prices continue to drop as technology improves). Also, a memory card with a fast read/write speed will be more costly than a card that offers a slower read/write speed. The read/write speed of the memory card, however, does directly impact your digital camera's performance, which is why acquiring the fastest memory card possible, in terms of its read/write speed, will be to your advantage.

# A Camera's Resolution Impacts the Quality of Your Pictures

One of the major factors impacting the overall quality of your photos is your digital camera's maximum resolution. Today's higher-end point-and-shoot and Digital SLR cameras have a resolution of 12 megapixels or higher. What this means is explained in greater detail in Chapter 2. What you need to know for now, however, is that not only will a camera with a higher resolution be able to take more vibrant and detailed photos, but it also will store each image as a larger size file, which can ultimately be enlarged or edited without causing any pixilation or distortion.

If you take a photo using the 3 megapixel (3MP) camera that's built into your cell phone, such as the iPhone 3G, and

then take the same image using a 12 megapixel point-and-shoot camera, such as the Kodak EasyShare M550, or an even better quality Digital SLR camera, you'll notice a tremendous difference in image quality. If you try to enlarge both images to make prints, for example, you'll discover that the photo taken using your low-resolution iPhone 3G camera will distort and pixilate very quickly. With the image shot using the higher-resolution camera, you'll be able to create poster-size prints (or larger) with no pixilation or distortion whatsoever.

In general, you want to purchase a digital camera offering the highest resolution possible. However, if the majority of your images will be viewed on a computer screen, shared online, or made into standard size 4"×6" or 5"×7" prints, any digital camera with a resolution of 10MP or greater will definitely serve you well.

If you're comparing two digital cameras, and one has a resolution of 10MP, while the other has a 12MP resolution, but the 10MP camera offers a better zoom lens or other features you know you'll want to take advantage of, go with the 10MP camera. Most amateur photographers won't notice the small difference in resolution between 10MP and 12MP.

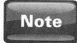

As an amateur photographer, you don't need to spend a lot of extra money just to purchase the latest, most technologically advanced camera that offers a higher resolution, unless that camera also offers features and functionality you'll utilize as you take pictures.

## Lens Quality Is Also Important

In addition to paying attention to a camera's resolution (which is measured in megapixels), and the size, shape, and quality of a digital camera's image sensor (which is measured in millimeters), another important consideration is the quality of the lens the camera uses.

In Chapter 2, you'll learn that the size, shape, and quality of a digital camera's image sensor is as important as a camera's resolution when it comes to image sharpness and quality.

A point-and-shoot camera with a single built-in lens gives you no flexibility in terms of lens choice. Thus, you'll want to choose a camera with a good quality built-in lens in order to ensure you'll be able to take the highest quality images possible.

The advantage of Digital SLR cameras is that the lenses are interchangeable. Chapter 3 offers the information you'll need when it comes to understanding how these lenses work, and why using the best quality lenses you can afford is important.

# Introducing Today's Digital Camera Technology

A camera's resolution, image sensor, memory card type, and lens all impact your ability to take professional-quality photos using a digital camera. When you start shopping for a digital camera, however, you'll discover an abundance of choices, based around several digital camera categories. Let's take a quick look at each digital camera category, and examine the major benefits and drawbacks of each. Determining what category of digital camera is best suited to your needs as an amateur or serious hobbyist photographer will help you narrow down your options.

## Digital Point-and-Shoot Cameras

For the average person, a mid-to-high-end point-and-shoot camera, priced between $100 and $400, is ideal. These cameras, like the Nikon COOLPIX cameras, are small in size and lightweight (as you see in Figure 1-6), so they're easy to carry around in a pocket or purse. They're also easy to use, powerful, and loaded with features designed to take the guesswork out of taking pictures. These cameras are designed so you wind up with problem-free images with almost every shot.

Over a dozen well-known camera and consumer electronics companies, including Canon, Nikon, Kodak, Fujifilm, Olympus, Lumix (Panasonic), Sony, Polaroid, Pentax, and Casio, currently offer a vast selection of point-and-shoot cameras that are readily available from photography specialty stores, consumer electronics stores (such as Best Buy or Radio Shack), mass-market superstores (including Wal-Mart and Target), office supply stores, and through online merchants.

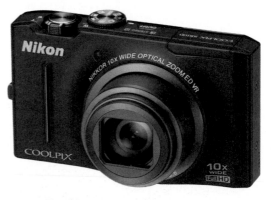

**FIGURE 1-6** Nikon's COOLPIX point-and-shoot cameras are compact and feature-packed (Courtesy of Nikon, Inc., Melville, New York).

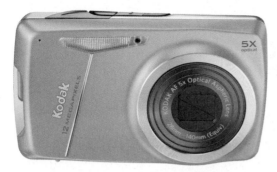

FIGURE 1-7  The Kodak EasyShare M580

Although the resolution and features that each point-and-shoot camera offers are slightly different, from the outside, many of these cameras look very similar. Figure 1-7 shows a Kodak M580 camera, and Figure 1-8 shows the Nikon S1100pj digital point-and-shoot camera. What you need to focus on is the camera's technical specifications, including its resolution, zoom capabilities, and the size (and ease of viewing) of the LCD display. How the camera feels in your hands and how intuitive the button and dial placement are should also be a consideration.

While Chapter 2 offers the information you need to know to become a savvy consumer when shopping for a point-and-shoot camera, what you need to know right now is that these cameras are housed within one unit. There are no removable lenses, and most don't allow you to attach an external flash unit. These cameras typically come with one rechargeable battery pack (and a charger unit); however, you can also purchase additional batteries. Aside from the battery, the only other accessory needed is a memory card. Depending on the durability of the camera, you might also spend an extra $15 to $30 for a custom-fitted, padded case to protect your investment, but that's optional, as is a small tripod, for example.

FIGURE 1-8  The Nikon COOLPIX S1100pj (Courtesy of Nikon, Inc., Melville, New York).

Today's point-and-shoot digital cameras have a single built-in zoom lens. How much zoom capability you have will vary greatly among camera makes and models. Some offer a 3x optical zoom, for example, whereas others offer a 5x or even a 15x (or greater) digital zoom. The greater the zoom capability of the camera, the closer you'll be able to get to your subject without you, the photographer, physically moving closer to the subject.

**Note**  You'll learn the difference between a digital zoom lens and an optical zoom lens in the next few chapters.

Another factor that differentiates the various point-and-shoot digital cameras is their resolution. Lower-end (and lower-priced) digital cameras in this category will have a resolution of 3MP or 5MP, for example. The higher-end digital

point-and-shoot cameras will offer resolutions between 10MP and 14.1MP (or greater). Yet, from the outside, you'll notice minimal differences between a 5MP versus a 14.1MP camera. What matters is the technology housed within the camera and the quality of the lens. This is what allows you to take better quality pictures.

As you start looking at the various digital point-and-shoot cameras, you notice manufacturers boasting about the special features and functionality that their particular cameras offer. The size of the camera's built-in LCD display—and how easy it is to view—is an important factor to consider, since the LCD display is your viewfinder and allows you to preview images and select and activate various features that your camera offers. Figure 1-9 shows a typical LCD screen built into a digital point-and-shoot camera.

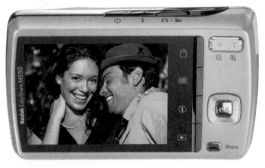

**FIGURE 1-9** The LCD screen built into a digital point-and-shoot camera is used as a viewfinder, to preview images, and to select features from the camera's menu options.

**Caution** One drawback to some digital point-and-shoot cameras is that the LCD screen can't be viewed easily in bright sunlight, making it very difficult to determine what you're shooting when outside, since the LCD display serves as your viewfinder. A larger, higher-definition (better resolution) LCD display will prove useful.

However, in terms of the other features and functions, focus in on what's important to you as a photographer and the types of photos you plan to take with the camera. Then decide which features and functionality are of interest to you.

**Tip** Many of the latest digital point-and-shoot cameras also have an HD video mode, which allows users to shoot high-definition video using the camera. Although this feature isn't designed for shooting long movies, it's great for capturing shorter video clips to share online, for example. Descriptions of this and other popular features now being built into digital point-and-shoot cameras, including front and back LCD displays, touch-sensitive LCD displays, and face and smile recognition, are covered in Chapter 2.

Because digital point-and-shoot cameras are completely housed in a single, palm-sized unit, these cameras rely on technology and built-in software, as opposed to high-quality lenses, a top-quality photo sensor, and a photographer's skill, to capture images. Yet, most amateur photographers, and even serious hobbyists, will be pleasantly surprised by how good the latest digital point-and-shoot cameras have become in terms of their ability to shoot amazing and professional-quality images, without the photographer needing a background in photography.

As the "point-and-shoot" name suggests, you literally turn the camera on, point it at your subject, press the shutter button, and take your photos. You can add a step and customize the settings manually on your camera, if you're taking pictures in a low-light situation or of a fast-moving subject, for example. But otherwise, the shooting process itself is pretty straightforward and simple. Once you've taken your photos, they're saved on a memory card. Using a simple process (described within Chapter 11), you can later transfer your images to a computer for viewing, editing, storing, sharing, or printing, or connect the camera directly to a photo printer to create prints.

 Digital point-and-shoot cameras priced between $25 and $99 typically offer low-resolution, a low-quality image sensor, and very few features. They're also not too durable and have a long lag time. Your photographs will be vastly inferior to the photos you could take with a more expensive and better quality camera that's priced between $100 and $300, for example.

Beyond the selection of features and functions built into the digital point-and-shoot cameras, once you narrow your choices down to a price range, you'll notice your options from the various manufacturers are rather similar. What differs, however, is the packaging and aesthetic look of the camera itself. To appeal to young women, for example, some camera casings come in bright pink or other feminine colors, whereas others are more masculine looking, with a black, silver, or metallic blue casing. The functionality of the different-colored cameras, however, is identical.

 One of the biggest complaints consumers have with digital point-and-shoot cameras is their lag time. Sometimes it takes several fractions of a second to several seconds, from the time you press the shutter button, for the camera to snap a photo. As a result, you miss out on many types of action shots, for example. Later, you'll read about how to partially overcome this problem. But a camera's lag time is definitely something you'll want to be aware of.

## Specialty Point-and-Shoot Cameras

Like any piece of consumer electronics equipment, such as an iPod, video camera, or cell phone, most digital point-and-shoot cameras are made to be durable, but they're not indestructible, waterproof, or built to withstand drops or rough treatment. However, if your goal is to take vacation photos, and you typically vacation on a beach, boat, or mountain, or you participate in extreme activities involving dirt, water, snow, ice, or mud, for example, seriously consider investing in a digital point-and-shoot camera that's designed to be extra durable.

The Olympus Tough series of digital point-and-shoot cameras, along with a select group of similar cameras made by other manufacturers (including Lumix), are designed to be waterproof. They can get wet or even submerged in several feet of water. These specially made cameras are also temperature-resistant and will work well in extremely hot or cold weather, and they're durable enough to be dropped from several feet onto a hard surface and not get damaged.

**Caution** Unless a point-and-shoot camera is water-resistant, don't let it get wet! In other words, keep it away from the beach, swimming pools, lakes, oceans, snow, or rain storms. Likewise, always use the camera's wrist strap so it doesn't fall. If not treated carefully, a camera's lens and/or LCD display can be scratched or broken easily.

While some point-and-shoot digital cameras are *water-resistant*, there are specialty cameras that are *waterproof;* these can be used underwater when snorkeling, swimming, or even scuba diving. Water-resistant cameras also allow you to shoot photos in rain storms, without damaging the unit. For example, if you visit a popular tourist destination, such as Niagara Falls or SeaWorld's Aquatica water park, you'll immediately discover the need for a water-resistant or waterproof camera.

There are other types of specialty point-and-shoot digital cameras as well. Polaroid offers a 5MP digital point-and-shoot camera with a 4x optical zoom lens that also has a built-in photo printer (www.polaroid.com/products/0/266909). Several companies also offer durable and very easy-to-use digital point-and-shoot cameras designed specifically for young children (ages three to nine). For example, there's the VTech KidiZoom Plus digital camera ($49.95, www.vtechkids.com/product.cfm/Kidizoom_Plus/1634/), which offers 2MP resolution and enough built-in memory to store about 500 shots without using a memory card.

**Note** Some specialty digital point-and-shoot cameras have a built-in lens for shooting wide-angle, panoramic images, or have other special features above and beyond what a typical point-and-shoot camera would offer.

## Digital SLR Cameras Offer Many Distinct Features and More Control

Digital SLR cameras give you, the photographer, much greater control over your photographs, plus they tend to offer significantly better overall picture quality. The lenses and image sensors in these cameras tend to be larger and better quality.

The drawback, when compared to digital point-and-shoot cameras, is that Digital SLRs are larger in size and heavier to carry around.

While some Digital SLR cameras are relatively inexpensive and targeted to amateur photographers, the primary audience for these cameras are more serious hobbyists, semiprofessional, and professional photographers who want to be able to swap lenses, shoot more vibrant and detailed images, and take advantage of optional camera accessories, like external flash units and lens filters, all of which are described in Chapter 3.

Digital SLR cameras also have manual shooting modes, which allow you to control every aspect of a shot from a technical standpoint, including manually focusing on your subject. These cameras, however, also have fully automatic shooting modes, as well as semi-automatic shooting modes, which give you some manual control, but allow the camera to adjust certain settings as you shoot.

Digital SLR cameras tend to be significantly more expensive than digital point-and-shoot cameras. They're often sold as camera bodies only, meaning you'll need to purchase your lenses, memory cards, and other accessories separately. Nikon, Canon, and other Digital SLR manufacturers also sell kits, which include a camera body, one general function lens, a battery pack, a charger, USB cable, and a few other basic accessories. Individual lenses, as well as other accessories, from flash units to tripods, are all sold separately.

 Perhaps the biggest advantage of shooting with a Digital SLR is that these cameras have little or no lag time. When you press the shutter button to capture an image, that shot is taken and saved in a fraction of a second, with no delay. Thus, shooting sporting events or fast-moving subjects (such as children or pets), for example, is easier.

Digital SLR cameras can be subdivided into distinct categories, including low-end, mid-priced, and professional-level, based on their price point and functionality. The Nikon D300s (shown in Figure 1-10) is an example of a popular, higher-end (but still mid-priced) Digital SLR camera.

### Low-End Digital SLR Cameras

For under $300, you can purchase a low-end Digital SLR camera that will offer you many of the advantages and much of the picture-taking control you'd otherwise have with a full-featured camera, but not all of the features and functionality that you'd enjoy with a professional-level camera. You'll also notice

a major difference in quality in the photos taken with a low-end Digital SLR versus professional-level equipment.

Lower resolution, poorer quality image sensors, and slower shooting speeds are some of the drawbacks to this camera category, although you'll have more manual control and options than if you were to use a digital point-and-shoot camera, and you can benefit from using a more powerful external flash unit, for example, when shooting in low-light situations.

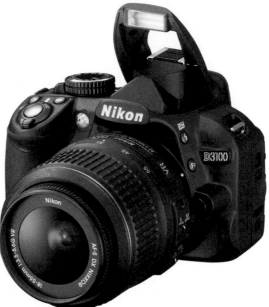

## Mid-priced Digital SLR Cameras and Hybrid SLRs

For amateur photographers and hobbyists alike, if you opt to go with a Digital SLR, this is the camera category that'll best suit your needs in terms of quality, functionality, and user-friendliness. A traditional mid-priced Digital SLR, from a company like Nikon or Canon, will give you a nice selection of optional and high-quality lenses and accessories to choose from. Plus, you'll be able to take full advantage of professional-level photography features, while also using automatic and semi-automatic shooting modes specifically designed for amateur photographers.

Hybrid Digital SLRs are a cross between digital point-and-shoot cameras and full-featured, mid-priced Digital SLR cameras. They're becoming more and more popular among amateur and hobbyist photographers, because they tend to be just as feature-packed and powerful as comparable Digital SLRs, but they're smaller physically and lighter weight.

Unfortunately, although hybrid Digital SLRs do offer interchangeable lenses, the lens selection is not as diverse as what Nikon and Canon offer. When you opt to go with a Nikon or Canon Digital SLR camera, the lenses are compatible with all of their camera bodies. Therefore, you can invest in a lower-end, less-expensive Canon camera body to start off, spend a bit extra when purchasing quality lenses, and then upgrade just the camera body later. Canon EOS lenses are interchangeable and compatible with all Canon EOS Digital SLR cameras. The same is true for Nikon Digital SLR cameras.

**Note** Camera model numbers and technical specifications change constantly. What's described here was current at the time this book was written and serves as a good overview of what's available. When you start shopping for a camera, you'll probably find slightly more advanced camera options from these companies, potentially at lower prices.

If you're just becoming interested in photography, any of the cameras in the Canon EOS Rebel series (which range in price from $550 to $900 for a kit) is a perfect choice. The lower-end Canon EOS Rebel XS 18-55IS Kit ($550) offers 10.1MP resolution, has a built-in 2.5-inch LCD display (with Live View feature), and is capable of shooting up to 3 frames-per-second when in continuous shooting mode. The camera is compatible with over 60 different Canon first-party lenses and has a really nice selection of built-in features and functions.

Also in the Canon EOS Digital Rebel camera series is the EOS Rebel T2i EF-S 18-55IS Kit ($900). As of mid-2010, this camera is the flagship in Canon's EOS Digital Rebel line. It features 18MP resolution, shoots video in 640×480 mode, has a built-in 3-inch LCD display, and can shoot up to 3.7 frames-per-second in continuous shooting mode. If you're an amateur photographer who wants to take on photography as a hobby and plans to invest time and money in it, this is a wonderful starter camera. It offers a wide range of optional lenses and accessories and is loaded with shooting features. Depending on shooting conditions, you can expect to shoot between 150 and 550 shots per battery charge.

**Tip** To learn more about the Canon EOS Digital Rebel lineup of cameras, lenses, and accessories, visit www.usa.canon.com/cusa/consumer/products/cameras/.

When it comes to Digital SLR cameras, Canon and Nikon both offer a wide selection of top-quality products. For example, the cameras that are most comparable to Canon's EOS Digital Rebel series (as of mid-2010) are the Nikon D3000 ($400 to $500), D5000 ($500 to $600), and D90 ($800 to $900).

These cameras offer Nikon's unique "Guide Mode," which provides in-camera assistance for selecting and setting camera settings and utilizing professional picture-taking techniques. The D3000, for example, offers a 3-inch LCD display, 10.2MP resolution, 6 predefined shooting modes, and can shoot at up to 3 frames per second in continuous shooting mode. The battery is capable of lasting up to 550 shots on a single charge (depending on shooting conditions), and the camera is equipped with a 23.6×15.8mm image sensor that captures 10.75 million pixels per image.

To learn more about Nikon's lineup of Digital SLR cameras, lenses, and accessories, visit http://imaging.nikon.com/products/imaging/lineup/digitalcamera/slr/.

The Sony NEX-5 ($649.99, www.sony.com/NEX) is a perfect example of a hybrid Digital SLR camera. It's about half the size and weight of a typical Nikon or Canon Digital SLR camera, yet it offers 14.2MP resolution, the same size image sensor as a full-size Digital SLR, and is compatible with a collection of Sony E-mount or A-mount lenses. This camera can also shoot 1080/60i HD video. As a result of this configuration, photographers can shoot with a camera that's as good in quality as a mid-priced Digital SLR, but has the convenience and portability of a digital point-and-shoot camera.

## Professional-Level Digital SLR Cameras

If and when you become serious about photography, the cameras in this category, from companies like Canon and Nikon, are priced in the several thousand dollar range for the camera body, plus you'll need to invest in lenses and other accessories. These cameras offer the most state-of-the-art features and functionality, the best quality lenses, the highest resolutions, and the finest quality image sensors. They also tend to be the largest in physical size and the heaviest to carry around. Yet, the picture quality is, without a doubt, superior to any lesser quality cameras on the market.

**Note**

For a professional-level Digital SLR camera, plan on spending between $2,500 and $5,000 for the camera body, plus between several hundred and several thousand for each lens.

Nikon's D3x, with its 24.5MP resolution, is among the company's most advanced camera body options, which is suitable for professional photographers. Canon also offers a lineup of professional-level cameras, including the EOS-1Ds Mark III (which as of mid-2010 is their top-of-the-line offering, with 21.1MP resolution).

Even in fully automatic mode, the quality of images you can take with any of these professional-level cameras is vastly superior to what you can take with a digital point-and-shoot camera.

In addition to higher resolutions and better image sensors, you'll find these professional-level cameras offer the ability to shoot a higher number of frames per second and offer a greater selection of built-in shooting modes. They're also a bit more complicated to use because they have many different manually controlled options, settings, and features.

## Cell Phone, Smartphone, and Low-End Digital Cameras

Just about all of the current cell phones and Smartphones (including the iPhone, Blackberry, Windows Mobile, and Android-compatible phones) have built-in digital cameras. Some of these cameras offer no frills or features—just the ability to point-and-shoot and capture low-resolution (2MP to 3MP) images, which can instantly be sent to people via the wireless web, or posted to popular online social networking sites, like Facebook or Twitter.

While you can't be too artistic or creative with these cameras, they do offer the ability to shoot just about anywhere and immediately share your images with friends, family, and co-workers. You also have the option to load these images into a computer to edit them or transform them into hard copy prints (in standard 4"×6" or 5"×7" sizes, for example). If you try to create 8"×10" or bigger enlargements, you'll quickly see the image quality of pictures taken with these low-resolution cameras deteriorate and become very pixilated.

Some of the newer Smartphones, like the Apple iPhone 4, offer a higher-resolution built-in camera with 5MP resolution and a built-in LED flash. You can also download apps for the phone that allow you to edit and digitally enhance your photos right from the phone, add special effects, and then distribute them easily via the wireless web. These newer phones are coming closer and closer to offering the image quality and functionality of digital point-and-shoot cameras. For some amateur photographers, they're good enough.

 Within a few short years, chances are the need for a separate digital point-and-shoot camera will be eliminated, because the features, quality, and functionality you want and need from a digital camera will be built into your handheld Smartphone.

For simply sharing low-resolution images with people online and being able to capture candid photos at parties or while socializing with friends, the cameras built into cell phones and Smartphones are adequate, as are the many low-end, extremely inexpensive digital point-and-shoot cameras you can purchase for under $50 from mass-market superstores (like Wal-Mart or Target), or even from the photo department within large pharmacies. The majority of these cameras work fine, but offer very low resolutions and few or no shooting features.

If your goal is to take good quality pictures in a wide range of situations, and have the flexibility to share these images online or to transform them into prints of any size, invest at least $100 to $300 in a good quality digital point-and-shoot camera, or $500 to $1,000 into a good quality Digital SLR with a general-purpose lens and some other basic accessories.

## Your Goals as a Photographer

The next chapter offers advice on how to choose the ideal digital camera and where to buy it. As you begin reading the next chapter, consider your goals as a photographer and what type of pictures you anticipate taking.

Will you be shooting images indoors or in low-light situations, or will you be spending the majority of your time taking pictures of your kids or pets who refuse to sit still? Does the concept of a point-and-shoot camera appeal to you, or are you someone who will want more control over your picture-taking abilities in order to tap your photographer's eye and imagination and take truly creative photos?

Once you know what your photography goals are, you'll be able to choose what type of camera best suits your needs. Then, it's just a matter of looking at the designs, features, and functions that the various manufacturers have built into the cameras in that category. Choose a camera that you believe will best meet your needs and budget.

# 2

# Buy Your New Digital Camera

## How to...

- Define your photography needs and budget
- Select the camera features that are important to you
- Choose the equipment that meets your needs
- Find the best deals before making your purchase

Before you go off and start taking pictures, you need to equip yourself with the right digital camera and accessories that allow you to shoot the types of pictures you want to take. As you'll quickly discover, however, there's no such thing as the perfect camera that's suitable for everyone. When you start shopping for cameras, you'll discover dozens of options from many manufacturers—like Kodak, Canon, Nikon, Sony, Olympus, Lumix (Panasonic), and Sigma—at many different prices, and all offering a unique combination of features and functionality. Two cameras might look very similar aesthetically, but when you examine them more closely, you'll discover each is unique in terms of what they offer.

This chapter will help you pinpoint your digital camera equipment wants and needs, set a budget, introduce you to some of the most popular and the latest features and functions of digital cameras, and then help you find the very best deal possible when making your purchase.

## Buying a Digital Camera Is a Lot Like Buying a Computer

When you look at the technical specifications of a digital camera, it can be as confusing as shopping for a state-of-the art computer, and in many ways, the two experiences are very similar. After all, even the most basic point-and-shoot digital cameras have powerful microprocessors, internal memory, built-in displays, recording media, and a plethora of other technological features to consider. And that's before you even start to think about the relevant photography features and functions built into the newest digital cameras.

Like buying a computer, many hardware manufacturers offer products at similar prices. However, each camera within a specific price category will have its own design, features, and functions that somehow set it apart from the competition—even though on the outside, multiple camera models from various manufacturers might look almost identical.

Now add to the mix the several different types of digital cameras, from simple point-and-shoot cameras costing under $200 to much more advanced, professional-quality Digital SLR cameras that can cost several thousand dollars just for the camera body.

Oh, and like computers, with each passing season, new models are introduced offering even more advanced features and functions. As a consumer, developing a basic understanding of the technology behind digital cameras will help you select the best one to meet your needs. Don't worry; you don't need to go back to school and obtain an advanced degree in computer science. The core knowledge you'll need to buy the perfect digital camera will be provided right here.

## Technological Considerations When Buying a Digital Camera

Whether you're looking to purchase a basic point-and-shoot digital camera, a more advanced Digital SLR, or a professional-quality Digital SLR, many of the technological considerations will be similar. When you look at the technical specifications of any digital camera, the following sections present a sampling of what's actually important.

### Battery Life

Some digital cameras still use standard "AA" or "AAA" batteries, but most use proprietary rechargeable batteries that will last between 100 and 800+ shots per charge (without using a flash). Obviously, you want to look for a camera that advertises a high number of shots per battery charge, but even so, purchase at least one or two extra batteries, and keep them fully charged and with you whenever you're taking pictures.

Instead of spending $30 to $50 for an extra name-brand battery for your camera, you can find replacement batteries for between $3 and $10 each online. Using NexTag.com (a popular price-comparison website), type in the make and model of your camera, followed by the words **replacement battery**, to find companies that sell inexpensive batteries for your camera.

## Features

All of the digital cameras on the market today are literally jam-packed with features and functions. Features include things like a camera's resolution, the power of the zoom lens (for point-and-shoot cameras), the capabilities of the built-in flash, how long a battery charge lasts, whether the camera is waterproof or water-resistant, and how easy it is to view the built-in LCD. Other camera features to consider are whether the camera comes with a sturdy wrist or neck strap and whether you need a separate case. Also, you need to determine whether the camera can connect to a computer using a standard or proprietary-size USB connector cable, or if it offers Wi-Fi or Bluetooth compatibility for transferring images between the camera's memory card and your computer (or an online photo service).

## Functionality

Technologically, today's digital cameras are extremely complex and advanced, which is what allows them to be so powerful, yet so easy-to-use without your having to understand any traditional photography principles to take professional-quality images. Even with a top-of-the-line, professional-quality Digital SLR, if you set it to Auto mode, you don't need to know anything about aperture, white balance, shutter speed, or any of the other more than a dozen photography concepts that were once absolutely essential for taking photos with a professional-quality film camera. In terms of functionality, look for a camera with an intuitive user interface, easy-to-understand onscreen menus, intuitive buttons and dials, plus lots of different menu-controlled shooting modes (for taking pictures in specific situations). Features like image stabilization, continuous shooting, and the ability to take panoramic images are all very handy for most amateur photographers.

## Image Sensor

In addition to looking at a camera's resolution, consider the shape and size of its built-in image sensor (measured in millimeters). The larger the sensor, the better quality images you'll be able to shoot. The *image sensor* determines the depth of field, image noise, diffraction, and overall image detail for the pictures you'll be taking.

## LCD Screen

The majority of point-and-shoot digital cameras don't have a viewfinder you look through. Instead, you have an LCD screen that acts as a digital viewfinder, as you can see in Figure 2-1. Digital SLRs have traditional viewfinders, but they also allow you to preview your images instantly on a built-in display. Regardless of the camera type, however, the biggest problem with these LCD displays is they're typically low resolution (not too detailed), and they're extremely difficult to see when it's too sunny.

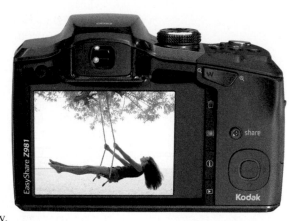

**FIGURE 2-1** Digital cameras have at least one LCD screen that displays the camera's menu system for selecting camera functions and acts as the viewfinder.

Ideally, you want a large LCD screen that is easy to see in a wide range of lighting situations. Regardless of which camera you choose, the image you see on these screens is of much lower quality than the image the camera actually photographs. When you view the images on your computer screen or use a photo printer to make hard copy prints, you'll discover your images are much more detailed than they appeared on the small LCD screens built into the cameras.

## Recording Format

*Recording format* refers to the type of memory card the camera uses. As you'll discover in Chapter 3, there's a lot to understand when it comes to memory cards. They're not all the same. Choose a digital camera that utilizes a common memory card format. Point-and-shoot digital cameras tend to use smaller (and less expensive) memory cards, like Secure Digital (SD) cards, MiniSD cards, memory sticks, SmartMedia, or xD-Picture cards. Higher-end Digital SLR cameras often use CompactFlash cards or MultiMediaCards (MMC). You'll soon learn that each type of memory card comes in a variety of different memory capacities and read/write speeds, which dramatically impacts the functionality you'll get out of your camera. But more on memory cards in Chapter 3.

## Resolution

Most digital cameras these days (except for those found within cell phones and smartphones) have a resolution of at least 10 to 12 megapixels. A higher resolution often means better quality photos, but it also determines to what size your images can be enlarged without being distorted. If you'll simply be displaying your images on Facebook, for example, lower resolutions are

perfectly fine. However, if you'll be making prints of your images, and perhaps creating 8"×10" or even poster-size enlargements, a higher resolution is better. The higher the resolution, however, the more storage space each image takes on your memory card and later on your computer's hard drive. Some user-friendly services like Facebook will automatically adjust the file size and resolution of your images for optimal online viewing; some other sites will keep your original image file size intact.

### Size and Weight of the Camera

Each digital camera manufacturer has its own camera designs. Ideally, you want a camera with intuitive buttons and controls, and one that's comfortable to hold. A compact point-and-shoot camera will weigh just 3.5 to 5.0 ounces, while a Digital SLR will be a bit more cumbersome and require two-handed operation.

### Speed

One of the biggest drawbacks of low-to-mid-range digital cameras is their lag time. You press the shutter button, but it takes a fraction of a second to several seconds for the camera to actually take the photo and store it on the camera's memory card. If you're trying to capture something that involves movement or action, lag time is a huge potential problem. Based on the lag time of your particular camera, you have to anticipate the action and press the camera's shutter button *before* what you want to shoot actually takes place. The semiprofessional and professional Digital SLR cameras don't have this lag-time problem, but their cost is significantly higher. Pay attention to the camera's shooting speed (which is measured in fractions of a second) when reviewing a camera's technical specifications.

## Did You Know?

## Megapixels Determine Camera Resolution

A megapixel is equal to one million pixels. Thus, an image shot at 12-megapixel resolution, for example, is comprised of 12 million separate pixels or colored dots. The more megapixels used to create an image, the more memory required to store it. When using a high-resolution camera, you'll want a memory card with a capacity of least 4 to 8 gigabytes (GB), although 32GB memory cards are now readily available. With lower resolution cameras, you can easily get by with a memory card with just a 1 or 2GB capacity.

## How to. . .    Become a Brand Loyal Photographer

If you're seeking out a Digital SLR camera that offers interchangeable lenses, as you select your camera, also pay careful attention to the selection and cost of the available lenses, flash units, and other accessories. Remember, with the higher-end Digital SLRs, you'll want to invest in the very best lenses you can afford. Here's the good news: as you upgrade camera bodies, as long as you stick with the same manufacturer, the lenses are typically interchangeable. In other words, if you start with a Canon EOS Rebel series camera (which is ideal for someone starting out in photography and who wants a good-quality Digital SLR camera), but you ultimately upgrade your camera body to a Canon Mark 5D, 7D, or 50D (or whatever the most recently released model is), all of your lenses will work on the new Canon camera body. The same is true for cameras from Nikon. So once you pick a brand and start investing in lenses, you'll probably want to stick with that brand when you upgrade. Chapter 3 focuses on lenses and accessories. That being said, several independent companies, like Sigma and Tamron, make lenses compatible with multiple camera manufacturers, but you'll still need to purchase the appropriate lens mount for your camera. However, a Nikon-made lens won't work on a Canon, or vice versa.

### Zoom Capabilities

Unlike Digital SLR cameras, point-and-shoot digital cameras don't have interchangeable lenses or lots of removable parts. These cameras typically have a single optical zoom lens built in. When shopping for a point-and-shoot digital camera, look for a powerful zoom lens. For example, a 5x zoom is less powerful than a 10x zoom. The more powerful the zoom lens, the more you'll be able to zoom in on your subject from a distance. A powerful zoom lens adds to a camera's versatility. Keep in mind that an *optical zoom lens* refers to the lens itself, whereas *digital zoom capabilities* refer to the zooming capabilities of the camera using internal software in combination with the lens. This latter feature isn't typically as good as an optical zoom lens.

## A Camera's Durability Matters, Too

Unless you're shopping for high-end, professional-quality equipment, another important facet to focus on is the camera's durability. If you're a parent and plan to photograph your kids in a wide range of situations, or if you're an active individual who enjoys sports or spending time outdoors in any weather

condition, having a camera that's waterproof, shockproof, and temperature proof is extremely useful.

Being able to shoot in the rain, in and around a swimming pool, while kayaking, under a waterfall, and/or in cold winter temperatures (while skiing or snowboarding, for example), and not having to worry about damaging your camera, opens up a wide range of opportunities for taking photos in places where you wouldn't necessarily want to bring a high-end Digital SLR. Plus, if you accidently drop a durable point-and-shoot camera, you don't have to worry too much about it breaking.

**Tip** Chances are whatever digital camera you purchase now will be technologically obsolete in three years or so anyway, so focus on selecting a camera you'll be able to take full advantage of right away—not one that'll take you months or years to figure out and master.

## Define Your Photography Needs and Budget

If you're feeling a little intimidated about choosing the perfect camera without overspending, or you're concerned about buying a camera that'll be too complex for you to figure out, don't worry. The first thing you need to do is sit down and carefully define your wants and needs, plus determine your level of existing photography knowledge (or lack thereof).

Ask yourself the following questions:

- What will you be taking pictures of primarily? Your kids, pets, parties, vacations, nature, action-oriented/ adventure activities, sporting events, products to sell on eBay.com, etc.?

- Where, and in what conditions, will you be taking most of your photos? Inside, outside, during the day, at night, in the rain, using artificial light, using a flash, underwater (when snorkeling, swimming, or scuba diving), etc.?

- How much manual control do you want over your picture taking? Are you interested in learning the fundamentals of photography and doing everything manually? Or are you more interested in a camera with an "auto" feature that does just about everything for you?

- What size camera are you looking for? Do you want something that easily fits in the palm of your hand,

a shirt pocket, or in a purse, and that's easy to use, such as a basic digital point-and-shoot camera? Or do you want a larger and heavier Digital SLR camera with interchangeable lenses and lots of optional accessories—a camera that'll give you maximum control over your picture taking and typically result in more professional-quality photos?

- What will you be doing with your photos once they're taken? Will you be posting them online to share with friends and family, creating traditional photo albums, or making enlargements and framing the prints, etc.?

- How much money do you have to spend on your camera, along with all of the necessary accessories and equipment, to be able to take the photos you want to take?

- Is there a particular camera brand you're partial or loyal to? Many professional photographers choose a brand, such as Canon or Nikon, early in their careers, and stick with that brand for decades, upgrading their equipment as needed.

Just by answering these questions, you should be able to determine if a point-and-shoot camera is best suited to your needs, or if what you're in the market for is a more advanced Digital SLR camera that'll be more cumbersome, but typically result in more polished pictures.

Once you know what camera category to focus on, and you know how much you want to spend, now you need to figure out what camera features and functions are most important based on the types of photos you plan to take. That's the focus on the next section of this chapter.

As you're shopping, revisit the previous technological considerations section, and make sure you choose a camera that offers the speed, resolution, and battery life you need. Beyond that, it comes down to research and taking a firsthand look at the cameras available in your price range from the various manufacturers, and then deciding which is the most suitable based on its design, weight, appearance, and how it actually feels in your hands.

**Tip** It's always best to try out a camera firsthand before purchasing a specific make and model. If possible, examine sample images taken with that camera as well. While many people focus on the appearance of the camera itself, delve deeper and pay attention to its shutter speed; the layout of the buttons, dials, and menus; and how easy the LCD screen (viewfinder/photo preview window) is to see. The camera's technical specifications—its resolution, image sensor, and speed, for example—are also important.

## Research Cameras by Visiting Manufacturer Websites

The websites of the popular camera manufacturers are an excellent resource for learning about new or soon-to-be-released equipment, and for finding out the technical specifications of digital cameras, allowing you to compare various makes and models.

Without taking into account digital cameras built into cell phones and smartphones, the following is a list of websites for some of the popular point-and-shoot and Digital SLR camera manufacturers:

| | |
|---|---|
| Canon | www.usa.canon.com |
| Casio | www.casio.com/products/Cameras |
| Fujifilm | www.fujifilmusa.com |
| Kodak | www.kodak.com |
| Lumix | www.panasonic.com/Lumix |
| Nikon | www.nikon.com |
| Olympus | www.getolympus.com |
| Pentax | www.pentaximaging.com |
| Polaroid | www.polaroid.com |
| Samsung | www.samsung.com |
| Sigma | www.sigmaphoto.com |
| Sony | www.sony.com |

## How to. . .   Read Up on Current Camera Makes and Models

Especially if you're serious about your picture taking, you'll probably want to put some research into purchasing your equipment. Since digital camera technology is always changing, you can stay up to date on the latest innovations by reading professional reviews in photography magazines like *Popular Photography* (www.popphoto.com), *Digital Photo* (www.dpmag.com), and *Digital PhotoPro* (www.digitalphotopro.com), all of which are available at newsstands. There are also countless, highly reputable photography websites, such as *Digital Photography Review* (www.dpreview.com), that publish equipment reviews.

*(Continued)*

Beyond reading what the pros have to say, go online and find consumer-written reviews for the cameras you're interested in. Reading these allows you to learn exactly what people like yourself, who have already purchased the equipment, think about it. You'll find consumer reviews on websites like Amazon.com, as well as on the sites of popular photography equipment online stores, such as B&H Photo Video (www.bhphotovideo.com).

# The Latest and Greatest Digital Camera Features and Functions

Whether you want to tinker with every possible setting and manually focus your camera as you take each picture, or you want to set the camera on Auto and let it adjust everything to help ensure the best quality picture possible, the latest digital cameras allow you to do either—and so much more.

Imagine you're at a party and you want to take a photo of a group of people. As a photographer, your goal is to get everyone to look at the camera and smile at the same time, plus avoid red eye. With adults, as any photographer knows, this is a challenge. Add a few kids into the mix, and getting that perfect group photo will probably take—at least—a handful of attempts. That is, unless your camera has Face and Smile Detection, as shown in Figure 2-2, which automatically focuses in on everyone's faces in your group and won't even let you snap the photo until everyone is looking at the camera *and* smiling.

**FIGURE 2-2** On many digital cameras, the Face Detection feature will work simultaneously on one or multiple subjects.

Face and Smile Detection are just two of the more advanced features found in many point-and-shoot cameras. As you begin examining the cameras currently on the market, you'll discover literally hundreds of amazing features, the likes of which didn't exist just five years ago.

Some of the newer point-and-shoot cameras have touch-screen displays, making it easier to navigate around the menus; two separate screens (one in the back and one in the front);

special low-light modes for taking pictures inside or outside at night; and even an HD Movie mode that allows you to capture short videos in addition to still pictures. In fact, even some of the high-end Digital SLR cameras, from companies like Canon and Nikon, now have an HD Movie mode.

A camera that has two screens allows you see what you're shooting when the camera is pointed outward, but also allows you to see what you're shooting if you turn the camera around, pointing it toward you (so you can be in the photo). Let's say you're on vacation; this feature is great if you like to take photos of yourself and your companions, but don't like to hand your camera to strangers and ask them to snap your photo. With this feature, you can do it yourself, and see what you're shooting if you have a camera with a forward-facing display/viewfinder.

Another helpful shooting mode built into many point-and-shoot cameras is *AF Tracking* (Auto Focus Tracking), which means the camera automatically focuses in on fast-moving objects, such as pets, children, or athletes participating in a sport. This mode helps ensure you wind up with blur-free photos, without having to manually adjust any camera settings.

Shadow Adjustment is another useful feature. When activated, it brings out more detail in shadows, so as the photographer, you can be less concerned with the lighting situation.

If you travel often and enjoy taking outdoor photos, for example, a camera with a built-in Panorama mode will allow you to shoot three or four images and automatically stitch them together to create a seamless panoramic image. This is ideal if you're visiting the Grand Canyon or another vast landscape and want to capture it in all its grandeur, without having to fiddle around with too many buttons and dials on the camera, or become a Photoshop expert in order to edit several separate images together after the fact.

**FIGURE 2-3** The Share button found on many Kodak digital cameras makes sharing images quick and easy via the Internet, assuming there's a Wi-Fi hotspot nearby.

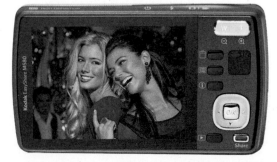

Shown in Figure 2-3, Kodak has trademarked the *Share* button that's now being built into many of its digital cameras. With the touch of a button, when the camera is connected to a Wi-Fi Internet signal, it can automatically upload pictures from the camera's memory card to one of several online photo services, such as Flickr. com or Kodak Gallery, or online social networking sites, such as Facebook, for

easy sharing. This functionality is available from a few other camera manufacturers, but can be added to almost any digital camera when you purchase an Eye-Fi memory card (www.eye.fi), which is described later in this book.

 Once you have a general idea about what types of photos you'll want to take with your camera, you'll find it much easier to narrow down which features and camera functions are most important to you. If you're shopping for a point-and-shoot camera, a built-in 10x or 12x optical zoom (or better) will certainly be useful in a wide range of situations.

These days Image Stabilization is pretty much standard in all digital cameras. Without this feature, if you move the camera even slightly when snapping a photo, you'd get a blurry image, like you see in Figure 2-4. With this feature activated, it compensates for minor camera movements, giving you crystal-clear images, as shown in Figure 2-5. As a general rule, you want to keep the camera as steady as possible when shooting.

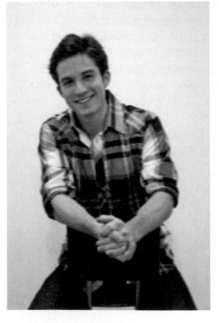

**FIGURE 2-4** The camera moved slightly while this photo was taken *without* the Image Stabilization feature activated.

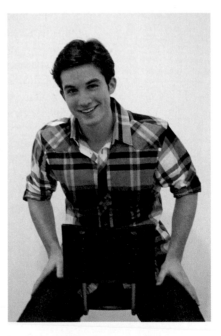

**FIGURE 2-5** The camera moved slightly while this photo was taken *with* the Image Stabilization feature activated.

However, if you're taking photos from a moving car, bus, boat, or train, some movement can't always be avoided, which is when Image Stabilization is really useful. Chapters 4 through 9 offer a wide range of photography techniques for shooting in a variety of different situations, including when you, the photographer, are in motion, or when you're standing still but trying to capture fast-moving subjects, so you don't end up with blurry or out-of-focus images.

## Limitations of Low-End Cameras

While digital cameras have become extremely affordable, the low-end models (costing less than $150 or so), including the cameras found in many cell phones and smartphones, often have some definite drawbacks that more costly and advanced camera models don't have. For example, some low-end point-and-shoot cameras have a limited 3x or 5x built-in zoom, compared to higher-end point-and-shoot cameras with a 10x to 15x zoom.

Low resolution is also another factor to consider, unless your primary goal is just to post your photos online (using Facebook or another service). With the resolution of today's cameras offering upwards of 15MP or more, settling for anything less than 8MP isn't recommended. The size of the camera's image sensor is also a factor. A low-end, small image sensor will result in poorer quality images.

Another potential drawback to low-end cameras, including those which use "AA" or "AAA" batteries, is short battery life. A decent-quality digital camera should have a battery life that lasts between 300 and 500 shots (without using a flash).

Perhaps the biggest complaint many people have about low-end digital cameras is their lag time. Lag time occurs when you press the camera's shutter button to snap a photo, but it takes between a few fractions of a second to several full seconds before the camera actually takes the photo and saves it to the memory card. If you happen to be shooting something involving action or movement, or trying to capture a particular moment—such as someone blowing out candles on a birthday cake or crossing the finish line of a race—a camera with a long lag time can be detrimental to your ability to capture those special moments.

Some features—like Red Eye Reduction, for example—slow down the shooting process even more. What this means to you, the photographer, is that when you're attempting to shoot anything involving movement or action, you need to become

very familiar with your own camera, including its unique lag time, and then anticipate the photo you want to take, *before it actually happens within your viewfinder.* Otherwise, because of the lag time, you'll often miss action-oriented photos, or your subject will have moved between the time the shutter is pressed and the camera actually takes the photo.

Unfortunately, low-end cameras have lag time, and without investing more money to purchase a higher-end camera, there's no getting around it. Once you start looking at cameras costing $500 to $1000+ dollars, including most mid-to-high-end Digital SLR cameras, lag time is no longer an issue.

## Cost Considerations

Especially if you're shopping for a Digital SLR camera, you'll need to consider more than just the cost of the camera when calculating your photography budget. As you'll discover, most Digital SLR cameras are sold in two ways: body only, or as a kit or package. When you purchase a Digital SLR camera body, it does not include any lens or accessories (except maybe for a battery and battery charger). A Digital SLR kit or package, however, will include the camera body, one or two interchangeable lenses, and a variety of other accessories.

Companies like Canon offer kits or packages for many of their Digital SLR cameras to make it easy for consumers to get everything they need to start taking pictures in one box—for a specific price. Typically, the company will choose a mid-priced, versatile lens to accompany the camera body, such as a 28–135mm lens. If you're buying your first Digital SLR camera, consider finding a nicely priced kit or package, as opposed to buying the camera body, lens, and the accessories separately.

When it comes to point-and-shoot cameras, everything is contained within the camera itself (except for the battery and charger, which is typically included with the camera), so you don't have to worry about interchangeable lenses. Everything you need to start taking pictures will be included within the box. You might opt to invest in additional accessories, however, such as extra batteries, a case, or tripod.

**Note** In most cases, digital cameras do not come with the required memory card. You'll need to purchase this separately, before you can begin taking pictures. Chapter 3 offers everything you'll need to know about choosing a suitable memory card for your camera.

## How to...

# Deal with Lag Time and Not Let It Ruin Your Shots

You can do a few things to compensate somewhat for a camera with a long lag time. For example, purchase a memory card with the fastest read/write speed possible, and make sure your camera batteries are fully changed. If your camera has a Continuous Shooting mode, and you need to capture fast-moving action, such as a sporting event or kids playing, take advantage of this mode. You'll wind up with a bunch of extra photos, because you'll be taking multiple images in quick succession, but you have a better chance of actually capturing the exact moment you want. You can always delete the unwanted images later.

# How and Where to Find the Best Deals

When it comes to actually purchasing your camera equipment, you have a variety of options, each of which has its own pros and cons.

## Photography Specialty Stores

If you're new to photography or really confused about what equipment to buy, the best place to find experts is at a local photography specialty store. These stores cater to amateurs, hobbyists, and professional photographers alike, and tend to carry a selection of low- to high-end new and used cameras, equipment, and accessories from a variety of manufacturers for which they are authorized resellers/dealers.

Typically, you'll pay suggested retail prices at photography specialty stores, and even their sale prices are often higher than what you'd pay for comparable items by shopping online. However, the benefit to shopping at a local photography specialty store is that you'll encounter very knowledgeable salespeople who will typically spend plenty of one-on-one time with you to analyze your needs and help you choose suitable equipment. These people will also be very familiar with all of the latest camera equipment and what features are offered, plus they'll be able to point out the often subtle differences among various camera makes and models.

Ritz Camera (www.ritzcamera.com) and Wolf Camera (www.wolfcamera.com) are both chains of photo specialty shops found in many malls across the United States, but you'll also find many independently owned and operated photography specialty stores just by checking your local Yellow Pages or by using an online search engine, such as Google.

## Consumer Electronics Superstores and Mass-Market Retailers

Whether you choose to visit Best Buy, Wal-Mart, K-Mart, Target, or another superstore that sells cameras and electronics, what you'll find is a decent selection of point-and-shoot cameras in all price ranges, plus a much smaller selection of mid-range Digital SLRs. The prices at these superstores are almost always competitive; however, the salespeople are typically not too knowledgeable about the specific camera makes and models and will be hard pressed to explain each camera's features to you.

Superstores are ideal if you know exactly what you want to buy already or if you want to actually see and try out demo models of the various cameras in the store. The return policies at these stores (when you have a receipt) are also pretty liberal for the first 30 days, so if you purchase a camera and discover you've made the wrong choice, or if you have a problem with the equipment, you can exchange it in-person with relative ease.

## Online Photography Retailers

Many online-based photography retailers offer a vast selection of new and used digital photography equipment at rock-bottom prices. When working with these establishments, however, it's essential that you know exactly what camera or accessory make and model you desire, as most of these companies won't spend time on the phone with you answering your questions. Although you'll pay less and have a huge selection to choose from (since these companies maintain a much larger inventory than even the biggest superstores), what you give up is highly personalized customer service and the ability to walk into a traditional retail store and take home your purchase that same day.

While you might not have to pay sales tax on your purchases (based on where you live and where you shop from online), you will probably have to pay shipping and handling charges, plus insurance. And, unless you pay extra for second-day or overnight shipping, you'll have to wait a few days to receive your order.

The online photography retailers all accept major credit cards and some accept PayPal or Google Checkout as well. Three well-established and highly reputable examples of online photography retailers are B&H Photo Video (www.bhphotovideo.com), Adorama (www.adorama.com), and Abe's of Maine (www.abesofmaine.com).

Before making your online purchase, read the company's return policy carefully, including any and all fine print. Many companies charge up to a 20 percent restocking fee for returns, plus you, as the customer, are responsible for return shipping charges and insurance. If there's a problem with the equipment, determine if you'll be able to work with the company (within the first 15 to 30 days) or if you'll have to work directly with the manufacturer.

 When shopping for camera equipment online, pay attention to price, as well as shipping and handling charges. However, also make sure the online business is reputable. Pay attention to customer reviews posted on sites like NexTag.com or BizRate.com, for example. Also, if you're purchasing a high-end or professional-quality camera, make sure the online business you purchase it from is an authorized reseller for that camera manufacturer and that you're not purchasing gray market equipment that might not come with a warranty. Gray market equipment is often heavily discounted, but it was not meant to be sold in the United States.

## Online Auction Sites (eBay.com)

Another online resource for finding and purchasing new or used camera equipment, often at a significant discount, is from an online auction site such as eBay.com. Again, you need to know the exact make and model number of what you're looking to purchase, and you should not expect to receive any type of assistance or technical support from the retailer or seller whatsoever. Be extremely mindful of the seller's positive and negative feedback from other customers, and make sure you read the terms of the sale and the product descriptions very carefully.

**Caution** When shopping for camera equipment on eBay.com, make sure you know if you're buying brand new (factory-sealed) equipment, refurbished equipment, or used equipment. Manufacturer-refurbished equipment often comes with a full warranty; however, if the reseller refurbished a used piece of equipment, you really don't know what you're getting. Also, unless you're buying from a highly reputable dealer, refrain from buying used camera equipment from an auction site, unless you can try out the equipment firsthand before making a bid or purchase, or you really trust the seller (based on their feedback scores or past business dealings).

Consider the following when deciding where to purchase your digital camera, accessories, and related equipment:

■ **Budget**   How much can you save off of suggested retail prices by purchasing from a specific dealer (taking into account taxes, shipping, insurance, etc., as applicable)?

- **Convenience**   How quickly do you want to receive your purchase, and do you want the added piece of mind that comes from being able to return your purchase in-person at a local retailer, versus shipping it back to an online retailer?

- **Personal preference**   Are you comfortable shopping online to save money, or do you prefer making major purchases in-person? Would you prefer to support a locally owned and operated retail store in your community, as opposed to an online-based company?

- **Product availability**   Local photography specialty stores and even consumer electronics or mass-market superstores often have limited stock on items. If the camera you want isn't in stock and readily available, are you willing to wait or choose an alternate model, or would you prefer to shop online with a merchant that has the camera you want in stock and ready to ship?

- **Sales and technical support assistance**   Again, if you have lots of questions, seriously consider spending a bit extra and shopping at a local retail store that's staffed by photography experts who can guide you through your camera purchasing decisions.

## Did You Know?

# Buying Used Equipment Can Save You Money

If money is tight, you can sometimes find used, but current model, camera equipment in pristine working condition at a fraction of the suggested retail price. Often, when photographers choose to upgrade their equipment for a newer or more sophisticated model, they're willing to sell their used equipment for a lot less than what they paid for it. For semi-professional or professional Digital SLR cameras, lenses, and accessories, finding photographers who took excellent care of their now used equipment is easy. Many are willing to sell it directly on eBay.com or Craigslist.com, or through a photography company that specializes in used equipment sales, such as Adorama (www.adorama.com), B&H Photo Video (www.bhphotovideo.com), or KEH Camera Brokers (www.keh.com). Many local photography specialty stores also dabble in used equipment.

# Protect Your Investment: Insurance and Extended Warranties

Regardless of what camera make/model you purchase, the store where you purchase it will typically accept returns within 30 days with a receipt. Beyond that, all digital cameras (that aren't considered gray market merchandise) come with a manufacturer's warranty.

Above and beyond what's offered by the manufacturer, which basically protects you against product defects, you can often purchase an extended warranty from many retailers when you purchase the camera. Before making this investment, however, determine exactly what's covered and what's not—and for how long. For example, if you accidently drop the camera, scratch the lens, or crack the display, chances are that won't be covered by an extended warranty, which is typically costly.

**Tip**   For an inexpensive point-and-shoot camera that will probably be obsolete within three years, purchasing an extended warranty is usually not necessary, especially if it doesn't cover accidental damage, loss, or theft.

High-end photography gear can often be covered through your homeowner's or renter's insurance, if you add an extra rider to your existing policy. Call your insurance agent to determine what's offered and what the cost would be.

# 3

# Digital Camera Accessories and How They're Used

## How to...

- Choose the perfect memory cards for your digital camera
- Make sure you have extra camera batteries on hand and where to get them cheap
- Pick the ideal lenses for your Digital SLR camera
- Select the right combination of accessories for your photography needs
- Get optimal use from all your camera accessories

Buying a new digital camera requires making a bunch of important decisions based on your needs, goals, and budget. The same is true when it comes to buying the accessories you'll need in order to capture the images you want, regardless of what type of environment you're in.

Even if you purchase the most basic point-and-shoot digital camera, you'll still need a few accessories, like extra batteries, memory cards, and a case. The more advanced your camera, however, the more choices you'll have in terms of the different types of accessories you'll want and need. If you've invested in a high-end Digital SLR camera, you can purchase interchangeable lenses (which can cost as much as, if not more than, the camera body itself), not to mention a wide range of other accessories—external flash units, filters, tripods, memory cards, extra batteries, and cases to protect, transport, and store your photography equipment.

As you get to know your new camera and begin learning about all of its features and functions, you'll probably discover just how much better your photos could be if you added some optional equipment. This chapter focuses on some of the many different types of accessories available for digital cameras—starting with the most essential, memory cards and extra batteries.

Your camera's manufacturer, such as Canon, Nikon, or Olympus, offers a wide range of accessories for your specific camera model. However, many third-party companies also manufacture compatible accessories. These third-party accessories could save you money and offer you additional features and functionality for your camera, so don't rule them out when deciding what to purchase. And, don't forget: Just as there are many places to purchase digital cameras, the same is true for photography accessories. You can find accessories at specialty camera stores, mass-market retailers, consumer electronics superstores, and online-based photo specialty stores.

# Everything You Need to Know About Memory Cards

Every digital camera requires a flash memory card. The memory card is the digital storage medium that you insert into your camera to store your photos once you've taken them. Unlike computers, most digital cameras don't have internal hard drives for storing data. Instead, they have a memory card slot into which a compatible flash memory card gets placed. This memory card acts as your camera's removable hard drive, allowing you to shoot and store hundreds or thousands of digital images (depending on the card's memory capacity).

You can remove memory cards from your camera easily and quickly. So, if a memory card fills up, you can simply insert another empty memory card into your camera and continue shooting. As you're about to discover, however, not only are there a handful of different memory card formats (only one of which will be compatible with your digital camera), but also there are many variations of memory cards for each specific format, variations that determine its *capacity* (available storage space) and *read/write speed* (how fast data is transferred from the camera and saved onto the memory card and how quickly data can be read from that same card).

When choosing the appropriate memory card for your camera, you first need to determine what format memory card your camera requires. For higher-end Digital SLR cameras, CompactFlash® (CF) memory cards (as shown in Figure 3-1) are the most common. Various point-and-shoot cameras may utilize Secure Digital (SD™), MiniSD™, MicroSD™, xD Picture Card, Memory Stick Pro Duo (MSDUO), Secure Digital High Capacity (SDHC™), or another memory card format.

Shown in Figure 3-2 is an xD Picture Card and SD™ memory card, both of which are much smaller than a CompactFlash

**Figure 3-1** CompactFlash memory cards

**FIGURE 3-2** xD Picture Cards and SD memory cards

memory card, allowing them to fit easily in tiny point-and-shoot cameras. They function the same as other memory card formats, however.

All memory cards are not alike. Once you determine what format memory card your camera requires, you still must choose the card's memory capacity, which determines how many images can be stored on that card as well as the read/write speed of the card. The larger the capacity and the faster the read/write speed, the better your camera will perform, but the more expensive the memory card will be, regardless of the card's manufacturer.

As a general rule, you'll want to acquire at least two (potentially more) compatible memory cards to ensure you never run out of storage space for saving images when shooting. Once a memory card becomes full, you can transfer your images to a computer, external hard drive, or an online photo service. You can also burn the images onto a CD or DVD. After you've transferred the images from your memory card, you can reformat the memory card (erase it) and re-use it over and over again.

 You never want to reformat a memory card until you're 100 percent sure you have a copy of your digital images stored elsewhere. The process for transferring photos from a memory card to your computer or another digital storage medium is explained, in detail, within Chapter 11.

## Memory Card Storage Capacity

A memory card's storage capacity—which can be anywhere from 512K to 64GB (or larger)—determines how many photos can be stored on the card. The camera's resolution (and the resolution you use to take photos), as well as the file format you save your photos in, will determine how much memory a single image requires.

The following bullet points will help you determine how many photos you can expect to store on a single memory card, based on the resolution of the camera and the photos you take:

■ For a 5 megapixel (5MP) resolution camera, each photo will be approximately 1.5MB in size. If you have a 2GB memory card, it'll hold approximately 1200 images. A 4GB memory card will hold approximately 2500 images, and an 8GB memory card will hold approximately 5100 images.

■ For an 8MP resolution camera, each photo will be approximately 2.3MB in size. If you have a 2GB memory card, it'll hold approximately 800 images. A 4GB memory card will hold approximately 1650 images, and an 8GB memory card will hold approximately 3200 images.

■ For a 12MP resolution camera, each photo will be approximately 4.6MB in size. If you have a 2GB memory card, it'll hold approximately 400 images. A 4GB memory card will hold approximately 800 images, and an 8GB memory card will hold approximately 1600 images.

These days 64GB memory cards are readily available from companies like SanDisk and cost several hundred dollars, but they hold thousands of images. Photographers are divided about using these high-capacity memory cards. Although they hold many images, which means you don't have to swap memory cards or transfer images to your computer as frequently, on the rare occasion something goes wrong with the camera or the card, or your equipment gets lost, damaged, or stolen, you run the risk of losing more images if you don't make frequent backups or file transfers. As long as you're diligent about making backups, you'll find these high-capacity memory cards very useful, especially if, like the SanDisk Extreme Pro CompactFlash card, it also features a high read/write speed (in this case 600x, or 90MB per second). If you're an amateur photographer, however, you can easily get away with using much less expensive 2GB or 4GB memory cards.

## Read/Write Speed

Aside from a memory card's storage capacity (measured in gigabytes), the second consideration is its read/write speed, which determines how quickly your digital photographic data can be transferred from the camera to the card (or later read from the card to your computer). Especially with point-and-shoot cameras that have a lag time, the faster the memory card, the better off you'll be, because your camera's speed and performance will noticeably improve with a faster memory card.

 If you'll be shooting a lot of high-action images, such as at sporting events, and utilizing your camera's ability to shoot multiple frames per second in rapid succession, you'll want to get a memory card with the fastest read/write speed possible.

Memory card manufacturers promote card speeds differently on their packaging. Some refer to how many megabytes per second the card is capable of storing data at (such as up to 90MB/second). Sometimes, this information is given as 100x, 200x, 300x, 400x, 500x, or 600x, for example. Either way, purchase the fastest memory card you can afford.

## Caring for Your Memory Cards

While most memory cards are very reliable and durable, backing up your images as soon as possible is always a good strategy. All professional photographers are extremely diligent about backing up their digital images often and in multiple places, especially when the images can't be retaken.

Even if you have plenty of remaining storage capacity on your camera's memory card, back up your images at least once per day whenever you're shooting. If this isn't possible, consider using multiple memory cards so if one card gets corrupted, lost, or stolen, you'll only lose all of your photos stored on that single memory card, and the photos on the others will be safe.

**Tip**   Putting your digital camera and memory cards through the x-ray machine at any airport TSA security checkpoint is perfectly safe.

Memory cards have no moving parts, but they can be damaged if they get dirty, treated roughly, get crushed, are exposed to extreme temperatures, or get wet, for example. When a memory card is not being used, store it in the plastic case (shown in Figure 3-3) it came in, and refrain from touching the card's exposed connectors with your fingers (or allowing these connectors to get dirty).

In general, memory cards are very reliable. However, if you notice a problem, remove the card from your camera immediately and try to retrieve and back up your images as soon as possible. If the image data stored on the card has become corrupted, you can purchase optional software that will often allow you to salvage the data, or you could hire a costly data recovery service. Chapter 15 will help you deal with recovering corrupted, accidently deleted, or lost photo data.

**Figure 3-3** When not in use, always store your memory cards in a protective case.

## Camera Batteries

The second most essential accessory for any digital camera is the battery that powers the camera. Most digital cameras these days use relatively small rechargeable battery packs, as opposed to single-use "AAA"- or "AA"-size alkaline batteries. Regardless of which make and model digital camera you purchase, if it requires a rechargeable battery, it will come with one battery, along with a compatible battery charger.

Depending on the battery, it'll take between 30 minutes and several hours to fully charge or recharge the camera's battery pack, and each fully charged battery will offer the ability to shoot between a hundred and several hundred images per charge, depending on the camera, whether you use the camera's built-in flash, and how much you use the camera's display.

Once a battery's power is depleted, you'll need to remove the battery from the camera, place it in the charger, and plug

## Did You Know?

## Purchase Low-Cost Replacement Batteries

No matter what camera make and model you purchase, chances are the manufacturer will sell extra rechargeable batteries for about $50 each. The good news, however, is that you can go online and purchase a third-party battery that's 100 percent compatible with your camera, often for as little as $5 each.

Instead of buying an official Canon, Nikon, Kodak, or Olympus battery for your camera, go to an online price-comparison website, such as NexTag.com, and type the exact make and model of your camera, followed by the word **battery**. For instance, if you own the Olympus Stylus Tough 6000, you'd type **Olympus Stylus Tough 600 Battery** into the search field at the top of the screen on www.Nextag.com.

On the Olympus website (https://emporium.olympus.com), you can buy the Stylus LI-50B battery kit for $54.99. When you search for a compatible non-Olympus battery, on NexTag.com, for example, you'll find them starting at $16.95, including a charger. The battery may be listed as a non-OEM battery, but it will work perfectly in the camera and save you a fortune. This strategy works for any battery for any make-and-model digital camera.

You can also search for replacement or extra batteries on eBay.com or Amazon.com. Batteries for Canon's Digital SLR cameras can be found for as little as $3.99 each (as opposed to $50). When shopping online for extra batteries, pay attention to what the online vendor charges for shipping and handling, as well as its overall approval rating from past customers.

the charger into an AC electrical outlet to recharge it. During this time, you won't be able to take additional photos—unless you purchase extra batteries and keep them fully charged and on hand when you're ready to shoot.

Even if you're an amateur photographer planning to just take photos of your kids or while on vacation, you'll definitely want to keep at least one or two fully charged batteries on hand whenever you're shooting, or you could wind up with a dead battery and a useless camera at the exact moment you want to take an important photo—like your child's home run at her Little League softball game or the perfect sunset during your vacation. When they're not in use, keep your extra batteries in a cool, dry place. Avoid exposing them to extreme temperatures or water. Try to keep them fully charged at all times. However, if a fully charged battery has been sitting unused for several weeks or months, plug it into the charger again before you plan to use it to ensure it's ready to go when you want it.

## Let's Focus on Lenses

If you've purchased a basic point-and-shoot camera, this section doesn't apply to you or your camera. However, if you'll be shooting with a Digital SLR camera that allows you to swap lenses, then you might consider investing in additional lenses to give you maximum versatility and more options when you're out taking pictures.

For any of the mid-to-high-end Canon or Nikon Digital SLR cameras, for example, literally dozens of optional lenses are available, both from the camera manufacturer, as well as third-party lens companies like Sigma, Tokina, and Tamron.

 Every Digital SLR camera manufacturer uses its own lens mounts. Thus, a lens designed for the Canon EOS 7D will work fine with a Canon EOS 50D, but not with a Nikon camera.

Because optional lenses can be very costly, an excellent strategy is to consider the lineup of lenses available before purchasing a Digital SLR camera. Down the road, you may want to upgrade your camera body with the latest model, but you want all of your lenses to be compatible with that new camera, too. If you switch from a Canon to a Nikon (or vice versa), you'll need to purchase all new lenses as well.

When you purchased your camera, if it came as a kit or package, it was bundled with what the manufacturer considers to be a good, all-purpose lens. If you were to purchase the Canon EOS Rebel XSi as a package, for instance, it might come with Canon's 18–55mm f/2.5–5.6 EF-S IS lens. We'll discuss what this lens-related technical jargon means shortly.

However, if you want a really powerful zoom lens (to shoot things far away), a wide-angle lens (for including a vast area in a single image), or a macro lens (for shooting something close up), you'll need to invest in additional lenses, which can cost anywhere from a few hundred dollars to several thousand dollars each.

The cost of an optional lens depends on a number of factors, including the manufacturer, the type and quality of lens, the quality of optical glass used, and the features the lens offers. Some of the latest lenses offer an optical stabilizer, which keeps your photos in focus even if the camera itself shakes a bit when you press the shutter button. A higher quality lens will reduce *flare* and *ghosting* (two negative impacts of unwanted light shining into the lens), plus improve the overall contrast in your photos. Because most lenses for Digital SLR cameras have an auto-focus feature, the lens you choose should have a fast auto-focus speed. Better quality lenses also tend to be more weather resistant. No, they're not waterproof. But, if you're outside shooting and it starts to rain lightly, resulting in your lens getting a little wet, it probably won't be damaged.

## Technical Jargon Related to Lenses

Once you determine what type of lens you need, it's easy to get confused by all the technical jargon associated with describing each lens, its quality, and its overall performance capabilities. Whether you're looking for an all-purpose "normal" lens, zoom (telephoto) lens, macro lens, or wide-angle lens, as you evaluate your options from the camera's manufacturer, as well as from third-party lens manufacturers, you'll want to examine the lens' focal length, aperture, and image stabilization capabilities, as well as its overall quality.

 **Tip** If you don't want to bother learning about the technical jargon related to lenses, once you define your photographic needs, go to any photography specialty store and describe those needs. Ask one of the experts working at the store to recommend appropriate lenses for you, taking into account your needs and budget.

## Focal Length

A lens' *focal length* is measured in millimeters (mm) and represents the distance between its rear element and its focal plane. This area is where the parallel beams of light that are entering the lens converge. The lens' focal length directly impacts its viewing angle, or how much of a scene you can capture in a single image. When you increase the focal length of the lens, your field of view gets smaller. Thus, you can zoom or focus in on your subject, while eliminating more and more of the background.

A lens with a variable focal length of 28–135mm, for example, is a great general-purpose lens. It allows for a pretty wide view of the scene, but also allows you to zoom in pretty well on your subject. Figure 3-4 was taken on a Canon EOS 40D camera equipped with a Canon 28–135mm lens. This shot was taken with the focal length set at 28mm. Without moving the photographer, camera, or subject, Figure 3-5 shows a shot taken with the lens' focal length set at approximately 70mm. Now, take a look at Figure 3-6. Again, neither the photographer, camera, nor subject moved. However, the lens' focal length was set to 135mm. Notice how much the photographer can zoom in on his subject without physically moving himself, his camera, or the subject.

For Figure 3-7, the camera lens was changed to the Canon Zoom Lens EF 90–300mm f/4.5–5.6 lens. The lens' focal length was set to 300mm, but the camera, photographer, and the subject did not move. Yet, for this shot, the photographer is able to really zoom in on the subject.

**FIGURE 3-4** The lens' focal length set at 28mm

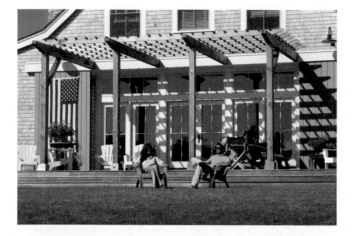

**FIGURE 3-5** The lens' focal length set at 70mm

**FIGURE 3-6** The lens' focal length set at 135mm

**FIGURE 3-7** The lens' focal length set at 300mm

**FIGURE 3-8** The lens focal length set at 18mm for a wider perspective

To get a wider view of the scene, as shown in Figure 3-8, this time the photographer kept the position of the camera, himself, and the subject the same, but switched to a Canon 18–55mm lens and set the focal length to 18mm. As you can see, this setting offers a much wider perspective of the scene.

If you're an amateur photographer, or even a more serious photography hobbyist, owning just one good quality lens, with a focal range of 28mm to 135mm, will meet your needs in virtually every situation, especially since images can later be cropped, edited, and enhanced using specialized photo-editing software like Photoshop.

Available for Canon, Nikon, and other popular Digital SLR cameras, the Tamron AF 18–270mm f/3.5 6.3 Di II VC lens is also a wonderful all-purpose lens that's ideal in many shooting situations due to its versatility.

**Note**   A *normal* lens is designed to approximate the perspective, but not the area, of any scene that's visible by a single human eye. A normal lens on a Digital SLR camera has a focal length of about 50mm. A lens with a focal length of more than 100mm is considered to be a *telephoto* lens, not just a zoom lens, because it allows you to zoom in on objects that are far away from you, the photographer, and, at the same time, only capture a small area of the background.

## Aperture

While the focal length of a lens determines how much of a scene you can capture in a single photo, the *aperture* of the lens determines how much light can pass through the lens to the image sensor. A lens' aperture is represented by a number and is referred to in terms of *f-stops*. When a lens' aperture is described, it will be preceded by a lowercase letter *f*. For example, a lens may have an aperture of f/2.8, f/4, or f/4–5.6.

When it comes to aperture, the smaller the number, the larger the opening, meaning more light will be allowed to enter the camera and reach its image sensor. By collecting more light, the lens can utilize a faster shutter speed and take better photos in low-light situations.

The description of a lens will list aperture based on its maximum aperture. If, however, you're utilizing a zoom lens with an adjustable focal length, the lens' maximum aperture will be listed as a range. Thus, a zoom lens might be described as a Canon Zoom Lens EF 90–300mm f/4.5–5.6. At a focal point of 90mm, the lens' maximum aperture is 4.5. However, when zooming in and setting the camera's focal point to 300mm, the lens' maximum aperture is 5.6.

**Note**  The faster the lens, and the smaller the maximum aperture, the more costly the lens will be. These lens will also be a bit heavier.

### Image Stabilization

Virtually all digital cameras have built-in *image stabilization,* meaning if you move the camera while taking a photo (or if you try to capture an image from a moving car, for example), the image won't turn out as a total indecipherable blur. Image stabilization is also built into many of the latest Digital SLR lenses, allowing you to shoot in low-light situations using a camera (without a tripod) and still often wind up with images that are in focus.

Depending on the camera's manufacturer, this feature may be called *image stabilization, vibration reduction,* or something similar. Image stabilization on lenses can be manually turned off if your camera body already has this feature, or you want to set all of your camera and lens settings manually for each image being shot.

## Types of Optional Lenses for Digital SLR Cameras

Initially, as you get started with digital photography, you may want to invest in a Digital SLR camera kit that comes bundled with a good-quality, all-purpose lens that will serve the majority, if not all, of your photographic needs. As you get more serious about photography or if you want to take specialized pictures, you may want to invest in more specialized lenses to meet those needs. This section describes some of the more popular types of optional lenses available for Digital SLR cameras. Keep in mind that each lens will cost anywhere from a few hundred to several thousand dollars.

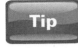 Before investing a fortune in a new lens, learn as much as you can by reading reviews published in reputable photography magazines or on well-known photography websites. If possible, try out the lens firsthand *before* purchasing.

### Prime Lenses

A prime lens has a fixed focal length and does not allow you to zoom at all. The focal length can't be adjusted. If you want to get in closer on your subject, you'll need to physically move yourself and your camera closer. Prime lenses typically use better quality glass than zoom lenses and have a wider maximum aperture, which is ideal for taking extremely well-focused shots in low-light situations.

All the major Digital SLR camera manufacturers, including Canon and Nikon (as well as some third-party lens manufacturers), offer prime lenses ranging from 35mm to 100mm. Most are priced under $500 each.

### Zoom/Telephoto Lenses

As the name suggests, a zoom lens allows you to zoom in on your subject. A lens is considered a telephoto lens if it has a focal length over 100mm. A really good telephoto lens could extend to 300mm or 480mm or greater, but these tend to get really costly. The Sigma 70–200mm f/2.8 II EX APO Macro HSM DG lens that has mountings available for Canon, Nikon, Sigma, Pentax, Sony, and Minolta, for example, will cost around $800.

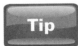 A telephoto zoom lens has a variable and adjustable focal length, so you can remain stationary, yet zoom in on your subject to varying degrees, simply by adjusting the lens.

Meanwhile, the professional-level Canon Zoom Wide Angle-Telephoto EF 28–300mm f/3.5–5.6L IS USM Autofocus Lens is priced around $2,400 for just the lens, whereas the Nikon AF-S Nikkor 500mm f/4G ED VR Autofocus lens has a retail price of around $8,500.

Yes, you can spend a fortune on a really high-quality zoom or telephoto lens for your Digital SLR. However, the average amateur photographer looking for a good-quality zoom or telephoto lens that allows her to zoom in on her subject and capture a stunningly detailed image, should plan on spending between $300 and $500 for this type of lens.

For some Digital SLR cameras, ultra-wide zoom lenses and super-telephoto lenses are also available. Each offers different functionality and specializes in capturing different types of images.

## Wide-angle Lenses

A wide-angle lens is ideal for shooting very wide areas, such as vast landscapes (like the Grand Canyon), an entire football field, or an extremely large group of people. Typically, a wide-angle lens will have a focal length between 24mm and 35mm. A 28mm lens is considered a standard wide-angle lens. A super-wide-angle lens might have a focal length of 12mm. A good quality wide-angle

**FIGURE 3-9** A wide-angle lens allows you to shoot very wide areas.

lens will be priced between $300 and $400. Figure 3-9 shows an image shot with a wide-angle lens set at 24mm.

In addition to traditional wide-angle lenses, a fish-eye lens also allows you to capture a wide area, but the lens provides an angle view of 180 degrees, which dramatically alters the normal depth perspective you'd typically see in a photo, adding a more circular perspective. A good quality fish-eye lens for a popular Digital SLR camera will cost at least $600 to $800.

## Macro Lenses

For a photographer who needs to shoot an object or subject from an extremely close-up perspective, in order to capture every minute detail, a macro lens is necessary. Some of the general-purpose lenses offered by Canon, Nikon, and the like, offer a macro feature built into the lens. However, if you want to shoot diamond rings or small bugs up close and capture every detail, you'll want to use a specialized macro lens with your Digital SLR camera.

Macro lenses have a very shallow depth of field (meaning only a small area of the subject closest to the lens will be in focus, and the background will be blurred out) and are designed exclusively for shooting objects very close up. When using this type of lens, you'll definitely want to mount your camera on a tripod, since even the slightest movement or even a vibration could result in a blurry image. Figure 3-10 shows a photo of a bug shot using the macro shooting mode of a Canon 28–135mm lens with a Canon EOS 40D camera.

**FIGURE 3-10** When you need to shoot something very, very close up, use a macro lens.

You can often save a fortune by purchasing a used lens from a photographer who has upgraded his equipment and has no need for his older lens. As long as the used lens isn't scratched and is in perfect working order, whether it's used or not, will have no impact on your ability to take photos. eBay.com, Craigslist.com, or a photography specialty store are great sources for finding used equipment in pristine condition.

## External Flash Units

Virtually all point-and-shoot digital cameras have small flash units built in. Larger, Digital SLR cameras also have pop-up flashes built in, but these flash units are not adjustable. They extend light straight outward toward your subject. However, these cameras also have a *flash hot shoe,* which is a connector located on the top of the camera that allows you to attach a compatible external flash unit (shown in Figure 3-11). Several different types of external flash units are used for various purposes. A slave flash connects to your camera's hot shoe via a cable (as opposed to directly mounting on the camera). This gives you even greater control over the direction of the flash's light when you shoot. (A wireless option is also available for many Digital SLR cameras.) The most common type of external flash unit is more powerful than the flash built into the camera; therefore, it provides more light in dimly lit areas where you're shooting.

**FIGURE 3-11** On top of most Digital SLR cameras you'll find a flash hot shoe for connecting an external flash unit.

While a camera's built-in flash might light up your subject in a dimly lit room, the background will remain dark. A more powerful external flash, however, can light up both the subject and the background, giving your photos more detail. If you purchase an external flash unit designed for your camera, chances are the camera itself will automatically control the flash's settings when you shoot in Auto mode.

Because you can adjust the angle of these external flash units, you can literally bounce light off of walls, the floor, or the ceiling to create different lighting effects. You can also add diffusers to external flash units to better control the light and avoid problems like red eye and harsh shadows when shooting.

When you shoot in low light using your camera's built-in flash, because you are aiming the light generated from that flash directly at your subject from a fixed angle, shadows will often appear in your photos. Using an external flash unit that tilts and

swivels, you can greatly reduce or totally eliminate shadows, thus creating more professional-quality images.

For a mid-to-high-priced Digital SLR, a good-quality external flash unit will be priced between $300 and $600. A flash's overall power (how much light it generates and the amount of area it'll light up) helps to determine a flash unit's price. How much area a flash unit will light up is referred to as its *flash range*.

How quickly the flash unit recharges and is ready to shoot another image (which is referred to as the *recycle rate*) is also a determining factor and something you should consider when choosing a flash unit. You want an external flash that offers a broad flash range and quick recycle time, but also has a good battery life.

**Note** Low- and mid-priced external flash units are typically powered by "AA" or "AAA" alkaline batteries. Depending on the batteries you use, you'll get between 100 and 500 flashes with a set of batteries. Using rechargeable "AA" or "AAA" batteries will save you money over time.

One drawback to a typical external flash unit that attaches to the top of your camera is that it will add weight. On the plus side, if you're using an external flash, as opposed to a camera's built-in flash, the camera's battery will last a lot longer.

## Did You Know?

# Flash Diffusers Come in All Shapes and Sizes

Sometimes a flash will give off too much light and cause your subject(s) to be overlit (*overexposed*). This abundance of light might also cause unwanted shadows or red eye. The solution is to use a diffuser with the flash. A *diffuser* is an inexpensive accessory that covers the flash and diffuses or deflects some of the light away from your intended subject. This accessory is often necessary when shooting a portrait with a flash, for example, and you don't have a full studio lighting setup.

For most point-and-shoot cameras, the Gary Fong Delta Point and Shoot Diffuser ($16.15, www.garyfongestore.com/flash-accessories/delta-point-and-shoot-diffuser.html) will help to eliminate shadows and red eye. It's a simple device that attaches over the flash of your handheld camera.

Even when using your Digital SLR camera's built-in pop-up flash, you can attach an inexpensive diffuser, like the Puffer Pop-up Flash Diffuser, also from Gary Fong ($22,

www.garyfongestore.com/flash-accessories/puffer-pop-up-flash-diffuser.html), shown here. It will reduce shadows and red eye whenever the camera's built-in pop-up flash is used.

Many different and inexpensive diffusers are also available for external flash units. For example, there's the LumiQuest Softbox III ($47, www.lumiquest.com/products/softbox-iii.htm), shown here. It attaches to any external flash unit using Velcro strips and is ideal for shooting portraits when you don't want any harsh shadows.

Any photography specialty store will offer a vast selection of diffusers compatible with external flash units. For example, there's the Diffuser Dome offered by Adorama.com for $39.99 or the Omni-Bounce from Sto-Fen Products (www.stofen.com) that snaps onto an external flash unit. This solution is much more economical than purchasing a complete studio lighting kit, which you'll read about in the last section of this chapter.

Whether you need to run out and purchase an external flash unit for your digital SLR camera will depend on where you'll be shooting your images. If you're taking lots of photos indoors or in dimly lit situations, but you want your images to appear well lit and shadow free, an external flash unit is a worthwhile investment.

Be sure to keep your external flash unit in a padded case to protect it against damage when you aren't using it. When using the flash, always have at least one fresh set of batteries on hand to ensure you'll be able to fully utilize the flash when and for as long as you need it during a shoot.

## Did You Know?

## Special Flash Accessories Created for Special Uses

In addition to the traditional external flash units that mount on top of Digital SLR cameras, serious photographers sometimes utilize specialized flash accessories (beyond basic diffusers) for specific purposes like shooting portraits.

When shooting portraits, for example, the Orbis Ring Flash ($199, www.orbisflash .com/the-orbis) automatically transforms the harsh light from your Digital SLR's external flash unit to help create shadowless photos. The unit attaches to your flash, but is also placed around your lens to create a literal ring of light that will illuminate your subject's face far more effectively and efficiently.

Similar to the Orbis Ring Flash is the Ray Flash from Expo Imaging ($199.95, www .expoimaging.com). This accessory is manufactured to fit perfectly on ten popular Canon and Nikon external flash units.

# Protect Your Equipment Investment with a Case

Whether you spend a hundred dollars on a basic point-and-shoot camera, or several thousand dollars on a semiprofessional or professional Digital SLR camera, lenses, and accessories, you'll want to protect your investment with a padded case. When you start examining camera cases, you'll discover they literally come in all shapes and sizes and are offered at many different price points.

For a handheld point-and-shoot camera, a basic case made from durable ballistic nylon should cost less than $25. Be sure to choose a small case that attaches to your belt, shoulder bag strap, or purse for easy accessibility. It should also offer a near perfect fit for your camera. Case Logic (888-666-5780, www.caselogic .com), for example, offers a selection of compact durable cases for point-and-shoot cameras that come in a variety of colors.

A well-made case designed to hold a Digital SLR camera, along with a range of lenses and accessories, will cost anywhere from $100 to $500, depending on the design and manufacturer. The more expensive camera cases are made like high-end designer luggage.

**Tip** Many camera cases look the same on the outside, but offer totally different compartment layouts and workmanship quality on the inside. To find a case that'll hold your camera gear, check out the cases firsthand in a retail store, as opposed to shopping online and relying on photos.

To select the perfect case for your camera equipment, consider the following:

- Examine the case's construction. Are the compartments well padded and the zippers or clasps well made? Does the case appear durable? Are the various seams well stitched, and is the material strong? Does the case have a comfortable shoulder strap?

- Based on your unique collection of camera gear, which might include the camera itself, extra lenses, a flash unit, batteries, battery chargers, lens filters, flash diffusers, extra memory cards, and other pieces of equipment, does the case offer separate compartments for each item? Is the layout of the case customizable using well-padded Velcro dividers? If you plan to purchase one or two additional lenses for your Digital SLR camera in the near future, this type of case offers room for your equipment collection to grow over time. Are there separate, sealable, and easy-to-access pockets for smaller accessories, like memory cards, lens filters, and spare batteries?

- Many larger camera cases have separate padded pouches for a laptop computer. Make sure your laptop computer will fit within the pouch, along with its electrical adapter and any other computer accessories you may need, such as a memory card reader.

- Is the camera case weather resistant and lockable?

Take your lifestyle and photography habits into account when choosing a suitable style of camera case—whether it's an over-the-shoulder case, backpack (shown in Figure 3-12), waist pack, sling bag, or rolling case (shown in Figure 3-13).

Many different companies, including Tamrac (800-662-0717, www.tamrac.com), Tenba (914-347-3300, www.tenba.com), and Lowepro (707-827-4000, www.lowepro.com), offer complete lines of camera and photography equipment cases, many of which are sold through camera specialty stores, mass-market retail stores, and online. Be sure to select a case that's best suited not only to your budget, but also to hold and protect the camera equipment you own.

 **Caution** Many photographers travel a lot. Make sure your case meets TSA guidelines for carry-on luggage when flying any airline. You never want to include any camera equipment as checked baggage because the airlines don't cover this equipment if it gets lost, stolen, or damaged.

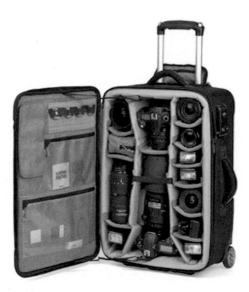

FIGURE 3-13  Lowepro Pro Roller x300 ($479.99) is a rolling case with extendable handle and smooth gliding wheels.

FIGURE 3-12  The Tamrac Model 3380 Aero 80 ($129.95) is a backpack-style camera case with a separate padded laptop computer compartment.

# Keep Your Camera Steady by Shooting with a Tripod

Depending on the types of pictures you'll be taking, there are times (particularly in low-light situations) when keeping the camera steady to avoid out-of-focus or blurry images is absolutely necessary. This is when a tripod becomes a valuable tool.

Tripods come in many sizes and are made from different types of materials. When it comes to selecting an appropriate tripod for your needs, first determine if you want a full-size tripod or a smaller, lighter-weight tabletop tripod. Based on your shooting style, you might prefer a monopod that doubles as a walking stick, such as the Trek Pod Go Pro ($229.99, www.trek-tech.com).

In terms of a full-size tripod, several considerations determine its price. First is what the tripod itself is made from. The type of tripod mount offered (how the tripod connects to the camera) is also a factor when it comes to price. As you start shopping for tripods, you'll discover that a full-size tripod with basic features will cost around $100. However, you can easily spend upwards of $1,500 on a professional-quality tripod made from ultra-lightweight material that offers precision settings and adjustability, but that can safely hold the weight of your camera and related equipment.

Other considerations include selecting a tripod that's suitable for the weight and size of your camera (including the lens and external flash unit, if you're using a Digital SLR). Otherwise, the tripod could collapse if your camera is too big or too heavy. Also, when using a long lens, your camera's center of gravity changes, so the tripod must compensate for this, as well as be manufactured to support the camera, external flash (if applicable), and lens' combined weight.

**Note** All tripods have a standard mount that screws into the bottom of your camera. However, some offer easily removable or magnetic mounts, which is a convenient option that makes it quick and easy to release your camera during a shoot.

If you'll be carrying the tripod around, choose one that folds up nicely and that's lightweight. It's also important to choose a tripod that offers strong, easy-to-set, and durable locks on the extendable legs. The top of the tripod, referred to as the head, where you attach the camera should also glide smoothly from left to right as well as up and down. When you shop for high-end tripods, you'll discover that the tripod legs and head are sometimes sold separately. This is because different styles of heads are available that serve different purposes and offer various types of movement or flexibility.

For semiprofessional photographers who need a durable and reliable tripod, many choices are available. The Vanguard Alta 283CT, for example, is a good all-around tripod that's made using carbon fiber capable of holding up to 18 pounds of camera equipment. When folded, this $299 tripod measures just 25¼ inches long, but it expands to almost 67 inches long and weighs 3.8 pounds.

The tripods available at mass-market superstores, like Wal-Mart, Best Buy, or Target, are low-priced consumer models suitable for most amateur photographers. To purchase a higher-end, professional-quality tripod, you'll need to visit a specialty

camera store or shop online. A few well-known manufacturers of semiprofessional and professional-quality tripods include:

| | |
|---|---|
| Flashpoint | www.adorama.com |
| Gitzo | www.gitzo.com |
| Manfrotto | www.manfrotto.us |
| Really Right Stuff | www.reallyrightstuff.com |
| Slik Professional | www.thkphoto.com |
| Tiffen | www.tiffen.com |
| Vanguard USA | www.vanguardworld.com |

 One handy feature offered on some tripods is a built-in level gauge that helps you determine when the camera is mounted evenly or is straight. This feature is particularly handy when you're setting up the tripod on uneven terrain.

For amateur photographers who don't need a full-size tripod, particularly for their point-and-shoot camera or a mid-size Digital SLR, a tabletop tripod is a handy accessory in many situations. Even more useful is the popular Gorillapod tripods ($24.95 to $99.95), which feature highly flexible yet sturdy legs (http://joby.com/gorillapod/original). Available in several compact sizes and suitable for different size and weight cameras, these tripods can hold a camera steady on a tabletop or even be wrapped around a pole or tree limb, for example. Because they fold up nicely, these tripods are easy to travel with, so they're great for vacationers.

# Additional Photo Accessories Worth Considering

Thus far in this chapter, you've read about some of the more common and "must have" camera accessories available. As you become a more serious photographer, however, there are a handful of additional accessories that'll be useful in various situations. Some of these optional accessories are described here. More are for use with a Digital SLR camera, as opposed to a point-and-shoot camera. How you utilize these accessories will be explored in greater detail in Chapters 4 through 10, which focus on taking professional-quality photos in a wide range of situations.

 Simply by reading a handful of photography magazines, like *Popular Photography* or *Digital PhotoPro*, you'll see ads and read reviews for all sorts of optional camera and photography accessories that amateur and professional photographers alike can utilize to gain more control over their camera's features and functionality and thus take better photos or be more creative when they're shooting.

**FIGURE 3-14** This is a polarizing filter designed for a Digital SLR camera's 72mm lens.

## Lens Filters

These are special, thin lenses that screw onto the end of a Digital SLR camera's lens and allow you to create a wide range of special effects, eliminate (or create) certain types of glares by manipulating light, and make the colors in your photos appear more detailed and vibrant, for example. Shown in Figure 3-14, the most common type of lens filter is a polarizing filter, which helps to reduce unwanted glare and can make certain colors in your images appear more vibrant.

 Many of the special effects that can be created in real-time using lens filters can later be created when you edit your digital images using specialized software, such as Photoshop, Aperture, iPhoto, Paint Shop Photo Pro, or another popular photo-editing application.

The cost of these filters depends on their quality. The most expensive filters use very high-quality optical glass and are super-thin. They'll cost anywhere from $20 to $100 each, depending on what they're designed to do. When purchasing lens filters, you must also know the exact diameter of the lens, which is measured in millimeters. This information is typically listed on the lens itself.

Tiffen (www.tiffen.com/filters.htm), SunPak (www.tocad .com/images/Sunpak_Filter_Catalog.pdf), Hoya Filters (www .hoyafilter.com), Heliopan (www.hpmarketingcorp.com), and Schneider Optics (www.schneideroptics.com) are examples of popular lens filter manufacturers for Digital SLR camera lenses. Lens filters can be purchased from photography specialty stores or online.

To learn more about the many types of lens filters available and how they're used, access the online tutorial offered at www.cambridgeincolour.com/tutorials/camera-lens-filters.htm.

 An extra bonus is that lens filters protect the lenses themselves from dirt and scratches. It's much cheaper to replace a scratched lens filter (priced under $100) than it is to replace or fix a broken or scratched lens (which could cost in the hundreds or thousands of dollars).

## White Balance Tools

The image sensor in your digital camera is what allows it to differentiate between and capture millions of different colors simultaneously and reproduce them perfectly in your photos. In certain lighting situations, however, it becomes difficult for your camera to automatically determine what color is solid white, impacting how the camera reproduces or re-creates other colors in your images.

Point-and-shoot cameras, along with advanced Digital SLR cameras, include an Auto White Balancing feature that helps the camera determine what's solid white in an image and then adjust the rest of the colors as needed. However, there are times when the Auto White Balance feature doesn't do its job correctly and transforms a solid white color into a gray or tan, which then impacts how the rest of the colors in the image are presented. In this situation, as the photographer, you can manually adjust your camera's White Balance feature. To do this, there are a handful of specialized accessories that make the white-balancing process quick and simple.

Two of the white-balancing tools used by many amateur and professional photographers alike in conjunction with their Digital SLR cameras are the 12-inch Lastolite EzyBalance Greycard ($40, www.lastolite.com/ezybalance.php) and the ExpoDisc Professional Digital White Balance filter from Expo Imaging ($69.95–$99.95, www.expodisc.com). You'll learn more about white balancing and how these products work in Chapter 4.

 White balance can also be adjusted in digital images after the fact, using specialized photo-editing software. Photo editing is described in Chapter 12.

## Light Reflectors and Diffusers

As a photographer, you often need to reflect, diffuse, or deflect light onto or away from your subject. Sometimes you want to eliminate shadows or create them. Other times, you might want to direct light into your subject's eyes to make them *pop* (photographer lingo for making them stand out or shine in the photo). See Chapter 6 for more information about these useful accessories for controlling natural or artificial light.

## Home Studio Light Kits and Studio Backgrounds

Professional photographers can easily spend thousands of dollars on professional studio lighting and backgrounds to create the perfect indoor images and portraits. However, by using much less expensive home studio lighting kits and backgrounds, available from companies like Photo Basics (www.photobasics.net), you can create professional studio-quality portraits and product shots right in your living room.

A wide range of two- and three-light kits, which include easy-to-understand DVD tutorials, can be combined with paper, cloth (muslin), or vinyl backdrops to create stunning images using almost any type of digital camera. These home lighting kits are particularly useful if you want to take your own, professional-quality portraits of your kids, family members, or pets, or if you want to shoot photos of products or items you plan to sell online (via eBay.com, for example).

You'll learn more about home studio light kits and backgrounds in Chapter 5.

 One additional "must have" camera accessory is a camera and lens cleaning kit. This kit might include a can of compressed air for blowing dust off the camera's lens, liquid lens cleaning solution, and a microfiber lens cleaning cloth. Using the right equipment to clean and maintain your lenses will prevent scratches and ensure your images turn out crystal clear. After all, the slightest speck of dust, smudge, or water drop on a camera lens can ruin an image. You can purchase camera and lens cleaning kits wherever photography equipment is sold.

# PART II

# Tips and Strategies for Taking Professional-Quality Photos in Any Situation

# 4

# Basic Photo Techniques for Shooting Like a Pro

## How to...

■ See life through your photographer's eye

■ Get to know your camera's layout and design

■ Take pictures by combining your photography skill and creativity

■ Master the fundamentals of photo composition

You're about to learn a handful of fundamental shooting techniques that can be used with any digital camera to help you shoot like a pro in almost any situation. The first step to improving the quality of the photos you take, however, is to get to know your camera. Within seconds, you should be able to turn it on, remove the lens cap (if necessary), press the appropriate buttons, and be ready to shoot. Having to tinker around with your camera, wasting time figuring out which buttons or dials to press, and not having a good feel for its operation will cause to you miss out on countless photo opportunities or make mistakes that lead to blurry, grainy, or poor-quality images.

After becoming well-acquainted with your camera, you can then use the basic shooting principles covered within this chapter to improve the quality of the photos you take. These techniques will form the foundation for the additional shooting techniques covered within Chapters 5 to 10 (each of which covers how to take photos in specific situations). Once you learn the basic fundamentals explained in this chapter, you can practice incorporating each of them as you take photos, so that operating your camera and utilizing these various shooting techniques will eventually become second nature.

**Note** Remember that taking professional-quality photos requires combining your knowledge and photography skill (both taught in this book) with your own creativity and artistic vision—your photographer's eye.

# Get to Know Your Camera

Life is fast-moving and there's no rewind button. As a photographer, you always need to be ready to shoot, without having to fumble with your equipment or wasting time over-thinking your shots. In most situations, you only have one chance to capture the perfect image. One of the main reasons why people miss out on incredible photo opportunities isn't because they were in the wrong place at the wrong time; it's because they were in the right place at the right time, but they weren't prepared to snap the photo.

 If you're shooting portraits or landscapes that aren't time sensitive, or your subjects aren't in motion, you typically have more time to prepare each shot.

As soon as you purchase a new digital camera, spend time getting to know it, even if you're an experienced photographer. Every camera feels different in your hands and has a slightly different layout of buttons and dials. Each camera also has its own unique collection of built-in features and functions that are accessible through menus displayed on the camera's screen.

Becoming familiar with the basic layout and design of your camera is absolutely essential to learning to use it intuitively. Without thinking too much, you should be able to analyze the location where you want to take a photo, turn on the camera, choose the appropriate shooting mode, and prepare to snap the photo—all within a few seconds or less.

 When you're on vacation, or you know you'll be wanting to take photos during an event (such as a wedding, birthday party, or your child's soccer game), always keep your camera easily accessible and ready for shooting. Don't store the camera at the bottom of your purse, in a messenger bag, or within a backpack, where it will take you several valuable seconds to find and pull it out.

Invest the time needed to become very comfortable handling your camera. Get to know exactly where the power button is, how to select the appropriate shooting mode for the situation quickly, and how you should hold the camera so you can easily reach the shutter button, as well as the other buttons or dials needed to focus the camera and set the zoom lens, for example. Also, learn to hold the camera in a way that keeps your fingers away from the front of the lens and so they don't cover the built-in flash—two common, yet easily avoidable mistakes.

If your camera has a traditional viewfinder, become accustomed to looking through it and framing your shots while

wearing your contact lenses, eyeglasses, and/or sunglasses. If your digital camera uses its built-in display as its viewfinder, determine the best way to hold the camera and view the screen simultaneously.

As you're shooting, it's also important to know how to quickly preview your images right after you've taken them, plus how to change shooting modes in seconds, so you can capture the same shot with and without a flash, with and without the zoom lens, or with another of your camera's special preset shooting modes—without having to consult the owner's manual, read onscreen prompts, or spend valuable seconds or minutes trying to find a specific button, dial, or menu option because you're unfamiliar with your camera's basic design and layout.

Photographers commonly want to switch quickly from using the camera's flash to shooting in "existing light" mode. Make sure you know how to do this, without hesitating or having to refer to the manual. Get to know your camera's lag time and how and when to compensate for it.

Learn about all of your digital camera's built-in features and functions, as well as its various shooting modes, so you know exactly what your camera is capable of and can quickly choose the perfect feature, function, and/or shooting mode for each shot. Many of the newest point-and-shoot digital cameras have literally dozens of preprogrammed shooting modes that can be selected by turning a dial on the camera or selecting the appropriate mode from the camera's interactive menu system shown on its display. These shooting modes will help you avoid common problems when shooting in specialized situations.

Although many cameras offer special preprogrammed shooting modes, on most cameras, you can also manually compensate for any situation to help ensure blur-free and well-lit shots. Chapters 5 through 10 focus on getting the best results when shooting in specific circumstances.

The following are just some of the preprogrammed shooting modes you may discover built into a point-and-shoot digital camera:

**Anti-shake**   If you're riding in a moving car and trying to snap a photo, or you're on a moving boat, for example, and can't hold the camera absolutely steady, this mode compensates for the movement to help insure a blur-free image. However, if you're on steady ground and using a tripod, turn off the Anti-shake (or Image Stabilization) mode to improve picture clarity.

**Available Light**    This shooting mode will make the best of any existing lighting situation—indoors or outdoors—without utilizing the camera's flash. Use this shooting mode when flash photography is not permitted, or when you want to capture the mood or ambiance of a scene without adding any artificial light from the flash. Figure 4-1 is a photo taken using only the natural light in the dimly lit, indoor area, while Figure 4-2 is basically the same shot, but taken with the camera's built-in flash. As you can see, when the flash is used, the mood and ambiance created with the natural light is replaced by the bright lighting the flash adds to the image. Whether you'd use a flash in a situation like this is a matter of personal taste, based on what you're trying to convey in your image.

**Best Shot Selector**    With this camera mode, the photographer can hold down the shutter button of a point-and-shoot camera for several seconds to take up to ten photos in quick succession. The camera then automatically saves only the best photo based on clarity and a variety of other factors.

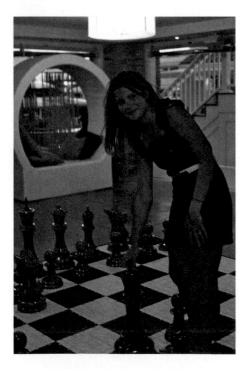

**FIGURE 4-1** A photo taken indoors using natural light

**FIGURE 4-2** A photo taken using a camera's built-in flash to supplement the natural light

**Blink Warning**    Using a camera's artificial intelligence and advanced programming, some point-and-shoot cameras, including several models in the Nikon COOLPIX lineup, have a blink detection warning. The photographer is warned if the subject might have blinked when the photo was taken using the camera's built-in flash.

**Face and/or Smile Detection**    The camera will automatically locate the faces of your subjects to insure they're in focus. This feature is particularly important if there are objects in the foreground as well as the background. Some cameras will also analyze your subject's face and won't take the picture until the person is looking directly at the camera *and* smiling.

**Flash Auto On/Of**    Even with the camera set to shoot in full Auto mode, you can choose whether to use the flash and override the camera's programming. This mode is useful when shooting in situations where flash photography isn't permitted or you want to rely on natural light when capturing a scene.

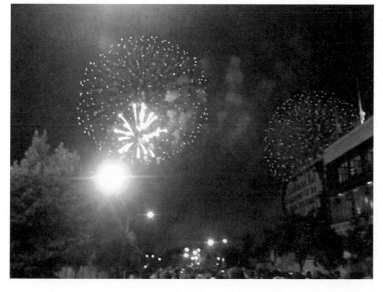

**FIGURE 4-3** In this shot, the camera's preprogrammed Fireworks mode was used but without a tripod, so the photo is blurry.

**Fireworks Mode**    Typically, taking pictures of fireworks so they appear in focus is tricky, as you'll learn in Chapter 5, because you're shooting at night, in the dark, while trying to capture the fireworks themselves. Fireworks give off only a small amount of light and that light is constantly in motion. The Fireworks preset shooting mode built into some point-and-shoot cameras automatically sets the camera to capture fireworks, so you don't have to fiddle with a bunch of settings or worry too much about timing. In general, you'll always want to use a tripod when shooting fireworks, however. Even if your camera offers a preprogrammed Fireworks mode, if you don't keep the camera totally still, your shots will turn out blurry, as you can see in Figure 4-3, where no tripod was used.

**Indoor Shooting**    This shooting mode will automatically adjust the camera to shoot the clearest and best-lit image when shooting indoors with artificial light.

**Landscape/Panoramic Assist Mode**    Capturing a vast landscape from a distance and making sure the massive objects that are located far away, such as buildings or mountains, all turn out clear and well lit is the purpose of this shooting mode. Figure 4-4 is an example of a landscape photo. Panoramic Assist mode allows multiple overlapping images to be taken and digitally edited together by the camera to create a single panoramic image. This mode replaces the need for a panoramic or ultra-wide-angle lens.

**FIGURE 4-4** A landscape photo, where everything in the distance is clear and well lit

**Night Scene**    When shooting at night, you must decide what aspects of your photo you want to appear well lit. What's possible and how your picture turns out, however, depends on whether you utilize just the available light or opt to use a flash. How powerful the flash is and the direction of the flash also impacts your nighttime photos. If you're shooting a city skyline at night, for example, and using this shooting mode (and no flash), your camera will automatically adjust for the low lighting conditions by lowering the shutter speed. To avoid blur, use a tripod to keep your camera steady.

**Portrait**    When you're taking pictures of people or pets—and can get them to sit still for a posed photo—it's called a *portrait* (as opposed to a *candid* photo, which is taken spontaneously with no setup or posing). By manually adjusting your camera and lighting, you can create many different moods and looks, as you can see in Figures 4-5, 4-6, and 4-7. When you set your point-and-shoot camera to Portrait mode, your camera will automatically utilize the available light, for example, and showcase your subject clearly.

**FIGURE 4-5** Here sunlight was used creatively to light up the subject and give him a warm glow.

**FIGURE 4-6**  In a studio setting, light was focused only on one side of the subject's face to create a shadow.

**FIGURE 4-7**  In a studio setting, only the subject was lit up, so no background can be seen.

**Portrait + Landscape**   You'll want to utilize this shooting mode to capture human subjects close up and also insure that the background (the landscape) remains in focus. Unless you adjust the camera focus on both the subjects and background, a camera set in Auto mode will typically focus on only the main subject—the human—and blur out the background. Figure 4-8 shows a subject and the background (a brick castle wall) in focus, whereas Figure 4-9 shows only the main subject in focus, with the railroad track in the background appearing blurry.

**Rapid Fire, Continuous Shooting, or Burst Mode**   Your camera may have a different name for this feature, but regardless of its name, this mode allows you to shoot multiple images in quick succession by holding down the camera's shutter button. Depending on the quality of your camera and the memory card's read/write speed, you may be able to shoot between 3 and 12 (or more) frames per second. This mode is ideal for shooting sporting events, or any fast-moving subjects. The images in

FIGURE 4-8 When set to Portrait and Landscape Combo mode, the camera auto-focuses on the close-up subject and the distant background.

FIGURE 4-9 Typically, a digital camera will focus on just the main subject, blurring the background.

Figure 4-10 are examples of shots taken at a rodeo's bull-riding event within a few-second period using a camera's Burst mode.

**Red-Eye Reduction** In this mode, the camera will utilize the flash, but automatically compensate for red eye. Even when using this feature, however, you'll discover how to avoid red eye in your shots by adjusting the lighting and/or by using a flash diffuser. If your camera already has a lag time, using this feature may cause it to react more slowly.

**Self-Timer/Self-Portrait** Employ this mode when you want to shoot the photo and be one of the main subjects at the same time. Many cameras allow you to set the self-timer to 10, 20, 30, or 60 seconds.

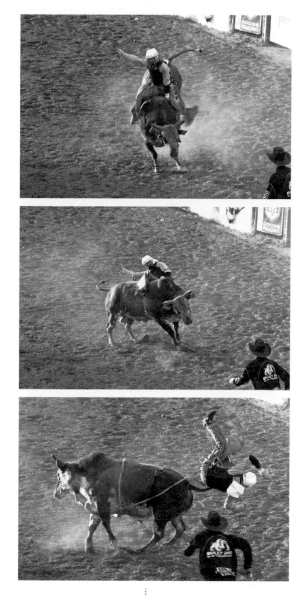

**Skin Softening**   This shooting mode automatically adjusts a person's skin tone, artificially improving his or her complexion, while still maintaining a natural appearance. This effect can also be added after-the-fact using photo-editing software.

**Shooting Through Glass**   When shooting through glass, the big problem you'll often encounter is unwanted glare. You'll learn how to overcome this in Chapter 8 by manually adjusting your camera and by blocking any light between the camera's lens and the glass you're shooting through. However, if your point-and-shoot camera has a Shooting Through Glass preset mode, it will automatically reduce or eliminate unwanted glare. As a general rule, never use a flash when shooting through glass.

**Shooting with Candlelight Lighting**   When you're shooting indoors or in very dimly lit areas, this shooting mode will make full use of the available light without employing a flash and auto-adjust the camera's settings to help insure your photos turn out crystal clear.

**Sports**   Even when holding the camera steady, if your subject is moving fast, you'll need to compensate to avoid an out-of-focus image. This shooting mode automatically adjusts your camera to capture a fast-moving subject without any blur.

**FIGURE 4-10** A moving subject shot using a camera's Continuous Shooting or Burst mode

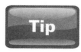

Although you can set your camera to Auto mode and take a picture in almost any situation using a point-and-shoot camera, you'll greatly reduce the number of out-of-focus images by selecting the appropriate preprogrammed shooting mode based on the situation.

**Sunset**    Typically, a photographer wants to have the sun behind him when shooting, so the sunlight lights up his subject. To avoid shadows and glare, you also want to avoid direct light shining into the camera's lens when taking a photo. When shooting sunsets, however, different rules apply, as you'll learn in Chapter 6. If your camera has a built-in Sunset mode, the camera's settings will automatically adjust to make the colors of the sunset as vibrant as possible.

As you practice using your camera, get into the habit of turning it on and off quickly, removing the lens cap (if applicable), and setting the menu options to their appropriate settings for the types of photos you'll be taking. At times, you'll have just seconds to whip out your camera and start shooting if you want to capture a moment. If you have to fumble with your camera, look around for the on/off switch, don't know how to access the proper menu options, or you're not comfortable simply holding your camera, mistakes can and will happen.

All too often people accidently place their finger in front of the lens, forget to turn the camera on, or don't remove the lens cap if they're in a rush to capture a specific photo. These common mistakes lead to poor photos or missing out on photo opportunities altogether. You can easily learn to avoid these common mishaps by practicing first.

Amateur photographers also commonly walk around all day with their camera lens fully exposed (no lens cap), which means dirt, dust, and fingerprints can easily get on the lens. Not to mention, it becomes much easier to scratch the lens if you accidently bump into something. A dirty or scratched lens will result in poor photos.

**Tip**    As a photographer, you always want to keep your lens protected and clean. Even the smallest speck of dust, a single grain of sand, or a fingerprint on the lens could ruin your images. In general, when you're not taking pictures, protect your camera lens by keeping the lens cap on—plus preserve battery life by turning off the power when you're not using the camera.

## How and Where to Learn More About Your Specific Camera

Because every camera is different, as you learn basic photography principles and strategies for improving your photos from this book, you'll also need to seek out details about operating your specific camera make and model.

 **Caution** Don't buy a new digital camera and then plan to use it for the very first time at an important event, such as a birthday party, wedding, social gathering, or vacation, where you want or need your photos to turn out nicely. Get to know your camera first and practice using it in advance. Go to a park, a zoo, or walk around your neighborhood taking pictures in different situations.

After buying your new digital camera, take it out of the packaging, charge the battery, and insert a new memory card. Before you start taking pictures, however, read the camera's manual. Most manuals for point-and-shoot cameras are designed to be read, cover-to-cover, in less than 30 minutes. Digital SLR camera manuals tend to be a bit longer, since these cameras have more features and functions you'll need to learn about, so plan on spending an hour or two reading these manuals, and then using them for reference later.

As you read the manual, have your camera nearby, so you can learn how to set it up for the first time. Learn what all of the camera's different buttons and dials are used for, how to set the resolution of photos you'll be taking, how to format memory cards, and how to prepare the camera for shooting. You'll also want to learn how to set the camera to its various preprogrammed shooting modes and how to preview photos on the camera's built-in display.

**Tip** When you turn on some point-and-shoot cameras, they will immediately be in Auto mode, ready to start snapping photos. Other cameras, however, will retain the exact settings from the last time you used it. So, if you were in Picture Viewing mode the last time you used the camera, that's the mode you'll be in when you turn it back on.

As you hold the camera in your hand, as though you're about to take a picture, memorize the geography of your camera. Teach your fingers where the power button, shutter button, flash controls, and other important buttons and dials are located. Make sure your fingers aren't accidently covering the lens or flash.

Some of the most common tasks you'll need to know how to do when shooting with a point-and-shoot camera or a Digital SLR camera in Auto mode include:

■ Turning on the camera and preparing to shoot

■ Overriding the Flash feature and turning it on or off when shooting

■ Using the zoom (or optical zoom) lens

■ Previewing photos as you take them

- Deleting photos while in Preview mode (although you shouldn't do this, unless it's absolutely necessary, until after you've transferred all of your photos to a computer)
- Using the camera's Self-timer

When actually taking pictures with your digital camera, as you look through the viewfinder, or use your camera's display as a viewfinder, you'll notice various icons are displayed while you're taking pictures. These icons will vary greatly based on your camera make and model and what shooting mode you're using. Learn what all the icons mean.

Getting to know your camera and learning how to manipulate the buttons and dials instinctively will require a combination of reading and investing time actually using the camera. In addition to the owner's manual, other reference and educational tools are available that might be useful:

- Read "how to" books about your specific camera make and model. These books may be written in an easier-to-read format or provide more in-depth information than the owner's manual. Several book publishers offer their own series of camera-specific books for Digital SLR cameras that are designed to supplement or replace the owner's manual. If you own a Nikon or Canon Digital SLR, you'll find many different books available that cover these cameras specifically. You can find them within the Photography section of a bookstore, order them through online booksellers (like Amazon.com and BN.com), or purchase them from photography specialty stores.

- Photography magazines often feature specific camera makes and models in articles, which combine equipment reviews with tips for using the featured camera. Check out some of the past issues of photography magazines to see when and if your camera make and model was featured, and then read the articles pertaining to your camera. The print editions of *Popular Photography* (www.popphoto.com), *Digital Photo* (www.dpmag.com), and *Digital Photography Pro* (www.digitalphotopro.com) are all available from newsstands, and past issues can be read online.

■ The Internet is also a wonderful resource for learning about specific camera makes and models. Visit the website for your camera's manufacturer, plus use Google or another search engine to find user-created enthusiast websites that focus on your specific camera.

■ Especially for Digital SLR cameras from Nikon and Canon, you'll find DVD and online-based classes and tutorials available that cover specific camera models. These classes are typically taught by professional photographers and go much more in-depth than what's covered within a camera's owner's manual. Blue Crane Digital (www.bluecranedigital.com) is an example of a DVD production company that produces 90-minute training videos for dozens of popular Nikon and Canon camera models. These videos are great for people who learn better from an instructor, as opposed to reading a technical manual.

■ Participating in photography classes is also an excellent way to learn how to use your camera. Many photography specialty stores, as well as Adult Education programs, offer digital photography classes, some of which are geared toward specific camera models. Camera manufacturers and photography magazines also offer classes taught in major cities. Here's a sampling of what's offered:

   ■ *Popular Photography* magazine hosts its Digital Days Photography classes and workshops in major cities (www.digitaldaysphoto.com).

   ■ Nikon offers its Nikon School (www.nikonschool .com) and Mentor Series of photo classes (www.mentorseries.com) that travel around the country throughout the year.

   ■ Canon Digital SLR owners can participate in special events, workshops, and classes taught by Canon's Digital Learning Center (www.usa.canon.com/dlc) and held throughout the country.

   ■ For its Lumix digital cameras, Panasonic hosts its Digital Photo Academy (www.digitalphotoacademy .com) in major U.S. cities throughout the year.

   ■ The New York Institute of Photography (www.nyip .com) offers in-person classes and remote-learning options for its photography curriculum.

 Some professional photographers teach photo workshops or host photography tours that offer one-on-one or small group photography instruction. For example, in Washington, DC, photographer E. David Luria offers Washington Photo Safaris (www.washingtonphotosafari .com), which are personalized photo tours of the city, along with its attractions and monuments. These half-day and full-day tours incorporate hands-on photography instruction with an informative guided tour.

## Create Your Photographer's Kit

As you're getting to know your camera and becoming acquainted with its features and functions, start gathering the optional accessories and equipment you'll need while on-the-go and shooting with your camera. The purpose of putting together your own Photographer's Kit is to insure that when you leave home, you don't forget any important pieces of equipment or accessories, such as extra batteries, memory cards, or your camera's external flash unit. If you keep everything in one place and well organized, you're less apt to forget something important.

 See Chapters 2 and 3 for information about finding and buying photo equipment and accessories for both point-and-shoot and Digital SLR cameras.

If you're a point-and-shoot camera owner, you'll want to invest in a small case for your camera that will hold the camera itself, along with one or two extra batteries and memory cards. If you know you'll be using your camera's built-in flash a lot, consider investing in a flash diffuser for your point-and-shoot camera. This accessory will work in conjunction with the built-in red-eye reduction feature to reduce or eliminate red eye in your photos altogether. Chapter 3 offers details about the Gary Fong Delta Point and Shoot Diffuser for point-and-shoot digital cameras.

Digital SLR users should choose a camera case or bag that's well padded and has pockets or compartments for the camera body, all of its lenses, an external flash unit, as well as extra batteries, memory cards, lens filters, and other accessories. Ideally, you want to be able to easily and safely carry around all of your photography equipment in a single case or bag—one that also offers quick access to your camera when you need it.

Include within your Photographer's Kit (which should be comprised of all the equipment and accessories you'll need while taking photos wherever you happen to be), a camera and lens cleaning kit (or at the very least, a microfiber lens cleaning

cloth). Photography Solutions, Inc. (www.photosol.com) offers its Digital Survival Kit Professional ($120) for professional and serious photographers, and its Digital Survival Kit Basic ($24) for amateur photographers. Both are compact, yet comprehensive, camera and lens cleaning kits suitable for most Digital SLR cameras.

**Caution** One of the most common mistakes made by amateur photographers is not carrying around an extra battery and memory card for their camera, especially when they're on vacation or attending an event or party during which they intend or need to take plenty of photos. A dead battery or a full memory card will render your camera useless for taking additional photos, unless you have replacements on hand.

Every photographer, whether amateur or professional, has their own arsenal of photography equipment and accessories, as well as their own shooting habits and techniques, which are developed over time. Figure out what works best for you, and what equipment you'll want or need for every shoot, and then put your Photographer's Kit together and keep it within the camera case or bag that's best suited to your unique needs.

## Practice Makes Perfect

You can memorize the owner's manual for your camera, read additional books, watch instructional videos, and participate in photography classes, but nothing will replace the need to practice taking pictures using your own equipment. Once you understand the camera's basic operation, experiment with its various features and functions. Then, as you learn photography shooting techniques and strategies from this book and elsewhere, practice using them. As with any activity that requires knowledge and skill, the more practice you have, the better your pictures will be.

During your practice sessions, which could include simply going outside and walking around the block taking pictures of the neighborhood, taking a trip to a local park or zoo, or going around your home photographing your furniture, pets, and/or kids, experiment using your camera's various shooting modes, features, and functions. Discover firsthand how the same subject, shot in the same location, but employing different photographic techniques or camera features, will result in vastly different photos, based on how you frame your images, utilize lighting, and take advantage of your setting's foreground and background.

## Learn About Your Camera's Limitations

Getting to know your camera also means learning firsthand about its drawbacks, so you can overcome them. As discussed in earlier chapters, many digital cameras have a lag time. There is a gap (between several fractions of a second to one or two full seconds) between the time you press the shutter button and when the photo is actually taken. Lag time is one of the most frustrating things related to inexpensive point-and-shoot digital cameras. Every point-and-shoot digital camera make and model (and some lower-end Digital SLR cameras) has a different lag time, which you'll need to compensate for, especially when taking photos of anything in motion.

And if you're using a feature like red-eye reduction, for example, the shooting process is even slower. What this means to you, the photographer, is that when you're attempting to shoot anything involving movement or action, you need to know your own camera and its unique lag time. Anticipate the photo you want to take—before the action actually happens within your viewfinder (such as the moment a player scores a touchdown in a football game or a runner crosses the finish line). Otherwise, because of lag time, you'll often miss action-oriented photos, or your subject will have moved between the time the shutter is pressed and the camera actually takes the photo.

Unfortunately, you can't do much to eliminate lag time on inexpensive digital cameras. A few tricks that might help speed things up, however, include:

- Make sure your camera's batteries are fully charged.
- Purchase memory cards with the fastest read/write speed possible.
- If your camera has a Continuous Shooting mode or Burst mode, and you need to capture fast-moving action, such as a sporting event or kids playing, take advantage of this mode. You'll wind up with a bunch of extra photos, because multiple images will be taken in quick succession, but you have a better chance of actually capturing the exact moment in time you want. You can always delete the unwanted images later.

The good news is the more expensive point-and-shoot cameras and the mid-to-high-priced Digital SLR cameras have little to no lag time. If you're really frustrated by the lag time of your inexpensive point-and-shoot camera, you may need to upgrade to better equipment.

As you get to know your camera, learn how long a battery charge lasts based on the types of photos you'll be taking. If the camera's manufacturer says a battery charge will last for 300 photos, for example, remember this is only an estimate and does not take into account heavy use of the camera's built-in display to view photos or of the camera's built-in flash. You'll discover your battery has a much shorter life if you use features and functions that drain a lot of battery power.

Even with extra batteries on hand, you don't want to get into a situation where you're trying to capture something very specific that will only happen once, but your camera's battery dies (requiring you to take a minute or two to replace it). Likewise, you want to keep an ongoing mental note of your memory card usage, so you don't suddenly run out of storage space at the least optimal time (requiring you to take a minute or two to swap memory cards).

The more time you spend using your camera, the better you'll know it. For example, the power and intensity of the built-in flash will vary greatly among camera makes and models. Some flashes will light up just a few feet directly in front of the camera, while others have a wider reach or some degree of adjustability. When you're taking photos indoors or in poorly lit situations and relying on your camera's built-in flash, you'll be able to take better pictures if you know your flash's capabilities and don't have to experiment too much when you're actually taking important photos.

Just as someone who knows how to touch type using a computer keyboard doesn't have to pay any attention to where the individual letter keys are located, as a photographer, strive to obtain that same level of familiarity with your camera.

## Camera Straps Serve a Purpose, But You Have Options

All digital cameras come with some type of neck strap or wrist strap, depending on the size and weight of the camera. These straps protect your camera from being accidently dropped and should be utilized. However, based on your own preference, and what you perceive to be comfortable, you may choose to use another type of strap. For example, for point-and-shoot digital cameras, you might attach an around-the-neck lanyard, as opposed to a wrist strap, so you can wear the lightweight camera around your neck for easy accessibility while on the go.

For heavier and larger Digital SLR cameras, a wide range of optional wrist straps, shoulder harnesses, and other devices are available that allow you to "wear" your camera, but not have its entire weight hanging around your neck. For example, Skytop Trading Company (www.skytoptrading.com) has custom-made leather straps and holsters for Digital SLR cameras that offer a variation on the traditional neck strap, plus offer added protection for the camera's body and lens. The Cotton Carrier Camera System replaces the traditional neck strap with a patented holster system that distributes the camera's weight around both shoulders, your back, and your upper-chest (www .cottoncarrier.com). The SLR Wrist Strap (www.optechusa .com/product/detail/?PRODUCT_ID=80) can be used to safely hold a Digital SLR camera in your hand, without wearing a cumbersome and sometimes uncomfortable neck strap, although this type of device offers less protection against dropping the camera and does not offer a hands-free option for carrying the camera like a neck strap or holster does.

Of course, if you don't like the logoed neck strap that comes with your camera and clearly displays the Nikon or Canon logo, for example, any photography store will offer generic camera straps in solid colors or decorative patterns. Some of these straps offer extra padding around the neck and shoulder areas, which makes wearing your heavy camera a bit more comfortable. Tamrac, a popular camera lens and accessory company, offers a selection of padded camera straps made from neoprene and other materials (www.tamrac.com/g_camerastraps.htm). For less than $30, you can purchase a custom-made camera strap that's padded and uses a designer fabric from Jodie's Camera Straps (www.jodiescamerastraps.com).

As you become familiar with your digital camera, you'll be able to determine what type of strap is best suited for your needs and that will also best protect your equipment, based on where and how you'll be shooting. A Digital SLR camera with a zoom lens and external flash unit attached will get heavy and uncomfortable if you're wearing it around your neck for an extended period. Depending on your gear and its weight, you might seek out other options if you'll be wearing your camera for long periods.

## Lens Cap Options and Accessories

While point-and-shoot cameras have a built-in lens cap that automatically retracts when the camera is powered on, the lenses used with Digital SLR cameras require removable, protective

lens caps. When not being used, lens caps protect lenses from dust, dirt, water, and scratches. Lenses, which can cost hundreds or thousands of dollars each, are made from very fragile optical glass that can scratch or even break very easily. A plastic lens cap, which comes with the lens (and that can be replaced for well under $5), should always be used to protect your lenses.

When not in use, a detachable lens cap can be stuck in a pocket or placed in your camera bag. However, many photographers wind up constantly taking their lens cap on and off. To save time and keep the lens cap from getting lost, for under $5, consider purchasing a lens cap strap (shown in Figure 4-11). One end of the strap attaches permanently to the plastic lens cap. The other end is an elastic band that wraps around the camera lens. In between the two ends is a thin string that allows the lens cap to dangle, out of the way, while photos are being taken, yet be easily accessible when the lens cap needs to be placed back on the lens.

**FIGURE 4-11** An optional lens strap keeps your lens caps from getting lost when not in use.

This very practical accessory will save you time and keep you from misplacing the plastic lens caps. Lens cap straps can be purchased from any photography specialty store or online from companies that sell camera lenses and photography accessories. You'll want a separate lens cap strap for each of your Digital SLR camera's lenses.

 If you opt to not use a lens cap strap, get into the habit of storing your lens cap in the same place (such as the same pants' pocket or compartment of your camera bag) while your camera is in use. This way you won't fumble around looking for it each time you need to cover your lens.

# Why Photography Is a Skill and an Art Form

One concept that will be reiterated several times throughout this book is how photography skills and knowledge need to be combined with your creativity in order to take good pictures. Using just your knowledge of how to operate your camera, you

can easily take in-focus photos. If you want your photos to be visually appealing, artistic, and capture the attention of viewers, however, you'll want to incorporate your own creativity into each photo you take. Thus, photography should be considered an art form, just like painting or sculpture.

Looking at the work of any truly great photographer, such as the late Ansel Adams (www.anseladams.com), it's easy to call his work art. While you may not intend to create art with your camera, by thinking of your photography as a creative and artistic process, your photos will become much more visually appealing. Whether you're taking candid snapshots of your kids or capturing vacation memories, for example, the images you'll wind up with will be more pleasing to look at, add more of a decorative element to your home or office when they're framed and displayed, and communicate more of a story.

The rest of this chapter explains some basic photography techniques that'll help you enhance your creativity and take more visually appealing photos in any situation. Again, you'll want to combine these techniques, and the strategies discussed in Chapters 5 through 10, with a basic working knowledge of how to operate your camera in order to achieve your desired results.

# An Introduction to Basic Photography Techniques

Whether you're using a point-and-shoot or Digital SLR camera, before you take any pictures, you need to follow these ten steps, which in most situations, should take no more than a few seconds:

1. Turn on the camera and remove the lens cap.

2. Choose your main subject(s) and focus in on them.

3. Select what you want, if anything, in your foreground and background.

4. Adjust your camera's controls or choose a preprogrammed shooting mode that's appropriate to the situation.

5. Take advantage of (or compensate for) the available lighting.

6. Determine the best camera angle to shoot from.

**7.** Frame your image within your camera's viewfinder.

**8.** Adjust the zoom and focus your image.

**9.** Hold the camera perfectly steady.

**10.** Press the camera's shutter button and snap your picture.

 If you're taking a posed portrait, for example, you'll have more time to plan your shot, adjust the lighting, pose your subjects, and experiment with different camera angles.

Some of these ten steps, such as turning on the camera and removing the lens cap, should become automatic and intuitive. These steps are part of the core knowledge you'll need to take pictures. However, some of these ten steps require you to tap into your own creativity to create photographic art, as opposed to just snapping a photo.

Choosing what to shoot, the angle to shoot from, how to frame your subject within the image, how to utilize the lighting (and shadows), and how to incorporate your subject's surroundings into each image are all a matter of personal taste and creative judgment. While you can use basic photography principles to help you make decisions that have visually appealing results, there are no actual rules to follow when it comes to creating photographic art.

## The "Rule of Thirds"

The "Rule of Thirds" is a basic photography principle that will help you take more visually interesting photos using any camera whatsoever. This principle deals with basic photo composition—the framing of your image, or how and where things appear within your photos.

Amateur photographers commonly place the subject of their photo dead center in the frame and don't take into account the foreground or background. This is a mistake. In most cases, placing your subject in the center of the frame is boring and predictable. It often makes it very difficult for the image to tell a story, show motion, or engage the viewer. In reality, placing your main subject off-center is more aesthetically pleasing. This is where the Rule of Thirds comes into play.

Looking through your camera's viewfinder, divide the picture area into vertical and horizontal thirds, as shown in

Figure 4-12. In other words, visualize a tic-tac-toe board overlaid on the potential image. Now, position your subject on one or two of the four lines to create a more interesting picture.

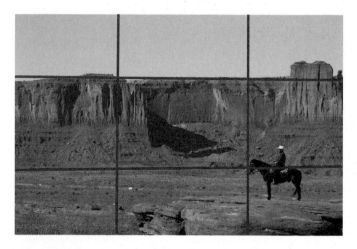

The main subject or focal point of the image should be positioned where two of the horizontal and vertical lines intersect, or along one of the lines. You can see this demonstrated using red dots in Figure 4-13. In this photo, the Yorkshire Terrier's face—the

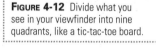

**FIGURE 4-12** Divide what you see in your viewfinder into nine quadrants, like a tic-tac-toe board.

focal point of the photo—is positioned off-center, along two vertical intersection points on the left side of the image.

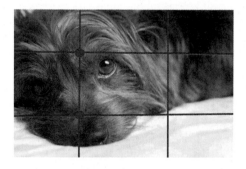

**FIGURE 4-13** The red dots show where the horizontal or vertical lines intersect.

If you look at Figure 4-14, the main focal point is in the lower-right quadrant of the image. Keep in mind, on most cameras, the tic-tac-toe lines are imaginary. You need to visualize them in your mind's eye as you look through your camera's viewfinder and take your photos. In some cases, however, you can set the camera's viewfinder to display these lines digitally in the viewfinder, but, don't worry, they won't actually appear in your photos.

As you're taking pictures, begin by looking at your subject through the camera's viewfinder and center the subject in the frame. If your camera has an auto-focus feature (like most Digital SLR cameras) that requires pressing the shutter button half-way, do this now, so the camera focuses in on your main subject. Now, reposition the main subject in the frame using the Rule of Thirds, and determine where in the frame your subject will be most visually appealing. Next, fully press the

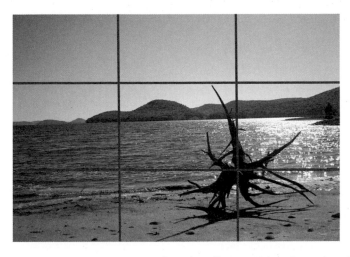

camera's shutter button and take the photo. Regardless of where your subject is in the frame, the camera will auto-focus on the subject and not on anything in the foreground or background.

The best way to get used to utilizing the Rule of Thirds in your own photography is to practice often and experiment. As you're learning, keep in mind you can always crop your images later when you edit them on your computer. Depending on how you crop an image, you can usually reposition the main subject and incorporate the Rule of Thirds after the fact.

Figure 4-15 and Figure 4-16 both utilize the Rule of Thirds to make the subject of each photo more interesting. These images are just a small sampling of how to apply this basic photographic principle.

**FIGURE 4-14** The main focal point of this image is the lower-right quadrant.

**FIGURE 4-15** Using the Rule of Thirds, the main subject is positioned away from the dead-center of the image.

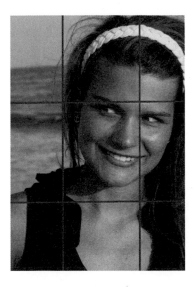

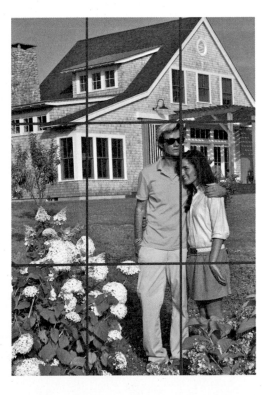

**FIGURE 4-16** You can use the Rule of Thirds to help add a sense of depth to a photo.

## Choose the Right Lens and Equipment for Every Shot

Aside from knowing how to operate your camera and choosing the appropriate shooting mode or camera features for any given situation, it's also your job as the photographer to choose the most appropriate lens (if you're shooting with a Digital SLR camera and own multiple lenses) and/or to utilize just the right amount of zoom as you frame your shot (using any type of camera).

As you frame your shot and take advantage of your photographer's eye to envision your image before you actually snap the photo, you also need to consider what photography equipment and accessories you have at your disposal and which of these items might potentially improve your photos or make them more visually appealing. In many cases, the slightest change in a lens filter, tripod, external flash unit, or flash diffuser can dramatically impact your images.

Thus, to truly capture what you perceive to be the absolute perfect shot in any given situation, you may need to utilize several pieces of photography equipment, in addition to your camera.

## When to Use a Tripod

As you already know, a tripod can be used to keep your camera perfectly still when taking a photo. If many situations, if a camera isn't held steady when snapping a photo, the image will turn out blurry.

Using a tripod is particularly important for keeping the camera steady in low-light situations, when using a telephoto zoom lens to really zoom in on your subject from a distance, or when shooting an object extremely close up (using a macro lens or the macro shooting mode on your camera). Sometimes using a tripod means the difference between being able to take a clear, blurry-free image and not being able to capture your subject with the clarity you desire.

**Tip**    When using a Digital SLR camera, if the shutter speed is less than the focal length of the lens you're using, seriously consider using a tripod to capture a clear image.

Depending on the size and weight of the tripod you purchase (you'll find tips for buying a tripod in Chapter 3), you may not have it with you every time you want to take photos in nonoptimal situations when you really need to hold the camera

extra steady. One common problem amateur photographers have is keeping their camera extremely still whenever they shoot photos. Even the slightest motion as you press the camera's shutter button can cause the image to be blurry or out of focus.

If a tripod isn't available, try these strategies for keeping your camera perfectly still when shooting:

- As you're about to take a photo and press the camera's shutter button, keep your body (especially your hand and entire arm holding the camera) as still as possible. Hold your breath for a few seconds as you actually take the photo and press the camera's shutter button.

- If possible, lean against a stable (non-moving) wall, tree, fence, pole, or another object to help steady your entire body as you take a photo.

- Place the camera on a table, ledge, fence, window sill, or another flat and stable object instead of holding it in your hands as you shoot.

- Turn on the Anti-shake feature of your point-and-shoot digital camera if you're forced to take photos in situations where the camera will be moving or unsteady, especially if you're also using a zoom lens. If you're shooting with a Digital SLR camera, turn on the Image Stabilization feature of your lens (and/or your camera).

## White Balance 101

Light plays a starring role in all of your photos. However, not all light is the same. There's sunlight, for example, plus artificial light created by a camera's flash, indoor light bulbs from everyday lamps, florescent lighting, halogen lighting, and other types of artificial light that our human eyes automatically adapt to. When it comes to digital cameras, however, even the most advanced models sometimes have a difficult time adapting to different light sources, which is why, as a photographer, you need to understand white balance.

Figure 4-17 is an example of a photo taken indoors using artificial light where the white balance needs to be adjusted. In Figure 4-18, the white balance has been adjusted. All digital cameras have an Auto White Balance mode that allows the camera to analyze the available light in any situation and adjust the colors that will appear in your photo automatically.

FIGURE 4-17  This image has white balance problems.

FIGURE 4-18  By adjusting the White Balance mode of your Digital SLR camera, color problems like this can be fixed in seconds.

To accomplish this, your digital camera focuses in on the color white in a scene and uses it as a benchmark. It then adapts all of the other colors in your photo accordingly. Usually, the Auto White Balance mode built into your camera will work perfectly … but not always, especially if you're using a more complex Digital SLR camera.

If you're using a point-and-shoot camera, typically you can't manually adjust the white balance. However, when shooting with a Digital SLR camera, you can manually override the Auto White Balance mode if you determine that the colors in your photos don't look right. Regardless of the type of light you're shooting in, the colors in your photos should always appear normal. There may be times, however, when anything that is white in real-life will appear gray, yellow, blue, or brownish in your photos (as in Figure 4-17), which as a result, will alter how all of the other colors appear.

To remedy this situation when shooting with a Digital SLR camera, you can change from using Auto White Balance to a preset White Balance mode, based on the type of light you're shooting in. For example, many cameras have a Bright Sunlight/ Daylight, Cloudy, Shade, Tungsten Light, White Fluorescent Light, Flash, and Custom setting, as well as the default Auto White Balance (AWB) mode. (*Tungsten Light* refers to a traditional incandescent light bulb used in your home, as opposed to fluorescent lighting.) Most of the time, choosing one of these preset White Balance modes will fix the colors in your photos as you take them, assuming you select the correct preset mode for the lighting conditions where you're shooting.

 While you can adjust the White Balance mode to override the Auto White Balance mode when shooting, you can also adjust it later when editing photos using specialized photo-editing software, such as Photoshop Elements, iPhoto, or any other program described in Chapter 12.

To manually adjust the white balance from AWB to a preset mode, you'll need to access your Digital SLR camera's Set-Up or Shooting menu and find the White Balance setting. How you do this will be different for each camera make and model. Check the owner's manual or onscreen help menus on your camera for details.

 The most common situation where you may have a problem with your Digital SLR camera's AWB mode is when shooting indoors where traditional incandescent light bulbs or fluorescent light bulbs are in use.

You many encounter situations when neither AWB mode nor any of the preset options work for getting the coloring right in your photos. When shooting with a Digital SLR, you can remedy this by manually adjusting the white balance using the Custom White Balance mode option in your camera.

In the location where you plan to shoot, under identical lighting, set your camera to shoot a photo in any manual focus mode. Snap a photo of a solid-white sheet of paper (or anything that's solid white such as a wall). Whatever white object you choose should fill the spot metering circle that you see when looking through your camera's viewfinder. The *metering circle* is the circle that appears in the center of the viewfinder.

Snap a photo of the white paper, then press the Menu button on your camera, and select the Custom White Balance (Custom WB) setting. Select the image you just shot of the white object, and press the Set button to store this image and set the White Balance feature of your camera for the location where you're currently shooting based on current lighting conditions.

 If the light changes where you're shooting, you may need to adjust the White Balance setting repeatedly.

To make adjusting the custom white balance even easier, several companies have created optional accessories for you to use. Most of these products simply replace the need for shooting a solid-white piece of paper to set the custom white balance on your camera. For example, Expo Imaging (www.expoimaging .com) offers its ExpoDisc ($69.95 to $169.95), which is designed

specifically for use with Digital SLR cameras. The ExpoDisc looks like a white lens cap that can be used to set the white balance of your camera manually. When ordering an ExpoDisc, you'll need to know the diameter of your lens (in millimeters). The company's website offers video tutorials and other information for utilizing ExpoDisc to best capture accurate colors when shooting.

An alternate tool you can use to help you manually set your camera's White Balance mode is the 12-inch, foldable Lastolite EzyBalance ($30, www.lastolite.com/ezybalance.php). It's a double-sided, 18 percent gray/white card, which replaces the need to shoot a solid-white piece of paper when setting your camera's white balance. To use this device, simply get your subject to hold the EzyBalance card, snap a photo (that zooms in on the card), and use that image to set your custom white balance.

**Tip** Until you're extremely comfortable shooting with your Digital SLR camera, leave the camera set in Auto White Balance (AWB) mode, which will work fine most of the time. Remember, you can always adjust the coloring in your photos later using photo-editing software.

## Decide What, Where, and When to Shoot

There are a lot of creative decisions involved with taking pictures, the most obvious of which is choosing what, where, and when to shoot. The *what* can refer to your main subject— the people, pets, location, object, sunset, historical landmark, building, or anything else whatsoever that you want to be the main focus of your photograph.

Once you determine what you want to shoot, the next thing to consider is *where* to shoot. Where is an interesting background for your subject(s)—one that will add visual appeal to the photograph without being a distraction. If someone is standing directly in front of an object (in the example used in the next two figures, a boat's mast), so it looks like the object is growing out of his head, that's a distraction, not to mention poor photographic judgment (as shown in Figure 4-19). Instead, move the subject slightly to the side, for example, so the object adds décor to the image or acts as a prop for the subject, but isn't a distraction (as shown in Figure 4-20). You could also adjust the shooting angle of the camera.

Deciding *when* to shoot is also an important consideration. If you're taking pictures at a basketball game, for example, capturing a player making a basket and dunking the ball will be a much more compelling image than that same player dribbling

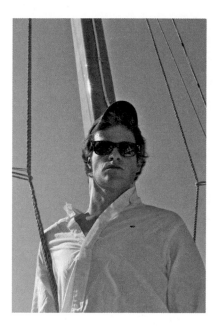

**FIGURE 4-19** Avoid background objects that will distract viewers from the main subject of the photo.

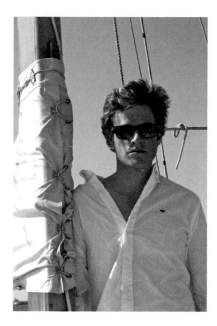

**FIGURE 4-20** By adjusting the placement of the subject, you can transform a distraction into a useful background or prop in a photo.

the ball down the court. Thus, timing becomes a critical element when shooting—after you've decided what and where to shoot.

If you're taking a picture of an animal at the zoo or in the wild, or a photo of a human infant, timing is also important. The most compelling photos will typically be when the animal or baby is looking directly at the camera. Yet, you can't pose a wild animal or ask a baby to cooperate. As a photographer, you have to be patient and remain ready to shoot, based on the subject's spontaneous actions. Chapter 7 offers additional tips for photographing people, pets, and wild animals.

Whether you're shooting random, candid images or planning your shots carefully and having your subjects pose for each picture, focus on the what, where, and when as you shoot each image, and consider how altering any of these elements could impact your photo for the better. Again, something as simple as changing your shooting angle slightly, altering the background, or allowing the subject to somehow interact with something in the foreground can dramatically change an image.

As you're experimenting and trying to capture the perfect shot, in between taking photos, quickly preview your previous image on your camera's built-in display (if time permits), so you can see what you've already captured and come up with other creative ways to shoot future images.

## Choose Your Main Subjects, Plus Your Foreground and Background

The real world is, of course, three-dimensional. However, when you take a photograph, you're capturing a piece of the multidimensional world using a two-dimensional medium. Fortunately, there are strategies you can incorporate into your picture taking to give your images more depth and make them more visually interesting.

The trick to doing this is to pay careful attention to the foreground *and* the background, as well as your primary subject. Sometimes, by capturing something in the foreground (in front of the image's main subject), as well as the background, you can give your photo a multidimensional feel, as shown in Figure 4-21. Here, the path and sign leading up to the lighthouse give the photo more depth and make it more interesting visually.

When adding objects to the foreground and/or background, make sure your camera focuses in on the main subject of your photo—not the foreground and background. Before trying this shooting technique, become familiar with the auto-focus operation of your digital camera.

On some cameras, you'll want to start off by focusing only on your subject at first. Press the camera's shutter down halfway, so the camera's auto-focus feature kicks in and focuses on your intended subject. Next, zoom out or reposition your subject to include the foreground and/or background (while keeping the shutter button pressed down halfway). On many cameras, when you take your photo, your intended subject will now be in focus, while the foreground and/or background will be visible, but most likely slightly out of focus.

**FIGURE 4-21** The pathway and sign in the foreground add depth to the photo, giving it a multidimensional feel.

FIGURE 4-22 The Grand Canyon with an interesting foreground

Remember you don't necessarily need to have people in your photo for this technique to work. Figure 4-22 shows the Grand Canyon. In this case, the background is the main subject of the image, but trees in the foreground are used to frame the image and make it more visually interesting.

In Figure 4-23, the photographer positioned the binoculars in the forefront of the image, but the vastness of the landscape in the background is clearly the intended subject. This image has a lot more depth, and is more visually interesting than just a close-up of the landscape itself, which is shown in Figure 4-24.

FIGURE 4-23 Placing something in an image's foreground can give the photo a sense of depth.

FIGURE 4-24 Without something in the foreground, the main subject is more one-dimensional looking.

As you're taking your photos, think about how you can frame your images using the landscape or objects around you, paying attention to what's in front of the subject, the subject itself, and what's behind the subject. Combine this technique with the Rule of Thirds, and try experimenting by shooting from a few different angles or perspectives. You'll quickly discover your photos will adopt a more professional quality.

For additional examples of how utilizing the foreground and background can make an image more visually interesting, see Figure 4-25 and Figure 4-26.

**FIGURE 4-25** Use objects in your foreground to give your photos a more professional look.

**FIGURE 4-26** In this case, tall grass is used in the foreground and background to surround the subject.

## Framing Your Shots

The term "framing your shot" doesn't just refer to putting a printed image into a picture frame and hanging it on your wall. When you're actually in the process of taking photographs, "framing your shot" refers to how you position your subject(s), choose your shooting angle, utilize the foreground and background, and take advantage of lighting and/or shadows. In other words, how you utilize your photographer's eye.

When you look through your camera's viewfinder, what you see within it is, in essence, what will ultimately be hanging on your wall if you snap the photo, print out the image, and

## Did You Know?

# 3D Digital Cameras Are on the Way

In late 2010, several camera companies announced or actually introduced special lenses capable of shooting three-dimensional images for their Digital SLR cameras. While this technology is still in its infancy, Panasonic was one of the first camera manufacturers to showcase a 3D lens for its Lumix G Micro System compatible Digital SLR cameras. Fujifilm and Sony have also announced 3D lenses for their respective Digital SLR cameras.

In reality, a 3D lens for a Digital SLR camera contains two lenses located next to each other, both of which simultaneously transmit light to the digital camera's single image sensor. When the two lenses work together (each taking the same shot from a slightly different viewpoint), a single multidimensional-looking image is created.

As 3D digital imaging becomes more commonplace and readily available, photographers need to pay even closer attention to everything happening in each photo's foreground and background because all of the images you take will appear truly three-dimensional. These lenses give you even greater creative control over your images and will allow photographers at all skill levels to create more realistic or lifelike images.

display it in a traditional frame. As you're taking the photo, think in terms of creating a finished product that'll look great hanging on your wall. As you're framing your shots and choosing exactly what to shoot, don't just pay attention to the main subject. Look at everything that appears in your viewfinder and see how everything interacts to create your image. You may determine that there's too much going on in the viewfinder and your picture will turn out too cluttered. Or you may discover your subject is positioned in front of an extremely boring background.

As you look through the viewfinder, make sure important objects (in the foreground, relating to the main subject, or in the background) aren't accidently being chopped out of the picture. For example, if you're taking a full-body shot of a person, make sure you see his or her entire head and body, as well as both arms, hands, legs, and feet in the image, and that you're not accidently cutting off a body part, which is an all too common mistake that can throw off the balance of an image, or make it look off balance or just plain silly.

Figure 4-27 shows a full-body shot of a person, but with the top of the subject's head and feet accidently cut out of the frame, whereas Figure 4-28 shows the same person, but in this shot, his entire body is captured in the photo.

When framing your photos, pay attention to details. Make sure your subjects are positioned correctly (using the Rule of Thirds), there are no distracting shadows, glare, or other lighting problems, and that you're utilizing the foreground and background appropriately to create the most visually interesting photo possible.

Most importantly, make sure what you want to be in focus actually is in focus, especially if you're using your camera's auto-focus feature. When using auto-focus, your camera will focus in on what it perceives to be the main subject of your photo. Most often, the camera gets this right. However, if there are objects in the foreground and/or the background, the camera sometimes auto-focuses in on the wrong thing, which means

**FIGURE 4-27** A full-body shot with a few pieces cut off

**FIGURE 4-28** A complete full-body shot

the object in front of or behind your main subject will appear in focus, but your main subject will appear blurry in the photo.

As the photographer, you must decide what aspect(s) of the image you want in focus and what elements you want to appear slightly blurred, if any. For example, blurring a background is appropriate when you want the people viewing your photo to focus on your primary subject. However, if you're shooting two main subjects in a single photo, you have to make sure both are in focus. For instance, you might have situations when you want both the main subject and the background to be in perfect focus, such as when you take photos of people standing in front of a major tourist attraction or landmark.

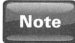 If you're using a Digital SLR camera, you can tinker more with manually focusing in on specific objects or elements within a photo and create some very interesting effects (such as motion effects) using blurs.

Good photographers will pay careful attention to how they frame each and every one of their shots—including their candid shots. This is one of the aspects of photography that makes it a true art form because it's up to the photographer to creatively orchestrate and shoot the most visually interesting images possible, based on the intended subject, location, and situation.

As with many aspects of photography, don't be afraid to experiment and be sure to practice framing your images. Over time, you'll see your artistic vision as a photographer become more defined, and incorporating creativity into your shots will become second nature.

## Consider Your Shooting Angle

Sometimes changing the angle or perspective from which you shoot your subject will dramatically alter the appearance of the photo, making it much more visually enticing, interesting, or artistic. And, more often than not, as the photographer, the change in shooting angle or perspective won't require you to move more than a few inches or feet in any direction. Shooting your subject from an angle, instead of head-on, will sometimes improve a shot dramatically.

Creativity and experimentation will definitely pay off when you start altering your shooting angles and perspectives—as opposed to always standing directly in front of your subject,

**FIGURE 4-29** The photographer stood directly in front of her subject and shot a photo head-on.

**FIGURE 4-30** A photo with the photographer looking up at the subject, but also from an angle

pointing the camera forward, and shooting an image head-on, as shown in Figure 4-29. (This photo is perfectly fine, but as a photographer, you always have options based on camera angles used.)

In addition to zooming in or out from your subject, see what happens if you crouch down and shoot upwards (shown in Figure 4-30), or climb up on a ladder or step and shoot downwards toward your subject. What happens if you move a bit to the left or right? As you look through your camera's viewfinder, keep the Rule of Thirds in mind.

Sometimes, something as simple as rotating the camera from horizontal (in Landscape mode), as shown in Figure 4-31,

**FIGURE 4-31** A shot taken in Landscape mode

**Figure 4-32** A similar shot in Portrait mode

to vertical (in Portrait mode), as shown in Figure 4-32, or vice versa, will dramatically alter your photo's appearance.

 You might discover that shooting something extremely close up (zooming in) or capturing it from an unusual angle will make for an amazing photo.

Figure 4-33 also shows how you can create interesting effects or more compelling images by shooting your main subject(s) from an angle, as opposed to head-on.

If you're visiting something massive, like the Grand Canyon, for example, you could attempt to take a panoramic image of as much as the eye can see by using the Panoramic shooting mode built into some digital cameras or a wide-angle lens, or by cropping together multiple photos using photo-editing software. No matter which method you use, if done correctly, this certainly makes for a spectacular visual.

However, if a wide-angle or panoramic lens isn't available, you can easily create equally interesting and visually stunning images by capturing in your photos just small sections of the large area taken from interesting angles or perspectives.

## Always Take Lighting into Account

When shooting photos outside on a sunny day, the sun itself can be a help or a hindrance to the photographer. As a general rule, you never want to point the camera toward the sun when taking a photo (unless you're shooting a sunrise or sunset). Doing so creates glare and reflections that can wreck your images. If the sun is directly behind the subject (facing the photographer), your subject will appear as a dark silhouette. To counteract this, in some situations, try using the camera's flash—even in daylight.

However, if the sun is to the photographer's back (and facing your subjects), it can shine a warm light on the people or objects you're taking pictures of. You can also adjust your shooting angle based on the proximity and direction of the available light source to create interesting shadow effects or glares that can potentially add an artistic element to your photos.

Unfortunately, you can't always control the sun's position in relation to the time of day and location where the subject is you're trying to photograph. In some situations, however, you can shoot into the sun for artistic purposes and use the flares created by the lens within the composition of your image to enhance it visually, as shown in Figure 4-34.

During daylight hours, when you point the camera toward the sun, you'll almost always see flares, glares, or reflections. To get rid of them, you can simply alter your position (as the photographer) and/or change the position of your subjects. Sometimes even the slightest change in position creates a totally different visual within your camera's viewfinder.

**FIGURE 4-33** This photo is shot from an angle, as opposed to head-on.

**FIGURE 4-34** This photo, taken on a ski slope in Utah, uses a glare from the sun shining through the trees to add an artistic element to the photo.

**FIGURE 4-35** A lens hood can keep unwanted glare from shining into your lens, or you can use your hand to block unwanted light.

To reduce glare and reflection, you can place your hand above the camera and block the sun. However, make sure you don't cover up the lens, or you'll wind up with a photo of your hand, not the intended subject. Using an optional lens hood (which attaches to the front of a Digital SLR's lens) can help to reduce glare caused by the sun. Figure 4-35 shows a sample of a lens hood. Lens hoods come in different sizes to block varying amounts of light, but when purchased, they must fit the diameter of your lens (measured in millimeters).

**Tip** Always pay attention to the location of the sun (or your light sources), in conjunction with the positioning of your camera and your subject(s). To compensate for bad lighting, take advantage of the special shooting modes built into your digital point-and-shoot camera. Be sure, however, to choose the correct shooting mode based on your situation.

Of course, if you're taking sunset pictures, you want to face the sun with your camera as you snap photos. In this situation, determine if your camera has a special built-in shooting mode for sunsets. If it does, use it.

## When to Use a Flash

There will be many situations, when shooting inside or outside, when utilizing your camera's built-in flash (or your Digital SLR camera's external flash unit) will be advantageous for taking the photo you envision. As you'll learn in Chapter 5, a flash is used to add artificial light to a setting easily. However, depending on the type of flash unit you're using, you may or may not have any control whatsoever over the intensity of the artificial light you're adding or the direction from which it originates and shines onto your subject(s).When you begin experimenting with your camera's flash, you'll quickly discover that it can do a lot more than just shine artificial light directly onto your subject when shooting in dimly lit situations.

External flash units can typically be adjusted, so instead of shining directly onto the subject, they can give off extra light at an angle. As the photographer, you can adjust the flash unit to bounce light off of a wall or ceiling, for example, or use a diffuser to make the artificial light less harsh.

Shadows occur when a flash is placed and used directly in front of a subject (as shown in Figure 4-36), as opposed to utilizing a light source (or multiple light sources) that surrounds the subject. Using a flash diffuser or adjusting the direction of the flash can reduce unwanted shadows.

All flash units have a range in terms of the size of the area they can light up when used. The small flash built into a point-and-shoot camera typically has a range of a few feet—meaning it can light up a subject located two or three feet in front of the camera, but will prove almost useless when trying to shoot something that's 15 or 20 feet away in a dimly lit locale, for example.

External flash units are typically much more powerful than built-in flash units. They give off more artificial light that can brighten a wider area. Because you can adjust the angle and

**FIGURE 4-36** Unless somehow diffused, when a flash is pointing directly at a subject as a single primary light source, expect shadows to appear in your photos.

direction of these flash units, you can intensify or diminish their impact by bouncing light off of nearby walls, the ceiling, or reflectors, or simply turning the flash away from a subject to reduce its impact. This will reduce or eliminate unwanted shadows as well as red eye.

**Tip** Using a multi-unit home-lighting kit, as opposed to a single flash, can also be used to eliminate shadows, since artificial light will surround your subject. Chapter 7 offers information about home studio lighting kits.

### Sometimes Natural Lighting Works Best

Even in dimly lit situations, there are times when shooting only with natural light works best to create a visually stunning, natural-looking image. When a camera is set on Auto mode, you can still override the camera's decision to utilize the flash in low-light situations and force the camera to take the best possible photo using only existing light.

## Did You Know?

# What Flash Guide Numbers Mean

Flash units are ranked based on Guide Numbers (GN). Professional photographers who utilize their camera and flash's manual shooting modes can use a flash's GN to determine the proper exposure to shoot at, without using a flash meter. A flash unit's GN is found by multiplying the flash-to-subject distance by the f-stop required for obtaining a correct exposure of the subject at that distance:

GN = f/stop × flash-to-subject distance

However, amateur photographers can use a flash's Guide Number as an indication of how much light it will emit and how powerful it is. The higher a flash's Guide Number, the more powerful the flash, and the farther away the light will reach when taking pictures. A typical flash built into a camera may light objects up to 15 feet away, while a more powerful external flash unit might have the ability to light objects up to 200 feet away. At the same time you look at a flash's distance, you also want to pay attention to how close to a subject the flash can be without overexposing the image. Some flash units must remain several feet away from the subject to avoid overexposure. Thus, if the camera is attached to the flash, this means that when the flash is used, the camera itself must be kept at a specific distance away from the subject, but not farther than the flash's range.

Just a few examples of when you'd want to do this are if you want to snap a photo of a couple enjoying a romantic candlelit dinner or a group sitting around a campfire. You'll also want to avoid using a flash when trying to take photos through a glass window or if you're trying to take pictures of something happening on a stage while you're sitting in the audience dozens or hundreds of feet from your subject.

# Special Situations Require Special Shooting Techniques

This chapter explained some basic shooting techniques that can be used in any situation to improve your photos and better allow you to incorporate your own creativity when taking pictures. However, in addition to these basic techniques, you'll encounter specialized situations that require unique strategies in order to capture professional-quality images.

For example, the techniques you use to shoot outdoors on a sunny day will differ from those you'd use when shooting indoor portraits of people using artificial light. There are also techniques and tips you can use for shooting photos while on vacation—ones that won't necessarily apply when you're taking photos at your child's soccer game or at your best friend's wedding reception.

Chapters 5 through 10 offer dozens of additional shooting tips and strategies that'll help you take professional-quality photos in a variety of specialized situations using either a point-and-shoot or Digital SLR camera. All of these tips and strategies will be a lot more useful, however, after you've taken the time to get to know your camera and its basic operation.

# 5

# Indoor and Nighttime Photos: Lighting and Flash Techniques

## How to…

- Decide when and if to use a flash
- Add an external flash to your Digital SLR camera
- Choose and use a home studio lighting kit
- Take great pictures at parties, weddings, and functions

The biggest challenge you'll most likely face as a photographer is controlling the light in various indoor and outdoor locations where you choose to shoot. Outside, you have to contend with glares, reflections, and shadows the sun creates in nonoptimal settings. Indoors, you have to deal with the potential challenges of working with artificial light, including shadows, plus overexposed or underexposed images, and white balance issues.

Your digital camera is probably equipped with a built-in flash. This flash isn't terribly powerful, but in dimly lit situations, it can shed light on your subject. Although your built-in flash is a useful tool that will often allow you to snap photos in situations where you otherwise could not, it has some definite drawbacks. For example, if your subject is too close to you when you're using the built-in flash, the photo will turn out overexposed (too well lit). Meanwhile, if your subject is standing too far away from you, and out of your built-in flash's range, what appears in the photo's foreground will be lit, but your subject will appear underexposed (too dark).

 When using a camera's built-in flash, your subject may appear too bright while the background appears too dark. In this case, use the Slow Sync Flash mode (also referred to as Nighttime Portrait mode) built into your point-and-shoot camera.

Another problem with a camera's built-in flash is that it emits a burst of harsh light directed straight out from your camera. Even when you use your camera's red-eye reduction feature, the harsh light will still create shadows and may impact the colors in your photos, especially if you're shooting in dimly lit situations.

The trick to using your camera's built-in flash is knowing how powerful it is and understanding, that for the flash to light your subjects properly, you can't stand too close or too far away. Every camera's built-in flash is different, so you'll need to experiment a bit and consult with your camera's owner's manual to determine the ideal distance between you and your subject when using the built-in flash in order to get the best possible lighting and exposure in your photos (with the least amount of shadows or other problems that a flash can cause).

If you're shooting with a Digital SLR camera and using its built-in flash, you'll encounter similar challenges and potential problems. However, with this type of camera, you have the option to use an external flash unit with your camera. These flash units, which are more powerful and adjustable, can also be used with an optional diffuser to soften the light and reduce shadows, plus lessen or eliminate red-eye problems. A properly angled flash, adjusted for the shooting situation, and potentially used with a diffuser, will also allow you to take photos without worrying about over- or underexposing your subject from a lighting standpoint. (More information about external flash units for Digital SLR cameras, along with optional diffusers, can be found in Chapters 3 and 4.)

This chapter focuses on using your camera's flash, as well as other artificial light sources, including home studio lighting kits, to take properly exposed photos indoors and in dimly lit situations. Since people enjoy taking pictures at parties and weddings, which are often held indoors, this chapter also offers strategies for taking professional-quality pictures at these types of events, plus it comes with a few handy checklists, so you don't miss out on taking important or memorable shots.

 Often the best photos at parties utilize creative lighting (since optimal lighting isn't always available), an unusual shooting perspective or angle, and/or show the emotions being conveyed by your subjects. Be creative when framing and later editing and cropping your shots.

# When and How to Use Your Camera's Built-in Flash

Natural light (with no flash) works in a wide range of indoor and outdoor situations, especially considering you can lighten or darken images and improve their contrast and colorization using photo-editing software after the fact.

Figure 5-1 shows a photo taken at an indoor birthday party using only natural light. As you can see, the natural light allows the ambiance of the setting to be captured, but everything is somewhat dark (underexposed). Figure 5-2 depicts the same shot, but the camera's built-in flash was used. Everything is better lit, but the flash created some shadows and took away the subtle nuances of the colors in the scene that the natural light created. The room's ambiance doesn't look as authentic when the flash is used.

FIGURE 5-1  A photo taken in natural, albeit dim, lighting

FIGURE 5-2  A photo taken using a camera's built-in flash

In Figure 5-3, the original shot (with no flash used) was edited using Photoshop Elements 9's Enhance features, and the lighting and other aspects of the image were adjusted using the Auto Levels, Auto Contrast, Auto Correction, and Auto Sharpen commands. If you combine your camera's capabilities in existing light mode, with the lighting, color, and exposure enhancement capabilities of photo-editing software, you can often get away without using the flash in many indoor and dimly lit situations.

**FIGURE 5-3** A photo taken in natural light but enhanced using Photoshop Elements 9

**Caution** Anytime you shoot in natural light and the scene is dimly lit, you need to hold the camera extremely steady or use a tripod to avoid blurs. A more portable alternative to a tripod is a one-legged monopod, which also keeps any digital camera steady when shooting.

When natural lighting won't work for your shots, your camera's built-in flash can be used to shed light on the scene and your subject, as long as you work within the confines of your flash's limitations. Based on the strength of your flash, your subject can't be too close or too far away. If you discover your camera's built-in flash has a range of between one and eight feet using zero zoom and between one and five feet using maximum zoom, you need to keep your subject within these distances to get the best results from your flash. In other words, your camera cannot be less than one foot from your subject, or farther than five or eight feet, depending on the zoom level you're using.

**Note** If you're shooting with a Digital SLR camera, you have the ability to manually adjust the camera's ISO and shutter speed to help compensate for a lack of light.

Many digital cameras have multiple flash modes to enhance their capabilities. When the camera is in full Auto mode, it decides when and if to use a flash (and which flash mode to use).

The Auto with Red-Eye Reduction mode employs the flash when necessary, but emits a low-intensity light before setting off the flash to contract the subject's pupils and reduce the unwanted red-eye effect in his or her eyes. Basically, smaller pupils reduce the red-eye effect, which appears when a bright flash is shot into someone's fully dilated pupils. The Anytime Flash mode (also referred to as Fill-in Flash mode) can be used indoors or outdoors to fill in subtle shadows and light up subjects who are *backlit* (a source of light, such as a sunset, is behind the subject, causing the front of the subject to appear dark). The Anytime Flash mode works in conjunction with natural light.

The Slow Sync Flash mode (which may be called Night Portrait mode on your camera) not only sheds light on your main subject, but also automatically sets the camera to use a slow shutter speed, so the dark and distant background will be better illuminated in your photo. When shooting outside in the evening or at night, this mode is ideal for taking a photo of a person standing close to you, but also in front of an outdoor landmark or building that's off in the distance. Your subject will be lit by the flash, and the slower shutter speed will allow more light to be captured to brighten what would otherwise be a dark background. After all, your camera's built-in flash can only illuminate an area several feet or yards in front of the camera, and won't have any impact on a building or background that's farther away. When using Slow Sync Flash mode, you typically have better results if you also use a tripod to keep your camera extremely steady. Because the shutter is open longer, the slightest movement will result in unwanted blurs.

## Using an External Flash Unit with Your Digital SLR Camera

As you learned in Chapters 3 and 4, using an external flash unit with your Digital SLR camera gives you a stronger and more controllable artificial light source when taking pictures. An external flash is typically connected to your camera via the *hotshoe* mount, which is located on top of your camera. Instead of just pointing forward, directly toward your subject, the external flash unit can be adjusted to affect the angle and direction of the light emitted from the flash. And with a diffuser, you can control the flash's intensity.

In most situations, an external flash will provide better results than a camera's built-in flash, providing you work within the limitations of the external flash. Again, the subject can't be too close or too far away from the camera in a dimly lit situation. Plus, you'll probably want to bounce the flash's light off of nearby walls or the ceiling, for example, to help reduce unwanted shadows.

The big problem with using any flash is that it shines a single source of light upon your subject. Unless this light is somehow diffused, it's bound to create unwanted shadows. If you take a look at professional portraits and photos shot indoors by professional photographers, however, the lighting typically looks perfect, and you'll seldom see unwanted shadows in their images.

Instead of using a single light source (the camera's flash), when a professional photographer shoots indoors, they'll often use a professional lighting system, comprised of two, three, or more lights that literally surround the subject with even light (which simulates daylight) from all directions, thus eliminating shadows. The intensity of the artificial light can also be adjusted, so it's not too harsh. Diffusers and reflectors (which are described in Chapter 6) can be used to direct, reduce, or diffuse light.

A professional photographic studio lighting setup costs thousands of dollars. For just a few hundred dollars, however, you can purchase a scaled-down home studio lighting kit that will allow you to achieve professional-quality results in your own home.

# Home Studio Lighting Kits

If you want to take professional-looking shots of your kids, family members, friends, or pets while indoors, without having to go to a professional photographer for portraits, you'll want to use a home studio lighting kit in conjunction with your digital camera and some photo-editing software. The results you can achieve will be equivalent to what you'd get after a visit to Sears Portrait Studio, The Picture People, or another professional portrait studio, and spending upwards of $100 or more per sitting for just a few prints.

From any photography specialty store, you can purchase individual lights that can be used in a home studio setting.

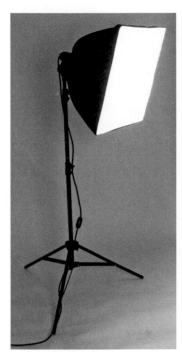

**FIGURE 5-4**  A traditional 20" soft box on a stand

However, you're better off purchasing a complete home studio lighting kit from a company like Westcott, which offers everything you need in terms of lights, stands, power cords, filters, and instructions, all in a single package.

A basic home studio lighting kit will contain two to five separate lights. Using a two-light system, you place the lights to the front right and front left of your subject, with the goal of surrounding him or her with light to eliminate shadows. If you add a third light, you can place it directly in front of your subject. And you can place a fourth light directly above your subject (pointing downward), while also positioning a fifth light behind your subject to brighten the background. Depending on your setup, where you place each light around your subject may vary.

When you start shopping around for a home studio lighting kit, you'll discover two main types. One type will utilize soft boxes to create a constant source of light. A single continuous light in a 20-inch soft box from Photo Basics (www .photobasics.net) is shown in Figure 5-4. While the light from each soft box will be at least 500 watts, the bulbs are placed inside a soft box to reduce the harshness of the light and create a softer light more suitable for shooting portraits, for example.

Continuous light kits can use one of several different types of light bulbs, including powerful incandescent, tungsten, halogen, or fluorescent bulbs. When you're ready to take photos, these lights get turned on, just as you'd turn on a house lamp, and they remain on the entire time you're shooting. The light remains bright and constant, so you don't need to use the camera's flash. With this type of lighting system, you'll find it's easier to use your camera's full Auto mode, yet still wind up with very professional results when shooting indoors.

**Caution**  Tungsten and halogen light bulbs generate a lot of heat quickly. Having to stand under them (as the subject in a photo) can make you very warm, and if they're used in a small room and left on for even a few minutes, you'll feel the temperature rise. When you're done shooting, allow the bulbs to cool down before packing up and storing your light kit.

An alternative to a continuous light kit is a strobe light kit. A strobe light kit is a multilight setup that works like a camera's flash unit, but is far more powerful. The 240- or 500-watt light emanates from multiple sources simultaneously, but only when the camera's shutter button is pressed. Similar to when you use your camera's flash, the strobe lights are triggered by your camera, surrounding your subject with a burst of light for a fraction of a second while the photo is being taken. The lights can be connected to your camera via a special cable

(called a *PC cord*), or you can set them off using a wireless remote trigger that connects to your camera's hotshoe. Figure 5-5 shows a strobe light and reflective umbrella from one of Photo Basic's popular home lighting kits.

A typical strobe light bulb will last for at least 500,000 flashes, and they do not generate any heat. They also simulate daylight nicely. Strobe light kits tend to appeal to more advanced photographers because they're a bit more complicated. To get the best results with this type of lighting system, you'll probably need to adjust your camera's aperture, shutter speed, and white balance manually. You generally can't simply rely on your camera's full Auto mode when shooting. (See Chapter 4 for information on how to adjust white balance manually when shooting with your Digital SLR camera.)

Continuous light kits are comprised of two or three soft boxes that face your subject, whereas a strobe light is often shined away from your subject onto a silver, gold, or white umbrella-shaped reflector, as opposed to shining directly onto the subject. The reflected light is then used to light up your subject. (You can, however, use a soft box with a strobe light.)

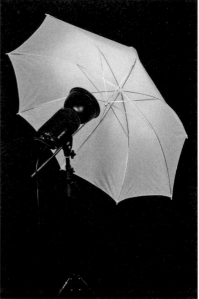

**FIGURE 5-5** A strobe light with reflective umbrella

**Note** A monolight strobe is self-contained and has its own power pack. A power pack strobe is wired to a central power pack. Because they use a special battery pack, as opposed to AC power, strobe light kits can be set up outdoors or anywhere, whether or not electricity is available. Plus, because they nicely simulate daylight, they can be used outside, in conjunction with daylight, in order to light up areas where natural sunlight doesn't reach.

Many different companies offer affordable home studio lighting kits. Ideally, you want to choose one that fits within your budget, gives you the flexibility you need to capture the types of shots you want to take, and utilizes high-quality equipment that's easy to set up. When it comes to choosing an appropriate lighting setup, first carefully determine what your needs are and what type of camera equipment you'll be using. Then, seek out professional advice to choose an appropriate lighting system based on your needs and budget.

## Home Studio Backgrounds and Other Necessary Equipment

If you're setting up an in-home photography studio, chances are you'll need professional backgrounds and a background stand.

A basic stand, which consists of two vertical metal legs and a horizontal pole to support your paper, muslin (cloth), or vinyl background, can be purchased for between $50 and $200, including a carrying case. When using large backgrounds, you'll need to invest in a stand.

## Did You Know?

## Photo Basics by Westcott Offers Complete Lighting Kits

For amateurs, serious hobbyists, and professional photographers alike, one of the best companies to purchase a home studio lighting kit from is The F. J. Westcott Company (www.fjwestcott.com), which has a complete line of studio lighting kits for amateurs, as well as a full product line of more costly, professional-level lighting equipment.

Within Westcott's popular Photo Basics product line (www.photobasics.net), you'll discover affordable and well-made constant and strobe light kits that are very easy to set up and use. What's unique about these kits is that absolutely everything you need in terms of lighting is included—the light units themselves, as well as the necessary bulbs, stands, cables, and soft boxes (or umbrella reflectors). Plus, each kit comes with an instructional DVD that will help you set up and start using your new light kit within a few hours.

The light kits offered with the Photo Basics product line are designed for ease-of-use and durability. Each kit also comes with a useful light fixture positioning pad to lay out on your floor. Imprinted on the pad are icons telling you exactly where to position each light in the system, your camera, and your subject, in order to get professional-quality results. Between the floor mat, the instructional DVD, and the free tutorials offered on the company's website, you'll learn everything you need to know about home studio lighting. Plus, you know you'll be purchasing the highest quality and safest equipment possible for your home photography studio.

From Westcott's Photo Basics line, a basic, two continuous light kit starts around $350. The Complete 1000-Watt 2-Lite Photography Kit includes two constant lights, two 500-watt photoflood bulbs, two 20-inch collapsible soft boxes, two 7-foot expandable stands, and an educational DVD. A slightly less expensive two-light kit is also available (priced around $229), as is a two-light kit with a green screen background to use with photo-editing software to add backgrounds to your images digitally (priced around $300).

In addition to the all-inclusive lighting kits, Westcott offers a wide selection of lighting accessories, as well as individual soft boxes and reflective umbrellas in a variety of sizes and shapes. From the company's website, you can also learn about its reflectors and diffusers (which come in multiple shapes, colors, and sizes), as well as background stands and background support systems.

All of Westcott's lighting, background, and accessory products are available from photo specialty stores worldwide, as well as from leading online retailers that sell photography gear. Visit the Westcott or Photo Basics websites for a listing of authorized dealers.

The prices for individual, solid color, scenic, or artistic backgrounds range in price from around $30 to several hundred dollars, depending on what they're made from (paper, cloth, or vinyl) and their size. A typical background size mighty be 5'×6', 6'×7', 10'×12', or 10'×24'.

For formal portraits, a solid color background (such as white or black) works fine. However, you can also choose to utilize an imprinted artistic background with a colorful, yet simple design. Themed backgrounds are also available that showcase specific indoor, outdoor, or even fantasy-like settings. Some backgrounds are made to look extremely realistic, whereas others add a more artistic or abstract backdrop to a photo. Backdrop Outlet (www .backdropoutlet.com/FAB-TEX/products/1075/) offers a collection of "Fab Tex" textured, foam-fabricated material backgrounds, which look like very realistic brick, stone, or wood panel walls.

Figure 5-6 showcases a brick wall background that is actually fake. This background is really imprinted on a large roll of paper and held up in the photo with an inexpensive stand purchased from a photography specialty store. Figure 5-7 uses a solid black cloth (muslin) as the background.

**FIGURE 5-6** This brick wall is really an imprinted paper background.

**Note** Muslins are professional cloth backgrounds made from a cotton material that absorbs light well. They can be dyed a solid color or painted with artistic and colorful scenes. They are often the background of choice for photographers shooting inside.

In terms of cost, reusable paper backgrounds (which come in large rolls, usually 53"×36' or 107"×36') are the least expensive, ranging in price from $30 to $100, depending on the dimensions. Colored and printed muslins range in price from $50 to several hundred dollars, whereas imprinted or painted canvases cost up to several hundred dollars each, based on the graphics used.

**FIGURE 5-7** A solid black muslin is used for the background in this image.

While you can utilize professional backgrounds using any digital camera, for professional-looking results you'll want to use these backgrounds with a home studio lighting kit, as opposed to your camera's built-in flash or an external flash unit (with a Digital SLR camera). Photographic backgrounds come in thousands of different colors and designs. To see a sampling of what's available, visit any of these websites:

| | |
|---|---|
| Backdrop Outlet | www.backdropoutlet.com |
| BackDropSource | www.backdropsource.com |
| Denny Manufacturing Company | www.dennymfg.com |
| Owen's Originals | www.owens-originals.com |
| PhotographyProps.com | www.photographyprops.com |
| Westcott | www.photobasics.net/backgrounds.cfm |

If you shoot your subjects against a solid color background, you can easily remove and replace the background with a professionally created digital background using photo-editing software. TubeTape (www.tubetape.net) offers a CD-ROM collection of 2,500 professional-quality digital backgrounds. EZ Backgrounds (www.ezbackgrounds .com) offers many different themed collections of digital backgrounds. Both retail for under $50 for a set. Or you can download digital backgrounds for free from many different websites that cater to photography enthusiasts. These backgrounds work with almost any photo-editing software, such as Photoshop Elements 9.

# Take Great Pictures at Parties, Holiday Events, and Weddings

When taking pictures at a birthday party, holiday event, wedding, or any type of formal social gathering, especially if the photos will later be displayed in a photo album, scrapbook, photo book, an online gallery, or as part of a digital slide show, you'll want each of your images to capture a specific memorable moment that will later become a cherished memory. When someone looks at just one of your party or event photos, they'll be able to reminisce about that special moment.

When all of your party photos are seen together, they should retell the story of the entire event in chronological order. To accomplish this, you need to capture all of the important moments that will help people reminisce about the event or party later. Capturing emotions in your party or event photos will create very compelling images. Tears of joy, laughter, surprise, and love are all commonly expressed at parties and social gatherings. As the photographer, look for interesting ways to capture these emotions as you take your pictures.

**Tip** When shooting any type of party or social gathering, combine posed shots, preplanned shots, and plenty of candid photos. The following URL leads to an online gallery featuring a sampling of posed, preplanned, and candid shots taken at a fashion-oriented party in Newport, Rhode Island: www.smugmug.com/gallery/13511989_2Ts28#.

When taking photos at any type of event or party, you'll want to put all of your photography knowledge to work and take full advantage of whatever equipment and lenses you have available in order to get the widest array of interesting shots possible. As always, pay attention to how you frame your images, as well as to the lighting and background. Be prepared to compensate for shadows or other lighting challenges.

**Caution** As a guest taking pictures at a party, make sure you don't get so caught up in shooting that you wind up experiencing the entire party or event looking through your camera's viewfinder. Balance your time between taking great pictures and actually enjoying the party or event.

One of the biggest mistakes amateur photographers make when shooting a party or special event is a lack of preparation. They don't fully charge their camera's batteries or don't bring along one or two extra memory cards. As a result, partway through the event, either their camera dies (due to lack of battery power), or they run out of room on their camera's memory card. Always bring one or two extra camera batteries (as well as your battery charger) to any event you'll be photographing, plus have at least one or two extra memory cards on hand. And if you'll be using an external flash unit that requires batteries, bring along plenty of extra batteries, especially if the party or event is taking place indoors or at night and you'll be relying heavily on your external flash unit.

## Strike a Pose

When shooting any party, event, or social gathering, posed photos are great. They allow you to get shots of everyone in attendance and group people together as appropriate. As the photographer, you control posed photos and have the ability to retake shots.

You decide who will be featured in each photo, the location where the photo will be taken, the background, and the pose your subjects should strike. Because you have time to set up each shot, you can make subtle adjustments to your camera's settings, control the lighting, and make sure that everyone is looking in the same direction and smiling, for example. If, after taking a shot and previewing it on your camera's display, you notice one of your subjects blinked or wasn't looking at the camera, you can easily retake the shot.

A posed photo requires you, the photographer, to plan and stage each shot. But the attendees are also required to stop whatever it is they are doing at the party to pose and be photographed. As the photographer, be sure to avoid interrupting the flow of the party or breaking guests away from conversations to pose for a photo. If they're annoyed at you, the photographer, capturing your subjects with authentic and natural-looking smiles, along with relaxed body language, will become challenging.

 When shooting posed photos at any party or event, always take at least two or three photos of each grouping in quick succession. If possible, change your shooting angle slightly or rotate the camera from horizontal to vertical.

## Preplanned Shots Tell a Story

Preplanned shots at a party are ideal for telling the story of the event after the fact when people are looking at your photos. These photos can capture the mood, ambiance, and the subtle details of the party. Some of these shots may be posed. Others might be spontaneous or candid. All of them, however, capture important moments that take place before, during, or after the event.

A preplanned shot might include the guest of honor's expression when he or she first arrives at a surprise party, a close-up shot of the birthday or wedding cake, a photo showing the pile of presents given to the birthday boy, or a shot of the birthday boy at the exact moment he blows out the candles on the cake.

**FIGURE 5-8** A preplanned shot of a party room after it's been decorated, but before the guests arrive

Figure 5-8 is an example of a preplanned shot of a wedding ceremony before the guests arrive. It shows the overall décor of the room and sets the scene for the party.

The following checklists offer suggestions for those "must have" shots you'll want to take at a specific type of event or party. Again, you'll want to mix these preplanned shots with plenty of posed and candid shots.

## "Must Have" Celebration Photos

Birthdays, anniversaries, engagements, promotions, graduations, holidays (such as Christmas, Easter, or Thanksgiving), and someone's retirement are all wonderful reasons to throw a party and celebrate. If your goal is to photograph these important events in a way that tells a compelling story, the following are a few suggestions for the types of preplanned shots you'll probably want to take (in addition to plenty of candid and posed shots of the attendees).

- The party setup (balloons being blown up, the tables being set, the band setting up, the room being decorated, etc.). Before-the-event photos set the scene. These types of photos are a great addition to a photo album, scrapbook, or online gallery that chronicles a special party or event.

- Guest arrivals. Capture people showing up to the party or event as they come through the entrance and are greeted by the guest of honor or host.

**FIGURE 5-9** Get a picture of the cake—before it gets cut.

**FIGURE 5-10** Be creative when shooting the cake.

- Close-ups of the cake. Be sure to take a few shots of the cake, from different angles and perspectives, before it's cut. Figure 5-9 shows a basic, head-on photo of a birthday cake, whereas Figure 5-10 shows a cake, but shot extremely close-up and from a more visually interesting perspective.

- If party guests bring gifts and place them in a pile during the party, be sure to snap photos of the presents before the guest of honor starts to open them.

- For a surprise party, get photos of everyone hiding before the guest of honor arrives, plus make sure you're in position and ready to capture the guest of honor's reaction when she walks through the door and everyone yells "Surprise!" The shocked or surprised reaction will probably last for at least a minute or two, so take plenty of photos, but that first moment's reaction makes for a priceless photo.

- Take shots of the food as it's served, as well as the presentation of desserts. If the food is served as a buffet, snap some photos just before the guests are allowed to eat.

- In addition to taking close-up pictures of the party's entertainment (the band, DJ, clown, etc.), be sure to take pictures of the guests interacting with and enjoying the entertainment.

- If groups of people are dining at separate tables, travel from table to table and take both posed and candid photos of the people at each table, preferably before the meal or in between courses, so you don't wind up with shots of people chewing their food.

 When taking a photo of a group of people sitting at a table, have half the people get up and stand behind the other half still seated at the table, so you don't show people's backs in a photo or make some people contort in order to be seen from a seated position. Also, consider standing on a stool or chair, so you can shoot downward to capture a group of people at a table, as opposed to shooting from a head-on perspective. This perspective allows you to show more in the photo, plus it creates a more interesting shot.

- Follow the guest of honor as he or she mingles with and interacts with the various guests. These shots can be either posed or candid.

- When someone makes a toast, get a close-up of the person raising his glass and making the toast, plus capture a wider shot of the party's guests also holding up their glasses.

- Capture the reaction of the guest of honor opening each of her gifts. Be on the lookout for moments of surprise or joy, and be ready to capture them.

- As the party winds down, take pictures of people saying their farewells.

 When shooting a holiday party, you'll want to capture many of the same types of images as you would at a birthday party. However, also make an effort to capture the festive holiday mood by taking close-ups of the decorations, such as the Christmas tree or the turkey being served at Thanksgiving. Also, at holiday parties, people often dress up accordingly, so be sure to take plenty of photos of guests in their holiday outfits.

## Wedding Photos You Won't Want to Miss Taking

Even if you're not the designated wedding photographer, if you're attending a wedding and taking photos, you definitely want to shoot some special images. Your goal should be to capture a really good selection of posed, preplanned, and candid photos taken before, during, and after the ceremony and reception. One of the best sources for ideas about how to shoot a wedding is to review the work of professional wedding photographers. Take a look at several wedding albums or online galleries to see the different types of shots and shooting techniques used to photograph various weddings.

If you have access to the bride and groom as they're getting ready for the ceremony, you can capture some really emotion-filled shots. Plus, you'll also want to capture photos of the wedding guests arriving and being seated before the ceremony (as shown in Figure 5-11). This type of shot helps to set the scene in a photo album or scrapbook.

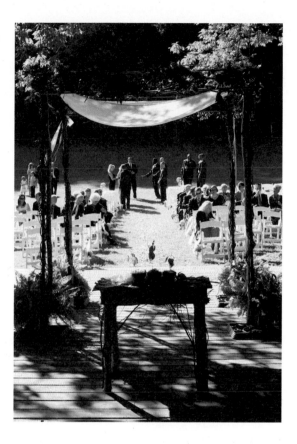

**FIGURE 5-11** Take pictures of guests arriving to a party or, in this case, a wedding ceremony.

 To ensure you don't miss any important shots during a wedding you're attending, consider shadowing the hired professional wedding photographer. You can bet he'll always be at the right place, at the right time, to shoot the most memorable wedding photos. Just don't get in the professional photographer's way or cause him or her to miss important shots.

**Wedding Ceremony Photo Checklist**   During a wedding ceremony, capturing the best shots takes precision timing. Make sure you're prepared, paying attention, and ready to shoot. The following are shots you'll probably want to get before and during a wedding ceremony:

- Guests arriving
- Wide shot of the ceremony location taken from the front and back of the room or area, before or as guests arrive (Again, Figure 5-11 shows the setting for an outdoor wedding as the guests start to arrive and arc scated.)

- Close-up of the rings (still in their boxes)
- Bride and groom getting dressed
- Close-up and full-body shot of the bride
- Close-up and full-body shot of the groom
- Close-up of the ceremony's musical entertainment (organ player or harpist, for example)
- Close-up of the wedding ceremony's officiate
- The couple's parents walking down the aisle
- The groom entering the room where the ceremony will be held
- The bride walking down the aisle
- Close-up and full-body shots of each bridesmaid
- Close-up and full-body shots of the groomsmen and best man
- Flower girl
- Ring bearer
- Wide shots of everyone seated for the ceremony (which showcases the entire venue where the ceremony is being held). Try to take a shot from the back of the room, as well as the front of the room (from the altar looking out at the crowd, for example).
- In addition to taking wide shots of what's happening at the altar (including the bride, groom, and the person conducting the ceremony), be sure to capture close-ups of each individual, focusing on his or her emotions.
- Close-up photos of specific events during the ceremony, like the exchanging of rings and vows, or lighting of candles

**Tip**    When shooting, use existing light during the ceremony, as a flash will be distracting and won't capture the natural lighting in the room or area where the wedding is being held.

- The bride and groom's first kiss as a married couple
- The bride and groom leaving the ceremony and walking down the aisle together

- Close-up of the bride's and groom's hands, with their new rings on
- Guests and the wedding couple leaving the ceremony venue
- Wedding couple getting into their limousine

 When shooting an outdoor wedding or event, your position as the photographer is important. Pay attention to light. In Figure 5-12, the photographer was shooting an outdoor wedding, but was positioned so the camera was shining almost directly into the sunlight, which caused serious and unwanted glare and reflections in the photos (which could not be removed using photo-editing software).

**Wedding Reception Photo Checklist**    The following are photos you'll probably want to take before and during the wedding reception:

- The reception hall being set up and decorated (before guests arrive)
- Guests arriving
- Table setup, showcasing flowers and centerpieces
- The receiving line
- The wedding cake (get multiple shots from different angles and perspectives)
- Close-ups of floral arrangements and table centerpieces
- A photo of the invitation and guest name cards on the tables

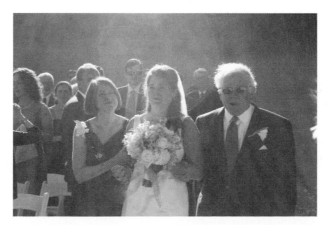

**FIGURE 5-12** When shooting any event or party, choose your shooting location carefully.

- Cake cutting ceremony
- Bride and groom feeding each other cake

 **Tip** To capture special moments that happen only once and very quickly, like the first kiss, the cutting of the cake, or the tossing of the bouquet, use your camera's Burst or Rapid-fire shooting mode.

- Toasts (close-ups of the toast givers, as well as the crowd holding up their glasses)
- Dancing
- The couple's first dance
- Bride with her mother
- Bride with her father
- Groom with his mother
- Groom with his father
- Bride and groom with each special or honored guest, such as a grandparent or great grandparent
- Bride and groom with their wedding party (group shot)
- Bride and groom with their parents and in-laws (group shot)
- Groom with his groomsmen/best man
- Bride with her bridesmaids (and maid of honor)
- Close-up of the band and entertainment
- Individual couples dancing, plus wide shots of the dance floor
- Table shots showcasing guests at each table
- Special events or traditions that take place during the reception
- Bride tossing the bouquet and someone catching it
- The wedding couple leaving the ceremony

 **Tip** Before the wedding, make a list of "special shots" you know you want to take and keep track as you take your photos. A special shot might include the bride dancing with her father, or the groom's college friends in a group shot, for example. There will be a lot of excitement and commotion during a wedding. If you don't write down the shots you definitely want and create your own checklist, you could easily get caught up in the moment and forget to take the photos you really want.

## Candid Shots Capture Real Emotions and Atmosphere

Candid photos can be taken at anytime and should capture people enjoying the party or going about their business as if the camera isn't there. Candid shots should capture spontaneous moments in time. As a photographer at an event or party, strive to capture a nice selection of posed, preplanned, and candid photos.

Every party or event has a before, beginning, middle, and end during which many things (such as toasts, speeches, cake cutting, present opening, or holiday traditions) take place. At a birthday party, the party location is set up before

**FIGURE 5-13** A candid shot as a wedding ceremony winds down and guests depart

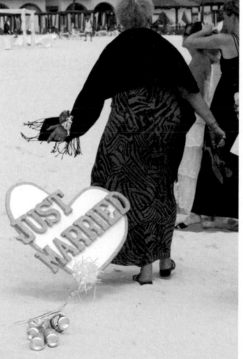

the guests arrive, which offers some good photo opportunities. As the guests arrive at the party, they are typically greeted happily, making for great candid photos. Then, as the party progresses, there are toasts, the presentation of the birthday cake, the guest of honor blowing out the candles on the cake, the opening of gifts, plus special entertainment or activities at the party—all of which you'll want to capture as the photographer.

As the party winds down, you'll also want to take pictures as the guests say their farewells. Figure 5-13 is a candid shot of someone from a wedding party at a beach destination wedding in Mexico leaving the ceremony. This type of unplanned, spontaneous shot adds a lot to a wedding album.

 **Note**   See the end of Chapter 7 for tips and strategies for shooting awesome candid photos of people.

**How to. . .**    # Take Eye-Catching Photos of Products You Plan to Sell Online

If you've ever had the inkling to become an Internet entrepreneur and start selling products on the Web, either through your own ecommerce website or via eBay.com online auctions, keep in mind that one of the most important elements of an online sales site is the quality of the product photography. Taking well-lit and extremely vivid product shots is absolutely essential, which means you'll need to use the right equipment.

To take professional-quality photos of smaller items or products, use a tabletop lightbox, which is surrounded by two constant lights. The lightbox is made from a white fabric that reduces or eliminates shadows and surrounds the product with even light. Using a wire frame, it creates a hollow box into which you can position the product you want to photograph. The box is then surrounded by at least two lights, so your product is perfectly lit from all directions, using a soft white light. As the name suggests, lightboxes are square or rectangle in shape and come in a wide range of sizes. They're often sold as part of a product lighting kit, which includes the lights needed to take professional-quality product shots.

For examples of high-quality product shots created using a lightbox kit, visit the website for fashion designer Kiel James Patrick (www.KielJamesPatrick.com), who takes all of his own product shots for his company's website using an inexpensive Canon Digital Rebel XTi, along with the Photo Basics 303 Digitent Kit (priced around $375). The photos are then edited using Photoshop CS5 before being posted onto the company's website.

The Photo Basics Educational PB500 Digitent Kit ($375, www.photobasics.net/details .cfm?id=49) comes with a 20" or 30" lightbox, two constant lights, and an educational DVD that takes all of the guesswork out of shooting professional-quality product shots indoors using a tabletop photo studio and your digital camera. Other companies also offer tabletop lightbox (also referred to as light tent) kits in a variety of sizes. For example, there's the Table Top Studio Store (http://store.tabletopstudio-store.com/specials.html), which offers lightboxes between 20" and 55", which range in price from $200 to $400. The Sunpak 620-EBox Portable Mini Studio in a Box (www.amazon.com/Sunpak-620-EBOX-Portable-Mini-Studio/dp/B000JC3NOY) can be found online for under $100 and is a no-frills, basic lightbox setup for taking professional-quality, well-lit shots of smaller products.

# 6

# Shoot Eye-Catching Outdoor Photos

## How to...

- Take the best photos based on weather conditions
- Avoid the problems of shadows and glares
- Shoot people, places, buildings, and objects outside
- Utilize reflectors and diffusers
- Use your flash outside to supplement natural light

With their point-and-shoot or Digital SLR camera set on Auto, most photographers can achieve excellent results shooting outside. The challenges of shooting with natural light (sunlight) are fewer than when shooting indoors, and the opportunities to capture great shots are typically more plentiful, even on overcast days.

As you'll discover from this chapter, your biggest challenges to shooting outside will be glares, shadows, and reflections, typically caused by the sun. If you pay attention to detail and the position of the sun while shooting outside, however, these problems are easily overcome.

From this chapter, you'll also learn how to shoot specific things outside—like people, buildings, sunsets, landscapes, and nature—plus, you'll learn how to shoot simulated panoramic images by linking multiple photos together with photo-editing software.

 Especially if you have an expensive camera, keeping it dry and not exposing it to extreme temperatures for extended periods of time is essential. In fact, in cold temperatures, you'll probably notice your camera acts sluggish.

# Equipment and Accessories You'll Need to Shoot Outdoors

For an amateur photographer looking to snap photos of friends and family, or anything else for that matter, in an outdoor setting, you won't need much more than your point-and-shoot or Digital SLR camera to capture some excellent pictures, providing you pay attention to lighting, glares, and shadows (which we'll focus on shortly).

If you're using a Digital SLR camera, in addition to the camera itself (and a lens, of course), consider investing in a lens hood, which attaches to the front of the lens to help reduce glares from overhead light (such as the sun). You should also invest in a Polarizing filter (which screws onto the front of the lens). When shooting outdoors, a Polarizing filter enhances colors and reduces direct and indirect reflections and glares. Another type of filter that you can use to improve some of your outdoor shots is a UV filter, which will eliminate haze caused by ultraviolet light. The impact on your photos when using a Polarizing filter, however, will be more dramatic.

Plan on spending up to $100 for a really high-quality Polarizing filter for a Digital SLR camera lens. However, you can purchase lesser quality filters starting around $20. They're available from photo specialty stores and online. Be sure to purchase the right size filter for your particular lens. They're measured in millimeters. See Chapter 3 for more information about optional lens filters.

**Tip** If you're shooting landscapes on a bright and sunny day with a Polarizing filter attached to the lens of a Digital SLR camera, you'll notice the blue sky's color will be richer and, in your photos, appear as a darker blue.

Thanks to powerful photo-editing software, however, you don't always need to invest in filters for your Digital SLR camera, because the impact the filters have on your digital images can be replicated after the fact using a program like Photoshop CS5 or Aperture.

A lens hood, which attaches to the front of your camera lens (and is described in Chapter 4), is an inexpensive and great accessory for reducing unwanted glare when your camera is facing an overhead light source such as the sun. You can, however, also use your hand (placed above the front of the lens),

a hat, or even a sheet of cardboard (as long as the item you use doesn't block the lens and wind up getting in your pictures, too).

Depending on where you're shooting and under what conditions, a tripod is often a useful accessory. Later in this chapter, you'll learn a handful of techniques to use when shooting outdoors to eliminate, soften, or redirect shadows and sunlight using reflectors and diffusers, which are optional, but useful for enhancing outdoor photos. A reflector or diffuser can be used in conjunction with any type of digital camera.

**Note** A reflector/diffuser is different in this case from a flash diffuser, which covers your camera's built-in or external lens to soften the light it shines upon your subject.

## Protecting Your Camera in Extreme Weather Conditions

Unless your camera is built to withstand extreme temperatures and weather (such as rain or snow), taking proper precautions before exposing your camera to adverse conditions is essential. Keep in mind, when it comes to photography equipment, there's a huge difference in meaning between *water-resistant* and *waterproof.*

Water-resistant, which is what most cameras are, means if your equipment gets sprinkled on by a few drops of water, it won't be damaged, assuming you quickly dry everything off using a soft cloth that won't scratch your lens.

Waterproof, however, means you can literally submerge your camera in water (to a predetermined depth), and it will continue to operate perfectly, making it ideal for taking pictures while swimming, water skiing, snorkeling, scuba diving, or standing under a waterfall, for example.

A typical camera can be used to take pictures in the rain. However, you'll definitely want to invest in a waterproof housing for your camera and lens or buy a waterproof "raincoat" for it. Vortex Media (www.stormjacket.com/SJ1 .html), for example, offers a complete line of specialty Storm Jacket camera covers (price range: $36 to $60) for Digital SLR cameras. These optional "jackets" allow you to take photos in extremely wet weather, while offering ample, raincoat-like protection for your equipment, including the camera body, lens, and an external flash unit.

One of the company's Storm Jackets is featured in Figure 6-1. Different models are available to protect various equipment configurations. The "Pro" models have an extra opening, allowing a camera to be mounted on a tripod and protected from weather at the same time. You can also choose from several stylish colors.

When it's raining, you can also shoot from under some type of covering, such as an umbrella, or from inside a car with an open window, or from a porch, to keep yourself and your equipment dry.

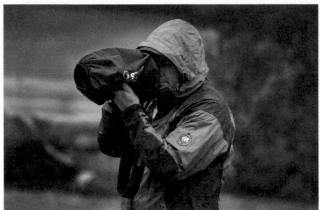

**FIGURE 6-1** You can keep your photo equipment dry when it's raining with a Storm Jacket™ from Vortex Media.

**Caution** If your non-waterproof camera does get very wet or covered in snow, turn it off and take steps to dry it as quickly as possible. Also, remove the battery and memory card immediately. After you hand dry the outside of the equipment and use a hairdryer (set on a cool temperature) to dry out the camera's insides, place the camera in its bag surrounded by silica packets, which will help absorb excess moisture you might not see inside your camera. Don't turn the camera's power back on until it is absolutely dry—inside and out. If your camera has accidently been submerged in water, contact a specialty camera store and seek out expert advice on how to handle the situation and hopefully salvage the camera.

When not in use, store your camera in a padded camera bag that's at least water-resistant, if not waterproof. You'll find information about choosing an appropriate camera case or bag for your equipment in Chapter 3. If you opt to take pictures in nonoptimal weather conditions, such as in the rain or snow, use common sense and as much protective gear for your camera as possible. In a pinch, wrapping or covering your camera (and lens) with a plastic bag, or placing a hat over it, will offer some protection from the elements.

If you've invested hundreds or thousands of dollars on the purchase of high-end camera equipment, don't take chances. Either purchase a waterproof housing for the camera before taking it near a swimming pool, a beach, into the rain, or around snow, or when you want to shoot pictures in really wet conditions, purchase a disposable waterproof camera for about $15 and use that instead. You can also purchase a second camera, like one of the Olympus Style Tough point-and-shoot

cameras. They're waterproof, so you can use it freely in wet conditions without fear of damaging your equipment—and you can count on taking great quality photos.

If you're visiting a tourist attraction like Niagara Falls, sitting in the first few rows of the killer whale show at SeaWorld (which are clearly marked "Splash Zone"), or experiencing a water ride at a theme park, and you see people coming out of the attraction, show, or ride soaking wet, chances are your camera will also get drenched if you bring it along to take pictures. Again, use common sense to protect your gear.

## Consider the Weather and Lighting Conditions When Shooting

When shooting anything outside—whether people, nature, objects, buildings, or landscapes—pay careful attention to the weather and lighting conditions. The position of the sun and its intensity will determine where shadows appear when shooting outside. Make sure those shadows don't negatively impact how your main subject looks in your photos. You'll need to compensate for shadows when shooting by adjusting your shooting angle, moving your subject, or by using a diffuser/reflector. Also, when you preview a photo on your camera's display, you may need to zoom in and study the detail of the photo to determine if subtle but distracting shadows are present, especially on someone's face.

Direct overhead sunlight shines from the sky straight downward and causes shadows. For example, if you're taking photos of a person wearing a baseball hat with the sun directly overhead, her entire face will be in shadow, while the rest of her body will be saturated with natural light. In a photo, this will look awkward. Likewise, if your subject is standing under a tree, and the sun is shining from above, distracting shadows caused by the tree's limbs and leaves will appear in your photo—and potentially over your subject's face and body.

Holding a thin white bed sheet between the sun and your subject on a very bright and sunny day acts as a diffuser to help soften the light and reduce shadows. However, you'll need one or more assistants to hold the sheet in the proper location and at the appropriate angle. An easier option is to purchase a diffuser and reflector kit from a photography specialty store. The 5-In-1 reflector/diffuser from Digital Juice (starting in price at $49.95, www.digitaljuice.com/products/products .asp?pid=1131) is an excellent and versatile product.

In situations where the sun is at an angle, it will still cause shadows. Let's say the sun's rays are pointing toward your subject; shadows will appear behind your subject and will most likely be visible if the photo has any type of background such as a wall (or even the ground) situated behind your subject and visible in your camera's viewfinder when shooting. Likewise, if the sun is off to one side, shadows will appear on the opposite side of your subject.

Along with the obvious shadows you see on the ground, behind, or to the side of your subject, based on the direction the sunlight is coming from, pay attention to the much more subtle shadows that may show up on your subject's face. You may notice unwanted or distracting shadows that need to be compensated for under your subject's eyes, between his nose and upper lip, below his lower lip, on his neck, or on his forehead (below his hairline and bangs). For instance, when taking photos of people with the sun positioned directly overhead, the area under their eyes and noses will have shadows, plus you'll sometimes see shadows on someone's forehead, as a result of the sun shining through her hair and bangs.

On a sunny day, sporadic clouds overhead can also cause shadows. If your subject is partially engulfed in a shadow, but with a lot of light behind him or her, your digital camera will pick up on that light, and your main subject will appear as a silhouette in the photo or be very dark (underexposed), while the surroundings are better lit, as shown in Figure 6-2.

The easiest way to fix this situation is to stand just a few feet away from your subject and take advantage of your camera's built-in or external flash. If the subject is less than a few feet from you, and you can adjust the flash mode between Fill-in and Full, choose the Fill-in mode. If the subject is more than five or so feet from your camera, and you have the option, set your camera's flash to Full mode. How you make these adjustments depends on the make and model of your camera and/or its external flash unit.

**FIGURE 6-2** Here the subject is within a shadow, but he's surrounded by natural night. If you don't use a flash to light up the subject, the subject will appear underexposed.

 Subtle shadows cast on your subject (or harsh light shining directly onto a person's face) will make any wrinkles, or the dark circles under his or her eyes, look much more pronounced. The easiest way to avoid this is to have a soft light shining on your subject from the front, so the entire face is well and evenly lit by a light that isn't too harsh.

If the settings of your camera aren't set properly to shoot on a bright and sunny day, you'll discover that your photos will turn out overexposed or underexposed. If overexposed, they'll look washed out, because too much light was reaching the camera's image sensor as the photo was taken. In most situations, direct sunlight does not create optimal conditions for shooting shadow- and/or glare-free images. To avoid having to compensate for shadows and glares, consider taking photos on a more overcast day, or find a well-shaded location. You could also shoot in the early morning or evening when the natural light is less harsh.

**Tip** Shooting outdoors in the shade prevents unwanted shadows, but you may need to use a flash, particularly if the light is brighter behind the subject, as opposed to immediately surrounding your subject.

Regardless of the weather condition, always pay careful attention to where your natural light is coming from and how it's impacting your subject. When your subject moves, if you change locations, or you alter your camera's shooting angle, the light's impact on your subject will also change—sometimes dramatically. Ideally, you want the light source (such as the sun) to be behind you (the photographer), and shining onto your subject. As you'll discover shortly, optional reflectors and diffusers can be used to redirect or block sunlight in order to reduce, eliminate, or control the direction of shadows in your outdoor pictures. A diffuser, when placed between the sun and your subject, can soften (but not totally block) the light that's shining onto your subject. A diffuser is made from a very thin, semitransparent white material that allows some light to pass through it. However, the light that reaches your subject will be a softer white light.

With the sun in front of you (the photographer, not the subject), however, you can create interesting silhouette or shadow effects, which are great for artistic purposes, but eliminate most or all detail from the subject that appears in the photo. Figure 6-3 was taken with the sun behind the subject, instead of behind the photographer, to create this silhouette effect. This setup also works well with nature, as shown in Figure 6-4.

**FIGURE 6-3**  By facing the sun or a light source, the photographer can create dramatic silhouette effects.

**FIGURE 6-4**  Silhouette effects can add an artistic element when taking nature photos.

## Did You Know?

# ISO Settings Determine How Sensitive Your Camera Is to Light

If you're using a Digital SLR and want to go beyond using the Auto mode, consider tinkering with your camera's ISO settings when shooting outside. How to adjust this setting varies based on your camera make and model, so check your owner's manual.

The ISO setting is a simple adjustment on most Digital SLR cameras, but it gives you a lot of control when shooting in various lighting situations. Basically, the ISO setting allows you to determine how sensitive the camera's image sensor will be based on the amount of light available when you're shooting.

Common ISO settings include 200 (when shooting in bright light), 400 (when shooting in typical daylight), 800 (when shooting in the evening or in dimly lit areas), and 1600 (for low-light situations). By adjusting the ISO setting to a higher number, your camera will become more sensitive to light. So, even without a flash, your camera will make better use of light in a dimly lit situation if its ISO is set to 800 or even 1600, for example.

In general, however, the higher you set your ISO, the grainier (or more noisy) your digital images will appear. To keep your images looking sharp and clear, without enhancing them after the fact using photo-editing software, you'll want to keep your ISO setting as low as possible, based on what's needed for the lighting conditions you're shooting in. In dimly lit situations, for example, you can sometimes boost the ISO in order to get away with not using a tripod, yet still achieve clear images, providing you hold the camera steady.

For many Digital SLR cameras, instead of using a fully automated shooting mode, you can opt to set just the ISO setting, yet have the camera auto-adjust the shutter speed and aperture, which gives you, the photographer, fewer things to fine-tune when shooting. If your ISO is not set correctly, however, your pictures will turn out dramatically overexposed or underexposed.

Originally, the ISO number referred to film speed, back in the days when cameras actually used film. Even though your digital camera doesn't use film, it does simulate how a film camera would utilize specific speeds of film in various lighting situations. On most point-and-shoot digital cameras, you cannot manually adjust the ISO setting. If you can adjust the ISO, and you're shooting outside on a bright day, keep the ISO setting as low as possible.

# Use Reflectors, Diffusers, or a Soft Box When Shooting in Sunlight

Serious hobbyist and professional photographers use reflectors and diffusers to block, redirect, or soften sunlight. Reflectors come in a wide range of sizes and shapes. If you're shooting full-body shots of people or large objects, a large, oval, or circle-shaped reflector works great (such as the reflector shown in Figure 6-5). You can, however, also buy much smaller reflectors and diffusers designed to block, redirect, soften, or intensify light on a small area, such as someone's face.

Reflectors and diffusers are usually framed using a thin, bendable, or pliable material that packs up easily for storage or transport. The surface of a diffuser is made from white, semitransparent fabric, whereas a reflector is made from a light-reflecting silver or gold material. When placed between the sun and your subject, a white diffuser diffuses direct light. Some light will shine through the white material and onto your subject,

but it will be transformed into a softer, white light, as opposed to harsh sunlight (if you're shooting outdoors). A solid reflector blocks light, allowing you to create shadows or totally block light from shining onto your subject. You can also angle it to reflect or deflect light in a particular direction.

Silver and gold reflectors are made from light-reflective material that bounces light and alters its color. For example, you can use a gold reflector to redirect sunlight and shine it onto someone's face from above, the side, or below, while, at the same time, giving your subject's face and body a rich, golden glow (like a suntan).

**FIGURE 6-5** A large reflector can be used to redirect light onto a subject's entire body.

Figure 6-6 was shot outside in natural light, using no reflector or flash. However, in Figure 6-7, a gold reflector was used. In this image, the subject's skin looks tan and more vibrant. Depending on how you position a gold or silver

**FIGURE 6-7** A gold reflector was used to give the subject a warm glow.

**FIGURE 6-6** In this photo, no reflector or flash was used.

reflector, you can make someone's eyes pop in a photo or eliminate shadows. By using multiple reflectors, positioned in front of, above, below, and/or to the sides of subjects, you can literally surround them with redirected light (or create shadows) and almost totally control the lighting in an outdoor environment when the sun is shining.

Reflectors and diffusers can be sold as separate units, but they're also available as more affordable and versatile 3-in-1 or 5-in-1 kits that allow you to change the surface material of the reflector/diffuser quickly. These units are also designed to fold up into a compact size for easy storage and transport when not in use.

A optional light box or soft box falls under the category of professional-level equipment. A soft white light is generated from a light bulb that's surrounded by a thin white material (shaped like a box around the light source). Soft boxes are typically used indoors to shine a soft light directly onto a subject. However, with an electrical extension cord or a powerful battery pack, you can use this type of lighting on outdoor shoots as well to supplement or enhance the available natural lighting.

Using a soft box, the light that shines on your subject won't be harsh, meaning it will actually fill in wrinkles and reduce or eliminate shadows on your subject's face and body. This type of lighting is ideal for portraits or situations when a flash will generate too much light or light that's too harsh for the situation.

A small or medium-size soft box (ideal for shooting portraits) costs anywhere from $50 to several hundred dollars. Larger soft boxes (for shooting full-body shots or larger objects) are a bit more expensive. However, the battery packs that power these units without A/C power tend to cost an additional several hundred dollars.

Lastolite (www.lastolite.us) and Digital Juice (www .digitaljuice.com) are two of many companies that sell reflectors and diffusers in different sizes and shapes. Lastolite also makes special silver/gold combination reflectors designed specifically for use with digital cameras. Prices for reflectors range from around $20 to several hundred dollars, based on their size, shape, and the material they're made from. Ideally, you want a reflector/diffuser that folds down to a small size for easy transport, but that pops open and has a durable and bendable frame. If the unit allows you to swap or change the surface area, you can be prepared for a wider range of situations without having to carry a lot of extra equipment.

Adorama (www.adorama.com) is a company that manufactures and sells inexpensive, yet professional-quality soft boxes, as well as a wide range of other photography lighting equipment. Soft boxes also come in a variety of sizes and shapes. Amateur photographers can transform an external flash unit for a Digital SLR camera into a small soft box that's suitable for shooting portraits and people, by encasing their flash unit within a Flashpoint Soft Box ($39) from Adorama or the LumiQuest Softbox III from LumiQuest ($46.95, www.lumiquest.com/products/softbox-iii.htm). You can learn more about photography lighting equipment in Chapter 5.

# Take Advantage of Clouds and Overcast Skies

Overhead and cloudy skies can be good for shooting if you don't need to capture the sky itself within a photo. When the sky is overcast, you won't have to contend with shadows or glares on your subject, but the sky will appear white, gray, or a very dull color if it's captured within your photos. Figure 6-8 shows the famous South Fork Ranch in Texas (known from the television series *Dallas*). As you can see, the sky is overcast and very dull. Using photo-editing software, however, you can always crop out the dull or dark cloudy sky and replace it with a more visually appealing blue sky, after the fact. Chapter 12 tells you how.

**FIGURE 6-8** On an overcast day, the sky can look dull in your shots. Using photo-editing software, you can replace it with a blue sky.

**FIGURE 6-9** If available cloud formations will visually improve your photos, include them in the framing of your outdoor images.

Especially during a sunset and on bright and sunny days, clouds can be used to your advantage and should be part of your photos. Clouds, especially if they're in visually appealing formations, add a great addition to your photos that breaks up a solid blue sky. Figure 6-9 was shot in Wyoming and features the actual (unedited) sky. As you can see, the clouds add a dramatic look to the image. Look back at Figure 6-4 again; you can see how clouds captured during a sunset can make the image much more interesting because the sun's vibrant colors bounce and reflect off the clouds in a stunning way.

How the sky (and clouds) appears in your photos is also affected by your main subject and the direction of the light source. Again, try to keep the sun behind you (the photographer) to achieve an evenly lit picture when shooting outdoors. If you're shooting people, having the sun behind you, but shining over your shoulder (as opposed to directly behind you), allows your subject to cast a slight shadow, behind and slightly to the side, which can give the photo more depth and make it look like the subject is actually part of the scene, as opposed to a two-dimensional cardboard cutout edited into the scene after the fact.

**Tip** If the sun is to the side of you (the photographer), but still shining onto your subject, you can create interesting lighting effects using shadows. Dark clouds that accompany a lightning storm can also make a dramatic addition to a photo, especially if you can capture the clouds before or after the actual storm, so there's no rain in the photo. Of course, if you can capture a bolt of lightning, that, too, makes for an impressive visual.

If the clouds overhead are moving, and you have time to really plan your shot to include the sky, wait for a break in the clouds so they're more spread out. A solid overcast sky isn't photogenic, but sporadic clouds combined with a nice blue sky make for an awesome photo. Also, you'll experience more interesting and vivid colors in the sky during sunrises or sunsets, so try to plan accordingly when you'll be outdoors.

**FIGURE 6-10** Depending on how you shoot it, a solid blue sky can create a two-dimensional effect in photos.

**FIGURE 6-11** Simply by adding a few clouds, a natural scene has more depth and realism.

Sometimes white fluffy clouds shown sporadically in an image can add a greater sense of depth. In Figure 6-10, the snow-covered mountain is surrounded by a solid blue sky. The image is beautiful, but the plain blue sky is somewhat dull. The mountain also looks somewhat two-dimensional, although this negative effect is counteracted somewhat with the trees in the image's foreground.

In another photo, shown in Figure 6-11, that shows the same basic scenario, a few clouds have moved into the area. This small addition adds a sense of depth to the photo, plus it makes the scene look more realistic. Neither of these photos has been edited to add a fake sky or clouds.

# Take Advantage of Water in Your Shots

Falling rain, puddles caused by rain, as well as rivers, lakes, or oceans, can all be used in photos in creative and artistic ways. Water reflects light. So, if you capture light reflecting in a particularly beautiful way off of water, the effect can be stunning. Likewise, a body of water, even a puddle, can act as a mirror-like surface, which can also be used to create dramatic effects within your photos.

In Figure 6-12, the main subject of the image is The Broadmoor resort in Colorado Springs, Colorado. In addition

**FIGURE 6-12** The lake reflects The Broadmoor resort, creating a mirror-like effect.

to framing the image using trees and nature in the foreground, the reflection of the building on the lake creates a visually interesting or even artistic effect.

As you can see in Figure 6-13, which was shot in Alaska, the snow-capped mountains are reflected on the lake, creating a dramatic mirror effect. So when shooting in the rain or near a lake, river, or ocean, pay attention to the water's reflective or

**FIGURE 6-13** In nature, the mirror-like effect that a still body of water creates can be used to enhance a photo.

mirror-like qualities and try to incorporate those effects into your own photos. Sometimes, what would otherwise be a basic or boring photo (if no reflection were present) can become a vibrant and visually interesting image when you capture a reflection in a still body of water, assuming you also shoot in good lighting and frame your image well.

Shooting nature sometimes requires putting several photographic techniques and shooting strategies together in order to capture a beautiful setting and do it justice in your photos.

For example, Figure 6-14 not only captures a stunning sunset that showcases a nice cloud formation (which accentuates the sunset) but also captures the sun's reflection in the water. The reflection —because it forms a line and is positioned effectively within the image—gives the photos a sense of depth. Plus, nearby land masses were used to frame the image taken at a small bay in Bermuda.

**FIGURE 6-14** This shot of a small bay combines several photography principles to create a stunning visual image.

## Avoiding or Using Glares

Glares are created when a digital camera's sensor captures certain types of excess light. In general, glares can be as annoying as shadows in photos and can take away from their clarity and detail, plus underexpose your primary subject. The trick to avoiding glare is to keep the excess light from shining into your lens, using a lens hood, for example, or by changing the direction you (as the photographer) are shooting, compared to the direction of the incoming light.

Under certain conditions, glares can actually be used for artistic purposes in your photos, however. You can see this demonstrated in Figure 6-15, which was shot on a ski slope in Utah. Glares can be artistically useful, particularly if you can capture them shining through objects, such as trees, or use them to help you frame or balance the image. When using glares, you want it to accent the photo, not become its main focus or an overly distracting element within your image.

In some cases, you'll be able to see how big of a glare you're capturing as you look through your camera's viewfinder. However, on a really bright day, the display on your camera may be difficult to see in real-time, so take advantage of the camera's Preview mode and check out your images in a shady area to make sure what you've captured in terms of the size and location of the glare is what you actually wanted.

 Using photo-editing software, you can add an artificial glare after a shot is taken pretty easily. However, editing out an unwanted glare is difficult and sometimes impossible.

**FIGURE 6-15** When used creatively, glare from the sun can add an artistic element to your photo.

# Specialized Shooting Tips and Strategies

Depending on what you're photographing outdoors, you may want to incorporate specialized strategies to help you capture the most professional-quality and visually impressive images possible. Let's take a look at a few specific situations where special considerations may be necessary.

## Shooting Buildings and Architecture

You can take many different approaches when shooting buildings or architecture, the most common of which is to stand at a distance from the building and snap a photo from a head-on perspective in order to capture the entire structure. Especially if you take lighting and the Rule of Thirds into account, this method certainly works. Yet, you'll probably notice that your photos lack pizzazz or originality.

Figure 6-16 is an example of a building (in this case, the former home of President George Washington in Mount Vernon, Virginia) shot from an ample distance to capture an entire building. The sky is a dull, grayish color, and although the entire

building is depicted, there's nothing special about the photo that shows off the stunning and historic architecture.

Figure 6-17 was taken moments later. Although the sky didn't improve much, by better framing the photo using the surrounding trees, more colors were brought into the image, thus improving its overall composition. (Using photo-editing software, this image could ultimately be enhanced further by replacing the existing sky with a gorgeous blue sly.)

**FIGURE 6-16** A basic, head-on shot of a building is often boring.

**FIGURE 6-17** Try to enhance the composition of a shot by properly framing the building.

If you look back at Figure 6-12, the photographer carefully framed the image of The Broadmoor using trees and lawn, as well as the lake and the reflection of the building on the lake within the image's foreground.

As you can see in Figure 6-18, the historic Biltmore Hotel in Coral Gables, Florida, is an extremely large building. To capture its size and fully showcase its historic architecture, a shot of the entire structure was taken from a distance, but also from an angle. Unfortunately, however, the shot was not taken at an optimal time of day. Instead of the sun shining evenly on the entire building, it's off to the side and casts a shadow on a large portion of the building. This shadow could have been eliminated if the shot was taken at a different time of day, when the sun was better positioned. However, what this photo demonstrates is that

**FIGURE 6-18** Even from a distance, you can make a building photo more interesting by shooting from an angle.

buildings and structures shot from an angle are more visually interesting.

Another approach you can take is to shoot the building from a very unique perspective, for instance, capturing only a portion of the structure. Or you can capture the entire structure, but in a much more visually interesting way using an unconventional shooting perspective. In Figure 6-19, only a small portion of President George Washington's former Mount Vernon home is shown in the photo, this time, from a unique perspective.

Figure 6-20 is a photograph of the Ryman Auditorium in Nashville, but even this famous building isn't very exciting when shot head-on. However, Figures 6-21, 6-22, and 6-23 demonstrate some creative ways to capture the same building and its unique architecture.

**FIGURE 6-19** Sometimes capturing only a small portion of a building from a unique perspective creates a great visual

**FIGURE 6-20** A head-on shot of a building isn't too creative.

If you want to take a photo of a building in a city, you can snap a photo of the city's skyline (or a portion of it) in order to capture the beauty, grandeur, and entirety of the structure, plus put the building in context with what surrounds it. Yet another

**FIGURE 6-22** Sometimes taking the same shot, but from a different angle or perspective, changes the look of your image dramatically. In this case, more of the surrounding buildings were captured.

**FIGURE 6-21** The famous Ryman Auditorium in Nashville looks great from any angle, but from across the street, you can capture the entire structure without a wide angle lens.

**FIGURE 6-23** When shooting historic or famous architecture, sometimes a close-up shot focusing on just part of the building is a more creative approach than capturing the entire building.

FIGURE 6-24 Photograph buildings from interesting perspectives and unique angles, like this photo of the Archives of The United States of America.

approach to photographing a massive building, is to stand on the street in front of it and focus upward, but from an angle. This shooting technique captures only the building itself, but it's the angle from which the photo is shot that makes it intriguing to look at. When photographing buildings, always try to capture them from an interesting or unique perspective.

An example of this shooting technique, which involves shooting upward and from an angle, can be seen in Figure 6-24, which showcases the Archives of The United States of America building in Washington, DC. This image was shot from an angle, but the photographer also crouched down to capture the structure from the perspective of looking upward, using the stairs in front of the building to create a sense of depth within the image. Just about the entire front of the building is showcased, but the angle offers a visual alternative to shooting it from a boring head-on perspective.

Just looking at a straight-on photo of the El Taj Resort located in Playa del Carmen, Mexico (shown in Figure 6-25), the architecture of the building doesn't look like anything special.

FIGURE 6-25 Don't just take the easy, obvious, and boring shot when shooting buildings.

The photo was taken from a slight angle, but it pretty much shows the entire main building of the resort from a head-on perspective. What you can't see looking at this photo is how unusual and beautiful the architecture of the building is and how it's situated right on the ocean.

However, by changing the shooting direction and perspective (as shown in Figure 6-26), the photographer showcases the building's unusual U-shaped design, as well as its oceanfront location. Just as you would when shooting a person, study the building or structure you plan to photograph and pick out its most beautiful and impressive angle from which to capture it in your photos. You should also do this when shooting historic locations or famous landmarks when you're on vacation.

Just as when shooting any person or object, taking interesting pictures of buildings or architecture requires you to tap your own creativity, take advantage of your surroundings, and utilize photography techniques (such as the Rule of Thirds) when looking through the viewfinder and framing or composing your images. You'll also want to capture within your photo some element of the structure that makes it special, unique, or impressive. For example, as you frame your images, focus on a building's grand entranceway, unique roofline, its use of archways, artistic windows, high ceilings, the structure's unusual shape, or the use of columns, to make your photos more interesting. Also take advantage of objects surrounding the structure, such as landscaping or other buildings, when framing your images.

**FIGURE 6-26** Just as you would when photographing a person, shoot a building or structure from its most interesting and beautiful angle.

## Capture Nature

The trick to nature photography is to capture it in a way that best utilizes the light, colors, and ambiance of the setting, and then add your own artistic creativity when framing or composing each shot. Showcasing vivid colors and rare occurrences, such as perfect rainbows, always makes for visually impressive shots, if you have your camera set properly when capturing them. However, you can also take mundane and ordinary settings, and transform them into stunningly beautiful images, simply by capturing the scene from the right angle and in the right light. Remember to use your creativity and your photographer's eye when shooting nature.

**FIGURE 6-27** Sometimes zooming in extremely close to something in nature will allow you to create photographic art from something very simple.

Also, don't be afraid to experiment with your lenses. A wide-angle shot may be suitable for capturing vast landscapes; however, you can sometimes capture a truly striking image by zooming in extremely close to an object, such as a flower or a leaf (as shown in Figure 6-27) or shoot a small area of a large landscape and focus in on a unique or eye-catching aspect of it.

When shooting close-ups, instead of shooting an entire flowering tree, plant, or bush, try focusing in on a single flower, or a portion of a flower, to create a more visually interesting image. When doing this, choose the part of the subject you want in focus and blur out the background, as shown in Figure 6-28. Also, fill up the frame with your object, and remember that contrasting colors will make your image more visually interesting. Try this technique shooting directly at the object, from its level, and from a head-on perspective, and then move slightly to the side, up, or down, and see if you can capture an even more interesting shot.

**FIGURE 6-28** Use your camera's macro lens to shoot a flower or object in nature extremely close up.

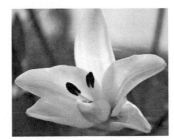

 While taking the Rule of Thirds and other techniques you've learned about photo composition, framing, and lighting into account, when in nature, try to capture vivid colors and shoot a scene from an unusual perspective. Unusual lighting will add to a nature photo's artistic qualities.

As you take your images, try to create a sense of depth based on the way you frame your images within your camera's viewfinder, and take full advantage of foreground and background objects. In a particularly beautiful natural setting, for example, you can make the main focus of your shot a specific tree, but complement the tree by showcasing the surrounding beauty. Putting the Rule of Thirds to work for you will certainly help when framing these types of images, as you can see in Figure 6-29 (which has a Rule of Thirds grid superimposed on it for demonstration purposes).

The angle or perspective you use to shoot a nature scene will allow you to give it a true sense of depth or multidimensionality. In Figure 6-30, as the viewer of the photo, you feel like you're standing at the end of a snow-covered pathway and could literally walk right into the multidimensional-looking image as your eyes follow the path to the back of the image and off to the left. This sense of depth was made possible because the photographer

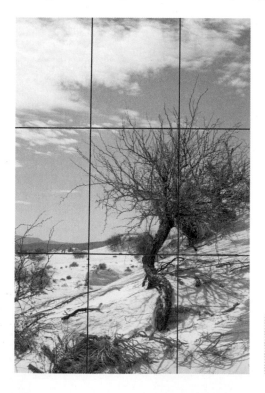

**FIGURE 6-29** Pick out one object in a scene and make it the main focus of your image when shooting nature photos.

**FIGURE 6-30** Create a sense of depth in your nature photos by selecting the right angle or perspective to shoot from.

**FIGURE 6-31** When shooting nature, capture color and a sense of depth in your images to make them more realistic.

chose a curved portion of the path to capture, plus carefully selected an appropriate way to frame the image with tree branches prominent in the foreground. Figure 6-31 demonstrates the same basic principle, but in an image shot during the fall and with the path going in the opposite direction. Aside from the beauty of the snow or the vivid colors of the fall leaves, there was nothing extraordinary about either location. The season and how the images were shot made each photo special.

Just as you have learned to frame your images when photographing people, for example, you can do the same when shooting landscapes and nature. Figure 6-32 showcases grass in the foreground, plus trees that help to frame the mountains in what's perceived to be the middle of the image. A snow-covered mountain is nicely centered and layered in the background. From the standpoint of colorization, there's also a strong contrast between the greens (grass and trees), blues (in the sky), and white (on the mountain).

**FIGURE 6-32** Whenever possible, frame your images to enhance their composition.

**Tip**    When shooting a wide-angle landscape photo, you need a clear main focus. Have the camera's lens focus in on something about one-third of the way into the image from a depth standpoint. This area of the image will be in perfect focus. The outlying areas will slowly become less clearly focused, which may or may not be visible to the naked eye, depending on the situation. However, you'll create a greater sense of depth.

## Photograph Landscapes and Panoramic Images

When you want to capture the vastness of a landscape, there's no better way to do this than to shoot with a wide-angle or panoramic lens. When using a Digital SLR camera, an 18–55mm lens will allow you to capture wide areas nicely, such as landscapes, city skylines, or very large groups of people.

Some point-and-shoot digital cameras have a built-in shooting mode that allows you to take panoramic images or create them within the camera (without using additional photo-editing software) by merging together multiple shots

into a single image. Or you can re-create this same effect using popular photo-editing software after the fact.

If you'll be shooting multiple pictures to edit together into one panoramic photo using any digital camera, you'll achieve much better results with a tripod. Without using your camera's zoom at all, point your camera to the leftmost region of the landscape that you want to capture in a panoramic shot and snap a photo. Pay careful attention to where the right side of the image ends. Next, rotate the camera slightly to the right, so the leftmost area of the new shot overlaps slightly (by about 20 percent) with what was showcased in the rightmost area of the previous shot. Snap another photo. Repeat this process two, three, or four times, until you've captured the entire scene. Remember, the edges of your shots must overlap.

After taking the separate shots, load them into Photoshop and use the software's Photomerge feature to combine them into a single, panoramic image. Using Photoshop CS5, for example, select Automate from the File menu, and then select the Photomerge feature. When the Photomerge window appears (as shown in Figure 6-33), select the photos you want to edit and merge together, as well as the perspective you want to use.

**FIGURE 6-33** The Photomerge window of Photoshop CS5 allows you to edit together multiple shots to create a single panoramic image.

The rest of the process is pretty much automated. Figure 6-34 is a sample panoramic image created from three separate images (shown in Figure 6-35) using Photoshop CS5's Photomerge feature. The result is impressive and took less than five minutes to achieve. You can create a panoramic image with shots taken with any digital camera and using many different photo-editing software packages, not just Photoshop CS5.

**FIGURE 6-34** A single panoramic image created in Photoshop and pieced together using several separate photos.

**FIGURE 6-35** These three images were edited together using the Photomerge feature of Photoshop CS5 to create the single panoramic image shown in Figure 6-34.

## How to. . .   Control What Your Digital SLR Camera Focuses On

When set on full Auto mode, your digital camera determines what it thinks is the main subject of your image and focuses in on that object automatically. Whether you're using a point-and-shoot or Digital SLR, when looking through your camera's viewfinder, you'll be able to tell what the camera is focusing in on by determining which of its individual auto-focus points it's utilizing.

Your point-and-shot digital camera may only display one or more boxes in the viewfinder to let you know what it's focusing on. However, a more advanced Digital SLR will have multiple auto-focus (AF) points, which appear as tiny lights or red squares within your viewfinder. They will probably form an oval around the viewfinder's center spot metering circle (in the center of the frame). The high-end Canon EOS 7D Digital SLR camera, for example, has a total of 19 AF sensors, whereas the more affordable Canon EOS Rebel Xs has 7 AF sensors.

You can rely on your Digital SLR camera to choose what it will focus on and see the results by pressing the shutter button down halfway when composing your image to allow the camera's auto-focus feature to kick in. Or you can manually select which of the auto-focus (AF) points you want the camera to utilize in order to ensure a specific area of your image, or a specific object, is in perfect focus, while the surrounding areas are more blurred.

The process for manually choosing which AF sensor or sensors to use when shooting a photo and deciding what the main focus of the image will be varies based on your camera's make and model. However, while looking through your camera's viewfinder and framing your image, you'll want to press your camera's AF Point Selection button and then use the appropriate dial on your camera to select manually which AF point overlaps with the main subject of your picture. Only the AF points that light up in your viewfinder are activated. When you think you've activated the appropriate AF point(s), press the shutter button down halfway to see how the camera focuses your image. If what you see in the viewfinder is acceptable, press the shutter button fully to snap the photo.

It will take a bit of practice before you're consistently able to focus in on very specific objects within a photo and have full control over what will be clear and what will be blurry. Take another look at the maple leafs shown in Figure 6-27. The leaf in the front and close to the center of the image is in full focus, while the surrounding leaves are slightly blurred and become blurrier the farther behind the main leaf they're positioned. In this case, the AF sensors that were activated focused on this particular leaf. The photographer could have chosen a different AF sensor just as easily, making the camera focus on a leaf located farther back in the image, so it would be in focus, while the front leaf would appear slightly blurry and out of focus.

Learning to control the AF sensors in your camera manually gives you much more creative control over the photos you take.

# 7

# Portraits and Candid Pictures of People and Pets

## How to...

- Snap eye-catching, candid photos of people and pets
- Take formal, posed portraits of people and pets
- Overcome the challenges you'll encounter shooting photos of people
- Set the scene for your photos
- Pose your subject

Most people enjoy taking pictures of their family, friends, children, and pets. When shooting photos of people, however, as the photographer, you have to take into account a handful of special considerations, including the setting and background, the lighting, and the best way to pose your subjects. For candid photos, utilizing the Rule of Thirds and framing your images, while also taking advantage of the available light (and/or using artificial light, such as a flash), are all important to consider.

This chapter focuses specifically on shooting tips and strategies for capturing people and pets using any digital camera, whether you're using a point-and-shoot digital camera, the camera built into your cell phone, or a higher-end Digital SLR. You'll discover how to make your portraits look like they were taken by professionals, plus you'll learn how to capture memorable moments as you snap candid photos of people, either indoors or outdoors.

As you're about to learn, when it comes to photographing people and pets, by following certain rules and strategies you will generate professional-looking results, but your own creativity as you frame your images is key to capturing the true essence and personality of your subjects, while also giving your photos a personalized and unique touch.

# Unique Considerations When Shooting People and Pets

Whenever you take pictures, your goal is to capture the beauty of something or to use your photographer's eye to transform something ordinary into a visually pleasing or interesting image. With people (and pets), you want to capture not only their appearance, but also their personality in your photos. People reveal their personality in many ways—not just with what they say, but also with their body language, facial expressions, and often with their eyes. If more than one person is being featured in a photo, how the various subjects interact is also a part of what you want to capture whenever possible.

There's a reason why most people look awful in their driver's license or passport photo—or in their police mug shot if they've been arrested. In most cases, even if they're attractive, they simply stare directly into the camera without smiling, plus these types are photos are generally captured in bad lighting that makes the image look flat and unflattering. As a photographer, this is an example of what you don't want when you take pictures of people (unless, of course, you're in law enforcement and shooting mug shots is part of your job description).

Depending on the types of photos you're taking, a big smile isn't always necessary to capture someone's personality. In many situations, if your subjects show any emotion whatsoever, or if they're obviously engaged in some type of activity, it can make for an interesting and thought-provoking photograph.

Just as you would with any other type of photo, as the photographer, you need to consider the Rule of Thirds, what will appear in the image's foreground and background, the lighting (taking into account shadows), and how to frame each image as you look through the camera's viewfinder (as shown in Figure 7-1).

When taking close-ups or headshots, for example, by using a narrow depth of field in your photos, the background will be blurred out, which ensures your main subject (who should be in perfect focus) is the focal point of your image. Depending on your goals, however, sometimes incorporating an in-focus (detailed) background into your portraits works better, especially when the camera is positioned horizontally as opposed to vertically (which is more common when shooting portraits).

**FIGURE 7-1** The perfect pose in a photo will be enhanced if you use the Rule of Thirds to also showcase a nice background that isn't distracting.

When taking photos of people or pets, you also need to take into account the subject's overall appearance, body language, facial expression, eyes, and what he or she is doing at the moment a photo is being taken, including his or her pose. A person's appearance includes his or her hair, makeup, clothing, and fashion accessories (including jewelry). As the photographer, you need to be mindful of all of these things. A few hairs out of place, too much makeup, blinking when the photo is being taken, or an awkward pose or body language can all negatively impact a photo. As the photographer, consider what you're trying to showcase or visually communicate about the people you're taking pictures of, while trying to accentuate their positive qualities and downplay anything that would detract from their appearance in your photo.

One of the best ways to become a pro at shooting people—either in posed portraits or candid photos—is to study the work of other photographers and to practice taking pictures yourself with as many different people as possible. As you look at other photographers' work, ask yourself what it is about each image that captures your attention. Although you can find literally millions of photos of people and pets online when browsing Flickr.com or Google Images, for example, you can also find interesting, fun, and thought-provoking photos of people published in magazines that you already subscribe to. When you start analyzing these photos as a photographer, you'll begin to formulate ideas in your own mind about how you can best capture people in your own photographs.

Especially when it comes to posing people for portraits, the body positions that look best in pictures aren't necessarily the most comfortable for your subjects and may even seem awkward to them. Making your subjects feel at ease is important, especially if you need them to hold a pose that looks great, but feels uncomfortable. Feeling uncomfortable can cause a person to become self-conscious or insecure, which will come across in your photos. People who are comfortable in front of the camera always appear the best in pictures, regardless of their physical beauty.

One way to help your subjects feel more comfortable as you're taking their picture is to allow them to preview your work as you're shooting. Show them a few sample shots, so they can see you're doing a good job and that they look great in the photos. Letting them preview photos also helps them understand why you may be asking them to hold a pose that seems unnatural or awkward. When they see how great the pose looks in a photo,

they'll feel less self-conscious. Anytime you're shooting photos of people, one of your primary goals is to help your subjects feel comfortable and confident in front of the camera.

**Caution** People, especially adults, are often very self-conscious when having their photo taken, whether for a posed portrait or candid shot. As the photographer, you're responsible for making your subjects look their best by helping them to hide some of their real or perceived physical flaws. Your camera's shooting angle, the lighting, the pose you ask your subjects to hold, the background, and your timing can all be used to conceal a subject's physical flaws, helping him or her feel more confident.

Everyone, even the most attractive models, have hang-ups about themselves. It might be a small scar on their face, a lazy eye, a receding hairline, discolored or crooked teeth, dark circles under their eyes, or their weight, their height—whether they feel too short or too tall—or their complexion. The list of reasons why people are self-conscious in front of a camera is extensive. However, most of these issues can be overcome or compensated for in pictures, so whatever your subject is self-conscious about can often be downplayed or edited out later using photo-editing software (described in Chapter 12).

For example, certain issues can be covered with makeup or by changing someone's hairstyle. Size-related issues can be compensated for by adjusting the camera angle or your subject's pose. Photograph an extremely tall person while he or she is sitting down or position yourself so you're looking down at the subject to make him or her look shorter. Likewise, you can make a short person appear taller by shooting from a slightly upward angle (so the camera is low).

**Tip** As you study your subjects prior to or as you take their picture, try to determine their best physical attributes. Some people really do have a "good side," and photos of them look much better when their head is tilted or turned in a specific direction, or when you capture them using a specific camera angle.

Because you're shooting with a digital camera, you can potentially take many photos in order to get just one perfect shot. So for each pose or "look," always take a handful of shots in relatively quick succession. Often, you'll discover that if you snap several photos within a several-second period, one will stand out as being the best. Your subject's facial expression, what she communicates with her eyes, and her subtle body movements all impact the photos. The slightest change, which happens within a fraction of a second, can make a huge difference.

When shooting posed portraits, playing upbeat music in the background often calms people down and gets them in the right frame of mind to pose for pictures and showcase their personality. Also, talking to your subject about things other than the photo shoot will help put their mind as ease and help them to relax. Another way to make your subjects feel more confident is to offer them continuous praise. If you ask them to do something, tell them how good they look. Or, after previewing a few of the pictures on your camera's display, reiterate how good the photos are turning out. Compliment your subjects often!

**FIGURE 7-2** If someone has incredible eyes, use them to draw viewers into the photo.

The approach you take with every person will be different because every person's appearance and personality is unique. Always focus on what you think makes a person special. For example, capitalize on someone's big hazel eyes in your photo (as shown in Figure 7-2), or if a subject's hair (or hairstyle) makes them stand out in a good way, showcase that in your photos.

Someone's bright smile might look amazing in pictures, or perhaps the way the subject stares off into space and makes the viewer wonder what she's looking at even though it can't be seen in the actual photo (as shown in Figure 7-3). Sometimes, a distant stare works much better in a photo than having your subject look directly into the camera and smile.

Depending on the attitude you're trying to convey with your photos, a hairstyle, outfit, and/or any accessories the subject poses with can dramatically change a person's look. Figure 7-4 and Figure 7-5 show the same person. Both pictures were taken within the same hour. All that changed was the background, the subject's jacket, and the addition of eyeglasses. However, the overall appearance and attitude of the two photos turned out very differently.

**FIGURE 7-3** Sometimes your subject's far-off stare is more attention-getting than having her look directly into the camera.

**Figure 7-4** Adding a fashion accessory or two to your subject's outfit can dramatically change his appearance.

**Figure 7-5** The addition of eyeglasses and a different background can totally change how someone looks in a photo.

Often, capturing photos of people, especially kids, is easier if they're actively doing something or posing with props. Figure 7-6, for example, captures a child climbing a tree. The photographer called her name and then simply yelled "smile!" This type of photo looks more natural than a posed photo. On the other hand, asking the subjects to pose with a prop can also work well. In Figure 7-7, the photographer used a wagon in a garden setting.

**Figure 7-7** Instead of just standing or sitting alone, which can make your subjects feel self-conscious or awkward, use props to give them something to focus on, help them relax, and look more natural.

**Figure 7-6** Especially with kids, catch them doing something they enjoy, call their name, and ask for a quick smile before snapping the photo.

## Equipment and Accessories You May Need

Aside from your digital camera, a memory card with lots of available space, and fully charged camera batteries, anything else you need in terms of equipment depends on where you're shooting. When using a Digital SLR camera, choosing the right lens is, of course, also important.

Lighting is a key consideration. Thus, you need to determine if your camera's built-in flash is necessary and adequate, or if you need an external flash (when using a Digital SLR) or some type of other artificial light source. A flash diffuser is an extremely useful tool when taking photos with a flash, but if you're shooting outside, one or more reflectors can be the perfect tool for controlling and directing natural sunlight and/or shadows around your subject.

For formal, posed portraits, you'll also need some type of background—either a natural setting outside or a paper, vinyl, or muslin (cloth) backdrop purchased from a photography specialty store. Depending on how you plan to capture your subjects, a posing stool, chair, or bench may be needed, along with certain types of props.

 Remember when shooting portraits, the focus should always be on the subject—not the background or on whatever prop they're holding or using. In addition, you might find a tripod helpful for keeping the camera steady, freeing up your hands, and allowing you to better frame your images so you can pay more attention to your subject, as opposed to camera settings.

The "rules" or guidelines for shooting candid photos are much less structured. Your goal is to showcase one or more people in a natural setting, without making the photos look posed or preplanned. Some preplanning on your part, however, is necessary. As the photographer, you always need to pay attention to lighting issues, as well as to setting, to ensure your subjects look their best and that your photos are well framed and in focus.

When shooting candid shots, the most important thing to remember is that timing is everything. The best candid shots are taken the moment something funny or unexpected happens, and you're able to capture the subject's expression or emotion, whether joy, laughter, surprise, or shock. You might not be a psychic, but a good photographer is able to sense when something is about to happen and knows to be ready with his or her camera.

If you plan to take portraits indoors, and you hope to achieve professional-quality results, consider investing in the basic equipment needed to create a home photography studio, including a lighting kit and a professional background. A description of what you need to put together a basic home-photography studio suitable for shooting portraits can be found in Chapter 5.

 Learn about the easy-to-use and inexpensive home lighting kits and backgrounds available from Photo Basics by Westcott; visit www.photobasics.net.

## Setting the Scene, Choosing Your Background, and Framing Your Shots

In most cases, when you're shooting people (or your pet), the focus of a photo should be on the main subject, not the background. This is why many professional photographers often opt to shoot formal (posed) portraits in front of a solid color or very simple background or by blurring out the background. This strategy applies in most situations. One exception is when you're on vacation taking pictures of the people you're traveling with in front of major tourist attractions, famous landmarks, or historical sites.

As a general rule, try to keep your backgrounds simple, so the focus of your photos remains on your main subject.

Even when shooting candid photos, however, the simpler your background is, the better your main subject will stand out in the photos. While you can't always choose your background when shooting candid photos, you can, however, choose your camera angle.

By adjusting your position as the photographer in reference to your subject (sometimes by just a few inches in any direction), what you see in the background through your viewfinder changes dramatically. Just modifying your shooting angle or perspective slightly changes almost any background, possibly making it more suitable to your photographic needs.

 When shooting candid photos, it's you, the photographer, who should change your shooting angle or perspective to alter the background. Don't ask your subjects to change what they're doing—or your photo will no longer be a candid shot.

Once you decide who to photograph, the next most important decision is where to take the picture. The setting should be consistent with the attitude you're trying to communicate in your photos, as well as with what your subject is wearing and his or her overall appearance. As the photographer, choose a shooting location that makes sense and that will allow you to create the best images possible, based on the lighting conditions and what you're trying to accomplish.

With the subject and background selected, the next step when shooting people or pets is to determine the best way to frame your photos and pose your subjects, again based on what you're trying to convey in the finished photos and the lighting conditions. Do you want to convey a fun or whimsical attitude or present a more formal portrait? Do you want the photo to highlight a person as a whole, or put more visual emphasis on one of his or her particular physical characteristics, such as the eyes or smile?

As you decide where to position your subject relative to the background, also consider taking advantage of anything in the foreground or of objects the subject can somehow interact with.

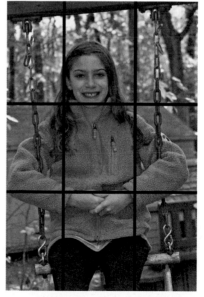

**FIGURE 7-8** In this example of the Rule of Thirds, the subject is positioned toward the center of the image.

Can your subjects sit on or lean against something so they're somehow interacting with their environment? Can you use objects in the foreground to frame the photo to give the image added depth? When framing your images, keep the Rule of Thirds in mind, rely on your eyes' natural field of vision, and then fine-tune the image's framing as you look through the camera's viewfinder.

In Figures 7-8, 7-9, and 7-10, the Rule of Thirds was utilized in three different ways as the photographer looked through his viewfinder to frame his shots. In Figure 7-8, the main focus of the image is the center, but the

**FIGURE 7-9** Here, the subject is positioned more to the side.

girl's head (a main focal point) is in the upper-portion of the shot. In Figure 7-9, the model is positioned more to the side and the image is framed horizontally. In Figure 7-10, the boy is situated in the left portion of the frame.

## To Zoom or Not to Zoom?

Once you have everything staged and set for taking the photo, determine how much of your subject you want to showcase in the image. Are you looking for a full-body shot (shown in Figure 7-11), which shows everything from the subject's feet to the top of her head, a shot from the waist up (shown in Figure 7-12), or a headshot, which primarily focuses on the subject's upper-chest, shoulders, and face (shown in Figure 7-13)? The type of shot determines the level of zoom, if any, you should use and/or how close you need to position yourself and your camera relative to your subject.

**FIGURE 7-11** A full-body shot shows a subject's entire body.

**FIGURE 7-12** A mid-body shot typically showcases a subject from the waist up.

**FIGURE 7-13** A headshot typically captures a subject's upper-chest, shoulders, and face.

When shooting a full-body shot, don't accidently cut off a body part, such as the person's feet, the top of his or her head, or an outstretched hand or foot.

Again, once you decide what portion of your subject you want to showcase within a photo, as the photographer, you also have the ability to choose your camera angle and the position or pose of your subject. You can shoot head-on toward your subject. (If you take a second look at Figure 7-13, the subject's entire body is facing the camera). Or you can angle your subject's body to one side, have him pivot at the waist, and turn his face toward the camera (as shown in Figure 7-14).

**FIGURE 7-14** A shot taken with the subject's body positioned at an angle, as opposed to head-on toward the camera

As a general rule, when shooting a close-up headshot, focus the camera and center the lens on your subject's eyes. When shooting mid-body shots, however, centering your camera's lens on the person's nose usually looks best.

You can also create interesting visual effects by positioning yourself above or below your subject and focusing the camera up or down. In Figure 7-15, the photographer used a stepladder to position himself a few feet above the subject and then angled the camera in a downward direction, with the subject looking slightly upward. Of course, you can also be creative and shoot from above *and* at an angle, for example.

**FIGURE 7-15** The photographer positioned himself above the subject and angled the camera downward.

Shooting from above (looking down at your subjects) will make them look shorter and potentially more youthful. If you crouch down and shoot upward toward your subjects, they'll appear physically larger, but possibly out of proportion in photos. Sometimes, when you, the photographer, can shoot from above your subject, you can use what's on the ground as your image's background. Figure 7-16 was taken from above the subject and uses the fall leaves on the ground as a colorful background for the image.

Sometimes, you can obtain the most dramatic or thought-provoking images by really zooming in on a person's face, as you can see in Figure 7-17. You can tap into

**FIGURE 7-16** The colorful leaves on the ground served as the perfect background when the photographer took this shot from above the subject.

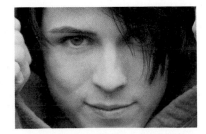

**FIGURE 7-17** Zooming in extra close on a subject's face can sometimes have dramatic and impressive results.

some of your own creativity here. This technique won't work for everyone, but if your subject has the right look and facial expression at a particular moment as you're shooting, consider zooming in really close and capturing it.

When really zooming in on someone's face, cutting out the top of his head, an ear, or the chin, for example, is okay. In these instances, creativity is more important than making sure the entire face fits within the frame. Of course, you can always crop an image after the fact using photo-editing software. Beyond taking the Rule of Thirds into consideration when shooting people or pets, determine if a photo will look better if you shoot using a horizontal (landscape) or vertical (portrait) perspective, based on how you hold the camera. Simply rotating the camera dramatically alters an image.

Figure 7-18 and Figure 7-19 show the same basic shot; however, the camera's rotation and how the Rule of Thirds was applied changed. Generally, a vertical (portrait) camera position is used when taking semiformal or formal portrait shots of people, but this rule is not an absolute. In situations like this, your personal taste and creativity override photographic traditions and rules. By shooting with the camera positioned horizontally, you can capture more of what surrounds your subjects.

When shooting someone standing or sitting, taking a vertical (portrait) shot typically makes the most sense, because it keeps the subject as the photo's center of attention, without your needing to capture too much background. When one or two people are photographed with the camera turned horizontally, you have much more room in the frame to showcase the background, the subject's actions, and any props.

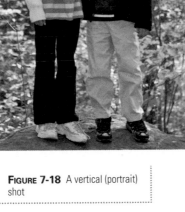

**FIGURE 7-18** A vertical (portrait) shot

**FIGURE 7-19** A horizontal (landscape) shot

In general, you have a lot of flexibility when shooting one or two people. As you deal with groups of people and have to fit everyone into the frame, your options diminish slightly, as you'll learn about in the "Posed Portraits of Groups" section of this chapter. In most situations when shooting groups of five or more people (especially large groups or entire families), you'll want to position your camera horizontally. A horizontal orientation gives you plenty of space to fit everyone into the frame and come up with appropriate and natural-looking poses for everyone.

Larger groups can be shot with the camera positioned vertically, but you'll need to layer the people into two or more rows or lines, one in front of one another, and at different heights (sitting on the floor, kneeling, and standing). In a group of six, three people can sit on a bench, while three more can stand directly behind the bench. You could also have one or two people on the floor, in front of the bench.

## Lighting Considerations

Always consider the lighting that's available or that you can add, and determine how you want to light your subject in each photo. Lighting is as important as choosing the right setting and background and the appearance of your subject (his or her hair, makeup, and outfit).

In terms of portraits shot indoors, you can light your subject(s) from above, from a head-on perspective (using a soft front light, or the brighter and harsher light from a flash), or you can set up lighting on one or both sides of your subject. You can also position multiple lights indoors to surround your subject and eliminate shadows altogether.

Whether indoors or outdoors, the positioning of your lighting source or sources has a tremendous impact on the look of your photos. For example, using just a top or overhead light alone will cause shadows on portions of your subject's face, especially under the eyes and nose. Using a soft front light is common for indoor posed portraits. This type of lighting helps to create the illusion of a smoother complexion. A flash is also a type of front light, but this typically creates a much brighter and harsher light that can overexpose a person's face and cause red eye, unless you use a diffuser or bounce an adjustable flash unit's light off a nearby wall or ceiling.

The type of light shining on your subject, as well as the direction the light is coming from, the light's intensity (brightness), and its color, can all impact a subject's appearance in a photo. Even minor adjustments in lighting can have a huge impact on how a photo turns out.

**FIGURE 7-20** When lit from just one side of the face, you can create interesting shadow effects in portraits.

**FIGURE 7-20** When lit from just one side of the face, you can create interesting shadow effects in portraits.

A single side light creates shadows, which you can carefully position on the opposite side of someone's face to create a very interesting visual effect (as shown in Figure 7-20). With a light positioned off to the side, you can adjust the shadow being cast by moving the light source up or down or closer or farther away from the subject. But, unless your goal is to create some type of special lighting effect, if you're shooting indoor portraits, consider a two- or three-light setup, with the lights positioned in front of the subject.

When using a two- or three-light setup, you can set one light off to the right of the subject, with the other positioned to the subject's front left. Then place a third light source directly in front of the subject. The best ways to position lights in an indoor home studio setting are covered in Chapter 5.

Ideally, when shooting people, you want your subjects to be well lit and surrounded by light, unless you're purposely using shadows to create some type of unique visual effect. Something as simple as a lighting adjustment can dramatically change someone's appearance in a photo, whether shot indoors or outdoors.

If you're using only natural lighting outside, your lighting source is the sun, and its position changes throughout the day. Keep the sun behind your back (as the photographer), so it shines directly onto your subject's face and body. If this positioning isn't possible, you can use reflectors to redirect sunlight or shoot in a shady area or on an overcast day. You can also use your camera's flash to supplement outdoor natural lighting. (If you take a second look at Figures 7-11 through 7-15, for example, all were shot outdoors in bright and sunny weather, but the camera's built-in flash was used to brighten the subjects.)

**Caution** If the sun is in the wrong position when you shoot outdoor posed or candid portraits, you'll wind up with unwanted shadows, glares, or silhouettes instead of well-lit subjects. If you have your heart set on shooting at a specific location, you may need to wait until a specific time of day for optimal lighting. Or you may have to alter your outdoor background to one with the best lighting based on the time of day you're shooting. Another option is to take advantage of an artificial light source, such as a flash.

## Posing Your Subjects

When it comes to posing your subject, the possibilities are limitless, as long as what you come up with looks natural, unless, of course, you're going for a bold or dramatic look. You'll probably find that if you simply ask someone to "stand

still" so you can take a picture, the person will begin to feel awkward and fidget, because your subject won't know how to position his or her body or what to do with his or her hands. It's better to suggest specific and defined poses for your subjects and to offer plenty of direction, so they'll remain calm and relaxed.

When posing subjects, they can be standing upright, leaning against an object, sitting down, kneeling, crouching, or lying down. What's important is that you make sure your subjects look relaxed. You'll want them to stand or sit up straight (no slouching shoulders) and position their arms in a way that looks natural and relaxed, which means the arms should be slightly bent.

How your subject positions his or her head, particularly when shooting headshots (close-ups), can make a huge difference. For example, if your subject tilts his head slightly toward the camera, his eyes, nose, and forehead will appear larger, whereas his chin will appear smaller. This position can also help to hide a receding hairline. Likewise, if the subject ever so slightly tilts her head back, her chin will look larger, for example, whereas her eyes, nose, and forehead will appear smaller. The distance between her upper lip and nose will also appear smaller.

If your subject tilts or turns his head slightly to one side, various aspects of his face will change, allowing you to accentuate or distract attention away from specific facial attributes, like a receding hairline, large nose, or double chin. As the photographer, very subtle angle changes in terms of camera positioning or the positioning of someone's head (and entire body) will impact how an image turns out.

In close-up photos, hands don't need to be featured in a photo at all. However, hands can be used in a variety of ways. The subject can rest her hand on her chin to communicate deep thought or both hands to cradle her head (Figure 7-21), which is more playful. Your subject can also rest his chin on his hands to create a pose similar to what's featured in Figure 7-22.

**FIGURE 7-21** A subject cradles her head in her hands, and the photographer captures the sides or edges of the subject's hands.

**FIGURE 7-22** Having your subject rest his head on his hands is another way to pose your subject.

When using hands in a photo, particularly in close-ups, fingers should not be clenched or interlocked. Instead, make sure your subject's hands look relaxed and naturally curved. These strategies typically work best if subjects are sitting down or leaning on something like a countertop or table in front of them.

 You never want someone's hands pulling attention away from his or her face in a headshot. As the photographer, shoot the edges or sides of someone's hands, as opposed to his or her palms or the backs of the hands for a more natural and aesthetically pleasing look.

As the photographer, consider angles and how things will appear when looking through your camera's viewfinder (as opposed to looking at something with your naked eye). Creating angles with someone's body tends to make for a more visually interesting picture. That being said, when someone is standing in front of your camera, avoid shooting a full-body shot or mid-range shot head-on. Instead, position your subject's feet at a 45-degree angle (related to the position of the camera) and have him twist his upper body (at the waist) toward the camera. This subtle change in body position means the difference between capturing a picture that looks like a police mug shot and a natural-looking and visually pleasing portrait.

By positioning someone at more of a 90-degree angle (virtually sideways to the camera), you can more clearly showcase her waistline and stomach, which is perfect if your subject is pregnant and wants to show this off, but isn't as good if she's simply overweight. Someone's belly (and excess fat) will appear less obvious if shot from more of a head-on perspective, as opposed to from an angle. If someone is physically fit, however, shooting from an angle typically works best when the subject is standing.

 Positioning someone so his or her body looks natural through your viewfinder is important, but equally important is making sure clothing isn't bunched up or wrinkled. Clothing should appear smooth and well fitting, with collars, sleeves, buttons, and accessories (such as jewelry) properly positioned and angled appropriately. A twisted necklace, or a crooked collar or necktie, can easily ruin an otherwise perfect image. As the photographer, your job is to pay attention to these details.

Sometimes, having someone sit in a chair or on the ground, for example, and extend one leg outward creates an interesting perspective, as shown in Figure 7-23. You can also create an interesting perspective by having someone stand up and reach toward the camera by outstretching one or both arms (as shown in Figure 7-24). Feel free to experiment with your subjects, trying different poses in various photos.

**FIGURE 7-23** By outstretching a leg or an arm, you can create interesting angles within a photo, which can add depth.

**FIGURE 7-24** Reaching one or both arms toward the camera can create interesting perspectives and angles for capturing creative-looking shots.

**Caution**    If your subjects insist on wearing makeup, make sure they keep cosmetics use to a minimum. They don't need full theatrical makeup to appear attractive in photos. Touching up and enhancing a portrait using photo-editing software is easier if the person's makeup looks natural.

## Using a Posing Stool or Chair

You'll often discover that people are more comfortable and feel more at ease if they're sitting in a chair or on a posing stool, as opposed to just standing upright for a posed portrait. You can do many things with a chair or stool in terms of posing options. However, as a general rule, keep the chair, stool, or bench either very simple looking or extremely dramatic (like a throne). Anything in the middle could become distracting, especially if the chair's color clashes with your subject's outfit. You can use a small stool, for example, which won't even appear in the photo, but gives you the benefit of having your subject sit down.

A chair can be useful because it has a back. As the photographer, you can create interesting effects and poses

by having your subject straddle a chair (as shown in Figure 7-25), or he could straddle the chair and lean out to the side (as shown in Figure 7-26). If your subject is sitting properly in a chair, pay careful attention to the positioning of his or her legs. The subject's legs should look comfortable and natural, but not held closely together.

**FIGURE 7-25** Consider having your subject straddle a chair to provide additional positioning options.

**FIGURE 7-26** When sitting in a chair, have your subject do something interesting with his legs, arms, or hands.

## Using Props in Your Portraits

For less formal portraits, using props can give your subject something to do with his or her hands or entire body, creating a more visually interesting image. For example, for a guy dressed in business attire, holding a cell phone, briefcase, or iPad may be appropriate. For a guy dressed in sportier attire, a football, skateboard, or Frisbee may be a good prop. Figure 7-27 shows an athletic guy holding a football.

**FIGURE 7-27** Choose a prop that looks appropriate in someone's hands based on the situation or your picture will wind up looking too contrived.

While you don't need to invest in purchasing the same, often costly props that professional photographers use, you can get good ideas about types of props and when and how to use them, by learning what professionals typically employ. One source of photography props for portrait photographers is www.photographyprops.com.

Having someone interact with a pet can make for an adorable picture, especially if the pet cooperates and allows the human subject to hold or interact with it in the photo. Small children can be surrounded by plush toys, balloons, colorful pillows, or holiday-themed props. However, for the safety of infants, keep things very simple. Allowing an infant to hold nothing more than a rattle, while secured comfortably in a baby seat or lying on the floor where the baby can't get hurt, is a good strategy. (When shooting infants, your job as the photographer is to crouch down to their level in order to capture your shots.)

Be creative with your use of props in photos. However, make sure they're appropriate and that the props don't take away too much attention from the subject.

If you're shooting portraits outside, take advantage of your surroundings. Perhaps have your subject pose along or on a fence (as shown in Figure 7-28), next to or in a particularly beautiful tree, perched on a tree stump near a lake, on the steps in front of an interesting building, or anywhere else that offers an interesting visual or setting.

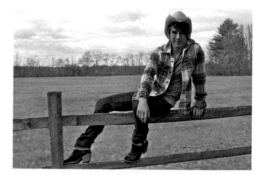

**FIGURE 7-28** Consider taking advantage of objects in your environment in your photos of people.

# Different Situations Call for Different Shooting Strategies

From a photographer's standpoint, taking photographs of people has some advantages and disadvantages. The advantages are that you can ask your subjects to pose in very specific ways and each person can convey many different looks and emotions using body language and facial expressions. The disadvantage is that shooting people offers limitless options, so as a photographer, you have to think fast and often react even faster to capture the perfect shot. Some people move unexpectedly, become self-conscious, sometimes have their own ideas, and opt to ignore directions from the photographer, or simply don't enjoy having their photo taken.

Each time you photograph a person (or people), as the photographer, you'll need not only to adapt to the setting where you're shooting, but also to modify your techniques to the individual subjects, based on their personality, insecurities, comfort level in front of the camera, and their unique physical qualities, which you may want to showcase or downplay in your images. So even if you're photographing people you know, like your own kids, friends, or relatives, each time you take pictures, you may need to utilize different shooting techniques to obtain the desired results.

## Posed Portraits of Individual People

Posed portraits of individual people, either indoors or outdoors, offer tremendous flexibility because your subject can pose in many different ways while standing, kneeling, crouching, sitting, or lying down. Depending on the attitude you're hoping to convey in the photo, you can capture your subject smiling, laughing, looking serious, or showcasing any other expression or emotion on his or her face and using body language.

However, your goal as the photographer is to always make your subject look the best he or she possibly can in your photos, which means using your photographer's eye to shoot images that utilize good composition to showcase men so they look masculine and females so they look feminine, based on their pose, body language, and appearance. A subject's pose can convey authority, femininity, masculinity, intelligence, confidence, friendliness, maturity, immaturity, or sexuality, for example, and what's being communicated in a photo can change in a fraction of a second if your subject alters his or her body language or facial expression. When choosing a pose for your solo subject, consider what type of attitude or emotion you want to communicate in the photo, and then guide your subject into an appropriate position to showcase the right body language and facial expression, so what you shoot looks natural.

**Tip** Encourage your subjects to use their imagination when having their photo taken. Ask them to imagine themselves in specific situations to help them convey the emotion or attitude you're looking for. For example, ask your subjects to think about a really big or juicy secret that they're keeping from someone. Or ask them to think about the funniest joke they've ever heard or the most exciting or romantic moment of their life, as you snap your photos.

The very best way to obtain ideas for poses and shooting scenarios for your subjects is to study the work of other photographers. Also, if you've planned a photo shoot with

someone in advance, ask your subject to cut out or copy casual or formal portraits that he or she has seen in magazines or online that showcase the type of vision your subject has for his or her own photos.

During the actual photo shoot, however, pay attention to every aspect of your model's pose. Make sure the position of her feet, legs, waist, torso, shoulders, arms, hands, and head, along with her facial expression, all look good through your camera's viewfinder—not just to the naked eye. Keep in mind that very subtle changes will have a huge impact on your subject's overall look in the photo. When possible, adjust your subject's pose to downplay any physical imperfections and better showcase his or her most attractive physical qualities.

When photographing a person, you can use the background to really set the mood or make a statement, even if it's slightly blurred or out of context. Especially when shooting people outside, be creative when choosing backgrounds and, when possible, have your subjects interact with the environment. For example, Figure 7-29 shows the subject positioned between two columns in an unusual way, whereas Figure 7-30 takes advantage of a window frame in an abandoned building to literally frame the subject. In this photo, the camera was actually rotated slightly, so the window frame and the subject appear at an angle. Remember, however, you always want your subject to remain the main focus of the image.

**FIGURE 7-29** Use elements of your surroundings to create interesting or visually unusual backgrounds, yet always keep your subject as the main focus of the image.

**FIGURE 7-30** Find interesting locations and backgrounds that can literally be used to frame your subjects to create unusual visual effects.

**Tip** When shooting headshots, don't be afraid to zoom in and fill the entire frame with someone's face (or a portion of it) if you can capture an interesting facial expression or really want to showcase someone's eyes or another aspect of his or her face.

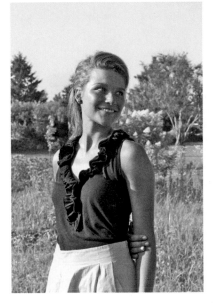

**FIGURE 7-31** Try shooting your subject looking away from rather than directly into the camera.

Many people believe that a good portrait consists of someone looking directly into the camera and smiling. This misconception is common. Often, you can create very compelling and visually pleasing photos of people by having your subjects look away from the camera and stare off into the distance, for example. When using this strategy, you want people to see your photo later and wonder what the subject is looking at because the subject's eyes are focused on something you didn't capture in the shot. Figure 7-31 is an example of someone staring away from, as opposed to looking directly into, the camera.

If someone avoids making eye contact with the camera, make sure the person isn't staring too far off to one side, and that he doesn't turn his head too much away from the camera. Use subtle movements. While your subject is looking into the camera, ask him to look just over your shoulder, for example, as you snap the photo. The photo won't look natural if your subject's eyes or entire head is turned too far to one side, or if he or she gazes too high or too low (toward the ground).

Another misconception is that your subject always needs to be smiling in pictures. Experiment with various facial expressions, and ask the subject to showcase different emotions. As the photographer, always be prepared to shoot. Sometimes, capturing a subject "off guard" or being spontaneous will result in the most compelling images. And don't forget to utilize lighting and shadows to your advantage when shooting formal or informal posed portraits.

## Posed Portraits of Groups

The trick to shooting two or more people together is to position your subjects in such a way that everyone is equally showcased in the photos and that your subjects look like they're comfortable together. Again, body language is extremely important. When two people tilt their heads toward or put their arms around each other, or somehow make physical contact or embrace, it demonstrates intimacy or closeness.

Yet, if one person stands directly in front of another, or turns away from another person, this conveys a very different

message in a photo. Choose poses that look natural when shooting multiple people, but that also look interesting or eye catching. Take advantage of and focus on each person's size and physical attributes when positioning and posing each subject.

Depending on the situation, position people in an order based on height, so the tops of their heads form a diagonal line (from tallest to shortest) when they're lined up. Or position the group so their heads line up to form an upward curve (with the two tallest people on the outside), a pyramid (with the tallest person in the center and the two shortest people on the outside), or as a V, with the two tallest people on the outside and the shortest person in front and center. Think in terms of clean and natural-looking angles and lineups, as opposed to a random hodgepodge of people of different heights scattered throughout a photo.

While a typical posed portrait involves everyone looking directly into the camera, this rule isn't set in stone. For example, if you're shooting a married or engaged couple, or two people who are dating, you can take a photo with one person looking into the camera, but with the second person looking lovingly at the first person, instead of into the camera. This type of pose is demonstrated in Figure 7-32.

You could also have both people looking into each other's eyes or capture both people looking at the same object located off in the distance (as shown in Figure 7-33).

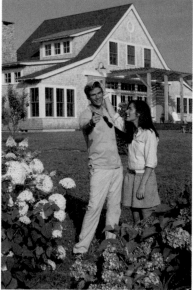

**FIGURE 7-32** Two people in a photo do not have to both be looking at the camera to create a great shot.

If one or two people need to be the center of attention in a photo, position them in the center of the group, with everyone else beside and/ or behind that person or couple. For example, if two people are the center of attention (say, a newlywed couple), they could be seated in two chairs, or perhaps the bride could sit on the groom's lap, and everyone

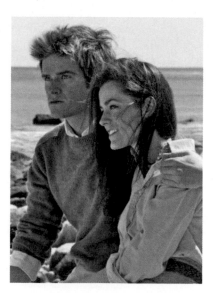

**FIGURE 7-33** Sometimes two or more people looking at something off in the distance, instead of directly at the camera, creates a compelling photo.

else could be standing in a semicircle behind and surrounding the chairs. Or the bride and groom can be standing like everyone else but positioned in the center of the photo.

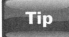

When shooting groups of people for a formal or posed portrait, make sure everyone is looking in the same direction and is showcasing the same emotion. If you're using a flash, check to see that nobody blinked by quickly previewing your photos and always take multiple shots, even if you think you captured the perfect shot right away. Give people a warning when a photo is about to be taken, by saying something like, "On three, say 'Cheese!'...One...two...three." When you get to "three," pause a fraction of a second, and then snap the photo.

## Posed Portraits of Infants and Kids

The trick to capturing great photos of kids is perfect timing because they seldom sit still, and their emotions, body language, and facial expressions constantly change. A child can go from laughing to crying in a few seconds. As the photographer, you need to determine what a child's most adorable qualities are and then capture them within your pictures.

Every kid has his or her own personality. Encourage your young subjects to be themselves. If you demonstrate how much fun you're having during the shoot, your young subjects will most likely relax and start to have fun as well. Do what's necessary to get your young subjects to simply showcase their own personality, and be ready to shoot whatever happens.

Kids are seldom self-conscious about how they look and rarely hide their emotions. So your biggest challenge as a photographer will be getting them to sit still to have their picture taken, which is something that many kids enjoy if you, as the photographer, create a fun and light-hearted environment for them.

When photographing children who don't belong to you, if the child is old enough, try to keep the parents out of the line-of-sight of your subject when shooting. This typically creates a more relaxed, stress-free setting.

Just as you would when planning any shoot that includes people, choose the appropriate setting, background, and lighting. If you have the ability to pose your young subjects, select poses that are simple and not overly pretentious. After all, you're looking to capture the subject's child-like qualities and personality. As the photographer, consider taking advantage of unusual shooting angles. Then, create a scenario so your young subjects are comfortable with you as

the photographer. Allow them freedom to express themselves openly and be silly. If, however, you need a child to sit still for a more serious picture, negotiate with him or her a bit. For example, allow the child to pose for some silly pictures first and after, as long as the child agrees to pose for a few of the serious pictures in between the silliness.

**Caution** As the adult photographer, you'll typically be much taller than your young subjects. Don't just stand upright and shoot down at your subjects. To get the best photos, you'll need to crouch down to their eye-level, or even consider getting down on the ground and shooting upward (and/or from an angle). Shooting a child from above makes them look smaller and typically won't allow you to capture them from the best possible angles.

# How to... Take a Photo of Yourself

One common problem some photographers face is being able to take a photo of themselves and the people they're with when on vacation. Imagine you're standing in front of a popular tourist attraction or historical site and wanting to take a photo of yourself with your spouse, but you're uncomfortable handing your camera to a total stranger and asking them to shoot a photo for you.

Well, there are easy solutions. First, you can purchase a point-and-shoot digital camera that features an LCD screen/viewfinder on both the front and back of the camera. This way you can hold the camera out in front of you and see what you're shooting when the camera is pointed at yourself.

If, however, you're using a traditional point-and-shoot camera with the viewfinder located on the back of the camera, when you point the camera at yourself, you can't see what you're shooting. Often, holding the camera out far enough to get yourself and the person or people you're with also in the shot is difficult. One solution to this dilemma is the xShot monopod (www.xshotpix.com). The monopod is basically a one-handed device priced under $30 that the photographer can extend out from the camera to take a self-portrait almost anywhere with ease (using the camera's autotimer feature).

A third solution to taking a photo of yourself is to attach the camera to a tripod (or tabletop tripod) and set the autotimer to go off in 15 or 30 seconds. Position the camera so it's facing you and on a ledge or at the appropriate distance away so you can include whatever background you want in the image, and then press the shutter button to snap the photo on a delay. This gives you ample time to take your position in front of the camera, smile, and pose, before the photo is snapped.

## Portraits of Pets

Photographing animals, including pets, requires a lot of patience and perfect timing, since even the best-trained animals rarely sit still and look directly into the camera when you want them

to. Plus, their attention span is very short. While you may be able to get a person to pose for 10 or 15 minutes at a time, you might just get 1 or 2 minutes at a time when you have your pet's interest and attention, so use the time wisely and plan on keeping your photo sessions short.

When taking photos of animals, including pets, focus in on their eyes (as shown in Figure 7-34). Their eyes can be extremely expressive. After all, animals don't smile. Unless you're going for a specific visual effect, crouch down and shoot from the pet's eye-level—not looking down at your pet.

**FIGURE 7-34** Most animals convey emotions through their eyes.

If you're taking photos of your own pets and know their personality, do things that'll encourage your pet to act a certain way or demonstrate a specific behavior, such as their natural curiosity or devilishness. If your pet has a really cute behavior, like sticking his tongue out (shown in Figure 7-35), try to capture that. Otherwise, you'll need to be patient and allow the animal to do his own thing, making sure you're in the right place, at the right time, and ready to shoot when the perfect opportunity arises.

Just as with people, when shooting pets, choose the ideal setting with the best possible lighting. Then try to position your pet in an optimal location to pose, keeping in mind you may need to adjust your artistic vision as you shoot, based on how the animal responds and acts.

Initially, if your pet isn't used to the camera, she may get scared by the equipment, as well as the flash. Work with your pet to put her at ease, so she becomes comfortable with a camera pointed at her, as well as with the noises the camera makes, and the bright light of the flash.

You'll almost always get the best results if you shoot your pet in natural light. When possible, shoot in extra bright settings because fur tends to absorb light. When editing your pet photos later, you may need to make lighting adjustments to brighten up your pet's face and diminish unwanted shadows.

Unless you're taking a picture of your pet doing something specific, such as your dog catching a Frisbee in midair, get as close to your animal subject as possible using your zoom lens, so the pet's face (especially his or her eyes) is prominent

**FIGURE 7-35** If your pet has a special habit or really cute facial expression, that's what you want to capture in your photos.

in the image. Always make sure the eyes are in perfect focus. By using your zoom, you can stand farther away from the animal, which will help put him or her more at ease, yet still allow you to get close-up shots.

Plan on taking many photos of your pet in order to capture that perfect shot. If your camera has a Burst or Rapid-fire mode, consider using it. You can always deleted the unwanted photos later, but taking lots of photos in quick succession increases your odds of capturing the perfect image.

 If you create a setting where your pet can do something he loves, like play fetch or roll around in the grass, you're more apt to capture his personality when shooting. Of course, you can always rely on bribery using his favorite treats.

Pets will usually be more at ease if they feel safe. One way to achieve this, and to help them get comfortable in front of the camera, while also getting great pictures, is to shoot photos of pets and their owners together (or people the pet knows really well).

## Capture Memories with Candid Photos

Whether you're shooting kids, adults, or pets, often candid photos are often the best ones because they're real, spontaneous, and capture moments in time that aren't contrived. The great thing about candid photos is that there are few rules. Your goal as the photographer is to capture real-life moments as they happen, which requires you to be ready to shoot and anticipate when something photo-worthy might take place.

When taking candid pictures, your job is to be totally unobtrusive and almost invisible to your subjects. You want to literally spy on them as they're enjoying their everyday life, or while at a party or event, and shoot photos of them doing whatever it is they're doing, without them posing and smiling for the camera.

As the photographer, you still need to be mindful of your setting, background, how you frame your images, and the Rule of Thirds, however. Plus, you have to make the best possible use of available lighting.

 The best candid shots are when something unexpected or spontaneous happens and you're able to capture it and people's expressions with your camera. Candids are often more visually interesting if you shoot your subject while he or she's engaged in doing something, as opposed to just sitting or standing around being inactive.

Some of the best strategies to utilize when shooting candid photos include:

- Taking your camera everywhere, especially to parties, gatherings, and on vacations, when you'll be spending leisure time with people you care about and want to photograph. In these situations, always be ready to shoot on a moment's notice.

- Whenever possible, take advantage of natural light and avoid using the flash. The natural light will make your candid photos look more realistic, plus you'll better capture the atmosphere or ambiance where each image is taken. Although a flash will add more light to whatever you're shooting, it will also distract your subjects, which may take away from the spontaneity of their actions.

- To avoid being in peoples' faces and distracting them as they go about their life (or enjoying a party or event), take advantage of your camera's zoom lens and capture people from a distance. With a zoom lens, you'll still be able to capture close-up images but without being intrusive. As the photographer, stake out a position that'll give you an unobstructed view of your potential subjects. You may need to do some planning because, if you know something specific is about to happen and you want to catch someone's reaction, you want the intended subject to be facing you and the camera, without having to shout out, "Hey, look over here!"

- Candid shots are usually more interesting if you shoot multiple people somehow interacting within a single image. Unless your goal is to shoot a candid portrait of someone specific, try to capture two or more people together, especially if you're taking pictures at a party, group-oriented event, or social gathering.

- Just as you would for other types of photos, take advantage of what's in your foreground and background when framing your images. Utilizing different shooting angles and unusual perspectives will also allow you to capture visually interesting images that help to tell a story about what's happening when the spontaneous photo was taken.

■ Take advantage of different shooting perspectives. See how things look at a party if you stand on a chair or crouch down and shoot upward toward your subjects. Not every candid shot should be taken from eye-level. Remember, while looking through the viewfinder, if you move just a little bit in any direction, you can change the entire framing and appearance of an image.

 **Tip** If you're taking photos at a party and a couple or small group sees you approaching, instead of carrying on with their conversation, they may turn to the camera, put their arms around each other, smile, and pose. This response is natural, so don't miss out on shooting these images. They make a great addition to a photo album, scrapbook, or digital slideshow showcasing the event after the fact, but be sure to mix these semiposed shots with truly candid shots.

Candid or spontaneous events only happen once. Don't worry so much about being creative with your lighting or overly artistic with how you frame a shot. Instead, focus on capturing your subjects acting naturally in whatever setting you happen to be in. If you take the time to overthink a shot, you might miss it altogether.

Especially when taking pictures at a party or gathering, try to avoid capturing too many people with their backs turned to you (the photographer). You can use the people who aren't facing you in the foreground or background potentially to create the sense of a crowd in your photos, but make sure your main subjects are facing the camera somewhat or you'll wind up with some very boring shots.

## Tips for Editing Portraits of People

Thanks to powerful photo-editing software, anytime you capture someone in a photo, you have an entire arsenal of tools at your disposal to enhance the appearance of your subjects after the fact. Chapter 12 focuses specifically on photo-editing software, like Photoshop Elements, Photoshop CS5, iPhoto, Aperture, Lightroom, and Portrait Professional, any of which can do a remarkable job fine-tuning your candid and posed portraits after they're shot. Chapter 13 covers photo-editing software plug-ins, add-ons, and accessories.

As you take the time to edit your portraits, start by correcting any lighting issues and using the color correction features offered by your photo-editing software. Beyond that, you can use the various photo-editing tools to smooth out someone's complexion, remove unwanted blemishes and wrinkles, whiten your subject's teeth, make his or her eyes pop, darken your subject's lips to make them more pronounced, or even enhance his or her cheekbones and jawline. While the possibilities are endless, keeping the people featured within your photos looking natural is usually best.

**Tip**   Need more ideas about how to pose people within your shots? Using Google Images (www .google.com/images), enter the search phrase **posing people for pictures**. You'll see thumbnails of more than six million sample pictures you can use for ideas and reference. Find photos with poses and settings you like and then reproduce similar images on your own, using your friends and family as your subjects.

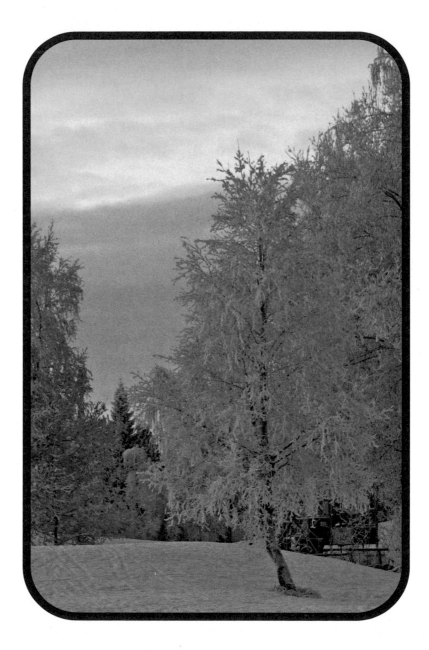

# 8

# Vacation Photography and Preserving Memories

## How to...

- Choose the best photo equipment and accessories for your trip
- Tell a story using your photos
- Capture the very best vacation photos possible
- Overcome the photographic challenges you'll encounter

The key to a stress-free and memorable vacation is to focus on the details and preplan. Choose a destination that offers the type of vacation experience you and your travel companions will truly enjoy and then spend your time participating in activities, touring, dining, shopping, being pampered at a spa, playing golf, or doing whatever it is that entertains you, relieves the stresses of everyday life, allows you to spend quality time with your traveling companions, and creates incredible vacation memories.

Of course, you'll want to capture your vacation experiences using your digital camera, so you can reflect back later and share vacation highlights with friends, family, and coworkers upon your return. Or you might opt to brag about your vacation exploits in real-time by uploading and posting vacation photos on Facebook, Twitter, or MySpace while you're still away.

As you begin making your travel reservations, planning your day-to-day itinerary, and then packing for your trip, don't forget to gather your camera and all of the related equipment and accessories needed to chronicle your vacation experience in a way that allows you to best capture and cherish those memories and experiences. However, while you want to shoot plenty of photos during your time away, you don't want to experience your entire vacation looking through your camera's viewfinder. If you're traveling with others, take turns being responsible for snapping photos, so you won't miss out on truly experiencing your vacation by focusing too hard on trying to chronicle every moment using your camera.

The trick to great vacation photography is to start snapping photos at the very beginning of your trip, like when you're getting on or off an airplane (as shown in Figure 8-1), and to chronicle your experiences in such a way that someone looking at your vacation photos later, in the order in which they were taken, will be able to relive your travel experiences through those images because they tell a visually compelling story.

Once you return home and have edited your vacation photos, you can share and archive them in many ways. Creating a photo book (using a service such as Blurb.com) is an easy and inexpensive way to create a high-quality keepsake featuring your photos and showcasing your images in a professionally bound, impressive-looking soft cover or hardcover book. You can also create a more traditional photo album or scrapbook, or choose your favorite images from the trip, frame them, and display select photos on the walls in your home or office.

**FIGURE 8-1** You can start snapping vacation photos when you're still at the airport, providing airport security permits this.

**Caution** Don't even think about taking pictures (even with your cellular phone's camera) inside the Customs and Immigrations area of any airport or near any security checkpoints.

Yet another option is to create an animated slideshow with your vacation photos, which you can watch on your television (by burning it to DVD) or share with others online. You can also create an online photo gallery or simply post your favorite images to popular online social networking sites. See Chapter 14 to learn about fun and innovative ways to showcase and share your vacation photos.

**FIGURE 8-2** Why buy postcards showing off famous locations when you can take your own photos?

Whether you're planning to take your kids to Walt Disney World, tour a major city, relax at a tropical resort, explore a different country, visit historical sites (such as Tulum, site of ancient Mayan ruins in Mexico, as shown in Figure 8-2), experience a natural setting (like the Grand Canyon or Yosemite National Park), or partake in a cruise around the Caribbean islands, for example, chances are you will have a lot to see, experience, and, of course, photograph.

**FIGURE 8-3** A scenic shot taken during a vacation

**FIGURE 8-4** Be sure to include the people you're traveling with in your photos.

**FIGURE 8-5** Taking candid shots can showcase funny or memorable things that happen on your vacation.

As you begin taking your vacation photos, you should have two goals in mind: First, shoot photos that retell the story of your vacation. Second, take a combination of scenic pictures (as shown in Figure 8-3), posed photos of the people you're traveling with (shown in Figure 8-4), plus plenty of candid shots, similar to the scene depicted in Figure 8-5.

Unfortunately, many vacationers wind up reviewing their photos after they return home from vacation and, unfortunately, discover that too many of their images are blurry (out of focus), overexposed, underexposed, or that the person taking the pictures didn't properly capture the intended subjects (heads or other body parts got cut off, for example), or the photographer stuck his or her finger in front of the lens.

Simply by utilizing the photography tips and strategies you'll learn from this chapter and throughout this book, you'll discover how to overcome these problems easily, ensuring your vacation photos are as spectacular as the trip itself.

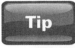 Always pack your photo equipment in your carry-on, not within your checked luggage. The major airlines will not replace any consumer electronics that are lost, damaged, or stolen from checked luggage. Putting your digital camera and memory cards through the x-ray machine at any airport TSA security checkpoint is perfectly safe.

# Choose the Best Photo Equipment for Your Trip

To take eye-catching, professional-quality pictures during your vacation, begin with one important piece of equipment—your camera. To shoot really great photos, however, you do not need to invest thousands of dollars on high-end photography equipment.

As you learned in Chapter 2, these days, for less than $250, you can purchase a really powerful, yet compact point-and-shoot digital camera that's extremely easy to use and packed with features and functionality. (For a really good point-and-shoot camera, plan on spending $200 to $400. However, if you're on a budget, you'll certainly find plenty of powerful camera models for around $150.) If you don't yet own a digital camera, visit any consumer electronics superstore, like Best Buy, or a store like Wal-Mart or Target, for example, and take a look at the incredible selection of point-and-shoot cameras that are available from over a dozen popular manufacturers, like Nikon, Pentax, Canon, Olympus, Sigma, Lumix, Samsung, and Kodak, to name just a few.

Because you're buying a camera to use during your vacation, one important facet to focus on is the camera's durability. The Olympus Stylus Tough (www.olympusamerica.com) point-and-shoot cameras, for example, are packed with features and functionality, plus they are waterproof (in up to 10 feet of water—which is great for snorkeling or taking pictures in swimming pools or at the beach), temperature-proof (down to 14°F), and drop/shock-proof (up to five feet)—meaning they're extremely durable.

Being able to shoot outside in the rain, in and around a swimming pool, while kayaking, standing under a waterfall, and/or in cold winter temperatures while skiing or snowboarding, for example, and not having to worry about damaging the camera or lens, makes the Olympus Stylus Tough ideal for taking vacation photos. Plus, if you accidently drop the camera, you don't have to worry too much about it breaking.

**Tip** Because you'll be carrying your camera everywhere during your vacation, you don't want it to weigh you down too much or be uncomfortable hanging around your neck all day. Look for an "ideal" vacation camera that's compact, lightweight, and powerful, and also very durable.

Ideally, you should purchase your digital camera at least a week or two before your vacation. This gives you ample time to shop around for the best deal and then take the camera home to learn how to use it properly. Instead of learning how to use your camera's features and functions while on vacation (and potentially making mistakes and missing photo opportunities that can't be re-created), invest the time to become familiar with your camera, practice using it, and experiment with its various features and functions *before* leaving for vacation.

Learn how to turn the camera's flash on and off manually, activate the camera's anti-shake feature, and turn on the features that allow you to take photos in low-light situations or shoot pictures through glass (which is essential if you'll be taking pictures from a moving car or tour bus).

At times, you'll have mere seconds to whip out your camera and start shooting if you want to capture something memorable. If you have to fumble with your camera, look around for the on/off switch, don't know how to access the proper menu options, or you're not comfortable simply holding your camera, mistakes can and will happen. Improperly setting up your camera before snapping pictures is the most common cause of missed photo opportunities and of blurry or out-of-focus photos.

**Caution** One common mistake is that vacationers purchase a new digital camera for their trip, but forget to buy extra batteries and memory cards before leaving home. When they reach their vacation destination, they either can't find the right accessories to purchase or the cost is several times higher because they're buying photo equipment at or near a tourist trap or from a hotel gift shop, as opposed to at a discount mass-market retailer or online.

## Be Sure to Pack Everything You'll Need to Take Great Pictures

In addition to the camera itself, consider investing in a handful of accessories before your trip, depending on what types of photos you plan to be taking based on your vacation itinerary. Here's a checklist outlining some of the accessories you should consider for your digital camera:

- Extra batteries (at least two)
- Extra lens cap (if applicable)

- Extra memory cards (at least two)
- Lens cleaning cloth and cleaning solution
- Memory Card Reader or USB cable to connect your camera directly to your computer
- Tripod or monopod
- Waterproof camera case (unless the camera itself is waterproof)
- Waterproof camera housing, so you can take a regular camera underwater when swimming, snorkeling, or scuba diving

 If you're shooting with a Digital SLR camera and own several lenses, pack a general-purpose lens, along with a wide-angle lens, and a reliable zoom lens in your camera bag. The zoom lens will be particularly handy if you're visiting tourist attractions or historical sites, for example, where you're not allowed to get too close to what you'll want shoot.

Even with a small point-and-shoot camera, a tripod can come in very handy. In most situations, you won't need (or want to carry around) a full-size tripod. Instead, you might find a much smaller desktop tripod more suitable.

 The Gorillapod portable tripod from Joby (http://joby.com/gorillapod/original/) is an extremely popular, flexible, and portable tabletop tripod that is ideal for vacationers. You can use it in a variety of different situations to keep your camera steady. For a handheld point-and-shoot camera, these tripods are priced under $25. They're available online or pretty much anywhere that sells cameras.

Having at least two or three memory cards on hand during your vacation is a must. With extra memory cards, you won't have to delete images stored on your camera during your trip (before you've had a chance to back them up and transfer them to a computer) and lose them forever in order to make room for new images as your vacation continues. In fact, you should always avoid deleting images from your camera while you're out taking photos regardless of the situation, but especially during a vacation. Although rare, deleting individual photos from your camera's memory card while it's in your camera could corrupt your memory card data and result in your losing some or all of the images stored on that memory card.

Data recovery software programs and services are available for you to use to retrieve corrupted or accidently deleted memory card data (described in Chapter 4), but you should do everything possible while traveling to protect your memory cards and the photos stored on them. Always store memory cards not in use within the small plastic container they come in or in a special memory card case. These cases help keep the cards away from damaging dust or dirt. Also avoid exposing the memory cards to direct sunlight or water.

Likewise, have a least two extra batteries on hand. Otherwise, if your single camera battery goes dead, so will the camera until you can recharge its battery. You never want your camera's battery to die midday, when you're out sightseeing or enjoying your vacation, and have no way to recharge the battery or replace it. With extra batteries on hand, when one dies, you can insert a fully charged replacement and keep shooting.

## Protect Your Camera from Getting Dirty or Damaged

Amateur photographers commonly walk around during trips (while sightseeing, for example) with their camera lens fully exposed (no lens cap), which means dirt, dust, and fingerprints can easily get on the lens. Not to mention, scratching the lens if you accidently bump into something is much easier. A dirty or scratched lens results in poor photos. As a photographer, you always want to keep your lens protected and clean. Even the smallest speck of dust, a single grain of sand, or a fingerprint on the lens could ruin your images.

For about $5, purchase a special micro-fiber lens cleaning cloth (from any camera or eyeglass store) that you can use to wipe down your lens if it gets dirty, without worrying about scratching the lens. Don't use anything but a proper lens cleaning cloth or cleaning solution, however, when trying to clean your camera's lens while on the go.

## Your Vacation Has Begun: Get Ready to Start Shooting

A good photographer is always ready to take pictures. During each day of your vacation, before leaving your hotel or resort in the morning, go through the following steps to ensure you and

your camera are ready to take pictures throughout the day and evening. Remember you don't want to miss out on any photo opportunity due to a dead battery, full memory card, dirty lens, or forgotten accessory.

**1.** Recharge your camera's main battery and at least one or two backup batteries so you begin the day with them fully charged. Since this process can take several hours, it's a good idea to recharge your camera batteries overnight (back at your hotel, for example).

 Get into the habit of inserting your camera batteries into the charger and plugging it in every night before bed while you're on vacation. You always want to have at least one extra fully charged camera battery at your disposal. Each morning of your trip, insert a fully charged battery in your camera.

**2.** Back up the photos on your memory card from the day before.

**3.** If you're using a new memory card, format the card in your camera and take a few test shots to make sure it works properly. Pack at least one or two extra (backup) memory cards in your camera bag, and always have them with you during your vacation.

**4.** Carefully clean your camera's lens, and make sure the camera strap is securely attached to the camera.

**5.** Pack your camera, memory cards, batteries, tripod, cleaning cloth, and other accessories in your camera bag, backpack, or purse, double-checking you have everything you'll need. If your camera is not waterproof, consider investing in a waterproof case, or pack your camera and accessories in sealable plastic bags to protect everything from water or dirt when not in use.

Simply following these basic steps will help to ensure you don't miss any photo opportunities. Keeping your camera's batteries charged and making sure your memory cards have plenty of space may seem like common sense, but these are two of the biggest reasons why vacationers miss incredible photo opportunities that can't be easily replicated later. If you learn just one thing from this section, it is to be prepared!

# Easy Strategies for Taking Professional-Quality Vacation Photos

As you already know, becoming a skilled photographer takes creativity and the ability to decide what, when, how, and where to shoot images that tell a story and are visually appealing. Without getting into anything too technical, let's review a handful of basic photography techniques that will immediately improve your ability to take eye-catching vacation photos. Just because you're an "amateur" doesn't mean you can't create professional-quality results whenever you take photos.

Keep in mind, each strategy can be used on its own or in conjunction with one another. They're listed here in no particular order, but each can potentially improve the quality of the vacation photos you shoot, regardless of what type of camera you're using.

Let's start with some basic shooting tips:

- Always be respectful of the rules! During your vacation, you might visit museums or attend a concert or show in a theater. Often, photography is not allowed within these types of venues. Sometimes photography is allowed, but the use of a camera's flash is not. In this case, make sure you know how to turn off your camera's flash, and utilize your camera's "existing light" shooting mode when taking your photos.

**FIGURE 8-6** Taking pictures of signs during your trip helps you re-tell the story of your vacation in a photo album or digital slideshow.

- If you want to put together a photo book, photo album, scrapbook, or slideshow of your vacation photos, be sure to snap photos of various interesting or scene-setting signs you see along the way (as shown in Figures 8-6 and 8-7) to document where you went as well as what you saw and experienced. You can be creative by making and shooting your own signs as well. For example, while on a beach, you can use a stick to write "Smith Family Vacation" in the sand, surround it with a few shells, and then snap a photo.

- When visiting an exotic or tropical destination, for example, take photos of the local scenery, as well as unique trees and flowers that you wouldn't typically

FIGURE 8-7 Words printed on objects, as opposed to traditional signs, also make great additions to photo albums, scrapbooks, and slideshows.

find near where you live. See Figure 8-8 for an example of how local exotic flowers and scenery were combined when shooting vacation photos in St. Lucia.

FIGURE 8-8 Be sure to take photos of the local exotic plants and vegetation as a reminder of how different your vacation destination was from your home.

■ To capture what the experience of visiting a distant destination with a very different culture is like, snap some pictures of the locals (but ask permission first!). Figure 8-9 is of a young boy from a tiny village along the Amazon River in Peru.

FIGURE 8-9 With their permission, take pictures of local residents when visiting a distant country.

■ Set your digital camera to shoot and save images in the highest resolution possible, so you can capture minute details in your photos. Using a high resolution also gives you the most flexibility later when editing your images and/or making large-size prints.

■ If you want even more visually stunning photos, plan your day around photographing sunrises or sunsets at visually appealing places like beaches, historical sites, or landmarks, for example,. To capture these types of photos, timing is everything, so plan your schedule accordingly.

## Simple Shooting Strategies for Vacationers

Now let's examine a handful of additional shooting strategies for taking more visually interesting and exciting pictures while on vacation and for overcoming some of the photographic challenges many travelers encounter in specific situations.

One of the most important strategies for taking great vacation photos is to utilize the Rule of Thirds, paying attention to the composition and framing of your photos as you're taking them. Review Chapter 4 to familiarize yourself with how to incorporate the Rule of Thirds into your photos. Figure 8-10 is an example of using a subject's surroundings to nicely frame an image that was taken at a resort in Hawaii.

| Tip | Don't forget to shoot images from different camera angles and perspectives. Use your creativity to choose interesting visuals that take full advantage of your surroundings. Pay attention and use what's in your foreground and background when appropriate. |
| --- | --- |

**FIGURE 8-10** When possible, use the natural surroundings to help frame your images.

### Always Be Ready to Shoot

Especially when you're on vacation, you never know when something exciting will happen. As the photographer, you always want to have your camera ready, so you can capture those spontaneous moments that you'll want to remember for a lifetime.

Instead of keeping your camera in a purse or backpack, buy a small case that attaches to your belt, or keep the camera where you can grab it within seconds, without having to search for it. As you get to know your camera, you should be able to press the power button, remove the lens cap (if applicable), and set up the camera so you're ready to shoot within a few seconds. For a small point-and-shoot camera, consider buying a lanyard, so you can wear it around your neck.

Some of the best vacation photos are when you can capture someone's reaction to something funny, scary, or exciting that happens spontaneously and unexpectedly.

## Hold Your Camera Steady

One very common problem amateur photographers have is keeping their camera extremely still whenever they shoot photos. Even the slightest motion as you press the camera's shutter button will result in a blurry or out-of-focus image. The following techniques help to keep your camera steady:

- As you're about to take a photo and press the camera's shutter button, keep your body (especially the hand and entire arm that's holding the camera) as still as possible, *and* hold your breath for a few seconds as you actually take the photo.

- If possible, lean against a wall, tree, fence, or another stable object to steady your body as you take a photo.

- When possible, use a tripod or monopod.

- Turn on your digital camera's anti-shake feature if you're forced to take photos in situations where the camera will be moving or unsteady, for example, while you're traveling in a car or riding on a tour bus or boat.

## Pay Attention to the Sun's Position

When shooting photos outside on a sunny day, the sun itself can be a help or a hindrance to the photographer. As a general rule, you never want to point the camera toward the sun when taking a photo, causing glares and reflections that can wreck your images. If the sun is behind the subject (facing the photographer), your subject will appear as a dark silhouette, which is generally a no-no. (To counteract this position of the sun, try using the camera's flash—even in daylight.)

In some situations, you can shoot into the sun for artistic purposes and use the flares created by the lens within the composition of your image to enhance it visually. During daylight hours, when you point the camera toward the sun, you'll almost always see flares, glares, or reflections. To get rid of them, simply alter your position (as the photographer) and/ or change the position of your subjects. Sometimes even the slightest change in position creates a totally different visual within your camera's viewfinder. However, if the sun is to the photographer's back (and facing your subjects), it can shine a warm light on the people or objects you're taking pictures of. See Chapter 6 for more tips on taking outdoor photos.

Of course, if you're taking sunset pictures, you want to face the sunset with your camera as you snap photos. In this situation, determine if your camera has a special built-in shooting mode for sunsets. If it does, use it. Instead of just shooting a sunset, however, like the one depicted in Figure 8-11, use nearby trees or objects to better frame the image and turn an already beautiful sunset into a more visually interesting photo. Figure 8-12 is an example of how a nearby tree can be used to frame a sunset photo.

When capturing outdoor scenery on your vacation, the best time of day to shoot is typically the early morning or around sunset. Take full advantage of the natural light and use it to your advantage when photographing your surroundings. Figure 8-13, for example, utilizes the glare of the evening sun to make a snow-covered tree in Norway look even more spectacular. In Figures 8-14 and 8-15, the Rule of Thirds is used, in conjunction with the colorful sunset, to make the snow-covered trees look much more vivid and beautiful.

**FIGURE 8-11** A typical sunset photograph, although beautiful, can also be boring.

**FIGURE 8-12** Frame your sunset images using nearby trees or objects to make the image more visually interesting.

**FIGURE 8-13** Whether you're shooting people, places, or nature, using the sun's glare in an artistic way can make an ordinary setting that much more visually impressive.

**FIGURE 8-14** While taking into account the Rule of Thirds (the position of the white tree in the foreground), as well as the lighting from the sunset, this otherwise ordinary scene looks vibrant, exotic, and extremely artistic.

The Golden Gate Bridge in San Francisco looks impressive in a photo any time of day, especially if you capture it from the right angle, such as from one of the parks located near the waterfront along San Francisco Bay. Figure 8-16 was taken in the evening just before sunset. Even with an overcast sky, the scene still looks artistic, thanks to the natural lighting that wasn't available an hour earlier.

**FIGURE 8-15** Sometimes including clouds in your image can add a dramatic effect, whether they're storm clouds or white and fluffy clouds.

**FIGURE 8-16** Choosing the best time of day to shoot your vacation photos can make a tremendous difference if you plan to utilize natural light.

## Check Your Exposure

Most cameras set to take photos in Auto mode will automatically adjust their settings to capture your subject as clearly as possible. In Auto mode, the camera determines when to activate the flash, for example.

However, with most digital cameras, you can override the Auto settings and select from dozens of special settings or shooting modes that allow you to take photos in specific situations. If you're shooting fireworks, sunsets, want to use the available light (without the camera's flash), are shooting an action-oriented event, or trying to capture a city's skyline at night, chances are your camera has a special shooting mode that will help you to capture clearer, more vibrant images than you would using the camera's Auto mode.

As you snap pictures, quickly preview the images as you shoot them. Once you're in Preview mode (viewing your pictures), you may need to zoom in so you can better see each image in detail. Determine as best you can (given the limited resolution of your camera's display) whether the photos are overexposed or underexposed and whether they're in focus. Make adjustments to your camera's settings while you can still reshoot images, as opposed to noticing problems once you get home.

**Tip** To compensate for bad lighting, take advantage of the special shooting modes built into your digital camera. However, be sure to choose the correct shooting mode based on your situation. When it's permissible, use your camera's built-in flash or an external flash unit to supplement existing light if needed.

Sometimes in low-light situations, especially if your subject is more than a few feet away, instead of utilizing your camera's built-in flash, take advantage of the camera's Shoot in Available Light or Existing Light mode. In this mode, the camera won't use its flash, but will make the best possible use of whatever light is available. When shooting in this mode, keeping your camera very still as you take pictures is absolutely essential. If possible, use a tripod.

Your camera's built-in flash can be useful for lighting up a subject that's within a few feet away from you. These small flashes have a very limited range (usually within five to eight feet). If you're in a low-light situation, and your subject is too far away, the flash won't do any good.

The opposite is true if you're shooting in a low-light situation with the camera's flash, but your subject is too close to the camera.

In this case, your image will be overlit and appear washed out (overexposed). Again, the Shoot in Available Light mode will probably come in handy, or you could simply move farther away from your subject and, if necessary, utilize the camera's zoom.

## Watch Out for Red Eye

Red eye occurs when photos are taken in low-light situations and the camera's flash is pointed directly into the subject's eyes. Instead of appearing as the subject's natural eye color, your subject's eyes will appear bright red—giving him or her a devil-like quality.

You can do a few things to avoid red eye as you're taking photos. If you use any photo-editing software, you can fix red eye in seconds with a few clicks of the mouse. As you're taking photos, however, if you notice red eye is occurring, here are a few things to do:

- Adjust the flash's intensity. (This may not be possible on many point-and-shoot digital cameras.)

- Adjust the flash's direction. (This only works when the flash's angle or direction can be adjusted. On many point-and-shoot digital cameras, the built-in flash has a fixed position—pointing straightforward.) If possible, try bouncing the flash off of the ceiling or pointing it slightly upward.

- Attach a flash diffuser to your camera's flash unit. This inexpensive accessory attaches in front of the flash and deflects the harsh light, yet still lights up the subject.

- If possible, change the overall lighting situation in the room. Making it brighter reduces the red eye effect.

- Utilize the Red Eye Reduction shooting feature built into your point-and-shoot camera. Almost all point-and-shoot cameras offer this feature. It does a pretty good job at eliminating or reducing red eye when using your camera's flash.

- If all else fails, fix the red eye digitally when you edit your photos later on a computer.

## Anticipate Shutter Lag

Shutter lag is one of the most frustrating things related to inexpensive point-and-shoot digital cameras. You prepare to

take a photo, press the shutter button, and then have to wait anywhere from a few fractions of a second to several full seconds for the photo to actually be taken and for the image data to be stored on your camera's memory card.

Unfortunately, you can't do much to eliminate lag time on inexpensive digital cameras—other than to anticipate the problem and work around it by pressing the shutter button a second or two before you actually want to snap a photo. Three tricks that might help speed up your camera include

- Making sure your camera's battery is fully charged.
- Purchasing memory cards with the fastest read/write speed possible (600x or 90MB/second, for example).
- Taking advantage of Continuous Shooting or Rapid-Fire mode, if available, if you need to capture fast-moving action such as a sporting event or kids playing. Although you'll wind up with a bunch of extra photos, since you're taking multiple images in quick succession, you have a better chance of actually capturing the exact moment you want. You can always delete the unwanted images later.

**Note** The more expensive point-and-shoot cameras and the mid-to-high-priced Digital SLR cameras have little to no lag time.

### Take Plenty of Posed and Candid Shots

When you're on vacation, chances are you want to pose in front of the tourist attractions you're visiting or have everyone gather for family photos at various times during your trip. These posed photos make a wonderful addition to your photo album, scrapbook, or digital slideshow. However, don't forget to experiment by shooting from different angles and/or repositioning the people you're shooting. If time allows, try two or three different poses.

As you take these posed photos, make sure you also properly incorporate the background, so those looking at your images later will easily be able to tell where they were taken. You'll have more "room" to work with in your frame—showcasing the people and the background—if you turn your camera and shoot using a horizontal orientation (Landscape mode) as opposed to a vertical orientation (Portrait mode).

Figure 8-17 shows a couple with the Hawaiian island they are visiting in the background. However, in Figure 8-18, although it shows the same couple, because it was shot as a close-up, the background is virtually eliminated from the photo so you can't tell where it was taken.

Posed photos are great because you can tell your subjects where to stand and what facial expressions you want them to have. You can decide when and where the photo will be taken, and, if necessary, you can often adjust the lighting or the angle from which you're shooting. As the photographer, you also have time to consider each image's foreground and background. Plus, you have the luxury of taking multiple photos to ensure you capture the perfect image.

As you'll discover, if you're trying to photograph a large group, getting everyone to look at the camera and smile at the same time is challenging, especially if young kids are in the group. Plan on investing a little extra time and taking a bunch of photos in succession to ensure you capture the perfect posed image.

**FIGURE 8-17** If you're visiting an exotic destination, make sure it appears in the background of your photos.

 **Tip**  If you're using a flash and you're worried about people closing their eyes when the flash goes off, one trick for reducing this problem is to ask everyone to close their eyes at the start. Tell them that when you count to three, you want everyone to open their eyes at the same time. Get ready to snap the photo and begin counting. When you say "three," wait a second for everyone to open their eyes, and then snap the photo.

In addition to taking plenty of posed photos, your finished photo album, scrapbook, or slideshow will be much more interesting and entertaining to look at if you also incorporate lots of candid photos from your vacation. These photos are taken spontaneously. Capture people laughing, talking, and interacting with one another. Take photos of people reacting to various things they experience during the trip or when something unexpected or funny happens.

Often, it's those spontaneous moments from your vacation that you'll remember the most, and being able to capture them in photos allows you to better cherish those memories for years to come and share them with friends and loved ones.

**FIGURE 8-18** Taking close-up photos is great; however, make sure you also take some that show off the place where you vacationed.

The trick to taking spontaneous photos is to be extremely observant of what's happening around you and to always have your camera on hand and ready to take photos. If you have your camera ready during your vacation, chances are you'll have plenty of candid, unexpected, and unplanned moments to photograph each and every day of your trip.

**Tip** If you're planning to create a photo book, album, scrapbook, or slideshow, shoot images that set the scene. Also when photographing famous landmarks, historical sites, or buildings, capturing them from unusual perspectives or shooting angles makes your pictures more interesting.

## Put Yourself and Fellow Travelers in Your Vacation Photos

Some travelers get so excited to be on vacation and seeing new things, they forget to take photos of themselves at their destination. Instead, they focus on taking shots of the tourist attraction, landmark, or historical site all by itself.

Obviously, taking some of these standalone shots is great, and they make a wonderful addition to your photo album, scrapbook, or slideshow. Don't forget, however, to put yourself and the people you're traveling with in your photos as well. Otherwise, you might as well just visit the gift shop and purchase a few postcards that showcase where you've been.

## Yes, You Can Shoot Through Glass

One of the challenges many vacationers face is taking images through glass when in their car or on a tour bus, or visiting an aquarium and wanting to capture pictures of the marine life in fish tanks. Obviously, if you can avoid shooting through glass altogether (by opening your car's window, for example), this is ideal.

**FIGURE 8-19** You can avoid glares like this by turning off the flash when shooting through glass.

When faced with the challenge of shooting through glass, the first thing you should do is determine if your point-and-shoot camera has a built in Shoot Through Glass or Existing Light mode. If so, use it. Figure 8-19 is an example of the type of glare that will appear in your photos if you attempt to take a photo through glass using the camera's flash.

 **Tip** When shooting through glass, always avoid using a flash or what you'll wind up with are a lot of annoying glares. What's actually behind the glass will be hard to see—or not even visible. And keep your camera as steady as possible.

Once you turn off your camera's flash and activate the appropriate shooting mode, if you must shoot through glass, make sure the glass is clean (fingerprint and dirt free), move in as close to the glass as possible, and use your hand, a hat, or a sheet of paper, for example, to block any and all light from shining between the end of your camera's lens and the glass.

If no light can get between the lens and the glass, you can capture clear images of what's behind the glass—the intended main subject of your photo, as shown in Figure 8-20.

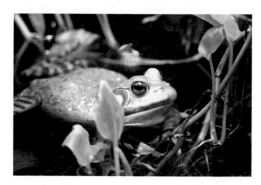

**FIGURE 8-20**  As long as no light gets between your lens and the glass, you can capture clear images through glass.

# Edit, Crop, and Archive Your Images After the Fact

After you return home from your vacation, one of your first goals should be to sort through your images carefully, back them up onto your computer's hard drive, and then use some type of photo-editing and archiving software, such as Photoshop Elements, to edit, enhance, crop, sort, and archive your images.

 **Tip** One of the very first things to do after you've shot your vacation photos is to create one or more reliable backups of your original, unedited images. In addition to storing your images on your computer's main hard drive, seriously consider investing in an optional external hard drive for your computer where you can save a second copy of all your photos, or utilize a remote backup service. See Chapter 15 for details about creating reliable backups of your photos.

# 9

# Photograph Sports and Subjects in Motion

## How to...

- Choose the right equipment for the task
- Shoot with precision timing
- Overcome the challenges of shooting subjects in motion
- Take professional-quality photos of sporting and action-oriented events

Whether you plan to take pictures at your child's Little League, soccer, or football game, or you hope to shoot other events that involve your subjects being in motion, capturing movement or action within photos can pose a challenge, depending on the conditions. Shooting high-action or fast-moving subjects requires that you use the right equipment and implement the appropriate shooting techniques, based on the situation and setting. In addition to framing your shots carefully and being concerned about proper lighting, capturing moving subjects in your photos requires precision timing, plus the ability to anticipate what's about to happen that might be photo-worthy. You'll also need to be confident and comfortable using your camera and related equipment. After all, you won't have time to fumble with your camera's settings, buttons, and dials when quick reflexes and perfect timing are of the essence. Also, the more you know about the sport or action-oriented event you'll be shooting, as well as the habits or potential movements of your subjects, the better you'll be able to anticipate ideal photo opportunities.

**Caution** The problem with shooting sports and other action-oriented events is that things happen only once, and they tend to happen quickly. You won't have a second chance to reshoot a missed photo opportunity because you weren't prepared or paying attention.

Most point-and-shoot and Digital SLR cameras have special shooting modes for capturing fast-moving subjects. On a Digital SLR camera, the fast-action shooting mode (or Sports mode) can usually be found on the camera's Mode Dial. On many cameras, the Sports shooting mode is depicted with the running man icon. However, even when using a special shooting mode, when your subject is moving fast, you still have to make multiple split-second decisions when taking pictures, based on how you want to capture the scene or motion-oriented event.

Any lag time on your point-and-shoot camera will make shooting action or motion much more challenging. You need to press the camera's shutter button to snap a photo well in advance of the action actually taking place. To help compensate for this, make use of your camera's Burst or Rapid-fire shooting mode, plus make sure you select the Sports shooting mode to somewhat reduce, but not eliminate, this problem. For shooting actions or sports, a low-to-mid-end Digital SLR camera will be a much better tool than a mid-priced point-and-shoot camera that has a lag time.

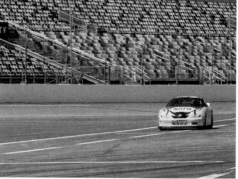

**FIGURE 9-1** This car is moving fast, but no Motion Blur Effect was used; the motion is perceived, not actually depicted, within the photo.

You could shoot your photos so your subject appears crystal clear and in focus. Later, when you look at your photos, it will appear as if you captured a split-second in time. The motion of your subject is perceived but not shown in the image. You can see an example of this in Figure 9-1. The car is in focus. By using a slightly different shooting technique, and by adjusting your camera's shutter speed, you could capture Motion Blurs, which visually depict motion, in your photos.

When you're taking action shots, you also have to decide whether you want the entire image to be in focus, or just the main subject of your image to be in focus but with the background slightly blurred (which is a different way to visually depict motion in photos).

As you frame your shots, the amount of zoom you use, if any, in order to get in closer to the action is also a consideration. You might want to take a wide-angle shot to capture everything happening in an area. Or you might want to zoom in on a specific action and shoot a close-up of your subject. How much

of a scene you capture in a photo determines what story, or how much of the story, that particular image conveys to the people looking at your photo later.

An action shot does not have to be sports-related. It can involve any type of movement, such as your subject walking or running, your dog catching a ball in midair, someone blowing out candles on a birthday cake, a person being handed a diploma during a graduation ceremony, or anything that involves your subject physically moving, either slowly or quickly, and where split-second timing is important to capturing the shot.

# Shutter Speed Is Important When Shooting Action

Your digital camera's shutter speed determines how long the camera's shutter remains open when snapping a photo, directly impacting how much information and light is captured by your camera's image sensor. Shutter speed (or *exposure time*) is measured in fractions of a second (or in full seconds for long exposure shots). In Auto mode, your camera determines what it thinks is the appropriate shutter speed for a shot. However, most Digital SLR cameras have a Shutter Priority mode (labeled as Tv on the Mode Dial on Canon Digital SLR cameras, for example) that allows you to override the Auto settings and set your camera's shutter speed manually in order to capture specific shots involving movement. Some point-and-shoot digital cameras also allow you to adjust your shutter speed manually.

If you're using a Digital SLR camera and manually making adjustments to your camera's settings (as opposed to shooting in full Auto mode), when shooting sports or action taking place indoors, you'll probably need to set your ISO to 800, in addition to increasing your shutter speed. More information about setting your camera's ISO can be found in Chapter 6.

When photographing a moving subject, your camera's shutter speed is important. The faster your subject is moving, the faster the shutter speed needs to be set if you want to capture a clear image. The shutter remains open a shorter amount of time as you increase the shutter speed. If you slow down the shutter speed slightly, you'll discover blurs in your image as a result of your subject's moving. In the right situation, a Motion Blur Effect will show your subject moving in the photo. Too much blur, however, and you won't be able to see any detail in your image.

# Equipment You'll Need to Shoot Sports or Action-Oriented Events

In addition to your camera, when shooting sports or certain other action-oriented events, a really good zoom lens (or telephoto zoom lens) for your Digital SLR camera may be useful, especially if you're positioned at a distance from where the action is actually taking place. The most useful type of lens depends on how far away from the action you are and how wide of an area you need to shoot.

**Tip** If shooting with a point-and-shoot camera, one with a powerful optical zoom lens will come in handy. Look for a camera with a 8x or stronger optical zoom lens for shooting sporting events from a distance (such as from the sidelines or bleachers).

Again, depending on the situation, if your subject is moving fast, holding your camera absolutely steady while taking photos is more important than ever, particularly if you're using a zoom or telephoto lens. A tripod is a worthwhile accessory to take advantage of.

Because perfect timing is essential for capturing moving subjects, using your camera's Burst or Rapid-fire mode may also be necessary. As you'll be taking many photos in a short amount of time, you'll require more storage space on your memory card. Having additional memory cards on hand, so you don't run out of storage space while you're shooting, will be more important than usual. As a general rule, however, try to keep your camera settings and equipment configuration as simple as possible when shooting moving subjects, so you have less to think about when taking time-sensitive pictures.

**Caution** Using a camera's built-in flash or an external flash will slow your camera down a bit, which could be detrimental to shooting fast-moving events. Therefore, if you can shoot a moving subject without a flash, you'll have better luck capturing the action, providing ample lighting is available.

## Choosing the Right Lens for the Task

If you're using a point-and-shoot camera, you don't have a choice about which lens to use. But you can decide which shooting mode will help you to best capture whatever it is

## How to. . .

# Capture Images When You're in Motion

The techniques you use to shoot a moving subject (when you, the photographer, are standing still) are different than what you need to do to capture in-focus pictures when you, the photographer, are in motion and unable to hold your camera perfectly steady (but your subject is relatively still).

As the photographer, if you attempt to take pictures from a moving car or tour bus, or you're aboard a boat or cruise ship that's rocking with the waves, holding your camera perfectly still when shooting will be impossible. In this scenario, you need to utilize the Image Stabilization or Anti-Shake feature built into your digital camera and/or lens. Otherwise, if the camera moves, even slightly, when you press the shutter button, you'll wind up with an out-of-focus and blurry image.

Most point-and-shoot digital cameras have a special shooting mode that can be activated when you can't hold your camera perfectly steady as you snap photos. Depending on your camera's make and model, this mode might be called an *Anti-Shake* or *Image Stabilization* mode. On your Digital SLR, this mode may activate automatically if the camera is set to Auto mode, but you may also need to manually turn on the Image Stabilizer feature built into your Digital SLR camera's auto focus lens, as shown here.

When Anti-Shake or Image Stabilization is activated, it compensates for slight camera movements when you're shooting an image. Thus, you should be able to take clear (in-focus) images from a moving car or while aboard a boat, for example.

you're taking pictures of. When shooting a moving subject, select the Sports mode on your camera.

Digital SLR cameras allow you to change lenses. The better quality (and more expensive) lenses for these cameras have faster reaction times, which is useful for taking pictures that require the camera's auto-focus feature to kick in quickly. If you're planning to shoot fast-moving subjects or sporting events often, invest in the highest quality lenses you can afford. What you'll be shooting, where you'll be shooting, and the distance you'll be from the subject determine how powerful of a zoom lens you'll need.

For wide shots of an entire field, court, or rink, for example, a 14–24mm lens will probably serve you well. If you want

to be able to really zoom in on the action and capture faces of individual players participating in a sport while positioned on the sidelines or in the bleachers, a 200–400mm zoom or telephoto zoom lens will probably be necessary, depending on how far away you are from the action. With a high-powered zoom, you'll most likely also need a tripod, especially if you're shooting in nonoptimal lighting situations (like within a school gymnasium).

**Tip**  When selecting your shooting location, think about the type of photos you want or need to take, in what direction your moving subjects will most likely be facing, and take into account the lighting conditions and how glares or shadows might impact your photos. Also consider the background you'll wind up capturing in your photos based on your vantage point looking at your subject (who will be in motion). If you're shooting an event on a field, track, or court, for example, determine where the important action will most likely take place, and make sure you have a great, unobstructed view from an appropriate shooting angle.

# More Strategies for Shooting Movement or Action

Preparation is key once you know you'll be photographing a moving subject. Using these strategies, you'll be more adequately prepared for the challenges you may encounter in this situation:

- Know how to operate your equipment. You do not have time to fumble with buttons and dials or consult the owner's manual for your camera to learn how to do something when an important, time-sensitive event is happening. Without having to think about it, know how to perform routine tasks—like quickly adjusting your camera's shutter speed, switching among shooting modes, turning on or off the Rapid-fire shooting mode, or swapping lens very quickly.

- Understand what you're shooting, so you can anticipate when the very best photo opportunities are about to take place (*before* they actually happen). If you're photographing a basketball game, for example, become familiar with the sport's rules, as well as the players, so

you can predict when and where on the court the best photo opportunities are most likely to occur.

■ Select your shooting position wisely. Depending on the equipment you own, the power of your zoom lens, the type of shots you want to take, and the available lighting, choose a shooting location that gives you the best possible vantage point for your shots. When selecting the best place, determine where the best shots will take place, in what direction your subjects will be facing, and how close you want to zoom in on the action. Make sure you have an unobstructed view of your subject and that you'll have a visually interesting background when taking wide-angle shots.

■ As always, consider how you'll frame your shots. However, because you're photographing events that involve motion or action, you won't have a lot of time when you're actually shooting to preplan. Therefore, in advance, consider how certain shots could be framed.

■ If you're shooting any type of sporting event, follow the main source of the action, such as the ball or puck. By determining where the ball or puck is headed, you can anticipate and prepare to shoot the best shots. During a sporting event or situation where you're shooting something in motion, if you're constantly asking yourself, "What just happened?", chances are you're missing a lot of really good photo opportunities. Anticipate what's about to happen!

■ Don't stop shooting after an event or action takes place. Try to capture reactions or the aftermath of an event as well, such as your child's facial expression after scoring a goal.

■ If you know a specific action-oriented event will take place any moment around a particular goal post, net, or basket, prefocus on that location (by pressing your camera's shutter button halfway down), and get ready to snap the photo at precisely the right moment. Remember, timing is everything!

■ Be prepared to shoot unexpected events, not just things you can anticipate.

■ Experiment using your camera's different shutter speeds. Once you've captured some really good shots,

manually increase or decrease the camera's shutter speed slightly, for example, to create a "motion blur" visual effect within any new photos you take.

- When photographing sports, you'll typically hold your camera and shoot in horizontal (landscape) mode to capture a wide area. However, when zooming in on just one or two people, consider switching to vertical (portrait) mode for a few shots. Doing this allows you to frame your images around something specific and eliminate unnecessary or unwanted background.

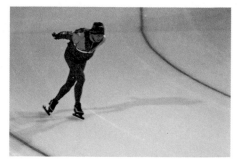

**FIGURE 9-2** Using the Rule of Thirds, you can tell where this fast-moving skater is headed, based on where he's positioned within the photo's frame.

- One of the most useful shooting modes when taking pictures of any split-second, action-oriented event is your camera's Burst or Rapid-fire mode, which allows you to shoot multiple consecutive shots at a time by holding down the shutter button. How many shots per second you can take depends on your camera's make and model. When something important is happening, to ensure you capture the perfect shot, your chances improve greatly if you shoot 5, 10, or 20 photos quickly within a few-second period, as opposed to just one or two. You can always delete unwanted images later. If you're shooting a sporting event and will be using this feature often, you'll need to stock up on high-capacity memory cards with fast read/write speeds.

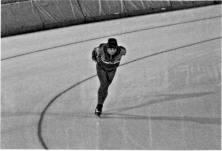

**FIGURE 9-3** With the skater coming almost directly toward the photographer, there's little sense of motion. The shot is boring.

- When your subject is in motion, make sure you capture him or her moving into the frame, not out of it, as shown in Figure 9-2. Doing this is easier if you use your camera's Sports or Rapid-fire mode to take multiple images in very quick succession. In the image of the same skater moving directly toward the photographer, shown in Figure 9-3, there is little sense of motion or direction. A shot taken seconds later (Figure 9-4), with the skater centered in the frame, shows motion, but does little to indicate where he is headed.

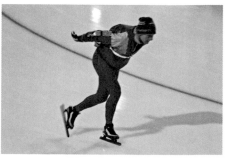

**FIGURE 9-4** Centering the skater in the frame does little to indicate where the skater is going.

 If your Digital SLR camera has an AI Servo AF mode (which is also referred to as *Continuous Autofocus*), use it to track fast-moving subjects continuously—keeping them in focus within the viewfinder—as you frame your image and you're setting up to take a shot at a specific moment. Once you've set up this shooting mode, press the shutter button on your camera halfway down to focus in on and track your moving subject while looking through the viewfinder until you're ready to snap the actual photo. This keeps the subject in focus, even if his or her distance from the camera or other elements change. How you activate this shooting mode will vary based on your Digital SLR camera's make and model.

## Practice Smooth Panning Technique

While you usually want to keep your camera perfectly steady when shooting a moving subject, at times, panning the camera while snapping photos in sync with your subject's movements will result in more powerful images that better showcase the motion. Panning your camera means moving it slowly in a fluid motion to the left, right, up, or down, while following your subject and shooting at the same time. Panning creates a blurred background while keeping your subject in focus—as opposed to blurring your subject slightly and having an in-focus background in your photos. Especially if you're panning while shooting in Rapid-fire mode, keep your panning movements slow and steady, which is easier if you're using a tripod.

As you move with your subject and pan, use the Rule of Thirds when framing your image. Your subject does not need to stay in the center of the frame (which is a common habit). Using this technique successfully takes practice. If you're handy with Photoshop or another photo-editing software package, you can re-create this effect using the Motion Blur effect on a background. Access the Filters pull-down menu from Photoshop CS5, for example, and select Motion Blur from the Blur submenu.

## Facial Expressions Make for Great Photos, Even in Action Shots

Sports isn't just about high-intensity action. It also involves emotion. As a photographer, capture those high-action plays, but also focus in on the facial expressions of your subjects (the athletes) during and immediately after those important moments. Often, you'll discover that a subject's facial expression conveys more in an image than an exciting action or motion. Combining action with emotion, however, allows you to create some amazing and memorable shots.

## Frame Your Shots Appropriately

As you compose and frame your shots involving a subject in
motion, pay attention to where your subject is positioned within
the shot and in which direction he or she is facing. Ideally, you
want to show your subject moving into the frame in order to
draw the eyes of the person looking at the picture in, as opposed
to capturing your subject leaving the frame.

Try to create a sense of depth by positioning
your subject based on the direction of his or
her movement, so it looks like the subject has
somewhere to go within the frame. Attempt to
demonstrate within your shots, based on how you
frame them, the direction the subject is headed, not
where he or she has come from. In Figure 9-5, the
jet ski is clearly moving from left to right within the
image but is angled in a way so it also looks like
it's coming forward, toward the person looking at
the photo.

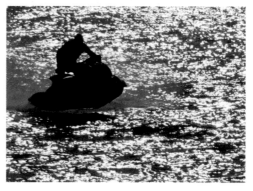

**FIGURE 9-5** By using the Rule
of Thirds and framing your shot
appropriately, show where your
moving subject is headed.

## Set Your Camera's White Balance
## if Shooting Indoors

Whether you're photographing your child's basketball game in
a high school gymnasium or hoping to capture the action of an
NBA game in a massive arena, chances are the indoor lighting
won't be ideal for picture taking. If you're shooting with a
Digital SLR camera, manually set your white balance before
shooting, otherwise your pictures will probably have an ugly
colored tint. This tint can be fixed using photo-editing software
like Photoshop Elements; however, you can avoid it altogether
by adjusting the white balance to either Tungsten or Fluorescent
light, depending on how the gym, stadium, or indoor building is
being lit. See Chapter 4 for more information about setting your
camera's white balance.

## Pay Attention to, but Don't Focus on,
## Your Background

As you're attempting to shoot a specific action-oriented event,
you may not have too much discretion when selecting your
background. If you do notice a background that's not ideal, try

adjusting your shooting perspective slightly. Move to the right or left, or position your camera a bit higher or lower (shooting upward or downward), or try shooting from a different angle altogether. The slightest change on your part will typically alter the background significantly, hopefully to something more amenable.

After the fact, when editing your images, you can always utilize a Photoshop plug-in, like Alien Skin's Bokeh (see the Web Chapter at www.mhprofessional.com for details), and highlight only the main subject while blurring out the background.

## If You're a Participant, Keep Your Camera Handy

In general, if you're an active participant in an activity and taking pictures, too, try to stay ahead of the other people you're taking pictures of. This way, you can turn around and snap photos of them coming toward and facing you. Otherwise, you'll wind up with boring shots of peoples' backs.

Remember to take plenty of candid shots of your family or friends engaged in the activity, but don't spend so much time and effort trying to take pictures that you miss out on the fun and excitement of participating in the activity yourself.

If you're using a point-and-shoot camera, keep it handy by storing it in an easy-to-access pocket or wearing it around your neck. When not shooting, however, keep your hands free so you can participate safely in the activity you're engaged in. Don't try to hold the camera in one hand at all times, and do something else as well, like skiing, biking, or hiking.

# 10

# Shoot Digital Video and Publish It Online

## How to...

- ■ Shoot videos using your digital camera or digital video camera
- ■ Edit your videos
- ■ Share your videos on YouTube or other online services

Since many of the latest digital point-and-shoot cameras, smartphones, cell phones, and even the newer Digital SLR cameras now have the ability to shoot video, let's shift focus for a bit from shooting still images to shooting short videos, editing them, and sharing them online. Nowadays you can also buy extremely inexpensive handheld digital video cameras like the Flip (www.theflip.com) that cost less than $200.

Online services like YouTube (www.YouTube.com), shown in Figure 10-1, which is owned and operated by Google, have changed the way people entertain themselves, watch videos, and share video footage on the Web. Anyone with a digital video camera (or a cell phone that shoots videos) now has the ability to produce short movies and share them with friends and family, or the general public, just by posting them online.

Thanks to videos going viral (meaning people see them, share them with friends, and then those people share them with their friends, and so on), people have literally become famous within a few days, just by posting a 10 minute—or less—video on the Web.

Here's just one example of someone becoming famous thanks to YouTube and a video they posted. In late April 2010, a 12-year-old singer/songwriter/pianist named Greyson posted a 3 minute, 38 second (03:38) video of himself shot at his middle school talent show (www.youtube.com/user/greyson97). In the video, he performed a cover of a hit song from Lady Gaga (a chart-topping pop recording artist). His performance was so amazing that within days word got out, the video went vital, and millions of people saw it. Greyson was invited to be a guest on *The Ellen DeGeneres Show* on television (http://ellen.warnerbros.com/music/greyson-chance.php),

and he wound up being signed to a major record label, with management representation—all within a week. As of mid-July 2010, his original talent show video had received almost 30 million views on YouTube.

Obviously, Greyson's story is somewhat unique, but plenty of other people have earned fame (and even fortune) thanks to the notoriety they've received on YouTube and other online services by posting their homemade videos.

Using special video-editing software, you can combine video footage, still images, titles, special effects, and music to create professional-quality videos to share on YouTube. For example, check out a video shot at the 2009 Big County Hot Air Balloon Festival in Abilene, Texas, at www.youtube.com/watch?v=Rdg6fXkEJWk. With video-editing software, you can also transform slideshows created with still images and give them a true movie-like quality with titles, special effects, and music. For a video featuring photos shot in Hocking Hills, Ohio, visit www.youtube.com/watch?v=9SNcdF9yRGY, or for images shot in New York City, visit www.youtube.com/watch?v=iyBdOFwYEZM.

Even if your goal is to shoot short videos and share them exclusively with immediate family and close friends, this chapter will help you learn the basics of shooting digital video, editing, and publishing your work online.

In addition to sharing your digital videos online, you can easily burn them onto recordable DVDs and distribute those to friends and family, so they can watch your creations on their own TV or computer that's equipped with a DVD player.

## There's More to Video Than Moving Pictures

Thanks to technology, the tools you need to shoot digital video, edit the footage, and then share it, are readily available and extremely inexpensive (compared to just five years ago). Up until now, you've been reading about how to use one single still image to tell a story, convey an emotion, or capture the viewer's attention by showcasing something compelling. The goal with video is basically the same; however, you have moving images as well as sound and the ability to add titles and special effects into the mix in order to tell your story and entertain or educate your audience.

The digital video feature built into your digital camera, smartphone, or cell phone isn't necessarily designed for you to shoot long home movies. This feature has been added so you can capture short video clips in situations when shooting single images isn't enough. These video clips can be easily edited together and shared online or via a recordable DVD, for example.

Because many of the online video sites like YouTube have strict guidelines about how long a video can be (usually less than 10 minutes), your focus is on editing your videos, utilizing sound, music, titles, and special effects, to tell a story in the shortest time possible and keep your online viewer entertained or interested. You'll be amazed at how much information or content you can convey in a video that's just a few minutes long.

To see the most popular videos on YouTube right now, visit www.youtube.com/videos?s=mp. You can also search popular videos by category, which are the most "favorited" by fellow users, or which are rated the highest by viewers. See what's possible based on the videos your fellow *YouTubers* (people who broadcast videos on YouTube) are uploading and sharing online.

# Lights, Cameras, Action! Let's Start Shooting Video

To start shooting digital video, all you need is a point-and-shoot digital camera or Digital SLR camera capable of shooting video, a smartphone or cell phone with a built-in video camera (such as an iPhone 3Gs or iPhone 4), a stand-alone digital video camera (such as a Flip), or even a webcam that's connected to your computer. A digital video camera saves your video footage on digital media, such as a flash memory card, as opposed to a videotape like many older camcorders did. Thus, as soon as the video is shot, it becomes a digital file, just like your still digital images or a document you create using Microsoft Word, for example. Your digital movie files will be much larger in size, however.

The process from shooting to sharing your video involves a handful of steps:

1. Shooting the raw digital video footage
2. Transferring the raw digital video file from your camera to your computer
3. Editing the raw video footage using specialized software
4. Adding titles, special effects, sound, and/or music
5. Saving the edited video in a suitable format and resolution for easy sharing online or for distribution via recordable DVD
6. Uploading the finished video to the Web

 YouTube offers a vast library of tutorial videos that cover each of these steps. You can watch the free videos by visiting www.youtube.com/video_toolbox.

## Use Video-Editing Software to Edit Your Videos

Once you shoot your raw video footage, you'll need specialized video-editing software and a computer. If you use a Mac, the iLife suite of applications includes iMovie (www.apple.com/ilife/imovie), which offers all of the video-editing functionality

you need to edit and share short videos, plus add all kinds of audio and video effects. This software is designed to be very easy to use, yet offers a powerful collection of features and functions.

iMovie (shown in Figure 10-2) runs on any iMac or MacBook computer. It allows you to combine video, still images, and audio quickly and easily, add effects, and then share your videos online, all with a few clicks of the mouse. Depending on your skill and creativity, the results can be quite professional looking.

Mac users will also find a wide assortment of third-party software applications designed for video editing. You'll discover a partial listing of these programs, from companies like Adobe (www.adobe.com), Roxio (www.roxio.com), and on Apple's App store for the Mac. If your needs are more advanced than what iMovie can give you, Apple also offers its much more powerful Final Cut Studio software (www.apple .com/finalcutstudio), which has professional-level video-editing capabilities.

For PC users running Windows 7, a selection of applications are also available that make editing and sharing videos a simple process. From Microsoft, for example, there's Windows Live Movie Maker (http://explore.live.com/windows-live-movie-maker), a free program for editing and sharing digital movies. Popular third-party, commercially available software applications for video editing include Adobe Premier Express

**Figure 10-2** iMovie for the Mac makes video editing and sharing very easy.

**FIGURE 10-3** Corel® VideoStudio® Pro X3 for Windows 7

and Adobe Premier Elements 8 (www.adobe.com), Corel® VideoStudio® Pro X3 (www.corel.com), Roxio Creator 2011 (www.roxio.com), and Pinnacle Studio (www.pinnaclesys.com), although dozens of others are available. You can see a sample screen from Corel VideoStudio Pro X3 in Figure 10-3. In Figure 10-4, you can see a sample screen from Roxio Creator® 2011. Both of these software packages are designed to make editing video a relatively simple and straightforward process.

You can also find shareware, demo versions of commercial software, and free video-editing software available for download by performing a search on the Download.com site.

**Tip**    For editing high-definition (HD) videos longer than a few minutes in duration, you'll need a higher-end computer that's equipped with plenty of RAM (memory), a fast processor, and a large hard drive. Longer HD videos take up a lot of storage space and editing them requires a good amount of computer processing power and memory.

Once you've shot and edited your video, the next stop involves sharing it, which means you need a computer with access to a high-speed Internet connection. Once you've created your video projects, you'll discover they are potentially very large files, depending on the resolution of your video. YouTube .com and other online video services offer online-based tools for

**FIGURE 10-4** Roxio Creator® 2011 for Windows 7

shrinking a video file size and altering its resolution; however, this is something you can also do from within your video-editing software. YouTube supports a wide range of popular video file formats. Visit www.youtube.com/t/howto_makevideo for a tutorial on producing and preparing YouTube videos.

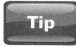

**Tip** Depending on how and where you're shooting video, you may need to use extra lighting or a separate microphone (aside from the microphone built into your camera or phone) to improve your work's production quality. You may also need a tripod to keep the camera steady, plus you might opt to use some type of backdrop when shooting.

## Digital Video Capabilities Built into Digital Cameras

Typically, when shooting video using the functionality built into your digital point-and-shoot or Digital SLR camera, you have all of the zoom capabilities you'd have available if you were shooting a still image. So you can pan the camera left, right, up, or down while shooting, or zoom in or out on your subject(s). Always keep your movements slow and steady, however.

Fast or jerky movements will distract the viewer and are difficult to edit. If you don't have the ability to zoom in when shooting video with your digital camera, you can always crop the video image and use a zoom effect when editing it later with specialized video-editing software. Or when shooting, simply move yourself and the camera in closer to your subject.

All digital cameras capable of shooting video have a built-in microphone for simultaneously recording audio as well as video images. However, the microphone's recording quality is typically poor and may not be suitable in all situations. You may find it necessary to attach an external microphone to your digital camera to capture better quality audio for your videos.

 When using the camera's built-in microphone, be mindful of how you hold the camera. As you're recording, the microphone often picks up the sound of your fingers moving around the camera's casing, especially if you accidently touch the actual microphone. If you accidently cover the microphone with a finger, it muffles the sound quality dramatically.

## Shoot Video with Your Smartphone, Cell Phone, or iPod

Many of the popular smartphones, cell phones, and Apple iPod models now have built-in video cameras capable of shooting short video clips. The most high-tech phones (like the iPhone 4) allow you to shoot in HD-quality video, but most offer much lower recording quality. For example, the Apple iPhone 3G or iPod Nano has built in VGA video-recording capabilities at 640×480 pixels, which is adequate for sharing online, but your videos will look amateurish if you watch them on an HD plasma TV or even in full-screen mode on your computer's monitor.

The Blackberry Curve, Blackberry Pearl, Blackberry Bold, and Blackberry Storm units also have a built-in video camera. The Blackberry Curve 8900 shoots at a 240×180 pixel resolution. This resolution is fine for sharing videos online or with another Blackberry user, but the video quality may look pixilated or blurry if you watch it on a full-screen monitor or TV.

As you'll discover, the video-shooting capabilities of a cell phone, smartphone, or iPod are limited to point-and-shoot videos, often with no zooming or other shooting effects possible. You turn on the video recording option, point the camera at your subject, and record your video clips, which can later be sent to a computer for editing or shared immediately via

the wireless web (if you shoot the video using a cell phone or smartphone with Internet access). These devices are great for shooting and sharing short clips where detail and crystal-clear resolution isn't essential.

You can transfer your video files from your cell phone, smartphone, or iPod using the wireless web (if the device can access the Internet directly), or you can use a USB connection to sync the files to a PC for viewing, editing, and sharing. The iPod Nano can easily be connected to a computer, allowing you to transfer video files from the iPod to the computer, where they can be viewed and shared using iTunes and/or edited using iMovie.

## Stand-Alone Digital Video Cameras

For shooting longer-length, higher-resolution digital video, the latest stand-alone digital video cameras typically offer better video and audio quality, plus the ability to zoom in and out while shooting, along with other features and functions designed for capturing much higher quality video footage than what's available from other devices.

Low-end, stand-alone digital video recorders are priced under $150 and offer excellent HD (high-definition) video-recording capabilities, but they won't offer the features and functionality, or high-quality audio, that you'll find in mid- to high-end digital video recorders priced between $400 and several thousand dollars.

For between $400 and $600, you can buy a powerful, stand-alone HD video camera that serves your needs. These stand-alone units are available from a wide range of manufacturers, including Sony, Canon, Kodak, Panasonic, and Samsung, and are sold at consumer electronics stores and mass-market retailers, as well as specialty photography stores or through online merchants that specialize in photography and/or video equipment.

 See Chapter 2 for a partial listing of retailers and online vendors that sell digital video cameras, including Best Buy, Radio Shack, Wal-Mart, Target, B&H Photo & Video (www.bhphotovideo .com), Adorama (www.adorama.com), and Abe's of Maine (www.abesofmaine.com).

If you're going to invest in a stand-alone digital video camera, make sure it shoots HD video and that it offers a nice selection of features and functionality, including a powerful

(25x or better) optical zoom lens. Pay attention to the unit's physical size and weight, its average battery life, and the type of digital media (which format memory card) it records on. If you're shooting long videos, keep in mind that you'll need to invest up to several hundred dollars more on a high-speed, high-capacity memory card that's compatible with your digital video camera.

**Note** The benefits to stand-alone digital video cameras are that they're designed to offer more shooting features and functions than the video mode of a digital point-and-shoot or Digital SLR camera, plus they're useful for shooting longer length, high-resolution videos. You can expect superior video and audio quality from the latest stand-alone digital recorders that shoot HD video.

### Did You Know?

## The Flip Offers HD Video Capabilities for Less Than $300

If you're looking for a low-cost, durable, and extremely easy-to-use HD video camera that literally fits into the palm of your hand and offers simple one-button controls, check out any of the Flip video recorders (www.theflip.com). Flips are sold at consumer electronics stores or online and are priced between $199.99 and $279.99, depending on the model.

The Flip Ultra HD ($199.99) offers 8GB of internal memory suitable for recording up to 2 hours of video. It shoots at 1280×720 (30 frames per second) HD resolution and has a 2-inch full-color screen that acts as the viewfinder and preview window. The unit offers a 2x digital zoom lens and utilizes a rechargeable battery designed to last about 2.5 hours per charge. The unit has a built-in microphone, headphone jack, and speaker.

Transferring video files from the Flip Ultra HD to a computer is simple. A USB 2.0 plug pops out of the Flip Ultra HD unit and plugs directly into a computer. You can also playback your video directly on the unit's screen or plug it into a monitor or TV using an HDMI Mini cable. What's appealing about this unit is that it's all contained within a single 4.25"×2.19"×1.17" unit that weighs just 6 ounces, and the point-and-shoot controls are so simple, a child can intuitively use it.

The higher-end Flip Slide HD ($279.95), shown in the photos on the next page, has 16GB of internal memory and will record up to 4 hours of video in 1280×720 (30 frames per second) HD resolution. Like the other Flip units, this one has a 2x optical zoom lens. This unit, however,

features a 3-inch, pop-up touch screen, which serves as the preview window, viewfinder, and control panel for the video camera. The pop-up screen makes watching videos in playback mode more convenient, as shown on the right.

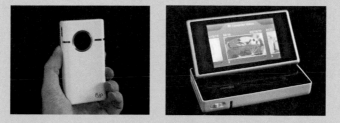

The battery life of the Flip Slide HD is around 2 hours per charge, and like the other Flip models, this one has a pop-out USB plug that connects directly into a computer for easy file transfers. The unit has a built-in microphone, speaker, and headphone jack. It also has a tripod mount and HDMI Mini video output jack for connecting the camera directly to a television or monitor. The Flip Slide HD measures 4.13"×2.17"×.98" and weighs 3.9 ounces, so it's extremely portable.

What the Flip units lack are a really impressive zoom lens, and they're not water-resistant or waterproof. An optional waterproof case ($49.99) is available so the units can be used for shooting while snorkeling or swimming. You can also compensate for the lack of a powerful optical zoom lens when editing your videos using specialized software. However, many other stand-alone digital video cameras have a 10x to 25x (or better) optical zoom lens.

Overall, the features, functionality, and ease of use make the Flip digital video cameras ideal for families or individuals on the go.

# Strategies for Shooting Videos to Share Online

When shooting video with any low- to mid-range digital video camera, don't worry so much about fancy cinematic shooting techniques. Instead, focus on capturing your main subjects as clearly and prominently as possible.

Many of the same shooting techniques you've learned in regard to shooting still images also apply to shooting video.

Here are a few simple shooting tips to keep in mind when recording digital video:

- Avoid excessive camera shaking or motion.

- Use the Rule of Thirds when framing your shots (see Chapter 4).

- When possible, shoot from two or three different vantage points or angles. If the situation allows (without missing anything important), stop the camera, reposition it, and then continue shooting.

- Don't overuse the camera's zoom-in or zoom-out feature. Your videos will look better if you physically move in closer to your subject, as opposed to using the digital zoom.

- Keep all camera panning (up, down, left, or right) movement and zoom lens movement very slow and steady when filming, otherwise your subject could wind up out of focus, plus the footage will annoy viewers when they watch later.

- Keep your main light source (such as the sun) behind you, so it's shining on your subject and not directly into the camera's lens. If you're using artificial light, use multiple light sources to reduce or eliminate annoying shadows.

- Before filming an extended or important video, try shooting a 5- to 10-second sample clip on location and then play it back right away. Ensure the audio and video quality is adequate, or, if needed, immediately make minor adjustments to the shooting angle, your proximity to your subject, the lighting, and so on, before shooting the main video.

- Avoid filming in areas with a lot of background noise, unless you're using an external microphone that's positioned very close to your subject. Otherwise, the microphone built into your camera will pick up all ambient noise in the area and will often drown out the audio coming from your intended subject.

 When using a digital video camera's built-in microphone to capture and record audio, the closer you (the shooter) are to the source of the audio (your subject), the clearer and better quality the audio recording will be.

- Unless you plan on doing a lot of editing later, only shoot the important moments. This also conserves battery life and the camera's data storage space.

- Avoid overusing special effects built into the camera. You can always add special effects (sparingly) later when editing.

- Make sure you have an ample supply of memory cards and extra batteries when shooting an important event. Plus, if you'll be filming something that's more than a few minutes long, ensure your camera is fully charged before you start and that it has enough remaining memory to store the entire video. You can always edit the video down later, before sharing it.

- Before editing your video, back up the raw footage.

For additional tips, enter the search phrase **video production tips** into any Internet search engine such as Google or Yahoo!. You can also find tips at Video Production Tips (www.videoproductiontips.com), Flip Spotlight (www.flipvideospotlight.com/resources/shooting.aspx), or Crutchfield (www.crutchfield.com/S-glMcyJXyzUs/learn/learningcenter/home/camcordertips.html).

## Why Resolution Matters

If your goal is to shoot video clips and simply share them online or watch them on your phone's or iPod's small screen, your shooting resolution isn't too important. However, if you want the option of watching your videos in full-screen or widescreen mode on a television or monitor, you'll definitely need to shoot high-resolution video, which creates significantly larger files.

The technical specifications for a digital video camera often list the maximum shooting resolution, which is based upon the number of rows and columns of pixels displayed. A low-end digital video camera might shoot only in CGA mode, which means a 320×200 resolution. Not so long ago, VGA (640×480) was an industry standard, especially for low- to mid-range video cameras.

These days, HD 720 video (1280×720) is the norm for most digital video cameras built into digital point-and-shoot cameras, Digital SLR cameras, many stand-alone digital video cameras, and some of the latest smartphones (including the Apple iPhone 4). An even better resolution, however, is HD 1080 (1920×1080), which is mainly available with high-end, stand-alone digital video cameras. The better your camera's resolution, the more detailed,

crisper, and vivid your videos will look when they're played back on almost any type of screen or monitor, especially on a larger format screen or monitor, such as a 50-inch plasma HD television.

Ideally, you want to shoot your videos with the best resolution possible. After you've edited your video, you can always use your editing software to decrease the overall resolution of your video so it's suitable for uploading to YouTube or watching on a small-sized cell phone or smartphone screen, for example.

**Note** Because it could take awhile to upload your videos to an online service, or the files may be too large to share directly with others through e-mail, you can publish your videos on YouTube and then embed the link (URL) for that video in your e-mails, blog, or on your website, as well as on your MySpace or Facebook page or within your Twitter feed. You can make your videos private (and password protect them) or share them with the general public.

## Keep It Short and Entertaining

Some egotistical and ultra-artsy Hollywood directors insist on making their blockbuster movies two to two-and-a-half hours long. However, when you're shooting your home videos with a digital video camera, especially if you plan to share your videos online, think in terms of very short lengths (no longer than 10 minutes). Most people who watch online videos have a very short attention span and are looking for a quick entertainment fix. For YouTube videos, a file can be in HD format, but it can't be larger than 2GB in size or longer than 10 minutes.

Although you might want to share 30, 60, or 90 minutes of video shot at your child's birthday party or during your last vacation, the average viewer will only have the patience to watch a few minutes of video, so focus on the most entertaining and visually impressive highlights when editing.

**Caution** Be mindful of the rules and regulations regarding permissible video content on YouTube (or any of the other services). Visit www.youtube.com/t/community_guidelines to review YouTube's guidelines relating to things like sexually explicit content, copyright infringement, hate speech, threats, and showcasing children in public videos.

## Publishing Your Videos on YouTube

The easiest way to publish and share videos on the Web is via YouTube or another video site. Then you can share the link with your friends and family or embed it in a blog, website,

**FIGURE 10-5** The YouTube Create Account link

Facebook page, or Twitter feed, for example, using a simple cut-and-paste method. Once you've loaded a video onto YouTube, click the Share button, and the site will automatically guide you through the process of sharing your video via e-mail, Facebook, Twitter, MySpace, and a handful of other online social networking sites and blogging services (including Blogger.com).

The first step to sharing your videos on YouTube, however, is to set up a free YouTube account, which takes just a few minutes. If you plan on uploading multiple videos, you can also set up a free YouTube Channel for yourself, which allows you to promote just one online location for people to find and see all of your videos.

To set up an account, go to **www.YouTube.com**, and click the Create Account link found in the upper-right corner of the screen (shown in Figure 10-5). You'll be asked to create a unique username (which can contain only letters and numbers), followed by some basic information about yourself, including your geographic location, date of birth, and gender (see Figure 10-6).

**FIGURE 10-6** Fill out all of the required information when creating an account.

**Get started with your account**

| Username: | |
| --- | --- |
| | Your username can only contain letters A-Z or numbers 0-9 |
| | Check Availability |
| Location: | United States |
| Postal Code: | |
| Date of Birth: | --- / --- / --- |
| Gender: | ○ Male  ○ Female |
| | ☑ Let others find my channel on YouTube if they have my email address |
| | ☐ I would like to receive occasional product-related email communications that YouTube believes would be of interest to me |
| Terms of Use: | Please review the Google Terms of Service and YouTube Terms of Use below: |

Terms of Service

1. Your Acceptance

Uploading materials that you do not own is a copyright violation and against the law. If you upload material you do not own, your account will be deleted.

By clicking 'I accept' below you are agreeing to the YouTube Terms of Use, Google Terms of Service and Privacy Policy.

I accept

You'll then be asked to enter a verifiable e-mail address, followed by a unique password (containing at least eight characters) that you create for your account. Upon filling in the Word Verification field, YouTube will send you a confirmation e-mail to activate your free account. In the future, you will sign into YouTube by entering the username and password you created.

Once your account has been confirmed, it will be activated within a few minutes, allowing you to begin uploading your own videos or subscribing to other peoples' YouTube channels. You'll also be able to send and receive private e-mails to and from other YouTubers, maintain a listing of your favorite YouTube videos, and have access to a variety of other features and functions.

After signing into YouTube with your username and password, click the Upload link located at the top of the screen (next to the search field) to upload a new video to share with others. The Video File Upload screen will be displayed in your browser (see Figure 10-7).

Click the yellow Upload Video icon to select the file you want to upload from your computer's hard drive. The uploading process begins automatically and could take up to 60 minutes (or longer), depending on the video's file size and your Internet connection speed.

**FIGURE 10-7** YouTube's Video File Upload screen

You Tube | Search | Browse | Upload                  jasonrich7 ▾ | Sign Out

**Video File Upload**

Upload video   or   Record from webcam

**Videos can be...**
- High Definition
- Up to 2 GB in size.
- Up to 10 minutes in length.
- A wide variety of formats

**YouTube direct mobile uploads**
Did you know you can upload directly from your mobile phone?
Set up | Learn more

**Advanced Video Upload**
Support for large (>2GB) files and resumable uploads (requires Java).
Try now | Learn more

**AutoShare**

Want to automatically share your activity feed (your uploads, favorites, ratings, etc.) to your profile on other websites? Choose a site to get started:

- Facebook - Connect accounts
- Twitter - Connect accounts
- Reader - Connect accounts
- Orkut - Connect accounts

**Important:** Do not upload any TV shows, music videos, music concerts, or commercials without permission unless they consist entirely of content you created yourself.

The Copyright Tips page and the Community Guidelines can help you determine whether your video infringes someone else's copyright.

By clicking "Upload Video", you are representing that this video does not violate YouTube's Terms of Use and that you own all copyrights in this video or have authorization to upload it.

Need more help? Watch this video or visit the Creator's Corner.

Upload problems? Try the basic uploader (works on older computers and web browsers).

**Promote your Videos with Promoted Videos**
Create and manage your video channel promotions on YouTube. Your promotion will appear with search results when people look for related content.
Get started now!

Help   About   Safety   Privacy   Terms   Copyright   Uploaders & Partners   Developers   Advertising

Language: English   Location: Worldwide   Safety mode: Off

As the video is uploading, you can complete the information fields located in the Video Information and Privacy Settings area of the Video File Upload screen (shown in Figure 10-8).

You'll be asked to enter the title of your video, which you should create yourself using a few descriptive words or phrases—your title should capture people's attention. Next, enter up to several paragraphs of text to describe your video in detail. Use keywords, descriptive phrases, and include as much detail as you desire to explain what your video is all about, who it will appeal to, and why people should watch it.

Next, create a list of Tags. *Tags* are single words or short phrases, separated by commas, that describe your video. Later, when people are searching YouTube based on a keyword search, the service will match up their keywords with the Tags you used to describe your video. This is how YouTube suggests videos for people to watch based on their interests. Tags are also used to catalog and categorize your video.

**FIGURE 10-8** Enter details about your video as the file is uploading.

After inputting a handful of related and descriptive Tags, you'll be asked to choose one general category (out of 15) that best describes your video's content. Some of your choices include Comedy, Entertainment, Education, How To & Style, Music, News & Politics, People & Blogs, Pets & Animals, and Sports.

The next setting to adjust as your video uploads is the Privacy setting. This setting determines who can watch your video. You can choose Public, which means anyone can search for and view your video. You can also choose Unlisted, which means that although it's available to anyone, that person has to know the special link (URL) in order to access it. Or you can select Private, which means you decide exactly who can view your video.

Upon inputting the required information, your video's Sharing Options will be displayed automatically. These include the direct URL, which you can share with others, as well as HTML code you can cut and paste into your blog. Now, all you need to do is wait for the upload process to finish.

After the upload process is done, the video will format itself for viewing on YouTube, and it will appear in the My Videos section of your account. It will also become available for viewing by you and the general public, if you selected Public or Unlisted as the sharing option.

## Share Your Video with Just Friends and Family

If you opt to share your videos only with a select group of people you know using YouTube, be sure to choose the Private option under the Privacy settings while the video is uploading. You can also skip YouTube altogether and directly e-mail your video file to the people you want to share it with or burn your videos to recordable DVDs and distribute them one at a time to your desired recipients.

One way to e-mail a large-size video file directly to someone else, when the file is too large to send using your e-mail service (or the recipient's e-mail service), is to use the free or premium YouSendIt .com service (www.YouSendIt.com), which makes sending extremely large files very easy.

## Promote Your Video on Facebook, Twitter, and Other Social Networking Sites

Once a video is uploaded and available on YouTube, you can incorporate it into your MySpace or Facebook page using the Share options on YouTube. You can also cut and paste the unique YouTube URL for your video into a Tweet (via your Twitter account), or cut and paste the HTML code provided by YouTube for embedding the video into a blog or web page.

Using the provided URL for your video or the HTML embedding code, you can promote your videos using e-mail and any or all of the popular online social networking sites, as well as your blog and/or web page. That is, if you want lots of people whom you don't know watching your videos. Otherwise, select the Private option and just disclose the link and viewing information to the people you want to grant access to so they can watch your video.

If you start creating a large following for your videos, establish a YouTube Channel and allow YouTube to display ads on your Channel page. Once you start generating significant traffic to your Channel page, you'll start earning revenue from the ad views, especially if you qualify to become a YouTube Partner, based on traffic to your Channel page and its popularity.

 Be mindful of copyright laws when shooting and sharing video. Don't try to smuggle your small digital video camera into a show, concert, museum, or tourist attraction where videotaping is prohibited. If you get caught filming, the authorities will often take away your camera. If you get caught posting restricted video content online, you could be sued for copyright infringement.

## How to. . . Shoot and Edit Video on an iPhone 4

In addition to building a video camera into its latest model iPhones, Apple has also made a scaled-down version of iMovie available for the iPhone 4 (it's a downloadable app, $4.99). The iMovie app allows you to edit your movies directly on the iPhone 4, and then share them via the wireless web or e-mail—all directly from your phone. Using the iMovie for iPhone app, you can also add music and visual effects to your videos and give them each a special theme.

For details about iMovie for iPhone, visit www.apple.com/iphone/features/imovie.html.

# PART III

# Edit and Digitally Enhance Your Photos

# 11

# Transfer Digital Images to Your Computer

## How to...

- Gather the equipment you'll need to transfer photos
- Move photos between your camera and computer
- Choose the best file transfer option
- Organize and store your images properly
- Avoid common file transfer problems

Once you've taken photos with your digital camera, it's in your best interest (for a variety of reasons that we'll explore shortly) to transfer those images from your camera's memory card to your computer's hard drive, an external hard drive, and/or an online photo service, as quickly as possible. Not only does this make viewing your images easier, since you're viewing them on a larger and much higher resolution screen, than using the LCD display built into your camera, but also transferring them ensures you have a proper backup of your images.

Once your images are safely stored on your computer's hard drive or an external hard drive, you can begin editing, cropping, and enhancing them (which is discussed in greater detail in Chapter 12), as well as share them with others (which is discussed in Chapter 13).

**Caution** Digital camera memory cards are not indestructible. Occasionally they do malfunction, especially if they're handled improperly. If the digital image files stored on your memory card get corrupted or accidently deleted before they're transferred to a computer's hard drive or an online photo service, your image files could be lost forever. Or you could pay a fortune to a data recovery service to retrieve your corrupted or deleted image files. See Chapter 15 for details.

# File Transfer Options

When it comes to transferring digital images (your photos) from your camera to your computer's hard drive, an external hard drive, an Apple iPad (or another storage/display device), or an online photo service, you have a variety of options, which include:

- A direct USB connection between your camera and computer. This method requires a USB cable, which typically comes with your digital camera. Shown in Figure 11-1, this method is typically the easiest and most straightforward way to move images between your camera and your computer's hard drive for storing, editing, and viewing.

**FIGURE 11-1** A digital camera connected to a computer via a USB cable

- Using a memory card reader connected to your computer. Some computers have built-in memory card readers, whereas others require that you connect an external memory card reader (as shown in Figure 11-2), typically via a USB connection (although a FireWire connection may be available if your computer and card reader support it). As you learned in Chapter 3, many different types of memory cards are available. Make sure you purchase an optional memory card reader that's compatible with the type of memory card your digital camera uses. However, some external memory card readers are compatible with many different types of memory cards and cost anywhere from $10 to $50.

- A Wi-Fi Internet connection so you can transfer files (your photos) from your camera to your computer (or an online service like Flickr.com or Facebook) wirelessly. Some of the newer digital cameras, for example, from Kodak, allow images to be transferred wirelessly between a camera and a computer (or online photo service) whenever the camera is within range of an Internet Wi-Fi hotspot. (On Kodak cameras, this is done by pressing the camera's Share button.) If this functionality is not built into your camera, you can purchase an optional Eye-Fi Connect X2 memory card ($49.99, www.eye.fi) that adds this functionality to almost any digital camera. The advantages of this feature, and how it works, are explained in greater detail later in this chapter.

**FIGURE 11-2** A memory card reader

 Without the Wi-Fi file transfer feature, you can't move files directly between your camera and an online photo service, without first transferring the images to your computer.

# The Equipment You'll Need to Transfer Images

Depending on which file transfer method you use, the equipment needed to transfer your photos quickly and easily from your camera's memory card to your computer's hard drive, an external hard drive, or another device will vary. For example, to make a direct USB connection between your camera and your computer, all you need is a USB cable. If you opt to remove your memory card from the camera and use a memory card reader to access the files on that card, you need access to a compatible memory card reader. Or if you plan to transfer your images wirelessly (via a Wi-Fi Internet connection) from your camera to your computer, and this function is built into your camera, you don't need any extra equipment. If Wi-Fi compatibility isn't built into your camera, however, you'll need an optional Wi-Fi-compatible memory card that adds this functionality, such as an optional Eye-Fi card. For this feature to work, you must be within range of a Wi-Fi hotspot.

 Instead of a USB cable connection between your digital camera and your computer, some high-end Digital SLR cameras have a faster FireWire port. If your computer also supports FireWire, you can connect the two devices via a FireWire cable (sold separately).

# Making the USB Connection

Every digital camera is equipped with a USB port, which allows you to connect a USB cable directly from your camera to your computer. Upon doing this, your computer, whether it's Windows- or Mac OS–based, will recognize your connected camera as an external file storage device. (The connected camera appears on the computer's desktop screen as if you've connected an external hard drive, for example.)

At this point, you can easily transfer files between the camera and computer manually, just as you would copy files between folders or directories on your computer by dragging and dropping the files with the mouse, or copying and pasting using the appropriate pull-down menu commands or keyboard shortcuts in the Windows or Mac operating systems.

When you're ready to connect your camera and computer via a USB connection, turn the camera off and the computer on.

Connect the USB cable to an available USB port on your computer (or its USB hub), and then connect the other end to your camera's USB port. Some cameras have a proprietary-sized USB port (shown in Figure 11-3) and require a special cable that comes bundled with the camera. Others use a standard-sized USB port and standard USB cable (which is available from any computer, electronics, or photography retailer).

Once the cable is connected properly, turn on the camera. A connection between the two devices should automatically be made, and an icon showing your camera's memory card should appear on your computer's screen. When you double-click this folder from your computer's desktop, you'll see thumbnails of the digital images stored on the memory card. On some digital cameras, you may need to turn on a specific feature manually after connecting your camera to your computer using a USB cable.

**FIGURE 11-3** Proprietary-sized USB cables have smaller-than-standard connectors to the camera.

**Caution** When connecting your camera directly to your computer via a USB cable to transfer files, make sure your camera's battery isn't almost dead. If the battery dies during the transfer process, your images won't transfer properly, and you could lose or corrupt your files.

At this point, you can create a new folder on your computer where you want to store your photo files (or choose an existing folder), and then drag and drop the images from the memory card folder to the newly created picture folder on your computer. How this method works varies, based on whether you're using a Windows- or Mac OS–based computer, but the process is straightforward if you have a basic understanding of how to copy or move files around on your computer.

If you have photo-editing software loaded on your computer, depending on the software and how it's configured, it may automatically activate and begin the image transfer process once a proper USB connection between your camera's memory card and your computer is made.

Once the USB connection between your computer and camera is established, you can use specialized photo-viewing,

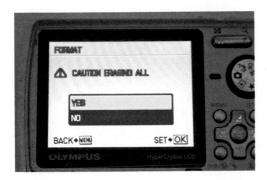

**Figure 11-4** Don't delete the photos from your memory card right away.

photo-editing, and/or image-management software, such as iPhoto or Aperture for Mac OS–based computers or Adobe Lightroom or Photoshop Elements for Windows- or Mac OS–based computers, to transfer, store, organize, and manage your digital images automatically on your computer. More information about these software packages is given in Chapters 12 and 15.

As soon as the file transfer process is complete, verify that all of your images have been copied correctly to your computer's hard drive (or an external hard drive). Until you're 100 percent sure all of your images are intact and accounted for, do not opt to delete the image files from your camera's memory card or reformat the memory card (as shown in Figure 11-4).

Once you verify all of your images have been copied correctly and are stored in the appropriate folder on your computer's hard drive (or an external hard drive), before you begin editing your images, make an additional backup copy of each image by following the steps outlined in Chapter 15. In other words, don't start deleting, editing, cropping, or otherwise manipulating your images until you've created a separate backup.

## Transfer Photos from Your Camera's Memory Card to Your Computer

Back in the days when cameras used film, each roll allowed the photographer to take just 12, 24, or 36 exposures. As you know, film has now been replaced in digital cameras by memory cards, which are removable mini–data storage devices. When a memory card becomes full, you remove it from your camera, store it safely, and then insert an empty memory card into your camera and continue taking photos. Depending on the size of your memory cards, instead of storing a maximum of 36 exposures, your digital memory card will be able to hold hundreds, maybe thousands, of images before it reaches its storage capacity.

Professional photographers always carry around at least two or three extra memory cards in case the memory card in their camera fills up or for whatever reason malfunctions. One common mistake that amateur photographers make is not bringing extra memory cards, for example, when they're on vacation. The card in their camera then fills up with images partway through the vacation. Now, unless they purchase a new memory card, or transfer the

photos on that card to a computer, they'll have to delete images and lose them forever in order to make room on the card for new photos.

If you deal with images stored on multiple memory cards, using a memory card reader is more convenient for transferring images between your memory cards and your computer. If your computer has a built-in compatible memory card reader, you're in luck. You won't need any optional equipment. When you plug a compatible memory card into the reader, that card will appear on your computer as a storage device where your digital images are stored.

You can then create a directory on your computer's hard drive or an external hard drive to transfer the images to, and then drag and drop the files in the directory, just as you would any other files on your computer. This process will vary a bit, based on whether you're using a Windows or Mac, but otherwise it's the same as copying any other type of files between directories on your computer (or between a USB thumb drive and your computer's hard drive).

If your computer doesn't have a built-in card reader, you'll need to purchase an external memory card reader that is compatible with the memory cards your camera uses. Any consumer electronics store (such as Best Buy or Radio Shack), camera specialty store, office supply superstore, or mass-market retailer (like Wal-Mart, K-Mart, or Target) sells a wide range of memory card readers (from companies like Dynex) that will connect to Windows- or Mac OS–based computers via a USB cable.

When you start shopping for a memory card reader, you'll discover two main types: one type is compatible with several memory cards and one type is compatible with only one type of memory card. Purchasing a memory card reader that is compatible with the type of memory card your camera uses is essential.

**Tip**    Be sure to purchase a memory card reader that is USB 2.0 (or later) compatible. If your computer supports USB 3.0, purchase a memory card reader that is also USB 3.0 compatible, so you can enjoy significantly faster photo file transfers.

Because some people have multiple digital cameras that utilize different types of memory cards or have other devices, such as a smartphone, that also utilize memory cards, investing in a memory card reader that is compatible with many types of memory cards makes sense. You can see an example in Figure 11-5. These, too, are readily available and allow you to

**FIGURE 11-5** A memory card displayed on a computer desktop as an external storage device

Memory card

connect just one external device to your computer (via a USB port) to access several different memory card types.

Once you connect the memory card reader to your computer via a USB connection and power on your computer, as soon as you insert a memory card into the reader, it will appear on your computer's desktop as an external storage device from which you can copy your images. The transfer process will be identical at this point to the process described previously.

## Transfer Photos from Your Camera Using Wi-Fi

If you already have a Wi-Fi hotspot set up in your home or office, or if you want to transfer your images wirelessly from your digital camera to your laptop computer (or an online photo service such as Flickr.com or KodakGallery.com) from a hotel room, coffee shop, or other remote location, utilizing this type of wireless file transfer process is very convenient. This method is also great for backing up your images to a remote location while on the go, usually with a single touch of a button on your camera.

Assuming your digital camera has built-in Wi-Fi file transfer functionality, the first time you use it, you'll need to set it up by telling the camera where you want to wirelessly transfer the files, whether it's a desktop or laptop computer, an online photo service (such as Flickr.com), or an online social networking site (like Facebook). Check the owner's manual for your camera for directions on how to set up this feature, as it's different for each camera make and model.

Once you've initially set it up, with the touch of a single button on your camera, if you're within range of a Wi-Fi Internet connection, your camera will automatically transfer your digital images from the camera's memory card to a computer or online service. Again, if your camera doesn't have this functionality built-in, you can add it by purchasing an optional Eye-Fi memory card.

Even though you're transferring your digital images to another location, never delete the image files from your camera's memory card until you're 100 percent certain the file transfer was successful, and you've verified all of your images were copied properly.

 If you transfer your photos to Facebook, the resolution and file size of your images will automatically be reduced dramatically—which is okay for viewing pictures online, but not good for archiving or printing images. Thus, Facebook is great for sharing photos, but it's *not* a good place to maintain a backup of your images.

## How to... Transfer Photos to Your Apple iPad

Many amateur and professional photographers alike have discovered that carrying a laptop computer to photo shoots (or while on vacation) can be cumbersome. Instead, they've invested in a tablet-based computer like the Apple iPad, so they can back up, view, edit, and even e-mail their images from virtually anywhere. Because the original iPad doesn't have a built-in USB port or memory card reader, you'll need to purchase the optional iPad Camera Connection Kit ($29) from Apple. This kit includes an SD™ memory card reader plus an external USB port (both of which connect to the iPad using the port at the bottom of the device). Using the USB port adapter, you can connect any digital camera to the iPad and transfer images directly from the camera's memory card to the iPad without having to go through an iTunes sync on your computer. The Apple Camera Connection Kit is available wherever Apple products are sold, including Apple Stores and Apple.com.

**Tip**  Instead of transferring your images to a computer, you can load them directly into a digital photo frame (without editing them), simply by inserting your camera's memory card into the photo frame and using the frame's internal file copy feature. How this works will vary based on the photo frame manufacturer and model.

# Properly Store and Label Your Images

As you shoot your photos and store them on a memory card, your camera will automatically assign each image a unique filename. The first part of the filename will typically be a number, followed by an extension. Many digital cameras (including all Digital SLR cameras) allow you to determine what format your images will be stored in. The most common format is .jpg; thus each image's name will be followed by the .jpg extension.

For example, if you're using a Canon Digital SLR that's set to store images in .jpg format, a typical filename begins with "IMG_", followed by a sequential four-digit number, and then the .jpg extension.

**Note**  Before you start shooting images, you can often set your camera to shoot in any of several different formats, such as .jpg, .tiff, or raw. While .jpg is the most common, other formats have advantages when it comes to editing, but they will most likely take up more memory than comparable .jpg images shot at the same resolution. Chances are the default setting for your camera is to shoot in .jpg format. If you're an amateur photographer, this setting is more than adequate.

From your camera's main setup menu, you can reset the sequential number sequence used to name your images, or preset the starting number the camera should use as you begin shooting. However, it's essential that you don't reset your camera's sequential image numbering system and then transfer your files to a central image directory that already contains images, or you run the risk of overwriting the old images with your new images because image filenames and numbers might overlap. Ensure that all of your image filenames remain different to avoid confusion, overwriting, or accidental deletion.

Ideally, each time you shoot and then transfer your images to a computer's hard drive (or another storage medium), create a unique folder in which to store your photos to keep them organized. Use folder or directory names that are self-explanatory, such as "Florida Vacation," "Melissa and Rob's Wedding," or "Rusty's Birthday Party." Within that directory, make sure each individual image name is unique.

Once you start editing, cropping, or enhancing each of your images, keep the original image (and its filename) intact.

Save each newly edited image with a different filename, using the Save As… command built into the software. For example, if the original photo of your cousin Joe fishing has the default filename IMG_1234.jpg (assigned by your camera when you shot the photo), and you edit the image using Photoshop Elements or another software package, select Save As… to rename that newly edited image to IMG_1234-Edited.jpg, or something more obvious like JoeFishing.jpg.

Ultimately, as you get creative and proficient using your photo-editing software, you may create multiple versions of single images. Thus, assigning a unique filename for each version of an image is essential, as is storing your images in organized folders, so you can find, retrieve, and view them later.

As you'll discover in Chapter 15, making a backup of your images is absolutely essential. While you can create a backup on your computer's main hard drive, a better strategy is to back up your images onto an external hard drive, or even use an online photo/file backup service (such as Carbinite.com). People take photos to preserve memories. Making sure you've preserved your images even if your computer crashes is essential.

## Avoid Common File Transfer Pitfalls

Even if you consider yourself to be highly computer savvy and are comfortable transferring files between your camera and computer, and can easily navigate your way around your computer to find, edit, store, and retrieve files, whenever you're dealing with technology, accidents can happen and things can go wrong. By taking a few basic precautions when transferring your images from your camera's memory card to your computer (or another storage device or service), you reduce the risk of problems that could result in lost (accidently deleted) images or corrupted data.

Although the basic file transfer process between a camera's memory card and your computer is designed to be easy and straightforward, regardless of what camera you're using, or whether your computer is Windows- or Mac OS–based, the following is a list of common mistakes you should avoid before and after the file/image transfer process:

- Before setting off on a photo shoot, bring along extra memory cards. If a card fills up, swap it out and insert a formatted (blank) memory card into your camera and keep shooting. Try to avoid deleting images on your memory card from your camera while you're shooting

or else you increase the chance of all your image data on that card becoming corrupted.

**FIGURE 11-6** Avoid touching the exposed connectors on your memory cards.

- Always store your memory cards in their protective plastic cases when they're not installed in your camera. Keep the memory cards away from dirt, water, or extreme temperatures.

- When handling the memory cards, avoid touching the exposed connectors (where the memory card connects to the camera or card reader). Dirt or oil from your fingers can cause a faulty connection. Figure 11-6 shows what these connection points look like on a memory card.

- Never insert or remove a memory card from your camera when the camera's power is turned on. Turn off the camera, remove the memory card, and then handle it with care.

- When transferring files between your memory card and your computer, an external hard drive, or an online service (such as Flickr.com or KodakGallery.com), make sure you set up a unique directory for each file transfer and ensure you won't be overwriting any photos already stored in an existing directory. Keep all of your image filenames unique to avoid accidently overwriting any older images with newly shot images. Accidently overwriting images because filenames are identical is a common mistake made by amateur and professional photographers alike if they're not careful.

**FIGURE 11-7** Do not allow photo-editing software to delete images automatically after they are transferred.

- After the file transfer process is complete, do not choose to delete the images on your memory card automatically until you've verified that the file transfer was successful and that all of your images are safely stored on your computer (or wherever they were supposed to be transferred to). Figure 11-7 shows the message from the Mac's iPhoto software after a photo transfer has been completed.

- Each time you start a new day of shooting (or a new photo shoot), start with an empty memory card by inserting it into your camera and reformatting it. Before using the format command, however, make sure you have a backup of all images already stored on that card. From your camera, you can opt to reformat a memory card at any time.

## How to... Back Up Images On-the-Go, but Without a Computer

Professional photographers often carry a pocket-sized, battery-powered remote image backup and viewing device, which is basically a computer hard drive with a built-in memory card reader and LCD display. This allows the photographer to quickly back up his or her memory cards virtually anywhere, anytime, without using a computer. It ensures a backup of important images that can't be reshot is always available, like images taken at a sporting event or wedding.

Although this optional piece of photo equipment isn't typically necessary for amateur photographers, serious hobbyists and professionals should consider investing in one. An example of a remote image backup device is the Epson P-3000 Photo Viewer ($399, www .epson.com). These devices are priced based on their storage capacity.

Other models are available for much less money. Some of them, such as the Digital Foci PST-251 Photo Safe II with 500GB storage capacity ($179.95, www.digitalfoci.com), however, don't have a built-in LCD screen for viewing stored images. This particular model can back up a 1GB memory card in about 3.5 minutes.

When packing for a vacation or getting ready for a photo shoot away from home, don't forget to pack your memory card reader and USB cable, along with your memory cards, extra camera batteries, and the digital camera itself. If you're traveling with a laptop computer, netbook, tablet computer, or iPad, or you'll be near a Wi-Fi hotspot, transfer and back up your newly shot images at least once per day. This way, if your camera gets lost or stolen, or if the memory card malfunctions, you won't lose all of your important photos.

# 12

# Digitally Fix, Edit, and Improve Your Images

## How to...

- Edit your images digitally after you've taken them
- Fix red eye and other problems
- Add special effects to your photos
- Change the file size of your digital photos
- Use popular photo-editing software

One of the biggest advantages to taking digital photos is that once they've been transferred to your computer—whether to a PC, Mac, or even a tablet device like the iPad—you can easily edit your images, fix imperfections, and dramatically alter the appearance of your photos using some really awesome special effects.

Utilizing specialized photo-editing software, you can compensate for many types of common mistakes made when shooting photographs, such as red eye, white balance problems, or imperfect lighting, plus quickly fix someone's complexion in a portrait, for example. Or, with a few clicks of the mouse, you can even change someone's eye color, remove unwanted objects from a photo, or change its entire background.

Some of the photo-editing software applications currently available, such as Photoshop Elements (for Mac and PC) and iPhoto (for Mac), are extremely intuitive and easy to use. They're designed for amateur photographers with the most basic of computer know-how, yet these programs offer extremely powerful tools for digitally fixing, editing, enhancing, and often organizing your images.

If your editing needs go beyond what the entry-level, consumer-oriented photo-editing applications are capable of, a wide range of more advanced applications are available, such as the full-version of Adobe's Photoshop CS5 (for PC and Mac) and Apple's Aperture 3 (for Mac), both of which provide an abundance of professional-level tools for editing and enhancing photos. These applications, however, are a bit more complicated to use (and the software is also rather expensive).

| Note | Because of their popularity, Photoshop Elements 9, Photoshop CS5, iPhoto '11, and Portrait Professional 9 were used for the photo-editing examples in this chapter, although the same results can be achieved using almost any photo-editing software. If you want to edit portraits |

of people, one of the easiest and least expensive, yet most powerful, photo-editing tools on the market is Portrait Professional 9 (or later) for both PC and Mac ($69.95, www.portraitprofessional.com). You'll learn more about this amazing software later in this chapter.

This chapter begins by explaining just some of what you can do in terms of editing your photos using virtually any of the photo-editing applications on the market and offers "before" and "after" examples of some common types of edits you can make to your own photos, such as cropping, color enhancement, fixing red eye, altering something within a photo, or improving an image's sharpness and clarity. How to manipulate an image's file size is also covered. Then toward the end of this chapter, you'll learn about some of the most popular photo-editing software currently available for PCs and Macs, so you can decide, based of your skill level, editing needs, and budget, which application is most suitable for you.

## You Don't Need to Be a Computer Wiz to Edit Photos Like a Pro

First, let's look at a small sampling of the many types of special effects you can easily add to your images. For example, you can quickly change one of your own full-color photos into a black and white or add a Sepia effect to give it an old-fashioned look and then add a themed digital border—all within a few seconds.

Figure 12-1 shows a photo taken at a modern-day rodeo held as part of the 114th annual Cheyenne Frontier Days in 2010. With a few clicks of the mouse in iPhoto '11 on the Mac, the photographer transformed this photo into an image that looks as if it could have been shot in the early 1900s (as shown in Figure 12-2). This dramatic special effect is just one that you can add to your own photos in a matter of seconds, using any of the popular photo-editing software packages.

When shooting outside, you can't control the weather. Using photo-editing software, you can, however, often alter the weather after the fact, using photo-editing software. Figure 12-3 was taken on a cloudy day at Borderland State Park in Massachusetts. As you can see, the sky is gray, which detracts from the photo's appearance. Using Photoshop CS5 on a PC, the photo was edited in about five minutes (as shown in Figure 12-4).

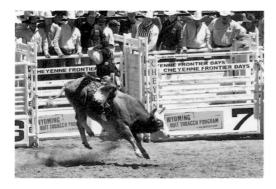

**FIGURE 12-1** A full-color photo taken at a modern-day rodeo using a digital camera

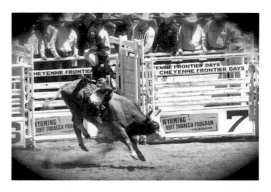

**FIGURE 12-2** The rodeo shot with the Sepia special effect added

The photographer literally cropped out and replaced the sky with a gorgeous blue sky overhead, making the revised version look like it was shot on a bright and sunny day.

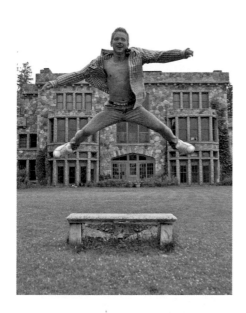

**FIGURE 12-3** With photo-editing software, you can change the weather after photos are shot.

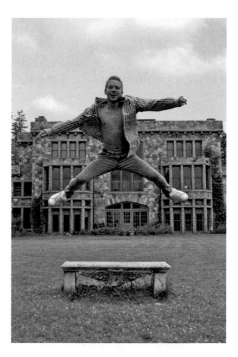

**FIGURE 12-4** By editing the background or, in this case, the sky, you can dramatically improve an image in just minutes.

Depending on what you plan to do with your digital photos, you may need to adjust their file size. After all, if you're shooting with a 8MP, 10MP, or 12MP digital camera, for example, each photo you take will be at least 3MB to 6MB (possible larger) in size, depending on the file format you use. If you want to create prints, poster-size enlargements, or photo gifts, you want to work with the largest file size possible for each image. However, if you plan to share your photos online, via e-mail, or post them on Facebook, Twitter, or on a blog, you want to shrink the file size of your images, so you can upload and later download or display them online faster.

**Note** Some online services that encourage photo sharing, such as Facebook, automatically adjust file sizes for you when you upload a photo.

As you begin editing your images, you may discover that to accomplish all of your editing and photo-organizing goals, several different software packages are necessary. Professional photographers commonly utilize several packages, sometimes when editing a single image. The average amateur photographer, however, can generally get by using just one well-rounded, entry-level photo-editing application such as Photoshop Elements 9 (or later). Each photo-editing software package offers dozens, or even hundreds, of editing tools, filters, and methods for improving, changing, or adding to your digital photos. Using your own creativity, you can mix and match any of these features as you edit your photos to create photographic art quickly and easily.

In addition to software-based photo-editing applications designed for both amateur and professional photographers, you'll also learn about several free photo-editing tools available exclusively on the Web. Some of these online-based tools are part of the popular online photo services discussed in Chapter 14.

You're about to discover there's an optional step between shooting and sharing your digital photos—a step that can dramatically alter the appearance and quality of your images. By editing and digitally enhancing your photos using specialized software, you can fix problems and/or give them a professional quality by subtly or dramatically altering their appearance after you've taken them.

**Did You Know?**

# Things Are Not Always How They Appear!

Every time you look at a magazine and wish you were as beautiful or handsome as that fashion model or celebrity featured on the cover, or you review travel brochures featuring gorgeous and exotic destinations as you're planning a vacation, keep in mind that the photos you see published in newspapers, magazines, on the Web, and in all forms of advertising, have almost always been heavily edited and enhanced by professional artists, graphic designers, and/or photographers, using advanced photo-editing software such as Adobe's Photoshop CS5 (or later).

Instead of spending 5 to 10 minutes editing a photo (which, as an amateur photographer, is how much time you'll typically be spending), professional Photoshop artists and graphic designers often spend hours, sometimes days at a time, editing a single image before it gets published. Advanced photo-editing software packages allow you to separately alter every single pixel in a digital image if you choose to. When you consider a 12MP digital photo contains approximately 12 million individual pixels, the editing process could require a lot of highly skilled and time-consuming work.

For amateur photographers, however, many photo-editing software packages offer editing tools designed to take seconds or just a few minutes to use, so you can create professional-quality results without investing hours in editing each of your images. An inexpensive, consumer-oriented package, like the latest version of Adobe's Photoshop Elements or Apple's iPhoto, gives you all of the editing functionality and tools you need in an intuitive program that's designed to be learned quickly.

If you are serious about photo editing, however, you can easily spend weeks or months learning how to use all of the advanced features built into the full version of Photoshop CS5 (or later), which is the photo-editing application used by most professionals. Just as taking pictures is an art form that requires some specialized skill and knowledge, editing digital photos is a separate skill and art form unto itself.

## The Basics: What's Possible When Editing Photos

When it comes to reviewing and editing your images, there are five main things to look for as you determine what editing, if any, needs to be done. Examine your photos and consider:

■ **Cropping**   Cropping allows you to focus in on a subject, delete unwanted background around the edges of your photos, or readjust the framing of an image, allowing you to better incorporate the Rule of Thirds after the fact.

- ■ **Clarity** Determine if the photo is in focus. Many photo-editing applications allow you to improve the sharpness or clarity of an image to get rid of minor blurriness or pixelation.

- ■ **Visual imperfections** Consider whether you need to digitally fix problems like red eye, improve your subject's skin complexion, or edit out (erase) some unwanted element in the photo.

- ■ **Color correction** For a variety of reasons, your camera may not have re-created the colors in your images exactly how they appear in real-life. This could be due to lighting issues, not adjusting the camera's setting correctly before shooting, or a result of a handful of other common problems. No worries. Using photo-editing software, you can tinker with a photo's contrast, exposure, color saturation, shadows, and a variety of other controls that alter how colors and lighting appear within your photos *after* you've taken them.

- ■ **Special effects** With hundreds of potential special effects that you can add to your photos with a few clicks of the mouse, determine which, if any, would improve your image, add visual impact, or make the photo more visually appealing to the people you'll be sharing it with.

Obviously, not all of your photos will require editing or modification. Plus, if you've taken 50, 100, or more photos during your last shoot, you might only opt to edit your top 5 to 10 picks prior to sharing them online or transforming them into prints. In many cases, if you utilize the Auto Enhance, Auto Smart Fix, and/or Auto Crop features built into the software you're using (such as Photoshop Elements or iPhoto), the software will automatically evaluate your images, one at a time, and make what it deems to be the appropriate fixes or edits. You also have the option of manually making adjustments and edits using any or all of the software's features, tools, and functions to alter your images in a way that's customized to your personal taste or artistic vision. And if you don't like the results, simply select the Undo option found on the Edit pull-down menu of most photo-editing applications. Or, if you want to start your editing from scratch, you can use the Revert To Original command, also available in most applications.

**Tip** After loading in your photo in Photoshop Elements 9, start with the Auto Smart Fix option on the Enhance menu. If the Auto Smart Fix command doesn't correct all of the color, lighting, and shadow issues within an image, you can also use the Auto Levels, Auto Contrast, Auto Color Correction, Auto Sharpen, and/or Auto Red Eye Fix commands, but doing this might not be necessary.

Next, we'll take a look at some of the features and functions built into virtually all of the popular photo-editing applications, so you can see what's possible when you invest less than five minutes in editing any of your photos. Remember, before you start the editing process, make a backup of each original image. If you make edits and accidently overwrite the original image when you save your changes, that original image will be lost forever if you don't have a backup.

**Tip** The more time you invest in learning how to use your photo-editing software, and then practice using it, the better you'll become at actually transforming your everyday snapshots into professional-quality images or photographic art. Like photography itself, photo editing is both a skill and an art form that takes a relatively short time to learn, but much more time to truly master.

## Cropping Your Photos

When you shoot digital photos with a high-resolution camera (10MP or better, for example), as you edit your photos, you can really zoom in on something minute within an image, and using your photo-editing software's Crop feature, edit the photo so the small object becomes the main subject of your photo. In essence, you have a telephoto zoom lens available to you after the fact. The higher the photo's resolution, the better this feature will work as you crop your images to zoom in on small objects. Lower resolution images will become pixilated if you try to zoom in too closely on tiny objects in a photo.

Figure 12-5 is a photo taken of a small airplane during a practice flight before the annual National Championship Air Races in Reno, Nevada. As you

**FIGURE 12-5** A photo taken without a zoom lens

Photo 74 of 919

**FIGURE 12-6** iPhoto's Crop command is used as an after-the-fact zoom lens.

can see, no zoom lens was used when initially taking the photo, so the airplane, which is surrounded by a lot of blue sky, almost gets lost in the photo. Once loaded into iPhoto on the Mac, however, using the Crop command (shown in Figure 12-6), you can reframe the image and really zoom in on the airplane. You can do this using any photo-editing software. Now take a look at Figure 12-7, which shows an edited version of the original photo; it showcases the airplane, plus takes the Rule of Thirds into account.

Aside from using the cropping feature as an after-the-fact zoom lens, you can also use it to make more subtle edits, crop excessive background around a photo's edges, or reframe an image. Figure 12-8 shows a sailboat shot during a sunset along the Potomac River in Maryland. With some minor

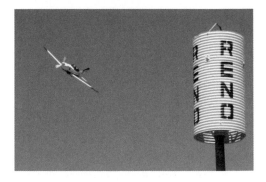

**FIGURE 12-7** The airplane and pylon are now the main focus of the image.

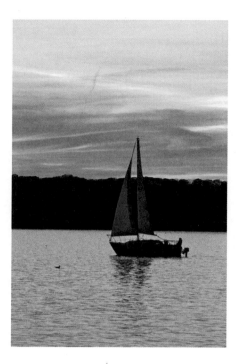

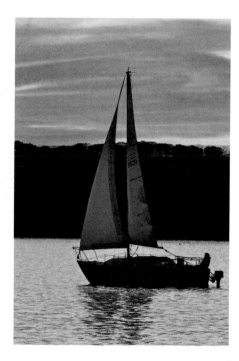

**FIGURE 12-8** This photo shows a lot of water and sky but doesn't really showcase the sailboat.

**FIGURE 12-9** After cropping the image, the focus is now on the sailboat.

cropping, the sailboat can be better positioned in the frame, making it the shot's primary focus, as shown in Figure 12-9.

Cropping also works very well with people featured in photos. As you're editing, you can zoom in on a subject's face or upper body, crop the photo, and transform a full-body shot into a headshot, for example. Figure 12-10 shows a "before" shot being edited and cropped using Photoshop Elements 9; Figure 12-11 shows that same image after applying the Crop feature.

When using the Crop feature, make sure to activate the Constrain (in iPhoto) or Aspect Ratio: Use Photo Ratio option (in Photoshop Elements 9). Selecting this option ensures that, as you crop an image, it retains the right proportions for printing later in a standard print size, such as 5"×7" or 8"×10". You can also adjust this setting to a specific print size, if you know you're editing a photo that you want printed as a 5"x7", for example.

**FIGURE 12-10** A photo being cropped using Photoshop Elements 9

**FIGURE 12-11** Using the Crop feature, you can focus in on a subject's face.

## Improving Clarity and Sharpness

Sometimes, you'll take what you think is an amazing photo (at least it looked great on your camera's small built-in display when you previewed it), but when you transfer your image to a computer and look at it blown up on a full-size monitor, you'll discover it is slightly out of focus. Don't immediately delete the photo! In some situations, you can clear up the blurriness using photo-editing software.

Photoshop Elements 9 has a command called Auto Sharpen (on the Enhance pull-down menu), which can be used to remove minor blurriness in a photo. This tool is found in almost all photo-editing applications. Photoshop Elements 9, like many others, also has a Noise Removal filter (found on the Filter pull-down menu), which can despeckle an image and remove its pixilated appearance, which occurs when an image is slightly out of focus or the lighting wasn't adjusted properly when the photo was taken. Both of these commands have a subtle impact on a photo's clarity. If the image is a total blur, these features won't do you any good. However, they can be used to sharpen a photo that's slightly blurry or out of focus.

When using iPhoto on the Mac, you'll find the features that improve a photo's clarity and sharpness by clicking the Edit icon and then the Adjust icon. The Adjust window will appear and display Sharpness and De-Noise sliders that you can adjust manually using the mouse.

As you become more acquainted with your photo-editing program, you'll discover there are additional features you can utilize manually to transform a slightly blurry image into one that's crystal clear.

## Erasing Unwanted Elements in a Photo

Occasionally, you'll shoot an image that contains something you simply don't want in that photo. It might be something small like a blemish on your main subject's face or some other distracting object. Using photo-editing software, you can often erase objects from a photo after the fact. Depending on which photo-editing software you're using, there are many different ways to do this, some of which require practice and skill; however, several of the necessary editing techniques are simple and take moments to achieve.

Figure 12-12 shows a green shirt with a small company logo on it. Using a photo-editing software package's Retouch brush (in this case, iPhoto), you can simply paint over the unwanted

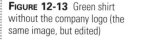

**FIGURE 12-12** Green shirt with company logo

**FIGURE 12-13** Green shirt without the company logo (the same image, but edited)

logo and make it disappear in a matter of seconds, as you can see in Figure 12-13.

In Figure 12-14, the dog's leash is somewhat distracting in the photo. Using the Spot Healing Brush and other editing tools built into Photoshop CS5, in a matter of minutes, you can literally erase the leash from the photo, as if it were never there (as you can see in Figure 12-15).

By utilizing the editing tools built into programs like Photoshop CS5 (or later), you can literally edit people, large objects, or entire backgrounds out of a photo. Or you can use your photo-editing wizardry to add people or objects to a photo. What you can do is really limited only by your imagination … and your ethics. Avoid altering a photo in such a way that you can get yourself—or someone else—into trouble.

In Figure 12-16, the photographer wanted to replace the entire gray background in a portrait, so he loaded the image into Photoshop CS5 and used the software's Magic Wand tool to separate the subject automatically from the background, so the gray background could be removed with a few clicks of the mouse (as shown in Figure 12-17).

With the original background of the image removed, dropping in a totally different background (in essence merging two photos together) to create a single image is an easy process, as you can see in Figure 12-18.

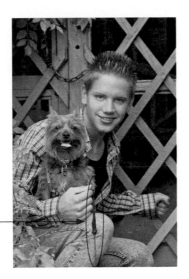

**FIGURE 12-14** In this photo, the dog's leash is a distraction.

**FIGURE 12-15** In this edited version of the photo, the dog's leash has been digitally removed.

**Note** While you can remove a background from almost any image using any photo-editing software, the steps and commands to accomplish this will vary based on which software you're using and how detailed your photo is. The examples featured in this chapter merely give you an idea of what's possible.

**FIGURE 12-16** Using programs like Photoshop, you can erase the background from an image.

**FIGURE 12-17** The gray background has been totally removed from the image now.

The ability to edit objects in an image and combine digital special effects also gives you a way to be tremendously creative, without having to spend too much time learning how to use complex photo-editing programs. Here's an example where a full-color photo was only partially transformed into a black-and-white image for purely artistic reasons. In Figure 12-19, the colorful hot air balloon was selected and singled out from the rest of the image and then placed on a separate layer using Photoshop CS5. The remaining parts of the image were then transformed into black and white. The layer containing the full-color balloon was placed over the newly created black-and-white image (placed on a separate layer) to create the eye-catching visual effect depicted in Figure 12-20.

## Color Enhancement or Correction

Even if you do absolutely everything right when shooting with your digital camera, you may discover that the photo-editing software you utilize can improve upon the vividness and clarity of the colors in your images even more. After loading your images into your editing software, take advantage of

**FIGURE 12-18**  A more colorful, digitally created background has been added to the original photo.

**FIGURE 12-19**  A full-color image can be transformed into black and white in seconds using photo-editing software.

**FIGURE 12-20**  You can combine digital special effects with editing techniques to mix black and white with full color.

**FIGURE 12-21** A photo prior to editing

the software's Auto Enhance (iPhoto) or Auto Color Correction (Photoshop Elements) feature to fine-tune colors automatically.

The impact these features have on your photos may be subtle (which is a good thing), but even the smallest of adjustments improves the professional look of your images. Figure 12-21 is a photo taken with a digital camera and imported into Photoshop Elements before any editing. Figure 12-22 shows the subtle change in the image's colors after applying the program's Auto Color Correction function (found on the Enhance pull-down menu).

**FIGURE 12-22** Notice the subtle changes in the photo after applying Auto Color Correction.

If you notice that the colors you see on your screen don't match up with the colors of your printed images, your computer's display may need to be calibrated. The Pantone Huey Pro ($99, www.pantone.com) is a device that quickly adjusts your computer's display, so what you see on screen is identical to the colors that your photo printer (or a professional photo lab) creates when printing your images.

Some photo-editing programs allow you to perform color correction automatically on photos or to use a manual color-editing tool to enhance the colors in a photo, making them more vivid. The intensity of these features is user-adjustable, based on your personal preference. After using the Auto Enhance feature this time in iPhoto '11, the Boost Color option (which you access by clicking the Effects icon when editing a photo) was set to 3 to obtain the result shown in Figure 12-23.

Using any photo-editing program, first use the "Auto" version of the Color Correction and/or Color Boost tools, for example. If you don't get the desired result from that, you can then manually adjust these

# Understanding Layers in Photoshop and Other Photo-Editing Programs

To become adept at photo editing using any of the Photoshop applications (as well as some others), you need to understand the concept of layers. When a photo is loaded into Photoshop Elements or Photoshop CS5 (or later), you can create layers. Each layer contains a different element of your editing, whether it's a new background, text, a special effect, or some other enhancement you're adding to a photo.

Think of each layer as a clear sheet of glass or plastic upon which only one edit or addition relating to your photo is placed. You then "stack" these layers over your photo. You can see through the blank areas of each layer, down to the bottom layer. Layers can be moved around, added, combined, or deleted as needed from the Photoshop Layers Panel, allowing you to experiment with different edits and effects without altering the entire image.

You can learn much more about layers and how they're used in the photo-editing process when using Photoshop by visiting the Support section of the Adobe website (www.adobe .com), and typing the phrase **What are layers?** into the search field.

and other color-related settings. Keep in mind, *color correction* fixes color-related problems in a photo, whereas color enhancement features give your photos more of an artistic flare.

## Altering Exposure, Contrast, and Saturation

An image can be improved upon or altered when you adjust its exposure, contrast, and/or saturation using photo-editing software. Each of these can be adjusted automatically, using the Auto Enhance command in iPhoto or the Auto Contrast, Auto Levels, or Auto Smart Fix commands in Photoshop Elements 9, for example.

When it comes to editing photos, *exposure* refers to lightening or darkening the entire image after it's been shot. Figure 12-24 shows a beach in Clearwater, Florida, at sunset without any editing. For demonstration purposes only, Figure 12-25 shows the same image, but with the exposure readjusted to make the overall image much lighter—to the point where it looks overexposed. This effect was created using

**FIGURE 12-23** iPhoto's Boost Color option makes colors in an image much more vivid.

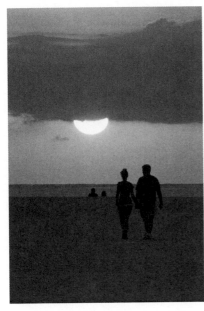

FIGURE **12-24** The original image with no edits

FIGURE **12-25** Using the Exposure feature in iPhoto, this picture is now much lighter.

iPhoto '11. Depending on how much you adjust the exposure, the impact on the image can be very subtle or pretty dramatic.

*Contrast* refers to the difference between the lightness and darkness of a photo. As you increase the contrast, the light aspects of the photo get lighter, whereas the dark aspects of a photo get darker.

A photo's *saturation* level determines the richness of the colors. Set to one extreme, your images will appear to be in black and white. Set to the opposite extreme, the colors will be overly intensified and extra vivid when you tinker with the color saturation. Depending on the photo-editing software you use, not only will you be able to adjust color saturation levels, you'll also be able to adjust *color temperature* (the coolness or warmth of the displayed colors), as well as a handful of other color-related options. However, when you utilize the Auto Enhance or Auto Smart Fix features, these color options are all automatically adjusted for you.

Using these features, you can fix a photo that's been underexposed (meaning it's too dark) or overexposed (meaning it's too light). You can also add or reduce shadows to improve an image's clarity. Often, an unedited photo that appears underexposed (too dark) can be brightened up and made to look perfect (from a lighting standpoint), whereas an overexposed image can be darkened. You can also lighten or darken certain areas of a photo.

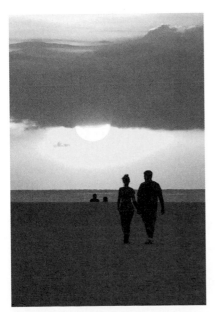

# Fixing Red Eye

When using a flash, one of the most annoying problems you'll encounter is red eye (shown in Figure 12-26). The good news is, even if you don't adjust the lighting or flash controls to eliminate this common problem when taking your photos, you can remove red eye quickly and easily after the fact using photo-editing software.

All of the popular photo-editing packages have an automatic red-eye

FIGURE **12-26** Red eye is a common occurrence when using a flash.

adjustment, as well as manual adjustments. To speed up your editing process, always try the automatic red-eye adjustment feature first and allow the software to compensate for the red eye and correct it in your photos.

Using Photoshop Elements 9, for example, after loading a photo, simply select Auto Red Eye Fix from the Enhance pull-down menu. If you're using iPhoto on a Mac (shown in Figure 12-27),

click the Edit icon followed by the Red-Eye icon. You can then click the Auto icon, allowing the iPhoto software to fix the red-eye problem or you can use the mouse to manually fix the problem.

**Figure 12-27** No matter what photo-editing program you use, fixing red eye is quick and easy.

**Tip** Learning how to shoot with a flash and avoid red eye is the best strategy for taking professional-quality photos that don't require a lot of editing. You can also utilize the Red Eye Reduction shooting mode built into many point-and-shoot digital cameras. However, if necessary, by using photo-editing software after the fact, this problem is easy to fix.

# Adding Digital Special Effects to Your Photos

Depending on the photo-editing software you use, you'll have dozens, perhaps hundreds, of preprogrammed special effects you can add to your images with the click of a mouse. For example, for dramatic or artistic purposes, you can transform a full-color image into a black-and-white image, as shown in Figure 12-28, or use a Sepia effect combined with a Blurred Edges effect to give your photos a true antique look (as shown in Figure 12-29).

Programs like Photoshop Elements 9 also have dozens of Filter effects that you can use to add a whimsical element to your photos. For example, you can use one or more of

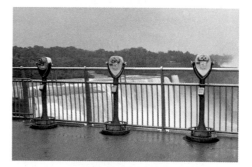

**Figure 12-28** Niagara Falls transformed into a black-and-white image

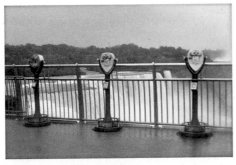

FIGURE **12-29**  When the Sepia effect is combined with a Blurred Edges effect, your images will take on an old-fashioned look.

FIGURE **12-31**  Another of Photoshop Elements 9's Distort effects

the Distort filters to create effects like the ones shown in Figure 12-30 and Figure 12-31. Again, you can use almost any photo-editing program and then incorporate the resulting photos into a traditional scrapbook or share them online in any number of ways (on a blog or sent via Twitter, for example). You can also mix and match the special effects offered in each program to give your photos a unique look.

FIGURE **12-30**  One of Photoshop Elements 9's many Distort effects

## Adding Digital Borders and Frames to Your Images

Other types of effects you can add to your photos (or digitally overlay over your existing images) are borders and frames. These effects are useful if you're creating a digital scrapbook, for example, or if you want to showcase your images in a nontraditional format online to give them pizzazz.

You can reshape your images into a heart or another design, as shown in Figure 12-32, or you can add pre-created frames or borders that are built into the application or that you download from the Web. You can read about add-ons for popular photo-editing applications that provide you with hundreds of different borders and frames in Chapter 13.

Figure 12-33 is an example of one type of border that adds an artistic jagged edge to the image, which is good for showcasing photos on a website or in a blog in order to make the image stand out. This particular example

FIGURE **12-32**  You can crop your image into a specific shape, such as a heart, which is great for scrapbooks.

**FIGURE 12-33** Using photo-editing software, you can easily add creative edges or borders to your images.

was created using Photoshop Elements in conjunction with an optional Artistic Expressions border available from Graphicauthority.com.

Instead of adding a traditional matte when printing and framing your images, you can add a digital matte that's built into your photo-editing application. You can add different colored and/or shaped borders and frames to add a holiday or special theme to your photos or simply as a way to showcase your creativity before sharing your photos with friends and family. Figure 12-34 shows a photo with a digital frame and matte added.

Most photo-editing programs allow you to create photo collages using templates that you simply drag and drop your photos into. Depending on the template you choose, you can create collages or combine two or more images into a single image, like the one shown in Figure 12-35.

How you utilize borders and frames (and whether you incorporate them at all when editing your photos) is a matter of personal taste. The ways in which you can use these editing tools are limited only by your own creativity.

**FIGURE 12-34** A photo with a digital frame and matte added. It's now ready to print and frame.

**FIGURE 12-35** You can create multi-image collages surrounded by digital frames, which are ready for printing and framing.

## Altering the File Size of Your Images

When you shoot a single image with your digital camera, that image is stored on your camera's memory card as a unique file with its own filename. That file will take up space on the

memory card, based upon the resolution it was shot in. The higher the resolution, the larger the file size. Thus, if you're shooting digital images with a camera that has a resolution of 12 megapixels, each image contains about 12 million individual pixels, which translates to a file size of at least 2.5 megabytes (MB) per image (when saved in .jpg format).

**Note** *Image size* refers to the dimensions of the image, either in inches or pixels (such as 5"x7" or 8"x10"). *File size* refers to how much storage space the image file requires, which is measured in megabytes (MB). *Image quality* or *resolution* refers to how many pixels per inch are used to create the image. A low-quality image uses fewer pixels per inch and won't be as detailed as a high-quality image. For online purposes, a resolution of 72 pixels per inch works fine. However, for making prints, 300 or 600 pixels per inch is much more suitable.

Using photo-editing software, you can manually adjust an image's size, resolution, and/or quality to alter its file size. A 2.5MB image shot using your digital camera can be transferred to your computer to be edited, printed, archived, and/or shared. The better the resolution of your photos, the more flexibility you'll have when it comes to editing your images, as well as printing enlargements. Depending on which editing software you use, and what effects you add to your images, as well as what image size and format you save your images in, the file size of an edited image may increase rather dramatically. Once edited, a single high-resolution image can easily be 20MB or larger.

If after the editing process you opt to share your photos online, using an online social networking service like Facebook, MySpace, or Twitter, an online photo service like Flickr.com, or if you want to send your images via e-mail directly to the intended recipients, having images with extremely large file sizes means they will take a long time to upload (and later download by those viewing the images).

After editing your images, you may find it helpful to shrink their file sizes manually to improve uploading and downloading times for sharing the images online. Once you decrease an image's file size, its resolution diminishes, which won't be noticeable when you're viewing the image online, in an e-mail, on Facebook, or as part of a blog or website. If you try to make large-size prints of an image with a reduced file size or resolution, however, you will probably notice the photo is fuzzy or pixilated. A handy guideline is this: When sharing photos online, smaller file sizes are useful. When editing, printing, and archiving photos, larger file sizes are necessary.

When you upload your digital images to certain online photo services and social networking sites, including Facebook, the file sizes of your images are automatically reduced dramatically. If this is the case, don't rely on those photos for archival purposes. If you're planning to keep an online backup of your images, choose a site that will maintain your original file sizes and resolutions.

If it becomes necessary to decrease the file size of an image manually, you can do this easily using any photo-editing software application. In Photoshop Elements 9, for example, from the Image pull-down menu, choose the Resize option followed by the Image Size command. When the Image Size dialog box appears, you'll be able to reset the image's size and resolution manually, plus see how the file size is impacted before you save the image.

**Caution**  When resizing a photo, make sure the Constrain Proportions command is activated to ensure the proportions in the image itself don't become distorted.

If you're using Photoshop CS5, the easiest way to shrink a file's size is to load the image, select the Image Size command from the Image pull-down menu, and then manually enter the dimensions of the image that you'd like in pixels, centimeters, or inches. You'll see how your alterations impact the file size in real-time—before you save the resized image.

From a Mac, you can easily decrease a photo's file size using Mac OS's Preview program (or any photo-editing application). Load your image into the Preview application. Next, from the Tools pull-down menu, select the Adjust Size command. Again, the lower the resolution, the smaller your file size will be. From iPhoto, you can also select a file size when you Export an image and choose among small, medium, large, full size, or custom.

When using software that allows you to organize and manage your photos, some of these applications allow you to alter the file sizes of multiple photos simultaneously, which is a huge timesaver. You can also download third-party applications designed just for altering the file sizes of multiple images at once.

In addition to altering an image's size, you can alter the image quality using most photo-editing applications. This, too, reduces file size. Depending on what you'll be using the final image file for, you may or may not want to reduce its quality, as opposed to the image size, in order to reduce its file size.

You'll discover the process for changing the file size of your images varies based on whether you're using a PC or Mac and what photo-editing software you're using. Be sure, however, to familiarize yourself with the process of altering image file sizes, especially if you plan to share them online (via e-mail, social networking sites, online photo sites, or as part of a website or blog).

 Always back up an image file before changing its file size. Once you shrink the file size of a photo, it loses resolution and you won't be able to increase it easily again, unless you go back to the original file.

# How to...   Learn to Use Photo-Editing Software

While some photo-editing software requires a very short learning curve, some of the more advanced applications require a significant investment of time to learn how to use the hundreds of features, tools, and functions built into them. To make the learning process quicker, there are dozens of "how to" books that cover specific applications like Photoshop CS5 (or later), Photoshop Elements, iPhoto, Aperture, and others. We think that one of the best is *Perfect Digital Photography, Second Edition* (McGraw-Hill/Professional, 2009).

You can also watch online and DVD-based classes that offer professional instruction for editing photos using applications like Photoshop CS5 (or later), plus you can register for in-person classes taught at photo specialty stores, through adult education programs, and by photography schools.

Simply by going online, however, you'll find literally thousands of free tutorial videos, produced by professional and amateurs alike, that teach you how to edit photos using popular applications. You can find these websites and videos by performing a search on Google or Yahoo!, using the search phrase **Photo Editing Tutorial** or **Photoshop Elements Tutorial**, for example, or by searching for free instructional videos on YouTube.com.

If you're interested in learning more advanced photo-editing techniques, the following are a few online resources worth visiting:

**Apple.com**   For its iPhoto and Aperture applications, Apple has dedicated sections of its website to offering free tutorials on photo editing using its popular applications on the Mac. Visit www.apple.com/ilife/iphoto/ for iPhoto tutorials, or www.apple.com/aperture/ for tutorials related to its more advanced Aperture application. A 30-day free trial version of the latest version of Aperture is also available from this site.

*(Continued)*

**BioRust.com**    From this free website (www.biorust.com), you can access hundreds of free tutorials, plus view a vast gallery of digitally edited photos, and learn how each was edited to create the visual effects showcased. The site also offers a Downloads section, from which you can obtain free text fonts, graphic backgrounds, borders, digital frames, and other graphic elements that you can incorporate into your photos when using photo-editing software.

**Kelby Training**    This site (www.kelbytraining.com) offers online-based video classes covering a number of photography and photo-editing subjects that are taught by world-renowned professionals. You can subscribe to watch these instructional videos on an unlimited basis for $24.95 per month or $199 per year. Here, you'll find a handful of different classes covering Adobe Photoshop CS5, for example.

**Photoshop.com**    Adobe, the creators of the Photoshop family of photo-editing applications for amateurs and professionals, offers this free website (www.photoshop.com) that contains video tutorials, how-to articles, technical support forums, downloads, and other free resources for Photoshop and Photoshop Elements users.

**PictureCorrect.com**    This website (www.picturecorrect.com) offers free tutorials covering hundreds of topics related to digital photo editing using many of the different photo-editing applications available to consumers.

**Tutorial Outpost**    This is one of many free websites (http://tutorialoutpost.com/tutorials/photoshop/photo-editing) offering free tutorials, how-to articles, and instructional videos that cover all aspects of photo editing, including how to use specific applications such as Photoshop CS5 and Photoshop Elements 9.

**Vandelay Design**    From this free website (http://vandelaydesign.com/blog/design/photo-editing-tutorials/), you can learn how to create more advanced special effects and utilize many of the photo-editing features, tools, and functions built into Photoshop CS5 and other popular photo-editing applications. The text and image-based *Photoshop: All the Basics for Beginners* section of this website is ideal for first-time users of Photoshop (http://vandelaydesign.com/blog/design/learn-photoshop-basics).

# Discover Photoshop Elements 9 for PC and Mac

Now that you've seen just a small sampling of what photo-editing software is capable of in five minutes or less, let's take a closer look at some of the popular programs on the market, starting with Adobe Photoshop Elements 9, a consumer-oriented application designed to be easy to use,

intuitive, and that requires a minimal time investment to learn. This application can handle all of the basic editing functions a typical amateur photographer needs in order to improve the quality of their images. It's also a highly useful tool for organizing, sharing, and archiving your photos.

Without a doubt, the most popular consumer-oriented photo-editing program on the market is Photoshop Elements 9. It's a scaled-down version of the company's professional-level Photoshop CS5 application. Adobe offers upgrades to its Photoshop family of applications every year or two, so by the time you get around to choosing your photo-editing software, don't be surprised if Photoshop Elements 10 and/or Photoshop CS6 are the latest version releases of these applications.

For Mac users, in addition to Adobe's Photoshop Elements 9, Apple itself offers iPhoto, which is part of its low-cost, yet powerful iLife suite of applications. iPhoto '11 is ideal for basic photo editing, but it's also a powerful tool for organizing and sharing your photos. Meanwhile, Apple's Aperture 3 software works in conjunction with iPhoto '11 and other iLife '11 applications, but as a stand-alone program, it offers professional-level photo editing and organizational tools designed for serious hobbyists and professional photographers alike.

Whether you're a Windows or Mac user, if you make the transition from being an amateur photographer to a serious hobbyist or even a professional, you'll probably want to upgrade to more advanced photo-editing software that offers greater capabilities. Or if your photo-editing needs are rather specialized, you'll probably need more powerful photo-editing software. Overviews of some of your choices are offered toward the end of this chapter.

 When you purchase new photo-editing software, after obtaining a general introduction to using the software, focus on mastering only the core features and functions you'll use most often, based on the types of photos you typically take and your own unique needs. Auto color correction, cropping, and fixing red eye are a few of the common tasks you'll want to learn how to do right away. There's no need to spend days or weeks right at the start learning about features and functions you'll seldom, if ever, use.

For PC or Mac users looking for an easy-to-use and intuitive photo-editing application, you can't go wrong with the latest version of Photoshop Elements ($99.99, but discounted with a mail-in rebate) from Adobe. The company also offers a more feature-packed edition, called Photoshop Elements 9 Plus ($139.99). One of the added features of the Plus edition is an

emphasis on automatic online backup of your images (with up to 20GB of online storage space included with the software).

**Note** For more information about Photoshop Elements 9 for PC or Mac, visit www.adobe.com/products/photoshopel.

Various incarnations of Photoshop have been around for more than 20 years, and the latest version of Photoshop Elements is chock full of editing and photo-organizing features, tools, and functions that until recently were only available in the most advanced and complicated photo-editing applications. Once you become acquainted with the onscreen tools and menus offered in Photoshop Elements, you'll have no trouble getting top-quality results from this application.

One of the best things about Photoshop Elements is that it offers several editing modes. You can use the advanced editing tools manually, or you can take advantage of the Guided Editing options, which offer step-by-step directions for performing dozens of common editing tasks, from cropping and sharpening photos, to handling color correction and adding specialized effects like borders.

Photoshop Elements' Edit Quick mode offers just a handful of the most common editing tools, allowing you to edit your photos, fix common problems, and enhance a photo's appearance quickly, without having to navigate through lots of confusing menu options. This feature is ideal for beginners first learning how to edit photos.

Along with offering dozens of tools for editing photos, Photoshop Elements has templates for quickly creating professional-quality photo books, greeting cards, photo prints, photo collages, web-based photo galleries, and animated slideshows using your own photos. Because these features are template-based, you don't need to add a lot of your own creativity (or need to know anything about graphic design) to generate professional-looking results with minimal effort. The software walks you step-by-step through the editing and creation process.

You can also share your images via e-mail, burn them to CD-ROM or DVD, or create an online-based photo gallery with absolutely no programming required, all directly from Photoshop Elements. Another great feature of Photoshop Elements is that you can add functionality and features to this already powerful application using third-party software, such as Photo Essentials 3 from OnOne Software (www.ononesoftware.com/elements8).

You can find more information about add-on software for many of the photo-editing applications in Chapter 13.

 You can download free and low-cost add-ons for Photoshop Elements 9 or Photoshop CS5 from the Adobe Marketplace and Exchange area of the company's website. Go to www.adobe.com/cfusion/exchange, and then click Photoshop. For example, here you'll find a free template for creating a wall calendar from your own photos.

For Mac users, iPhoto offers much of the same photo-editing, organizing, and sharing features as Photoshop Elements, but it also works seamlessly with other popular Mac applications, especially those in the iLife and iWork suites. Thus, iPhoto is often a preferred choice among Mac users, as opposed to Photoshop Elements 9. Ultimately, which software you choose should be based on the functionality and features offered in an application that you want and need as you edit, organize, and share your own photos.

## Edit Photos for Free Online Using Photoshop.com

To see a sampling of what's possible using Photoshop Elements 9 or Photoshop CS5 (or later), visit www .Photoshop.com, an online community for Photoshop users located around the world. Here, you'll find online galleries featuring work from other photographers and artists, along with free tutorials and other resources for Photoshop users.

From Photoshop.com, you can also access free online-based photo-editing tools that let you upload, edit, and share photos entirely online, without using any software on your computer. These online tools allow you to perform a wide range of common photo editing and fixing tasks and can be accessed using any web surfing device. Using Photoshop.com's online-based editing tools is a fun and free way to learn the basics of photo editing, without having to purchase and install any software on your computer. It's an ideal photo editing and sharing tool for beginners.

Along with handling basic editing functions, Photoshop.com offers one-click white balance adjustment, easy image cropping, red-eye correction,

FIGURE 12-36  Photoshop.com's one-click Sketch special effect

color correction or color boosting, and the ability to add special effects to an image. Figure 12-36 shows the one-click Sketch special effect being used to make the photo look like a drawing.

The Decorate feature built into Photoshop.com lets you add cartoon bubbles, clip art, text, and other elements to your photos to give them a whimsical appearance, as shown in Figure 12-37.

FIGURE 12-37  You can decorate your images using Photoshop.com.

After editing an image, you can use the online image-resizing tool to resize the image quickly for display on a cell phone or website or to send it via e-mail easily, for example. You can upload photos from your cell phone or smartphone, or any other wireless device, edit them using tools from Photoshop.com, and then share your edited images on Facebook, Flickr, Photobucket, and/or Picasa. (Photoshop.com is designed to work seamlessly with these services.) You can then send your edited images back to a mobile wireless device, such as a cell phone, or to any e-mail address, for example.

## Other Consumer-Oriented Photo-Editing Applications

For consumers, Photoshop Elements 9 is definitely the market leader in this software category, but you do have other options for basic photo editing, whether you choose free (shareware) software, which you can download from the Web, online-based photo-editing applications, or other commercially available software packages priced under $100 (several of which are showcased in this section).

### How to... Choose the Best Photo-Editing Software

When you start evaluating the features, tools, and functions built into the popular photo-editing, organizing, and sharing applications, you'll notice one thing—a lot of overlap in terms of what the individual applications are capable of. Even though the general selection of features, tools, and functions is virtually identical, each application does offer at least a handful of unique features or tools. Plus, each application's user interface, learning curve, and ease of use differ.

Some applications also have a main focus or strength. For example, the biggest strength of Photoshop Elements 9 is its editing capabilities (although the software does handle photo sharing and archiving as well), whereas Google's Picasa is a wonderful tool for organizing and sharing photos online, but its editing tools aren't as powerful or robust as what you'll find in other applications.

*(Continued)*

Especially if you're a newbie when it comes to photo editing, choose an application that is well rounded, and that offers an intuitive user interface with a built-in (interactive) help feature. Ideally, you want an application that has a lot of Auto functions and features for photo editing, so you can make adjustments and corrections to your photos with a single click of the mouse, and not have to manipulate each setting manually.

Also, choose an application that offers all of the editing, organizing, sharing, and archiving tools you know you'll utilize based on your own preferences and needs. Otherwise, you may wind up having to use two or three separate programs in order to manage all of the tasks that one better-designed photo application can easily handle.

As you shop around for photo-editing software, take advantage of the free trial versions available for download. These allow you to test out the features and functions firsthand, before purchasing the software.

Let's take a brief look at some of the other popular photo-editing applications on the market that are suitable for amateur photographers.

## Corel PaintShop Photo Express and PaintShop Photo Pro X3 (PC)

These two photo-editing applications from Corel (www.corel .com) are designed to help Windows 7 users organize, edit, create, and share their photos with ease. PaintShop Photo Express ($39.99) is ideal for noncomputer savvy, amateur photographers who want to edit their photos and correct common problems like red eye quickly and easily. Users also have a bunch of easy-to-use templates at their disposal for creating customized greeting cards, photo books, collages, slideshows, and other creations with their photos.

The Express version of the software makes organizing hundreds or even thousands of individual images a straightforward process using folders and albums; plus the software has tools for quickly sharing photos online, making prints, saving photos to DVD, or uploading them to Facebook or Flickr.

When you plug a digital camera, memory card reader (containing a memory card with your photos), or even a cell phone with a built-in camera into your computer's USB port, either version of PaintShop Photo will detect the presence of

new photos and automatically transfer them to your PC and
import them into the software's built-in Media Organizer.

From PaintShop Photo's Media Organizer, you can view and organize photos, view thumbnail previews of your images, as well as catalog, tag, rate, and search through your images with ease. These useful features are found in most photo-editing and organizing applications.

For slightly more advanced photographers, Corel's PaintShop
Photo Pro X3 (or later), which is priced at $59.99, offers
enhanced photo-editing, organizing, and sharing tools; plus
it also allows you to work with HD video files (not just still
images) created with your digital camera.

## Google's Picasa (Online Based, PC, and Mac)

Created by Google, Picasa for PC and Mac combines
downloadable software with a robust online photo service, so
you can easily edit, organize, and share your digital photos. This
software and online combo offers the same functionality that
you'd get from any of the other popular software packages, but
the great thing about Google Picasa is that it's totally free. Visit
http://picasaweb.google.com to download the Picasa software
and begin using the online-based photo service.

That's right—using the free downloadable software, you can
edit your photos and then upload them to the Web and create
impressive slideshows, photo collages, and online galleries (also
referred to as *Web Albums*), with absolutely no programming
required. The photo organization tools offered by Picasa allow
you to tag your photos, organize them, and then quickly search
for specific images without having to sift through hundreds or
thousands of thumbnails.

When you set up a free Google account to use Picasa,
you're given one gigabyte of free online storage space to store
and archive your images. That's enough space for several
thousand photos. For a small annual fee, you can purchase
additional online storage space, if needed.

Some of the newer digital cameras automatically record location data noting where each image was shot. This is called *geo-tagging*. If this geographic data exists, Picasa will allow you to use Google Maps and geo-tags to showcase and graphically track exactly where you've been and where your photos were taken.

Through a variety of partnerships with photo labs and other services, professional prints and a wide range of photo gifts can be created and ordered directly through Picasa. The goal of this service is to offer basic, yet highly functional, photo-editing tools, plus an easy and inexpensive way to organize, share, and archive your photos both on your computer and on the Web. The editing features aren't as robust as what you'd find in Photoshop Elements 9, for example, but with Picasa, you can easily fix common problems, perform quick edits, and add a few special effects before sharing your images. A PC and Mac version of the software is available, and new features and functions are constantly being added.

**Note**  If you're a blogger who uses Google's Blogger.com service, or you utilize any of Google's other online-based applications or services, you'll discover that Picasa works seamlessly with almost all of them.

Whenever you create an online gallery or online-based slideshow using Picasa, each project or gallery is given its own unique URL, which you can opt to make public or private. You always have absolute control over who can view your photos online, plus you can archive them securely.

Anytime you're working with an online-based photo service, whether for editing, viewing, achieving, or sharing your photos, having a high-speed Internet connection (Broadband or DSL, for example) is definitely beneficial. If you only have a slow, dial-up Internet connection, using the online components of Picasa, or any other photo service, will be time consuming, since upload and download times, especially when large-size image files are involved, will be slow.

## iPhoto '11 (Mac)

Created by the folks at Apple specifically for Macs, iPhoto '11 is designed to work seamlessly with other popular Mac programs in the iLife and iWork suites of applications. iPhoto offers the ultimate in easy-to-use photo-editing, organizing, sharing, and archiving capabilities. The majority of functions and features built into iPhoto are icon-based, and many work automatically.

For example, when a digital camera or memory card reader containing a memory card is connected to your computer via a USB connection, iPhoto will automatically import your new

images and place them in their own folder (referred to as an *Event*). The software will divide up Events by the date photos are shot, but allow you to rename, merge, or organize your Event folders in a variety of ways.

One specific iPhoto feature is face recognition, which is used to organize your images based on who appears in them. Using geo-tagging, iPhoto will also organize photos based on the location where each photo was shot. Thus, you can organize photos easily based on who's in them, where they were shot, and when they were shot, as well as by keyword or file/folder name.

Once placed in an Event folder, your images can be edited or easily shared with others. The software works seamlessly with Apple's online-based MobileMe service and allows you to create and publish fully customized online galleries and slideshows with a few clicks of the mouse. You can also back up your photos online.

Editing photos is very easy with iPhoto. All of the most commonly used tools for fixing problems with photos appear as icons when you click the main Edit icon. Individual icons allow for one-click image rotation, easy cropping, straightening, color correction, red-eye elimination, and basic photo retouching. A single click on the Effects icon gives you access to nine popular special effects you can add to your images. For example, you can boost colors, fade colors, transform an image into black and white, use a Sepia effect, or blur a photo's edges, all from the Effects window.

By clicking the Adjust icon, which appears after clicking the main Edit icon, you can manually adjust ten different elements, again with just a few maneuvers of the mouse on onscreen sliders. You can manually adjust an image's exposure, contrast, saturation, definition, highlights, shadows, sharpness, temperature, and tint individually, or you can simply click once on the software's Enhance icon, which automatically adjusts everything for you in the photo.

When you choose to crop an image, iPhoto will automatically suggest how the image could best be cropped, or you can easily override the automated settings to crop an image anyway you'd like. With the red-eye correction feature, you can click on the Auto button to have iPhoto automatically fix this common problem, or you can use the software's built-in tools to fix red eye manually.

Once you've edited your photos, iPhoto allows you to create prints with any photo printer, or order prints online

directly from a professional photo lab that Apple has partnered with. You can also use templates to create themed slideshows, greeting cards, photo books, or a calendar using your own images, or opt to share photos in groups or individually, as iPhoto is seamlessly integrated with your e-mail account, Facebook, or Flickr.

You can even burn photos onto DVD or publish your slideshows or albums online via the MobileMe service, again with just a few clicks of the mouse. All of the features, tools, and functions built into iPhoto are designed with amateur photographers in mind. Little to no learning curve is necessary to get the most out of iPhoto, especially if you're already comfortable using other applications on your Mac. iPhoto also automatically works with Apple iTunes, so you can sync and edit photos taken with your iPhone or easily transfer photos to and from your iPad, iPod, iTouch, or another compatible device.

For most Mac users, iPhoto is the only software needed to edit, organize, share, and archive photos. iPhoto is part of iLife, which as a suite of applications is priced at just $79. The latest version of iLife can be purchased wherever Apple software is sold, including from Apple's website at www.apple.com/ilife, which offers video tutorials and plenty of additional information about how to use iPhoto. iPhoto '11 (or later) can be purchased online from the new Mac App Store, either as a stand-alone application or as part of the iLife suite.

**Note** Every two years or so, Apple introduces a new version of iLife (including iPhoto). At the time this book was written, iPhoto '11 was the most current edition.

## Photo Editor X (PC and Mac)

Designed for Windows 7 and Mac OS X users, Photo Editor X ($30, www.photoeditorx.com) is a powerful collection of professional-level photo-editing tools built into a single, consumer-oriented software package that's pretty straightforward and easy to use. The goal of Photo Editor X is to take the power and functionality of a complex and advanced, professional-level photo-editing program, such as Photoshop CS5, and offer similar functionality in an easier-to-use, less costly application designed for amateur photographers and hobbyists. The software offers many editing features comparable to what's offered in Photoshop CS5, but at a fraction of the price. Plus, Photo Editor X comes

with a 200-page illustrated "how-to" manual covering many aspects of beginner to advanced photo editing. DVDs or online streaming videos containing more than three hours' worth of tutorials are also provided.

One strength of Photo Editor X is its ability to edit portraits, giving users the ability to truly fine-tune, manipulate, and enhance a person's appearance in photos. Resizing images, cropping, color correction, and converting images among file formats (it supports .raw, .jpg, .tiff, .gif and .bmp formats, among others) are also functions built into the software.

Using Photo Editor X's editing tools, you can fix, change, or manipulate colors and lighting in photos, alter or replace backgrounds, as well as add digital frames and borders. Like Photoshop Elements 9 and Photoshop CS5, Photo Editor X uses layers so you have greater flexibility when editing.

 Photo Editor X is mainly a powerful photo-editing application. It is not designed to handle the photo organizing, sharing, and archiving tasks offered by other applications. While this software is more complex to use than some other applications, it's also packed with more editing features and functions, which gives it greater versatility. If you invest the time needed to read the owner's manual and watch the video tutorials, you'll be editing photos like a pro in no time.

## Photoscape (PC)

If you're looking for very basic photo-editing software at a very affordable price—absolutely free—consider downloading Photoscape for all recent versions of Windows (www.photoscape .org). This software offers editing tools for quickly fixing common problems in digital photos. You can resize photos, adjust brightness, and make color corrections, fix white balance, add frames and graphic elements to your photos (including clip art), fix red eye, and crop photos with a few clicks of the mouse. You can also merge multiple photos together to create a simulated panoramic photo or a photo collage using templates, slice a photo into multiple pieces, convert the file format of a digital image, and create prints in various sizes.

Don't expect a flashy user interface with Photoscape. The software is, however, designed for ease of use, and to provide commonly needed photo-editing tools and functions that are useful to amateur photographers. At the time this book was written, Photoscape 3.5 was available.

## Picture Window Pro (PC)

Like Photoshop CS5 or Photo Editor X, Picture Window Pro ($89.95) for Windows 7 is designed to provide a comprehensive photo-editing toolkit for amateur and semiprofessional photographers alike. The software includes more than 50 photo manipulation and retouching tools, allowing users to take full control over every element of their photos when editing. You can incorporate a wide selection of special effects and digital filters into your images.

Using your photos, Picture Window Pro can be used to create professional-looking prints and slideshows in a variety of popular formats; plus it can be used to lay out and design complete photo pages and collages for albums or photo books.

Picture Window Pro offers some tools for organizing photos; however, its main focus is to offer advanced photo-editing capabilities for amateur and hobbyist photographers. Digital Light & Color, the developers of Picture Window Pro, offers a free, downloadable, 30-day trial version of the software, and you can download the user's manual for the software for free. Visit www.dl-c.com to learn more about this software.

**Tip** Picture Window Pro is a powerful photo-editing tool designed for people who need more editing control than what the more basic, consumer-oriented applications offer, but who don't want to invest the time and money in buying and learning a complex, professional-level application.

## Portrait Professional 9 (PC/Mac)

Portrait Professional 9 (or later) for PC and Mac ($49.95, www.portraitprofessional.com) is an extremely easy-to-use, inexpensive, and very specialized photo-editing application. As the name suggests, it's designed exclusively for editing portraits (photos of people). Instead of investing anywhere from 15 minutes to several hours per image editing a portrait to get professional-looking results in Photoshop CS5 (or even Photoshop Elements), you can create amazing results in less than 3 minutes per image using Portrait Professional. The edited photos will be equivalent to anything you could potentially accomplish after spending weeks or months learning how to master Photoshop CS5.

There's absolutely no user's manual to read or any lengthy learning curve needed to use Portrait Professional. The software is extremely intuitive and easy to use, starting as soon as you install it onto your computer and load your first image for editing. Each step of the editing process is explained graphically, on the left side of the screen, as you're editing your own images. Plus, as you make any changes or edits, you can simultaneously view a "Before" and "After" of the image on your screen. Anything you don't like, you can simply undo with a click of the mouse.

When you load one of your portraits into Portrait Professional, the software will guide you to click the mouse on very specific points on your photo, so it can create a map of the subject's face. Portrait Professional then uses artificial intelligence built into the software to automatically fix problems in the image, including the subject's complexion.

You can also manually change someone's eye color, brighten their irises or teeth, give them an instant tan, lighten or darken their hair color, remove blemishes on their face (such as acne), enhance the subject's jawline, redden or plump their lips, or make many other subtle or significant edits to a photo until it's absolutely perfect.

Using your mouse and onscreen sliders, Portrait Professional 9 allows you to fine-tune and adjust any portrait in a matter of minutes and then save the edited portrait in any of a handful of popular file formats. The software works best on photos of teens and adults (as opposed to portraits of infants or kids, who have different facial structures and already smooth complexions; Portrait Professional 10, when it's released, will have a mode for editing photos featuring kids). Whether you're creating a wedding photo album, editing someone's prom or senior photos, creating professional headshots or a portfolio for an actor or model, or just want to improve the quality of the posed or candid photos you take of your friends and family, Portrait Professional is a "must have" photo-editing tool for amateur, serious hobbyist, and professional photographers alike.

Figure 12-38 shows a portrait prior to any editing whatsoever. You can see some of the

**FIGURE 12-38** A portrait before being edited with Portrait Professional 9

model's minor complexion issues on his face. After loading the image into Portrait Professional 9 and spending less than two minutes "editing," Figure 12-39 shows the remarkable results: 95 percent of which were done automatically by the software, before the photographer did some quick fine-tuning with the manual editing controls. As you can see, the model's complexion is now clear and smooth; his eyes "pop" just a bit more;

**FIGURE 12-39** The portrait after less than three minutes of editing using Portrait Professional 9

his teeth have been whitened a bit; and he's been given a slight tan. These "edits" can be done easily using the Portrait Professional software.

At the time this book was being written, Portrait Professional 10 had been announced, but was not yet released. By the time you read this book, the 10th edition of this powerful software will most likely be available.

# Professional-Level Photo-Editing Applications

As you've read this chapter, you've seen only a small sampling of what's possible when it comes to editing photos. The possibilities are limited only by your own imagination, artistic vision, skill using your photo-editing software, and the power and capabilities of the software itself.

Up until now, you've read about photo-editing software that's designed more for amateur photographers but that professionals can also use. This next section offers information about more advanced (and more costly) photo-editing software that is commonly used by professional photographers. These packages are more advanced and offer much more powerful photo-editing tools and capabilities.

## Adobe Photoshop CS5 (PC and Mac)

Professional photographers, graphic artists, and other creative professionals who require total control over their images when editing opt to use professional-level photo-editing software. In this software category, the industry leader is Adobe's Photoshop CS5 (or later). Several editions of Photoshop CS5 are available from Adobe (www.adobe.com/products/photoshop/family/), priced starting at $699 for the full version of the software. Both a PC and Mac version of Adobe CS5 are available.

A few paragraphs can't begin to explain the thousands of features built into this software. What you need to know, however, is that it's extremely powerful, and it requires a significant time investment to learn how to use it. While Adobe has other applications to help photographers organize and share their work, Photoshop CS5, unlike the scaled-down, consumer-oriented Photoshop Elements 9, is designed for advanced photo editing.

Because Photoshop CS5 is used by so many photography and graphic design professionals, literally hundreds of optional add-on products are available from third-party developers, plus thousands of free downloadable resources that give this software even greater flexibility and more powerful editing tools and features, allowing photographers not just to edit digital images, but to literally transform their work into photographic art.

If the power and complexity of Photoshop CS5 is more than you need, but the latest edition of Photoshop Elements doesn't offer enough, Adobe's Lightroom 3 ($299, www .adobe.com/products/photoshoplightroom) software offers photo-editing, organization, and sharing functionality in a tool that's best suited for serious hobbyists and professional photographers. It's designed to manage and organize single images, as well as entire groups of photos simultaneously. Lightroom 3 is primarily a photo organizational and sharing tool with built-in editing features, as opposed to a full-featured editing tool like Photoshop CS5. Lightroom 3 can be used as a stand-alone photo-editing, organizational, and sharing tool, or it can be used seamlessly with Photoshop CS5.

 Free 30-day downloadable trial versions of Adobe Photoshop CS5, Lightroom 3, and Photoshop Elements 9 are available directly from Adobe's website (www.adobe.com/downloads/).

## Apple's Aperture 3 (Mac)

Picking up where the features and functionality of iPhoto leave off, Mac users who are serious photography hobbyists or professional photographers will appreciate the advanced photo-editing, organizing, sharing, and archiving features built into Apple's Aperture 3 software ($199, www.apple.com/aperture).

Aperture 3 is a viable and less costly alternative to Photoshop CS5, and it works seamlessly with other Apple applications. Individual photos or entire image libraries can be transferred easily between iPhoto and Aperture, so you can take full advantage of the advanced editing capabilities of this highly specialized application.

Like iPhoto, Aperture 3 uses facial recognition to sort images automatically based on who is featured in them. However, photo libraries can also be sorted by name, date and time the photos were shot, the location where they were shot (using geo-tagging), or by keywords or filenames.

In terms of its editing features, Aperture 3 offers hundreds of editing tools and presets to make the editing process for single photos or groups of photos less time consuming and more straightforward. The learning curve for mastering Aperture 3 is significantly less than for Photoshop CS5, but the software is more complicated than iPhoto, due to the more advanced features the software offers.

In essence, Aperture builds on the features and functions offered by iPhoto, although it is a stand-alone application. When it comes to sharing your photos, if you opt to create an animated and themed slideshow featuring your images, you can easily add audio and video clips to your presentation in addition to still images. Plus, you'll discover more advanced special effects and editing tools for making your slideshows look truly professional.

Designed exclusively for the Mac, Aperture 3 (or any later version) also allows you to share photos online, create professional-quality prints or photo books, and it supports the .raw format utilized by more than 150 mid-to-high-end Digital SLR camera models. A free, downloadable, 30-day trial version of Aperture 3 is available from Apple's website, or the software itself can be purchased wherever Apple computer products are sold. Aperture is also sold online and can be downloaded instantly to your computer from the Mac App store.

**Tip**    Many of the photo-editing applications featured in this chapter work well with optional add-on software from third-party developers, as well as specialized tools like graphic tablets, which make complex photo-editing easier. You'll learn about these optional add-ons and tools in Chapter 13.

**How to. . .    Edit Photos on Apple's iPad**

Apple's iPad tablet is an extremely powerful tool for amateur and professional photographers alike. Not only can you quickly and conveniently transfer images from your digital camera to an iPad virtually anywhere, but the iPad is also an ideal device for showcasing images and sharing them with others.

To transfer photos to your iPad, you'll need to purchase the optional iPad Camera Connection Kit ($29, http://store.apple.com/us/product/MC531ZM/A), which allows you to connect a USB cable between the iPad and your digital camera for easy photo transfers. The kit also includes an external SD memory card reader for the iPad. Or you can transfer digital images to your iPad from your computer using the iTunes' sync capabilities.

The built-in iPad Photos application allows users to display photos (either separately or as part of an onscreen slideshow), as well as share them via e-mail or through Apple's MobileMe online service. By purchasing and downloading optional third-party iPad apps, Apple's popular tablet device can be used to edit photos while on-the-go. Several powerful photo-editing apps for the iPad include Photogene for iPad ($3.99), PixelMagic ($3.99), FilterStorm ($2.99), CameraBag for iPad ($2.99), and PhotoPad (free), each of which offers a wide range of editing features and functionality. These and many other photography-related apps for the iPad can be downloaded from the App Store on iTunes. On the App Store on iTunes, you'll also find apps designed to make transferring photos between a digital camera and the iPad and/or between the iPad and a computer or online photography service.

Although not as powerful as PC- or Mac-based photo-editing applications, many of these iPad apps offer the basic editing tools needed to improve or enhance a photo dramatically while on-the-go and then immediately share your edited images (via e-mail or by uploading them to a website or online photo service) from virtually anywhere a wireless or Wi-Fi Internet connection is available.

The original iPad does not have a built-in digital camera (like the iPhone); however, future versions of this device most likely will, meaning that, in the future, you'll be able to use the iPad as a digital camera to shoot photos, as well as edit, display, and share them.

Apple iPhone users can also download photo-editing apps from iTunes (a fee may apply, depending on the app), so photos taken using the iPhone's built-in digital camera can be edited directly on the phone itself and then shared via e-mail, text messaging, or uploaded to an online social networking site, without first transferring the photos to a computer.

Similar photo viewing, sharing, and editing functionality is available on other popular tablet devices like the Blackberry PlayBook. Visit Blackberry's App World to learn about third-party apps for your Blackberry phone or PlayBook.

# 13

# Photo-Editing Software Plug-ins, Add-ons, and Accessories

## How to...

- Enhance the capabilities of your photo-editing software
- Find or download plug-ins and add-ons for your photo-editing software
- Use photo-editing accessories such as pen tablets or monitor calibration tools

Even after taking spectacular photos with your digital camera, by becoming proficient using Photoshop Elements 9 or Photoshop CS5, or another powerful photo-editing software package, you can do some pretty amazing things to your images after the fact as you edit and enhance them. As you're about to discover in this chapter, many third-party add-ons and plug-ins are available, both for free and for a fee, that will greatly expand what's possible as you edit your images using many of the most popular photo-editing applications, including the various versions of Adobe's Photoshop.

Some of the add-ons and plug-ins will save you time when performing certain types of edits, whereas others will give you extra graphic assets, such as digital borders, which you can incorporate into your photos during the editing process. When using Photoshop CS5, if you're working with a complex photo, separating the subject (or any object in a photo) from the background can be a time-consuming and tedious process that requires a high level of precision. However, if you use the optional Mask Pro 4 plug-in from OnOne Software (www .ononesoftware.com), in conjunction with Photoshop CS5, removing a background from almost any image, including a highly detailed one, becomes an automated and reasonably quick process. If you like the idea of adding themed digital frames and borders to your photos to enhance their visual appeal, check out Graphic Authority (www.graphicauthority.com), one of many companies

that offers, for a fee, entire CD-ROM-based collections of digital borders, frames, edges, photo collage templates, and other graphic elements that you can easily incorporate into your images when using programs like Photoshop Elements 9, Photoshop CS5, or Aperture 3.

In addition to the variety of add-on software and plug-ins available, after you've devoted the time necessary to becoming proficient editing photos, you may also want to take advantage of various computer peripherals, such as pen tablets, that make the editing process easier.

**Note** Good photographers not only know how to take powerful pictures using their camera, but also typically learn how to utilize photo-editing software and tools to improve upon their images before sharing or displaying them.

This chapter goes beyond just using the photo-editing software described in the previous chapter. Here, you'll discover how to edit and manipulate your digital photos to give them a more professional quality using software add-ons and plug-ins, as well as optional equipment typically used by the pros. Keep in mind that the software and accessories described in this chapter are of specific interest to serious hobbyists and professional photographers, not amateur photographers who typically have only the most basic photo-editing needs.

# Plug-ins and Optional Add-on Software for Your Photo-Editing Program

Even the most powerful photo-editing tools have their drawbacks. Plus, without added help, certain editing tasks are extremely tedious, time-consuming, and require precision to generate acceptable results—for example, removing a background from a highly detailed photo so the end result looks realistic and natural. Although Photoshop Elements and Photoshop CS5, for example, offer the tools to handle this task (rather well), much time and skill are required.

To give photographers more editing options and reduce the amount of labor and time required to handle routine tasks, like removing a background or retouching a portrait, third-party software developers have created plug-ins and add-ons for software that, at least partially, automate difficult, time-consuming, tedious, and/or repetitive tasks.

A *plug-in* is an optional program that's designed to work seamlessly with another program, to give it added features, tools, or functionality. Plug-ins are typically not stand-alone applications, however. If you add a plug-in to Photoshop CS5, for example, you must use it in Photoshop CS5. When you install a new plug-in, you'll notice additional menu options for using it appear in the main program's menus. For example, if you install Fluid Mask 3 in Photoshop, you'll find the Fluid Mask 3 tools now listed under the Filters pull-down menu in Photoshop.

An *add-on* can often work as a plug-in to a popular application, but it can also be used on its own as a stand-alone application, or it may include graphic elements that you can import directly into a program. When used by itself, the add-on has very specialized or limited functionality because it's designed for a specific purpose; add-ons aren't designed to be complete, photo-editing solutions like Photoshop Elements or Photoshop CS5.

Using a plug-in like EZ Mask or Fluid Mask 3, both of which you'll read about shortly, you can remove the background of even the most complex and detailed image and make the edited photo look natural and realistic—all within minutes, not hours. Likewise, with programs like Portrait Professional 10 (which is both a stand-alone program and a plug-in for Photoshop CS5) and Imagenomic's Portraiture 2, retouching portraits becomes a much easier task, yet the end results are highly professional.

Plug-ins and add-ons for Photoshop CS5 and Aperture 3, for example, are designed to work seamlessly with the software they're designed for. These add-ons and plug-ins actually add features, tools, and functionality that companies like Adobe or Apple left out of their software, or they automate certain tasks so you can accomplish them quickly. Each add-on or plug-in is designed to handle a specific task or function or to give users access to additional tools.

Let's take a closer look at just some of the optional plug-ins and add-ons available for the popular photo-editing applications. Again, these tools are designed for more serious photographers who are extremely comfortable using the professional-level photo-editing applications on the market, such as the latest versions of Photoshop, Lightroom, or Aperture.

## Did You Know?

### Resources for Photoshop Enthusiasts

For serious users, *Photoshop User* magazine (www.photoshopuser.com) offers insightful articles, advanced tutorials, product reviews, and other informative resources. The magazine publishes eight issues per year. Single issues are available at newsstands ($9.95 per issue). A subscription is included with an annual membership to the National Association of Photoshop Professionals ($99, 800-738-8513). This magazine is a great resource for learning about new releases and upgrades to Photoshop, as well as optional add-ons, plug-ins, and related accessories.

In addition, every year thousands of hard-core Photoshop users, graphic artists, and photography professionals gather at the Photoshop World conference, which hosts live workshops, features expert speakers, and showcases all of the latest software and technology related to Photoshop and photo editing. For information about this trade show and conference, call (800) 738-8513 or visit www.photoshopworld.com.

## Requirements for Using Optional Plug-ins and Add-ons

As you learn about the various plug-ins and add-ons available for the photo-editing software you'll primarily be using, focus on your own needs and whether a specific plug-in or add-on offers features, tools, and functions you'll actually use. Also, determine if the add-on or plug-in is designed to save you time by making an otherwise time-consuming or tedious task faster to accomplish.

Finally, focus on what software, hardware, and equipment the add-on or plug-in requires to work properly, paying careful attention to software version numbers. Before installing an add-on or plug-in, you typically must have the full working version of the primary program it's designed for already installed and functioning on your computer. A plug-in designed for Photoshop CS3, for example, might not work with Photoshop CS5. Be sure to read the hardware and software requirements for the plug-in or add-on, before installing it on your computer or attempting to use it.

If you search online, you'll finds thousands of free plug-ins and add-ons for the various photo-editing applications. However, some work better than others and not all will give you the professional results you may want or require. Before purchasing a plug-in or add-on from a third-party developer, determine if something with similar features, tools, or functions is available for free.

## A Sampling of Add-ons and Plug-ins

When you visit the Photoshop.com or Adobe.com websites to learn more about Photoshop, Photoshop Elements, or Lightroom, or the Apple.com website to learn more about Aperture, you'll also discover information about hundreds of add-ons and plug-ins for these popular photo-editing applications. You can also learn about plug-ins and add-ons by reading photography magazines, like *Popular Photography* or *Digital Photo Pro,* or from magazines specifically about Photoshop, such as *Photoshop User* or *Layers* (also available from newsstands). Among the many places on the Web where you'll find free Photoshop plug-ins and add-ons are Plugin Site (http://thepluginsite.com/resources/freeps.htm), Photoshop Road Map (www.photoshoproadmap.com/Photoshop-plugins), the Web Resources Depot (www.webresourcesdepot.com/free-photoshop-plugins-collection), and Plug-Ins World (http://photoshop.pluginsworld.com). Some of these sites also offer plug-ins and add-ons for other popular photo-editing applications as well as Photoshop. This section offers just a sampling of some of the more popular and powerful add-ons and plug-ins for the various photo-editing applications.

Keep in mind, by the time you read this book and start shopping for plug-ins and add-ons for your photo-editing software, newer versions may be available. Always purchase the most recent version of software (including plug-ins and add-ons), providing it's fully compatible with your existing computer configuration and any software you're already using.

### Alien Skin Photo Bundle

Designed to work with Photoshop CS3 (or later) for Windows or Mac OS X, Photoshop Elements 4.0.1 (or later) for Mac, and Photoshop Elements 6 (or later) for Windows, Alien Skin Software's Photo Bundle ($595) is comprised of five plug-ins, each of which handles a very specific function. Some of these plug-ins are also compatible with other photo-editing applications, including Corel PaintShop Pro 7.0 (or later), Adobe Fireworks CS4 (or later), and/or Adobe Lightroom 2 (or later).

Plug-ins included in the Photo Bundle are

- **Bokeh** (www.alienskin.com/bokeh)   This plug-in is used to handle focus manipulation within an image, allowing the editor to determine what object(s) should be crystal clear and what should be blurred. In other words, this utility can be used to make a main subject "pop" (which is photographer lingo for appear more prevalent or stand out in a photo). If purchased separately, this plug-in sells for $199.

- **Blow Up 2** (www.alienskin.com/blowup)   This plug-in is used to create extra large (up to billboard size) and very sharp enlargements when the resolution of a standard digital image doesn't otherwise allow for enlargements beyond a certain size without becoming blurry or pixilated. If purchased separately, this plug-in sells for $249.

- **Exposure 3** (www.alienskin.com/exposure/index .aspx)   This plug-in offers tools for creating 500+ effects that were originally possible using a traditional 33mm film-based camera. For example, you can re-create the look of a Polaroid photo, Kodachrome image, or make your photos look vintage. Exposure 3 is also ideal for editing and creating stunning black-and-white photos from your full-color digital images. If purchased separately, this plug-in sells for $249.

- **Image Doctor 2** (www.alienskin.com/imagedoctor)   This plug-in is used for retouching images with greater functionality and simplicity than what you can otherwise do with Photoshop or Photoshop Elements alone. It's ideal for restoring old photos or retouching new ones. For example, when editing photos of people, Image Doctor 2 makes it easy to remove unwanted problems with someone's complexion, tattoos, scars, and other undesirable blemishes, while also making someone's skin look wrinkle-free and smoother. If purchased separately, this plug-in sells for $199.

- **Snap Art 2** (www.alienskin.com/snapart)   This plug-in takes photographs and adds special effects to make them look like watercolor paintings, oil paintings, comic book art, pencil sketches, or other types of illustrated art.

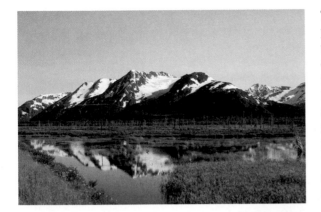

**FIGURE 13-1** A photo of a landscape before using the Snap Art 2 plug-in in Photoshop

These tools are ideal if you plan to print your images on canvas and want them to look like artist-created paintings or hand-drawn images as opposed to photographs. Using Snap Art 2 in Photoshop CS5, a landscape photo originally shot in Alaska (as shown in Figure 13-1) was transformed to look like an oil painting in less than 15 seconds (as shown in Figure 13-2), and a photo of a person was transformed to look like a hand-sketched artist's

**FIGURE 13-2** With a few clicks of the mouse, a landscape photo is transformed into an oil painting.

**FIGURE 13-3** Using Snap Art 2, transforming a photo to look like a pencil sketch takes just seconds.

drawing in pencil (as shown in Figure 13-3). By using Snap Art 2, the photographer created both examples with just a few clicks of the mouse. If purchased separately, this plug-in sells for $199.

**Tip** From the Alien Skin Software website (www.alienskin.com), you can see many sample images created using the company's plug-ins, view video tutorials on how to best use the plug-ins, plus download free demo versions of each plug-in separately.

Aside from the plug-ins that are part of the company's Photo Bundle, two additional plug-ins are sold separately. Eye Candy 6 ($249, www.alienskin.com/eyecandy) is a collection

of 30 Photoshop filters ideal for designing graphic elements for websites, including buttons, icons, and backgrounds. It's also useful for creating logos or title images and is geared more for using Photoshop as a graphic arts program, as opposed to a photo-editing tool.

Xenofex 2 ($129.99, www.alienskin.com/xenofex) is a Photoshop plug-in used for manipulating lighting, as well as creating 14 useful special effects that simulate burnt edges, cracks, crumbles, tears, rips, lightning, clouds, and other elements that can be incorporated into graphic images or photos.

## EZ Mask

Designed by Digital Film Tools, EZ Mask ($195, www .digitalfilmtools.com/ezmask) works with Photoshop CS3 or later for Windows or Mac. It's an easy-to-use, interactive masking tool for separating detailed objects within a photo from the background, allowing users to replace a background in an image much faster than if they used just the tools built into Photoshop.

Using broad strokes of the mouse when viewing an image in Photoshop and while running EZ Mask, with this add-on you mark the main subject or object in a photo, which takes just a minute or two, allowing the software to then analyze each pixel and determine if it belongs to the subject (or object) or the image's background. The plug-in then separates the background so you can remove it.

Without using an add-on like EZ Mask, tracing a detailed object to separate it from its background can take hours to do correctly and is extremely precise and tedious work. With EZ Mask, the process takes just a few minutes and is almost entirely automated. This add-on is ideal for amateur, hobbyists, and professionals alike who occasionally want to remove or replace the background in an image without spending hours trying to accomplish this task.

## Fluid Mask 3

Similar to EZ Mask, Fluid Mask 3 from VertusTech, Inc. ($149, www.vertustech.com/fluidMask/overview.html) works as a stand-alone program for Windows or Mac or as a plug-in for Photoshop CS2 (or later). It's an easy-to-use application that makes removing backgrounds from even the most detailed images extremely quick and easy, even if you haven't yet mastered the intricacies of using Photoshop.

Fluid Mask 3 is ideal for amateur, hobbyist, and professional photographers alike who need to replace the backgrounds in photos or quickly separate detailed subjects or objects within a photo from the rest of the image. Using Photoshop alone, tracing intricate objects like hair on a person or animal, lots of separate leafs on trees, or other jagged edges that surround a subject or object can take a great deal of time, and if not done with absolute precision, the end result will look unprofessional, unrealistic, or unnatural. Using the intuitive interface of Fluid Mask 3, you simply need to trace or color in a subject or object roughly within a photo using the mouse, and the plug-in then analyzes the surrounding pixels and separates the subject or object from the background—within minutes. The result will be an edited image with clean, smooth, and natural-looking edges. All of the minute details in the photo remain intact.

To see how this plug-in works, Figure 13-4 shows the original image of a lizard. With Photoshop CS5 loaded, the photographer activated the Fluid Mask 3 plug-in from Photoshop's Filters pull-down menu. (Once initially installed, the plug-in becomes a permanent addition to the main program's menu of options or commands.)

**FIGURE 13-4** The original lizard photo, prior to using Fluid Mask 3

Using Fluid Mask 3, the photographer then used the mouse to color over the background portions of the image in red, while highlighting the main subject in green (as shown in Figure 13-5). The background of the image was removed using the Fluid Mask 3 plug-in (see Figure 13-6). Back in Photoshop, the photographer can drop in an entirely new background as a new layer. For this demonstration, the photographer chose a photo of a forest in the fall as a new background (as you can see in Figure 13-7).

Before purchasing Fluid Mask 3, you can download a free 14-day trial version of the plug-in. This plug-in is one of the easiest and most powerful masking tools capable of removing backgrounds from images.

## Graphic Authority Collections

While not designed for actually editing photos, the Collections add-ons offered by Graphic Authority include hundreds of themed digital frame, border, and photo collage templates that

**FIGURE 13-5** From within Photoshop CS5, the Fluid Mask 3 plug-in is activated.

**FIGURE 13-6** Fluid Mask 3 removes the photo's background in minutes.

**Figure 13-7** Using Photoshop CS5, a new background is imported into the image.

can enhance a final image you want to display in an album, scrapbook, photo book, greeting card, or on the Web.

Each digital border, frame, or photo collage is created as a template and can be loaded into Photoshop, so you simply need to load in the appropriate template for the frame or border you like and then literally drag and drop the edited photo into the template (into the Photoshop layer labeled "Insert Photo Here"). Each template can be resized and rotated (from portrait to landscape mode, or vice versa) and its color scheme modified with relative ease.

Designed for professional photographers who create themed portraits or complete albums for their clients, Graphic Authority offers over two dozen digital frame, photo collage, and border Collections, each of which has a unique theme. Some of the popular themed Collections include Family Portrait, Baby Boutique, Urban Youth, Senior Sports & Portraits, Artistic Expressions, Artisan Portrait, Wedding Volume 1, and Rockstar.

Each Collection is sold separately on three CD-ROMs for $179 and includes several dozen templates. Individual templates are also available for download for $79.95 each. Or you can purchase the company's entire library of frame, border, and photo collage templates as a bundle of 42 CD-ROMs for about $2,500.

Each individual template was created by a professional graphic artist and is designed to be digitally merged with a photographer's image using Photoshop in well under five minutes, allowing him or her to create highly professional-looking results with no graphic design experience whatsoever. Creating similar borders, frames, or photo collage effects without using these templates can take several hours each, plus require a strong working knowledge of Photoshop, as well as graphic design skill and artistic talent. Using templates created by Graphic Authority, adding graphic elements to a photo takes just minutes and requires no special skills whatsoever, as well as only a minimal working knowledge of Photoshop.

Figure 13-8 shows how two separate photos can be transformed into an attractive and professional-looking photo collage in seconds using a template from Graphic Authority's Artistic Expressions collection. To see additional samples of the templates offered in each Collection or to order the Collections on CD-ROM, visit Graphic Authority's website (www.graphicauthority.com). The company's website also offers

useful video tutorials for quickly achieving the best results using templates from the company's various Collections.

Graphic Authority's templates work with all versions of Photoshop, including Photoshop Elements and Photoshop CS5 (or later). A working knowledge of Photoshop's layers functionality is needed to utilize these templates, however.

## Imagenomic Portraiture 2

Designed as a powerful plug-in for the latest versions of Photoshop (Windows/Mac), Aperture (Mac), or Lightroom (Windows/Mac), Portraiture 2 ($199.95, www.imagenomic.com) eliminates the time-consuming task of retouching portraits of people. In just minutes, this plug-in will help you smooth a subject's skin, remove unwanted blemishes, and fix imperfections with a subject's hair, eyebrows, eyelashes, lips, and other facial features.

**FIGURE 13-8** A photo collage created using a template from Graphic Authority's Artistic Expressions Collection

The software creates professional results quickly, but the user isn't required to be a master at using Photoshop, Aperture, or Lightroom, since the plug-in employs an almost fully automated process for retouching portraits. Portraiture 2 also has a powerful manual retouching mode, giving you total control as you fine-tune any portrait's appearance.

Portraiture 2 is powerful and works well as a plug-in in conjunction with popular editing software, but it's more difficult to use than Portrait Professional 9 (described in Chapter 12), and also more costly. You can download a 15-day free trial of the plug-in from the company's website.

## Plug-In Suite 5

onOne Software (www.ononesoftware.com) offers a collection of separate plug-ins that handle a variety of different specialized tasks and that add features, tools, and functionality to the latest versions of Photoshop Elements (Windows and Mac), Photoshop (Windows and Mac), Lightroom (Windows and Mac), and Aperture (Mac).

The Plug-In Suite 5 is a bundle of the company's six most popular plug-ins, available for the discounted price of $499.95. However, each plug-in bundled in this suite is also sold separately for $159.95 each. The six plug-ins offered as part of Plug-In Suite 5 include the following:

■ **Genuine Fractals 6**    This tool is for making extra big enlargements from digital images, without worrying about pixilation or blurriness. Images can be enlarged over 1000 percent with no loss of sharpness or detail.

■ **PhotoTools 2.5**    This plug-in can be used to add more than 200 visual effects to an image quickly and easily. Effects can be mixed and matched to give an image a truly unique appearance. In addition to combining effects, you can control how the effects blend together.

■ **PhotoFrame 4.5**    Using this plug-in, you can easily add any of more than 1000 artistic and/or themed frames, textures, backgrounds, edges, and borders to your images, or create stunning photo collages using precreated templates that require no graphic design skill, artistic ability, or creativity to utilize. This plug-in lets you add those finishing touches to your edited images, making them ideal for framing, incorporating into scrapbooks, albums, or photo books, or for showcasing on a website or within a blog.

 onOne Software offers 30 sample, professionally created border and edge effects for use with Photoshop CS2, CS3, CS4, and CS5 as a free download from its website. Visit www .ononesoftware.com/detail.php?prodLine_id=42.

■ **FocalPoint 2**    Add a very realistic and natural-looking depth of field to your images after you've taken them, plus choose exactly which subjects or objects in your photos will be clear and which will be blurry. This plug-in is a powerful, yet very easy-to-use tool for hiding or distorting distracting backgrounds without editing them out of a photo altogether. FocalPoint 2 can also be used to give photos a multidimensional appearance by accentuating subjects or objects in the foreground and/or background of an image.

■ **PhotoTune 3**    Although photo-editing programs like Photoshop have powerful, built-in color correction tools, PhotoTune 2 makes the process of color correcting images fast and simple. In as few as two steps, color problems that exist within an image can be corrected or colors can be enhanced or boosted using automated tools. This plug-in has a special tool designed just to color-correct skin tones in portraits.

■ **Mask Pro 4** This useful utility works much like EZ Mask or Fluid Mask 3. It offers 12 automated tools for removing backgrounds from photos with an ease and quickness that's simply not possible without using this type of plug-in.

**Tip** The onOne Software website (www.ononesoftware.com) showcases dozens of sample images created using each of its plug-ins, plus offers video tutorials and other resources that'll help you generate the best results possible. A free 30-day trial version of each plug-in is available for download. As with some of the other tools described in this section, the plug-ins offered as part of Plug-In Suite 5 are designed to generate professional-quality results, but most don't require more than a basic working knowledge of Photoshop or whichever photo-editing software you're using the plug-in with.

Designed specifically for amateurs and hobbyists and for use exclusively with Photoshop Elements (Windows and Mac), onOne Software also offers Photo Essentials 3 ($69.99). This package includes five tools for easier and more powerful editing. The utilities offered with Photo Essentials 3 allow you to improve the color of your photos (using a color enhance function upgraded from what's built into Photoshop Elements).

You can also more easily remove unwanted backgrounds; add any of more than 40 additional special effects (not otherwise found in Photoshop Elements); plus add edge effects, digital frames, or borders; and/or enlarge pictures to make crystal-clear poster-size prints using this suite. These easy-to-use add-ons are designed for people who want to add impressive effects and benefit from professional photo-editing techniques, without having to master complicated photo-editing software.

## TopazLabs Plug-In Bundle

Yet another powerful bundle of plug-ins for popular photo-editing software, including most versions of Photoshop, Lightroom, iPhoto, and Aperture, is available from TopazLabs. Its Plug-In Bundle ($179.99, www.topazlabs.com/bundle) includes useful plug-ins for optimizing and enhancing color, as well as adding artistic effects, improving the detail within images, removing visual "noise" from images, removing unwanted backgrounds, smoothing edges, and improving the quality of images that have been compressed for use on the Web.

A free, 30-day trial version of the award-winning Plug-In Bundle is available from the company's website (www.topazlabs .com/downloads/bundle.html). From the Gallery section of the website, found by clicking the Community icon, you can

access a vast and impressive sample library of images created by TopazLabs Plug-In Bundle users, utilizing the various plug-ins offered.

 Some of these plug-ins only work with specific versions of certain photo-editing programs, so be sure to read the technical requirements for each plug-in prior to using it. For example, the ReMask plug-in for removing backgrounds only works with Photoshop, Photoshop Elements, and PaintShop Pro, but does not work with Aperture, Lightroom, or iPhoto.

### Backdrop Designer Plug-in

One of Photoshop's popular features is the ability for users to remove or replace the backgrounds in their images. Using the Background Designer optional plug-in from Digital Anarchy ($199.99, www.digitalanarchy.com), you can choose from hundreds of digital backgrounds that come bundled with this software and then customize each one of them to best meet your needs when editing a photo. This plug-in is particularly useful for editing portraits and incorporating backdrops, like colorful textures or 3D drapery behind the subject. It works with almost all versions of Photoshop and Photoshop Elements for the PC and Mac.

## An Introduction to Pen Tablets

Most people interact with their computer using a standard keyboard and a mouse and view what they're doing on a monitor. When using most applications, this setup is perfectly adequate, although computer industry leaders continue to innovate new technologies for making the way we interact with computers more high-tech and intuitive.

For example, in mid-2010, Apple, the company that first created the mouse, re-invented it yet again with the introduction of the Magic Trackpad for its Mac desktop and laptop computers ($69, www.apple.com/magictrackpad). The Magic Trackpad, which sits next to a keyboard, is a multitouch device that remains stationary. Instead of using your palm to move the mouse around on your desk, with the Magic Trackpad, you use special gestures with your fingers to move the onscreen cursor and perform various other mouse-related tasks. The technology works very much like the Multi-Touch mouse built into the MacBook Pro, only the Magic Trackpad is 80 percent larger, giving you more room to scroll, swipe, pinch, and rotate with your fingers as you control what happens

on the screen. A simple finger tap replaces the mouse button click when using this device. Instead of a cable, the Magic Trackpad connects to the computer using a wireless Bluetooth connection. Because it offers extremely precise control over the onscreen cursor, the Magic Trackpad can help you edit photos when using your favorite photo-editing application.

Although the Magic Trackpad is certainly a useful innovation, for a while now, graphic artists and photographers alike have been using a pen tablet (instead of a mouse) to edit photos and utilize the features and functionality of Photoshop or other programs. Pen tablets offer a variety of advantages, including better precision when editing or retouching detailed images.

A *pen tablet,* which may also be referred to as a *graphics tablet,* is a flat surface that utilizes a pen-like pointing device instead of a mouse. You hold the pressure-sensitive, pen-like device just as you would any writing instrument and use it to move the cursor on the screen with gestures that simulate writing on a pad of paper. When you use a program like Photoshop with a pen tablet, you'll find the process of using many of the software's photo-editing tools quicker and more accurate.

A handful of companies offer graphic tablets for use with PCs and Mac-based computers. Pen tablets come in a variety of sizes and cost anywhere from $50 to several thousand dollars.

## Wacom's Pen Tablets

Wacom (www.wacom.com) is a pioneer when it comes to pen tablets for everyday consumers, professional photographers, and graphic artists. The high-end Cintiq tablets, for example, have displays built right into them, so you can literally draw on your photos using the pen-like device that sits on your desk or lap. These units cost at least $2,000, but are extremely handy tools for professional photo editors and graphic artists.

**Note** Pen tablets are an optional peripheral for desktop or laptop computers and are an alternative to using a traditional mouse. They're totally different from tablet-based computers, like the Apple iPad, which are stand-alone computing devices.

The more common (and affordable) option for serious hobbyists and professionals are the Intuos 4 Professional Pen Tablets from Wacom, which are available in four sizes (small, medium, large, and extra large). These devices are available in wired and wireless versions (which use either a USB cable or wireless Bluetooth to connect to the computer). The Intuos 4

tablets don't have a built-in display. They're simply used as a surface for utilizing the pen-like device (sort of like using a mouse pad with a mouse).

For the typical hobbyist or amateur photographer who likes the idea of editing photos with a pen-like device, Wacom's low-end Bamboo tablets are priced starting at $69. The Bamboo tablet also serves as a multitouch device for use with your fingers (in addition to or instead of using a pressure-sensitive, pen-shared device). The Bamboo tablets are designed to work with Photoshop Elements and other low-end consumer-oriented photo-editing applications.

## Additional Computer Peripherals and Accessories for Photographers

Another optional but useful accessory is a monitor calibration device. Monitor calibration devices are used to ensure that the colors you see displayed on your computer's monitor or screen are accurate and identical to the actual colors captured in your digital photographs and printed when you use a photo printer or have prints created at a professional photo lab.

A monitor that isn't properly calibrated will display inaccurate colors. Thus, when you view and edit your digital images while looking at them on your monitor, you'll see misleading color content, which could potentially result in your edited pictures possessing colors you didn't intend.

Priced at $89, the Spyder Express 3 from Datacolor (http:// spyder.datacolor.com/product-mc-s3express.php) is a consumer-oriented monitor calibration tool that works with any desktop and laptop computer screen. The Spyder Express 3 device is placed on your monitor (or display) and the provided software (available for Windows or Mac) automatically walks you through the quick and easy calibration process anytime it's needed.

Designed for more serious hobbyists, the Spyder 3 Pro ($169, http://spyder.datacolor.com/product-mc-s3pro.php) offers slightly more advanced precision technology for calibrating a monitor or display. According to Datacolor, the third generation of its colorimeter technology utilizes a new user interface, as well as a state-of-the-art optical design to provide more accurate, reliable, and consistent color, with added manual and automatic controls over white point and gamma.

Priced at $227, the company's Spyder 3 Elite (http://spyder .datacolor.com/product-mc-s3elite.php) is designed specifically

for professional photographers, giving them maximum color viewing control over their monitor or display. This package offers software that's been tweaked to provide better analysis and calibration for more types of monitors and projectors in a variety of different lighting situations.

X-Rite Photo is another company that offers a handful of different monitor calibration devices, starting with its entry-level Pantone Huey ($89) and its slightly more advanced Pantone HueyPro ($129)—both of which can be used to calibrate LCD or CRT monitors in a variety of different lighting situations. For example, how colors appear on your monitor differs depending on whether the room where you're working is lit with sunlight, traditional light bulbs (incandescent light), or fluorescent light. Plus, things will look different in a bright versus dimly lit room. The Huey and HueyPro compensate for different lighting situations, as well as for different monitor or display types.

Like the Spyder 3, the Huey and HueyPro include a patented calibration device that attaches to your monitor with suction cups when it's in use. The color calibration software that comes with the device is almost totally automated and offers step-by-step directions for checking and fixing the color calibration of your monitor or display.

Strictly for professional wedding, portrait, and event photographers, the ColorMunki Photo from X-Rite Photo ($499) is a complete color control solution for calibrating displays, projects, or printers, to ensure all colors onscreen and in print are accurate and consistent. For more information about X-Rite Photo's monitor calibration devices, visit www.xritephoto.com. Here, you'll find detailed product descriptions, video tutorials demonstrating how the products are used, plus other tips and strategies to ensure you're always seeing and working with truly accurate colors as you view and edit your digital images.

To help you capture accurate colors when shooting in any lighting situation, and to save you time doing color-correction editing after the fact, X-Rite also offers its ColorChecker Passport ($99). This device also helps to adjust a digital camera's white balance settings when shooting. The ColorChecker Passport works with Adobe Photoshop, Photoshop Elements, and Lightroom via a proprietary plug-in, as well as with its own stand-alone software. This accessory is very useful for all Digital SLR camera users.

**Note** The prices listed for products and software described throughout this book were the Manufacturer's Suggested Retail Price at the time this book was written. When you shop around, you'll often find products available for significantly less, especially if you use a price comparison website (like www.nextag.com) when shopping for photography equipment online.

# PART IV

# Showcase, Share, Present, and Store Your Photos

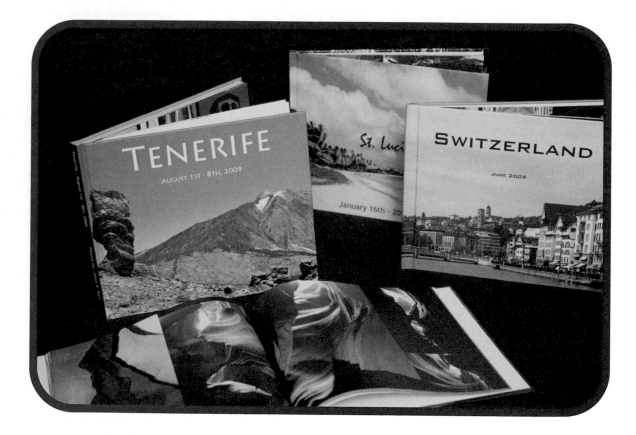

# 14

# Show Off and Present Your Images

## How to...

- Make prints using a photo printer versus a photo lab
- Create attractive photo albums
- Publish professional-quality photo books
- Produce photo gifts people will cherish
- Showcase your images as a computer screensaver or wallpaper
- Display your images in a digital photo album
- Use online photo services to create and share images and slideshows
- Send your photos via e-mail
- Share your photos with Facebook, Twitter, and other services

Now that you know how to take professional-quality photos, you'll definitely want to showcase them, share them with others, and enjoy them yourself for many years to come. After all, photos are a way to capture and share memories that you can reminisce about and reflect upon later.

Having the right image framed and hanging on your wall at home or in your office, for example, can bring you back to the moment the photo was taken and serve as a continuous reminder of a happy occasion, favorite location, or loved one. Plus, that framed photo can add to the overall décor of the room, especially if you choose a unique frame and add a single or double matte.

As you'll discover in this chapter, you can show off and present your images by creating traditional prints or by keeping your images in digital form. For example, in addition to creating hard copy prints from your digital images (using a photo printer or professional photo lab), you

can share your images digitally in a multitude of ways via the Internet, your computer, cell phone, or even your TV (with a DVD player, Apple TV, or TiVo Premiere DVR). How you go about sharing and showcasing your images depends on a number of factors, including how creative you want to be, your budget, how many people you want to share your images with, and what form you want the images to take. The possibilities are truly endless.

Of course, you're not limited to any one medium. You can create prints of your favorite images, frame them, and display them proudly on the walls of your home or office, have those same images transformed into note cards, imprinted on coffee mugs, or incorporated into eye-catching digital slideshows to share online, distribute on DVD, publish on YouTube (see Chapter 10), or view on your TV. You can also publish your digital images online on your Facebook page, using an online photo service (such as Flickr.com), or via Twitter; e-mail them directly to friends or loved ones; or store them on your Smartphone, iPad, or computer and then display them as your wallpaper and/or screensaver. These days, many people store entire photo collections on their cell phones (or iPad), as opposed to carrying around actual prints in their wallets, and use their digital devices to show off photos and brag about their kids, grandchildren, pets, or latest vacation.

**Note** You can utilize any of the ideas in this chapter once you've shot your photos, transferred them to your computer, backed them up, and edited them. Most options available to you when it comes to showcasing and sharing your images are extremely inexpensive, quick, and easy to create.

# Transform Digital Images into Traditional Prints

Long before there were computers, the Internet, smartphones with specialized photo apps, and digital picture frames, people took photos, had them developed at professional photo labs, and then displayed their prints in picture frames, photo albums, or scrapbooks. Bringing your photos to a lab, however, meant waiting anywhere from one hour to a week to have your prints developed from film.

**Note** Prints can be created in a variety of sizes, from wallet-sized (2.5″×3.5″) to jumbo-sized (24″×36″ or 36″×54″) posters. However, standard 4″×6″, 5″×7,″ or 8″×10″ prints have been the norm for decades.

In recent years, one-hour photo labs in pharmacies, supermarkets, and mass-market retailers began offering a wider range of options with faster delivery times. Nowadays, if you bring a memory card or USB flash drive containing your digital images to a local pharmacy, for example, you can have prints created in minutes or within an hour. Yet, for the very best quality prints, spending a bit extra and being a bit more patient is necessary in order to have your photos printed by a professional photo lab.

Although, today, you can have prints made directly from the digital files stored on your camera's memory card, a USB flash drive, or CD-ROM, by any one-hour or professional photo lab, you also have another option. You can purchase a photo printer, connect it to your computer, and create your own prints at home, in almost any size, at your convenience. The photo printers available today are able to produce incredibly high-quality prints, often for the same price (or a bit less) than what even the discounted one-hour photo labs charge.

If your goal is to frame a few of your images or to create a traditional photo album or scrapbook, you need to transform your digital images into hard copy prints. Whether you do this yourself using a photo printer or pay a photo lab or one-hour photo service to do this for you, the choice is yours.

# Create Prints Using a Photo Printer That's Connected to Your Computer

In recent years, not only have photo printers dropped dramatically in price, but their print quality has greatly improved. In many cases, the prints you create from an inexpensive photo printer at home are equal to or better in quality than prints created at a one-hour photo lab or even a professional photo lab. Plus, if you're a savvy shopper, you can buy replacement ink cartridges on the Internet, and the cost of creating prints of any size will drop dramatically.

## Choose the Perfect Photo Printer

Photo printers are different from laser printers or traditional ink jet printers because they have a different purpose. Instead of printing page after page of black text on white 20-pound copy paper, for example, photo printers are designed to print photos on special photo paper, using specialized ink that keep the colors in your prints crisp and vibrant for many years.

Photo printers come in all shapes and sizes and are offered by a wide range of companies, including Kodak, Canon, Epson, and Hewlett-Packard (HP). Some printers are limited by what size photo paper they can print on. For example, smaller photo printers are designed exclusively for printing 4"×6" or 5"×7" prints and nothing larger. The Epson PictureMate Show can create a 4"×6" color print from your digital image in under 40 seconds. This portable printer also has a 7-inch LCD screen for viewing images, so it serves as a digital photo frame as well.

The majority of photo printers available, however, will accommodate 8.5"×11" photo paper, meaning you can create prints of any size up to 8.5"×11", including 8"×10" prints, which are ideal for displaying in picture frames. As you'll learn in the next section, photo paper also comes in a variety of popular print sizes. For photographers wanting to create their own larger-format prints up to 13"×19", for example, specially designed photo printers are available from companies like Epson.

You'll probably find, however, that a standard-size photo printer, one that accepts photo paper up to 8.5"×11", will be more than adequate for your at-home (or at-work) photo printing needs. Of course, you can always go to a local photo lab or use an online photo service to have poster-size prints created from your digital images.

**Tip** If you want to create one or more posters from your digital images, ShortRunPosters.com will create 18"×24", full-color posters for as little as $2 each. These posters can be ordered online. An inexpensive alternative to paper-based, large format posters is to have a company called WallZaz.com (www.wallzaz.com) create giant removable wall decals from your photos. Prices start at just $9 for an 18"×12", full-color, removable wall decal.

The price of a good-quality photo printer is between $100 and $400. However, aside from the one-time cost of the printer itself, the availability and cost of replacement ink cartridges is a consideration too. Some photo printers have just two cartridges—a black cartridge and a color cartridge, each of which costs anywhere from $10 to $40 each. Some photo printers, however, require individual color ink cartridges, which sell for up to $15 each. Thus, you may need to purchase between six and eight separate ink cartridges for your photo printer at any given time.

**Caution** Most photo printers are compatible with both the Windows and Mac OS–based operating systems. Some even work with the iPhone, iPad, or other smartphones and wireless Internet devices. However, make sure your printer has drivers available for the latest version of the operating system you currently use.

Once you determine whether you want a portable photo printer (which won't create prints larger than 5"×7"), a full-size photo printer (which will create prints up to 8.5"×11"), or a professional-level, wide-carriage photo printer, which can create poster-size prints, the next step when choosing the perfect printer is to evaluate the various features each printer offers. The photo printers offered by companies like Kodak, Canon, Epson, and Hewlett-Packard all create high-quality photo prints.

**Caution** You'll see a print quality difference between color ink-jet printers (which can also print photos), dedicated photo printers, and professional-quality photo printers, which tend to be more costly and can usually create larger size prints. For professional photo lab quality results, a high-end photo printer is ideal. However, the average amateur photographer will be happy with the print quality offered by almost any dedicated photo printer costing less than $300. If you plan to use a generic, low-cost, color ink-jet printer to create prints from your digital images, however, make sure the printer is capable of printing at least 1200×4800 dpi.

Some of the most common dedicated photo printer features to look for include:

- A built-in LCD screen for previewing photos before they're printed. Figure 14-1 showcases the Epson Artisan® 835 Premium All-in-One, a printer that can create 4"×6" prints in less than 10 seconds each. Like many photo printers, it has an LCD preview screen.

- A built-in memory card reader for making prints without connecting the printer to a computer or digital camera.

- A USB port for connecting the printer to a computer or directly to a digital camera.

- A network port for connecting the printer to a local area network.

- Wi-Fi and/or Bluetooth compatibility for wirelessly connecting a computer or digital camera to the photo printer.

- Multiple-size paper trays, so you can keep a supply of different-size photo papers in the printer, allowing you to print a 5"×7" print followed by an 8.5"×11" print, for example, without stopping to swap paper.

**FIGURE 14-1** Many photo printers have LCD displays to preview images before they're printed.

- ◾ Fast print speed. How quickly can the printer create a 4"×6" borderless print? Most good quality photo printers can do this in under 30 seconds. Keep in mind, print speed for photo printers (when printing photos) is significantly slower than black-and-white laser printers or full-color ink-jet printers that aren't designed to print photos.

- ◾ The capacity of the paper tray. For convenience, choose a printer with a capacity of more than 30 sheets of photo paper or 100 sheets of regular paper.

- ◾ Calculate the average cost-per-print. Many companies publish this information, based on 4"×6" prints (including the cost of ink and paper). The cost-per-print varies from under 30 cents per print to more than 70 cents. However, printers that create more costly prints don't necessarily translate to higher-quality prints. More often the cost relates to how much the printer company gouges you for replacement ink cartridges and brand-name photo paper.

Although a printer may seem perfect, based on its technical specifications and promotional literature, research what other consumers, like yourself, think about the printer and how well it works. You may discover a large number of people who purchased a particular photo printer don't like it because the print quality is poor, the ink cartridges are too expensive and don't last, or the printer's manufacturer doesn't keep up by creating the latest drivers needed for the printer to run flawlessly with the very latest versions of the Windows 7 or Mac OS–based operating systems.

Some printers are prone to paper jams or don't inform you in advance when one of the ink cartridges is about to run out. Each time you start making a print, but the printer doesn't finish, due to a malfunction or user error, it costs you money in wasted ink, plus it wastes costly photo printer paper. If you read a lot of negative consumer reviews about a particular printer make and model, seriously consider buying a different printer.

Before making your purchase, ask to see several actual prints made from the printer you're looking to purchase. If possible, compare the quality of the prints to prints created by a professional photo lab. When doing this, however, make sure the prints from the photo printer were created using high-quality (four star or five star) photo paper, with a similar finish to the photo lab prints you're comparing the photo printer prints to.

FIGURE 14-2 The Kodak ESP 7250 All-in-One printer is a high-quality and affordable all-in-one photo printer.

As you'll discover in the next section, the quality photo paper you use helps to determine the quality of the prints you wind up with, regardless of the printer make and model.

Some photo printer manufacturers, including Kodak, offer all-in-one photo printers, which also serve as traditional printers, scanners, copiers, and fax machines. These printers are ideal for home offices or busy households. An example of an affordable, yet powerful all-in-one printer, which is shown in Figure 14-2, is the Kodak ESP 7250 All-in-One ($199.99). In addition to handling multiple tasks, it utilizes low-cost, high-capacity ink cartridges. The photo print quality is superior.

## Did You Know?

# Polaroid Still Makes Instant Print Cameras

Although the instant cameras of yesteryear are long gone, Polaroid recently re-invented the "instant camera" concept by combining it with digital camera technology. The Polaroid PoGo Instant Digital Camera ($199.99, www.polaroid.com/products/0/266909/Instant_Digital_Camera) is a full-featured, handheld digital camera with a tiny, built-in photo printer. You can shoot digital images, which you can save on a memory card and transfer to your computer, edit, e-mail, and share online—just as you would with any digital camera. But the PoGo Instant Digital Camera can also instantly print small, full-color, 2"×3" prints in about one minute each using its built-in printer.

If you already have a digital camera (or cell phone camera), but like the idea of being able to create hard copy prints anywhere, anytime, the Polaroid PoGo Instant Mobile Printer ($49.99), shown here, is a tiny, battery-powered printer that fits in the palm of your hand. Like the PoGo Instant Digital Camera, it can create tiny (2"×3") full-color prints in about one minute each when you connect your digital camera or cell phone to the printer via a USB cable or a wireless Bluetooth connection.

One great feature of the Polaroid instant camera and printer is that it doesn't use any ink whatsoever. Instead, these devices use proprietary Polaroid photo paper, which comes in packs of 30 sheets for about $11. Each sheet will print one 2"×3" image and has a peel-off, sticky back that transforms the prints into colorful stickers.

## What You Need to Know About Photo Paper

As a general rule, purchase the highest-quality photo printer you can afford in order to create the best-quality prints possible. The type of photo paper you choose also dramatically impacts the quality, appearance, and durability of your prints. All of the photo printer manufacturers have their own lines of photo paper that they recommend for their specific printers. However, photo paper from any manufacturer will work with any nonproprietary, traditional photo printer, so Epson photo paper will work with a Kodak or Canon photo printer. Likewise, generic Staples- or OfficeMax-brand photo paper will work with any photo printer.

Regardless of what brand of photo paper you purchase, you still have four additional choices—its quality, finish, size, and the number of sheets in a pack. Photo paper is graded using a star system, based on its quality. Five-star paper is roughly equivalent to what professional photo labs use. It's a bit thicker than lesser quality photo papers and is designed to hold the ink better and resists fading over time. Ink is also designed to dry faster (or instantly) when using five-star photo paper, which means fewer or no accidental smudges caused by touching the print too quickly when it comes out of the printer. Unless you're planning to frame your prints or archive them in a photo album, for example, you can probably get away with slightly less expensive three- or four-star photo paper for your everyday use.

How your image looks once it's printed is also determined by the paper's finish. Most photo papers come in a matte, semi-gloss, or glossy finish. As these names suggest, the paper finish determines how much shine the printed photo has. Glossy photo paper creates slick and very shiny prints, which is typically what you'd get from a one-hour photo lab. Semi-gloss paper has less shine, whereas matte-finished paper has no shine whatsoever.

Many professional photographers utilize a fourth photo paper choice—a high-quality "luster" photo paper—when creating wedding albums or portraits because the finished prints look much more formal and classy. This type of photo paper tends to be more costly, but the finished prints look extremely professional as the color reproduction tends to be superior.

In addition to photo paper made by the popular photo printer manufacturers (Kodak, Canon, Epson, and Hewlett-Packard), as well as generic, low-cost photo papers sold by office supply superstores, several photo paper companies manufacture extremely high-quality, archival photo paper suitable for creating museum-quality prints. These top-quality photo papers, from companies like Canson (www.cansoninfinity.com), Ilford

(www.ilford.com), Harman (www.harman-inkjet.com), and Hahnemühle Fine Art (www.hahnemuehle.com), are typically available only from photography specialty stores, professional photo labs, and online sellers that cater to serious photographers.

Photo paper that's promoted as "archival" is a bit more costly, but it won't fade for at least 20 and potentially up to 100 years. Lesser-quality, nonarchival photo paper can fade after a few months or years, especially if the prints are exposed to sunlight or humid air.

If you're framing your images, a glossy finish print under a glass or plastic frame reflects light more, which can be distracting. So for framed prints, consider a matte, semi-gloss, or luster finish paper.

Photo paper also comes in a variety of popular precut sizes, including 4"×6", 5"×7", and 8.5"×11". If you know you'll only be making 5"×7" prints, for example, to include in photo albums, purchase packs of 5"×7" photo paper, as opposed to more costly 8.5"×11" paper, which you'd then have to cut to the appropriate size. Most photo printers have adjustable paper trays that accommodate smaller paper sizes.

You can save money on photo paper by purchasing packs of 50, 100, or 250 sheets; however, photo paper also comes in 25-sheet packs from most manufacturers. Another way to save money on photo paper is to look for sales. Office supply superstores, like OfficeMax and Staples, constantly run promotions or sales for name-brand photo paper. If you're a savvy shopper, finding buy-one-get-one-free or 25 to 50 percent off sales is easy.

### Don't Forget the Ink

Ink cartridges for photo printers can get costly. Therefore, choose a printer that utilizes high-capacity, low-cost cartridges that generate a high volume of prints before running out. All of the printer manufactures sell their own ink cartridges for their printers, which are typically costly compared to compatible ink cartridges from third-party manufacturers.

Not all ink cartridges are alike. In addition to determining the price of each replacement ink cartridge, find out how many prints you can expect to get out of each cartridge before it runs out. You might not get more than twenty-five 8.5"×11" prints from some ink cartridges.

For the best print results from any photo printer that utilizes ink cartridges, use cartridges created for your specific printer by the printer's manufacturer. That being said, you do have other

options. For almost any popular photo printer, you can purchase low-cost, but fully compatible, ink cartridges via the Internet and save up to 80 percent. Use a price comparison website like Nextag.com, and search for your exact photo printer make and model followed by the word **ink** to find low-cost replacement ink cartridges for your specific printer.

Depending on the printer make and model and the quality of the third-party ink you use, you might encounter problems. For example, one common problem with third-party ink is that it can be of inferior quality. Some third-party ink cartridges also don't meet the quality standards of the printer manufacturers and clog more often or produce colors that are less vibrant or that fade over time. Although many third-party ink companies offer top-quality alternatives to ink cartridges sold by Kodak, Canon, Epson, Hewlett-Packard, and the like, you may need to experiment a bit with cartridges from several companies before finding suitable non-brand-name replacement cartridges.

Consumers who attempt to refill ink cartridges in an attempt to save money and be environmentally friendly report similar issues. Where you get the cartridges refilled and the quality of ink used for the refill impact the quality of your prints. Plus, if the refill process isn't done correctly, it could lead to leaking, clogging, or other problems.

## Maintaining Your Photo Printer

The best thing you can do for your printer is to use it periodically, so the ink cartridges don't dry out or get clogged. Every photo printer, however, comes with a utilities program that allows you to adjust and clean the print head and/or fix the printer alignment. These utilities should be used periodically to keep your photo printer working at its peak efficiency.

If you notice the color quality of your prints isn't correct, one of your ink cartridges may be empty, clogged, or running low, or the photo software on your computer isn't calibrated correctly. Check the "troubleshooting" section within your printer's manual to determine the appropriate fix for the type of problem you're having with your photo printer.

 Sometimes if your prints come out looking vastly different than the image you see on your computer screen, your monitor may not be properly calibrated. You can purchase several tools, such as the Pantone Huey Pro ($99, www.pantone.com), that will quickly adjust your monitor or laptop computer screen so what you see on the screen replicates the colors your photo printer prints. See Chapter 13 for more details.

## Ordering Prints Using a Professional Photo Lab

If you don't want to create your own prints at home (or at work) using a photo printer, you can transfer your final edited or cropped images back to a memory card, or copy them to a USB flash drive or CD-ROM, and then bring the files to a one-hour or professional photo lab to have them transformed into prints of any size (or into various other photo products, which are described later in this chapter).

The quality of the prints you get, however, varies greatly based on whether you go to a one-hour photo lab or pay a bit extra to have your prints created at a professional photo lab.

### One-Hour Photo Labs

One-hour photo labs are typically the least expensive option when it comes to having prints made from your digital images. You'll find these photo labs within large pharmacies, Wal-Mart stores, and many other mass-market retailers. Photo retail stores also offer one-hour photo services within many malls and shopping centers across the United States.

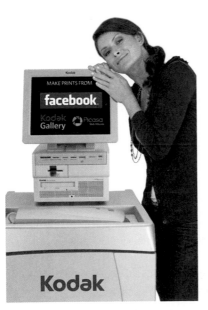

The problem with these one-hour photo labs is that, although they're inexpensive, convenient, and quick, they're also totally automated, with photo processing machines typically operated by people who know little to nothing about photography. So if their equipment isn't perfectly calibrated, or if your images need to be fine-tuned to print in the clearest and most vibrant colors, the one-hour photo places usually won't generate the best results.

Another option is to visit a store that offers a do-it-yourself photo printing kiosk, such as a Kodak Picture Kiosk (you can find the one closest to your location by visiting Kodak.com and selecting Kodak Picture Kiosk from the Kodak Store pull-down menu). The Kodak kiosks, shown in Figure 14-3 (and others like them), feature easy-to-use touch-screens and built-in software that allows you to load your images from a memory card, USB flash drive, or CD, choose the print size and number of prints you want, and then edit

**FIGURE 14-3** Kodak Picture Kiosk

or crop your images before printing them. The prints are created in a few minutes. Typically, these kiosks are more expensive than using a one-hour photo developer, but they're also more convenient.

## Professional Photo Labs

For the best results, visit a professional photo lab and bring them a memory card, USB flash drive, or CD containing the digital images files you want printed. These labs are operated by trained professionals and use the highest-quality photo paper and equipment to ensure top-quality and highly professional results. While these labs can sometimes print your images right on the spot, they commonly take several hours or up to a full day to create prints from your digital files.

Some professional photo labs also allow you to upload your images to their system via the Internet, so you can pick up your prints at a specified time without having to wait for them. Yet another option is to use an online-based professional photo lab that creates top-quality prints and then mails them directly to your home or office, typically within 24 hours after the files are uploaded.

Yes, you will pay a premium to have your digital images printed at a professional photo lab, regardless of the size prints you request. However, the quality will be superior to what you'd get from a one-hour photo processor or from your non-professional-quality home photo printer.

On the Internet, you can find literally thousands of professional photo labs capable of creating high-quality prints from your uploaded digital images. Many of the online photo services, including Flickr.com, SmugMug.com, Snapfish.com, Shutterfly.com, RitzPix.com, Wal-Mart Photo Center (http://photos.walmart.com), and KodakGallery.com, also offer an option for ordering prints online. You'll learn more about these services shortly.

**Tip** If you take the same digital images to five different one-hour and professional photo labs, and ask for the same size prints from each, the quality of your final prints will differ vastly based on the type of printing equipment used by each lab, how well it's calibrated, and whether a human actually checks the images as they're being printed to make subtle adjustments to the printing process in order to ensure the best results. Therefore, you may need to visit several photo labs before finding one that offers the quality you want at prices you can afford.

## Did You Know?

# FotoFlōt Is an Option Beyond Paper Prints

If you're thinking about making large-size prints of your favorite images and then having them professionally matted and framed, consider, instead, having FotoFlōts created from your digital images by visiting www.fotoflot.com. This proprietary printing process prints your images on a special acrylic that can be mounted on a wall without a frame.

As you can see from this image, the final product is extremely classy and contemporary and fits into any home or office décor. The flat acrylic image surface is hung about a centimeter from the wall to give the FotoFlōt a multidimensional look. FotoFlōts, which are available in 46 different sizes (up to 15"×30"), come with easy-to-use wall-mounting hardware.

FotoFlōts aren't cheap. Prices range from $50 to $235, based on size, which is slightly more expensive than professional framing. The finished products, however, are eye-catching and draw attention to your images when hung on any wall. There is no frame or glass (which can create glare.)

A FotoFlōt is created by adhering a photographic print to a lightweight, 1/8"-thick acrylic panel. Both are laser trimmed, fusing print and acrylic, to produce a polished edge. The result is a very contemporary piece of artwork that's created from your digital print—one that is both visually stunning and extremely durable.

To learn more about this unique photo printing and display option or to upload your images and have them transformed into FotoFlōts, visit www.fotoflot.com.

Another option to traditional framing is to have your images printed on canvas. This transforms the print into something resembling a fine art painting or piece of artwork, which you can either frame or use to create a gallery wrap canvas that needs no frame. A wide range of companies print photos on canvas in many different sizes. However, as with any other type of printing service, print quality and workmanship vary greatly among companies.

CanvasOnDemand.com is just one online-based company that offers a canvas printing service. You can upload your photo(s), choose your options, and have the printed canvas shipped to your home or office within a few days. Prices range from $59 for an 8"×10" gallery-wrap canvas to over $500 for a 40"×60" floating frame canvas (which has a much more contemporary look). When used for decorating, larger size canvases definitely look better and more professional when hung on a wall.

# Showcase Your Images in a Photo Album or Scrapbook

If you want to go "old school" to show off and archive your photos, you have two options: a traditional photo album or a scrapbook. With either, you can display large groups of photos and arrange them in an order that tells a story. A traditional photo album allows you to organize and display your prints in a binder or book that contains specially designed pages.

Like picture frames, photo albums come in all shapes and sizes, and range in price from extremely inexpensive (under $15) to hundreds of dollars for a hand-crafted, leather binder containing handmade paper upon which you attach your photos. Epica (www.epica.com/photo-albums) is just one example of a company that manufactures high-end, hand-crafted photo albums that cost as much as $700 each. Exposures is an online-based store (www.exposuresonline.com) that specializes exclusively in offering a vast selection of high-quality photo albums and related supplies, as well as picture frames and photo storage solutions. While some photo albums are more suited for keeping in a drawer or file cabinet, others can easily become fine family heirlooms that should be proudly displayed on a coffee table, for example.

When creating a photo album, choose an album cover you like and one that protects your photos. What's more important, however, is the way you mount the photos on the page and what type of pages the photo album contains. The type of page should depend on how and where you'll be storing your albums and how long you want them to last. If you go into any specialty photography or arts and crafts store, you'll find photo album supplies designed for archival purposes, so the paper won't turn colors over time, and the kind of tape or glue used for attaching photos to the page that won't dry out or dissolve as the years go by.

**Tip** Be sure to invest time and creativity into the organization of your photo albums so they tell a story. An album can chronically showcase someone's life, a special event, or a vacation, for example. It can also showcase a collection of random images in an interesting and artistic way.

Some photo albums come with a predefined number of pages bound into the cover, whereas others are designed

**FIGURE 14-4** Plastic "pocket pages" like these can be inserted into three-ring binder-style photo albums.

using a three- or four-ring binder concept, so you can add and remove pages with ease. For noncreative individuals, plastic "pocket pages," as shown in Figure 14-4, are the easiest because they offer clear plastic pockets in a predefined layout—all you do is insert your photos. These plastic pages are designed to protect your images by enclosing them in plastic. Pocket pages are available in a variety of sizes and formats to accommodate prints of different sizes. They're also very inexpensive. A package of 10 plastic pocket pages typically costs under $10.

"Sheet protector" pages, which are also referred to as "magnetic" photo album pages, are constructed using a heavy paper or card stock. Your photos are attached using static cling and then held in place with a clear plastic overlay that covers the photos to create a seal. As you can see from Figure 14-5, the benefit to this method is that you can arrange your photos anywhere on the page and tap your creativity to create unique and interesting layouts, using different size prints on the same page (which is not possible with plastic pocket pages that have predefined slots for inserting photos).

*Designer pages* are photo album pages made from paper or a heavier card stock; you then mount or attach photos to the pages using photo corners, glue, or two-sided tape. These pages have no plastic overlay and are similar to what you'd find in a scrapbook.

Speaking of scrapbooks, if you have the time and creativity to create one from scratch, you'll discover it's a wonderfully fun and interesting way to showcase your photos. You can custom design each page of a scrapbook using your photos, along with a wide range of other scrapbooking supplies, like stickers, ribbons, rubber stamps, and other crafting materials, which you can use to tell a visual story on every page.

Scrapbook binders or covers come in a wide range of colors, shapes, and sizes. Vast selections of scrapbooking supplies are also available for to use to personalize your scrapbook. Scrapbooking can be a time-consuming project, but the end result is a method of displaying your photos that's uniquely your own. Visit any arts and crafts superstore, such as Michaels (www.michaels.com), which has more than

**FIGURE 14-5** Sheet protector pages offer more layout options and look classier than plastic pocket pages.

1,000 retail stores nationwide, to purchase scrapbooking supplies or take scrapbooking classes. In addition, the gift shops at many tourist attractions, including Walt Disney World in Orlando, Florida (www.DisneyStore.com), sell precreated scrapbooking kits with themes. These are ideal for easily creating vacation scrapbooks and include all of the materials you'll need, except for your personal vacation photos, of course.

 For first-time scrapbookers or people looking to save a little time when creating their scrapbooks, theme-oriented kits are available from arts and crafts stores to help you get started. Little Red Scrapbook (www.littleredscrapbook.com) is an online-based scrapbooking club that creates new scrapbook kits monthly. You can also use any Internet search engine, such as Google.com, and type the search phrase **scrapbooking kit** to find kits available for purchase online.

# Publish Professional-Quality Photo Books

For technologically savvy people, traditional photo albums and scrapbooks are considered "old school." A newer way to showcase photos is via a photo book, which you create using a computer and then publish like a traditional book, to create a stunning, professional-quality paperback or hardcover book. Thanks to print-on-demand technology, photo books can be printed one at a time at a very low cost.

While many companies offer photo-book publishing services, one of the most powerful, easiest to use, and that offers truly impressive results is Blurb.com. To create a photo book using Blurb.com, visit the company's website and download the free BookSmart book design and layout software for Windows or Mac OS–based computers. Once the software is installed, it will walk you through the photo-book design and layout process; you'll be able to quickly and easily create professional-quality results with no graphic design experience or skill needed.

Blurb.com's software, shown in Figure 14-6, utilizes templates that were created by professional graphic designers. All you need to do is literally drag and drop your digital images onto the onscreen templates and then add text or captions if you wish to create each page of your photo book.

Like many photo-book publishers, Blurb.com allows you to choose from a variety of trim sizes for your book. You can also

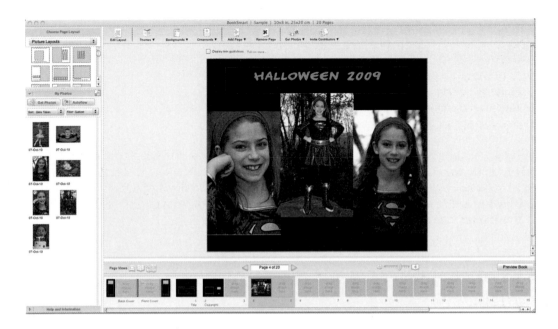

**FIGURE 14-6** Blurb's BookSmart software uses templates to make photo-book publishing easy.

create a paperback book, which is the least expensive option, or select an ImageWrap (shown in Figure 14-7) or dust jacket hardcover book. Once your book is designed, you can also select the paper used to publish your book.

Upon completing the final photo-book design and layout using the BookSmart software, your digital book file will be uploaded to the Blurb .com service. Within 7 to 10 business days (faster if you pay for expedited service), you will receive a professionally printed and bound, full-color photo book in the mail, which you'll be excited to share with friends and loved ones or to showcase on your coffee table at home.

**FIGURE 14-7** A selection of Blurb.com's ImageWrap hardcover photo books.

 Using BookSmart, you can be as creative as you want when designing each page of your photo book. You can totally customize each page with photos, text, and graphics, as well as change the color schemes, or you can simply drag-and-drop your digital images into your choice of templates.

Photo books are surprisingly easy to create and take far less time than creating a scrapbook. Plus, the end result is a published book that looks like something you'd purchase at a bookstore, only the book you create contains your images. Depending on the type of cover, the book's trim size, and the number of pages, prices for Blurb.com's photo books start at just $12.95 (for a 7"×7" softcover book), and go up to over $60 per copy (for a 12"×12" hardcover book).

Blurb.com is definitely a leader in the photo book creation and publishing business. However, other companies that also offer this service include

| | |
|---|---|
| BayPhoto | www.bayphoto.com |
| Black River Imaging | www.blackriverimaging.com |
| Kodak Galley | www.kodakgallery.com |
| Mpixpro | www.mpixpro.com |
| ShutterFly | www.shutterfly.com |
| SnapFish | www.snapfish.com |

The overall quality of photo books created by the various companies varies dramatically, as does their pricing and publishing options, however. Not all of these services offer templates or easy-to-use layout and design software for creating the photo books.

**Tip** Many professional photo labs and even one-hour developing services offer photo-book publishing as an optional service. Ask to see a sample book before ordering your own, however, to ensure the finished product will be professional-looking in terms of the print quality, cover, binding, and overall craftsmanship of the book.

# Create Photo Gifts That People Will Love

Instead of giving a friend or loved one a copy of a generic photo, you can easily create and order a photo gift that transforms one or more images into a meaningful and, in some cases, functional keepsake. Companies like CafePress.com will print your photos on hundreds of different products, including

**FIGURE 14-8** A collage photo mug created using the CafePress service

shirts, sweatshirts, boxer shorts, baseball hats, aprons, mouse pads, coffee mugs (shown in Figure 14-8), magnets, stickers, and other household items (like clocks). Your photos can also be transformed into professional-looking greeting cards, note cards, or holiday cards.

Many photo gifts are extremely affordable, costing between $10 and $30 each. Some companies also offer more unique and higher-quality photo gift products. For example, you can have your photo transformed into a 500-piece jigsaw puzzle or a full-color, extremely cozy 40"×60" throw blanket (shown in Figure 14-9).

**FIGURE 14-9** A full-color photo throw blanket makes a fun gift.

If you're looking for a unique, one-of-a-kind birthday, anniversary, or wedding gift for the person or couple who has everything, a photo gift could be the perfect solution.

When it comes to creating photo gifts, the possibilities are truly endless; you can choose from hundreds of different products, plus you can edit or customize your photos and, in some cases, create eye-catching or meaningful photo collages.

Photo gifts can be ordered from most one-hour photo services or professional photo labs, as well as from the majority of online photo services, like Kodak Gallery (www.kodakgallery.com) or SmugMug.com (www.smugmug.com), which are described later in this chapter.

PersonlizationMall.com (www.personalizationmall.com/personalized-photo-gifts-s34.store) is an online-based company that offers hundreds of different customizable products that can be imprinted or created using your digital images.

# Computer or Smartphone Wallpaper and Screensavers

If you're one of those people who are stuck working at a desk in front of a computer screen all day, or if you just want to customize your desktop or laptop computer screen, you can easily transform the appearance of your computer's desktop wallpaper and screensaver by using your photos as your computer's wallpaper and/or screensaver.

When you add your own image to your computer's desktop wallpaper, you're adding your own personality and something unique to the look of your computer. Figure 14-10 shows a photo used as desktop wallpaper on a MacBook Pro laptop computer. Both Windows 7 and Mac OS–based computers offer the ability to customize your wallpaper and screensaver using digital images stored on the computer's hard drive.

**Note** To create desktop wallpaper using a PC running Windows 7 or a Mac, follow the directions on the eHow.com website (for Windows 7, www.ehow.com/how_2109473_make-desktop-wallpaper-background.html, and for Mac, www.ehow.com/how_5734_change-background-picture.html). For complete step-by-step directions for creating a personalized photo screensaver using a PC-based computer running Windows, visit www.microsoft.com/windowsxp/using/setup/tips/diyscreensaver.mspx. If you're a Mac user, visit http://support.apple.com/kb/HT2485.

**FIGURE 14-10** A MacBook Pro with custom wallpaper created from a digital image

FIGURE 14-11 Adjust the
Desktop & Screen Saver options
found under System Preferences.

When creating a screensaver, you can use an unlimited
number of photos, and you can also add special transition
effects with ease to create an onscreen slideshow. Figure 14-11
shows how you can customize the photo screensaver on your
Mac by adjusting the Desktop & Screen Saver options under the
System Preferences menu. Similar screensaver customization
can be done on a PC running Windows 7.

You can also use your photos to customize the wallpaper and screensaver of your cell phone,
smartphone (including the iPhone and Blackberry), or tablet (including the Apple iPad). Directions
for how to do this vary based on your cell phone, smartphone, or tablet's make and model.

## Digital Photo Frames

A traditional photo frame is designed to hold one or more photos
and transform them into a work of art that can be displayed on
a wall or on a desk, for example. Framed photos can transform
or improve the décor in any room, but if you want to change the
photo, you have to take apart the frame, mount your new image,
put the frame back together, and then rehang it on the wall.

If the photo was framed using a single, double, or triple matte, you have to contend with adjusting those as well and making sure the matte's color and size match the new image.

The newest digital photo frames, however, offer a new method for showcasing multiple photos anywhere you would display a framed photo. A digital photo frame is basically an LCD display designed to look like a traditional photo frame. However, digital frames have internal memory capable of storing hundreds or, in some cases, thousands of digital images. They also have the ability to receive new images via the Internet. The software built into the latest digital photo frames can display your images in a slideshow format. You can often add transitional effects to make the digital slideshows more visually interesting as your images are displayed.

Digital photo frames come in a wide range of sizes and are available from dozens of different companies. Like TVs or monitors, the size of a digital frame is measured diagonally across the screen from the lower-left corner to the upper-right corner. The larger the display size and the higher the resolution, the more costly the frame. For between $100 and $300, you can purchase a really good resolution 8-inch or 10-inch digital frame that contains plenty of memory and a handful of useful features. However, for prices starting around $40, good quality, though smaller, digital photo frames are readily available.

FIGURE 14-12  Kodak's Pulse digital frame

For example, Kodak (www.kodak.com) offers the 5-inch EasyShare P520 digital photo frame for around $60. The company's 7-inch, full-featured Kodak Pulse, shown in Figure 14-12, is priced at around $130, whereas the somewhat less feature-packed 8-inch EasyShare M820 is priced around $120. These frames accept digital images taken using any digital camera, although they also utilize Kodak's proprietary Share button, which makes file transfers very easy between Kodak digital cameras, digital frames, and photo printers.

CEIVA Logic (www.ceiva.com) is another company that offers digital photo frames, but their frames offer a more robust selection of features and functions, including the ability to transfer photos to a CEIVA digital frame from anywhere using the Internet (and the optional CEIVA Picture Plan online service). The frames also have a memory card reader built in, as well as a USB port for direct connections between a camera or a computer. CEIVA's frames, like the CEIVAshare™ Digital Photo Frame shown in Figure 14-13, are priced starting at approximately $130 for a digital frame with an 8-inch display with a resolution of 800×600.

FIGURE 14-13  The CEIVAshare™ Digital Photo Frame

CEIVA digital frames also offer another great feature (when a user subscribes to the Picture Plan service for a low monthly fee after the free initial 12-month period)—displayable programming channels. When connected to the Internet via a Wi-Fi, broadband cable connector, or phone line, users can access and display online programming that can include up-to-the-minute and full-color local weather forecasts, news headlines, sports scores, and other information, in conjunction with displaying their own digital images. Users can also create customized digital greeting cards using their images and send them to a CEIVA frame. The optional CEIVA Picture Plan, however, is not required to load digital images into the frames and display them.

**Tip** When any digital photo frame connects to the Internet, it can receive images from anywhere. Therefore, you can send photos directly to your grandparents' frame remotely, for example, from almost anywhere using a device with a wireless Internet connection.

As you'll discover, prices for digital frames vary dramatically based on the size of the display, the display's resolution (look for a frame capable of displaying images at 800×480 pixels or better), the frame's memory capacity, as well as the features and functions offered. A digital frame with a 1GB memory capacity will hold thousands of images, depending on the resolution in which the images are saved before they're transferred to the frame. Photo frames are a great way to showcase many images in your home or office, without taking up a lot of wall space with individual frames.

You can load your digital images into a digital photo frame in several ways. In most cases, you can insert your memory card directly into the frame and copy the images. You can also connect your digital camera directly to the frame via a USB cable or connect the frame to your computer (via a USB cable) to transfer images. With some frames, you can also transfer images via a Wi-Fi or Bluetooth wireless connection or the Internet. Most photo frames will display images saved in any popular format, such as .jpg. Some are also designed to play movie files and/or audio files as well.

**Tip** When connected via a USB cable to a computer, a photo frame looks and acts like any other type of external storage device (like a USB flash drive or external hard drive), so you can simply drag and drop images from a folder on your computer, or the digital photo frame folder that appears on the computer screen, using the computer's mouse. If you know how to copy files on your computer, the process of transferring images to your digital frame will be intuitive.

## Did You Know?

# Your iPad Can Transform into a Digital Photo Frame

An Apple iPad, or another tablet-based device, can be used for a wide range of work- and leisure-related applications based on the apps you have loaded. Built into the iPad, however, is the ability to transform the unit into a high-resolution digital photo frame with the touch of a button. Any images stored in the iPad's Photos app can be displayed on the iPad's entire screen as an animated slideshow. While your iPad is sitting on your desk (in its docking station recharging, for example), it can also display your digital images in a slideshow format that you can program and control by tapping the device's Settings icon, followed by the Picture Frame icon.

Digital photo frames are sold wherever cameras and consumer electronics are sold, including Wal-Mart, Best Buy, Radio Shack, and Brookstone stores, as well as photography specialty stores and online. As technology advances, digital photo frames continue to drop in price with each passing year, yet their functionality and capabilities, not to mention their available display sizes, resolution, and storage capacities, continue to increase rather dramatically.

## Online-Based Photo Services

One of the worst things that can happen to a digital photographer is that the computer's hard drive crashes and all of his or her digital images get lost, corrupted, or deleted forever. The absolute importance of maintaining a reliable backup of your images is discussed more in Chapter 15.

To address the need amateur and professional photographers alike share for a remote backup service, many online services have emerged. Services like Flickr.com (from Yahoo!), SmugMug.com, Apple's MobileMe, Snapfish.com, Shutterfly .com, RitzPix.com, Slide.com, Wal-Mart Photo Center (http:// photos.walmart.com/walmart/howitworks), and KodakGallery .com all offer the ability to back up thousands of images on a remote server via the Internet, so if something happens to your computer, you'll still have access to all of your images. However, these same services have evolved to offer a wide range of other features photographers truly appreciate.

For example, these services allow you sort your images into folders or categories, for easy search and retrieval, and easily share single photos or groups of your images with others in the form of impressive-looking online galleries or slideshows—with absolutely no programming required. Many of these online-based services, including Google's Picasa service (http://picasa .google.com), also allow you to crop, edit, or enhance your images digitally using a robust selection of free online features and tools. Plus, you can order prints of any size, as well as create photo gifts using your images.

When it comes to sharing your photos, these services allow you to create easy-to-navigate and visually appealing online galleries. An online photo gallery created using SmugMug.com is shown in Figure 14-14. Once you've uploaded your images and have customized your gallery, you can invite people to view your images online. By adjusting the options offered, you can determine if people can simply view your images online, or if they can download them, order prints, or share them with other people. Essentially, these online galleries serve as highly functional websites (that require no programming whatsoever to create).

Many of the popular online photo services are advertiser supported and are free of charge to users, allowing you to upload, store, and share your photos. Some services, however, charge a flat monthly fee to utilize their service or charge based on the amount of storage space your images require. Of course, if you opt to order prints or photo gifts from the labs associated

**FIGURE 14-14** An online photo gallery created using SmugMug.com

with these services, you have to pay for what you order as well. However, you'll often find that the prices are extremely competitive when compared to one-hour photo or professional photo labs.

In addition to making a backup of your digital images on a remote service, figure out what other features you might want from an online photo service, and then visit the various services and choose one that offers the functionality you desire at a price you're comfortable paying. Each service offers a slightly different array of features and functions to differentiate itself from its competition.

 Many of the online social networking sites, including Facebook (www.facebook.com) and MySpace (www.myspace.com), allow members to store an unlimited number of photos and share them with others for free. However, when you share photos on Facebook, remember they are downgraded to a lower resolution.

# Create Impressive Digital Slideshows

Throughout this chapter, the concept of digital slideshows has been mentioned numerous times. Now, let's delve into what these actually are and why they represent an ideal way to share and showcase your digital images. Just like a traditional slideshow, a digital slideshow allows you to present a group of images, one at a time, on a computer screen, via the Internet, or on a TV (that's connected to a DVD player or TiVo DVR, for example). You can easily add special effects, music, sound effects, and image transition effects to make your slideshows more appealing and interesting to watch.

 Slide.com is a free, online-based service that allows you to create animated slideshows easily from your digital images. You can also add a wide range of special effects, including music, and then share your slideshows via the online social networking sites, a blog, or your own website.

Once you've shot and edited a handful of images that you'd like to showcase in a digital slideshow, you can create this type of presentation with no programming skills required—just use one of the online photo services listed in the previous section. Many photo-editing applications, including Photoshop Elements, Apple Aperture, and countless others (described in greater detail within Chapters 12 and 13), also allow you to create slideshows that you can incorporate into blogs, websites, your Facebook or MySpace page, or burn to DVD (to watch on TV, for example).

 Anytime you publish your images online, even in slideshows, keep in mind that they're often accessible by the general public—not just your immediate friends, family, or coworkers. Refrain from posting online any incriminating or embarrassing images you don't want your boss, children, parents, neighbors, or total strangers, for that matter, to see.

# Share Your Images via E-mail

Thanks to the online photo services and online social networking sites, sharing your images with the general public, or large groups of friends, family members, or coworkers is very easy. However, you can still use direct, person-to-person e-mail to share your images with just one recipient. Just as you'd add any other type of attachment, you can add one or more digital images as attachments to an e-mail, as shown in Figure 14-15.

Once you've saved an image on your computer's hard drive as a .jpg file, for example, you can simply attach it to an outgoing e-mail to send to one person or a small group of people (the recipients). E-mail is an alternative to posting your images on the Internet, which the general public has access to unless you password protect your online images and slideshows.

**FIGURE 14-15** You can add your images as an attachment to an e-mail.

If you want the recipients of your photos to be able to print them out on their own photo printer, send them a high-resolution image file, which means the files you'll be e-mailing will be rather large (often 5MB to 8MB each).

 If the e-mail service you use (or the e-mail service the recipient uses) doesn't allow you to send or receive large files as attachments, you can use the YouSendIt.com service to e-mail large digital image files to one or more recipients. YouSendIt.com offers a free and a premium paid service for sending large files via e-mail.

If you want your recipient only to view the images you e-mail on his or her screen, or if they'll only be displayed online in a blog or on a website, you can shrink down the image size considerably. Most photo-editing programs, as well as some e-mail programs, allow you to resize a digital image quickly and easily. As with any e-mail attachment, the smaller the file size of your digital images, the less time it takes to upload and send the image attachment via e-mail and the quicker the recipient is able to download and view what you send.

# Publish Your Photos Online via Facebook or Twitter

As of early 2011, Facebook, one of the world's largest and busiest online social networking sites, boasted of having a whopping 500 million active users, while MySpace has more than 200 million active users. Twitter also has a fast-growing user base comprised of several hundred million active users. If you want to get in touch with your friends online, meet new people, or interact with people across the street or around the world via the Internet, joining a free online social networking site, if you haven't already done so, should be at the top of your to-do list.

Once you've set up a free account with Facebook, MySpace, Twitter, or any other online social networking site, you can create your own personal "page," which is your area on each site to share information about yourself, including your photos. Built into many online social networking sites are robust and easy-to-use photo-sharing tools that allow you to publish online galleries and/or digital slideshows and share your images with friends, family, coworkers, or the general public, depending on how public you want to be when it comes to sharing details about yourself as well as your photos.

After you've posted your images in online folders or galleries, people who view them can download them, post comments about your images, or if the photos feature people, the people within the images can be digitally tagged, making it easier for users to find photos of other people (or themselves) that have been posted on these services.

 When uploading and tagging photos using any online service, including Flickr.com and Facebook, make sure you understand the Privacy settings and how they work for that particular service. Once you or someone else is tagged in a photo, if the Privacy settings are not adjusted properly, that tagged photo could become visible to the general public and searchable through Google or Yahoo!, for example. Tagging a photo associates someone's full name, and potentially their exact location (referred to as *geo-tagging*), along with other information and keywords with a particular photo. So if you use your cell phone to post a photo on Facebook of your kids at the park, for example, a stranger could identify your kids, obtain their full names as well as their exact location—if you don't have the photos password protected. For privacy reasons, parents should be very cautious about tagging their kids in photos posted to any online service.

Once a photo is tagged with someone's identity, that photo links to their page on that online social networking site and can be viewed potentially by anyone. There are, however, ways to password protect photos and remove unwanted tags. Before posting photos of yourself (and tagging them), or allowing yourself to be tagged by other people in their photos, learn how the tagging process works on the various online services and be diligent about knowing what photos of yourself (and your family members) are viewable by the general public.

Once you're a member of Facebook, MySpace, or Twitter, you can post photos to your page from a cell phone or any wireless Internet device, so while you're on vacation, you can post images of what you're doing in real-time—from your laptop computer, iPhone, Blackberry, cell phone, or digital camera with Wi-Fi connection capabilities—as long as you have a connection to the wireless web available.

Online social networking sites are continuously being updated to incorporate new features. Currently, photo sharing is one of the most popular and easiest features that people use these services for.

## View Your Photos on TV

Most DVD players have the ability to play DVDs created using a personal computer. So if you have a collection of digital images or slideshows saved on a DVD, you can insert that

DVD into any player that's connected to a TV and display your photos or play your slideshows on your giant flat-screen TV, as opposed to your computer screen.

You can also connect your desktop or laptop computer directly to the Video In or HDMI jack of your TV if you purchase the appropriate adapter. If you have a TiVo DVR unit that's connected to the Internet and your TV, you can also view images stored on many of the popular online photo services, as well as watch slideshows or videos from YouTube.

# 15

# Catalog, Organize, Back Up, and Archive Your Images

## How to...

- Begin to think like a photographer
- Organize your digital images on your computer's hard drive for fast retrieval
- Back up your digital images
- Recover lost, corrupted, or accidently deleted images

All amateur, serious hobbyist, and professional photographers have to contend with one challenge on an ongoing basis: keeping track of the photos they've shot. Before you know it, your personal archive of digital images will probably be in the thousands. And if you haven't taken the time to rename each and every image file with a filename that makes sense and that's highly descriptive (as opposed to a generic, camera-created filename like IMG_1234 .jpg), finding one particular image could mean having to look through dozens, hundreds, or even thousands of image thumbnails manually on your computer until you find the right one.

This final chapter is all about organizing, backing up, and recovering your digital images. Unfortunately, these tasks are somewhat mundane and nowhere near as fun or exciting as actually shooting photos, but these steps are nevertheless essential, especially when you're dealing with images of once-in-a-lifetime moments that can't be reshot.

As you begin to delve into the world of digital photography, start thinking like a photographer. As you go through your everyday life with camera in-hand, discover new ways to shoot people, places, and things that are important to you or that you encounter, and be ready to snap photos during important and meaningful moments in your life and in the lives of those around you. There's a big, exciting, and beautiful world filled with incredible photographic opportunities that are waiting just for you!

# When You Think Like a Photographer, You'll Take More Photos

As you become more comfortable using your digital camera, you'll discover that being a photographer is both fun and rewarding. Photography is also a wonderful creative outlet and the perfect way to literally collect and save memories. If you've purchased a point-and-shoot digital camera, it's most likely small enough that you can carry it around just about everywhere you go because it fits easily into a pocket or purse. Plus, chances are you also have a camera built into your cell phone or smartphone.

 **Tip**    Digital SLR cameras are larger, heavier, and more cumbersome than point-and-shoot cameras, which is why many serious hobbyists and even professional photographers also own a highly compact digital point-and-shoot camera, so they can literally shoot photos anywhere, anytime, and never miss a shot.

You'll discover that simply by having a camera available, you'll start taking more pictures in more situations as you go about experiencing your everyday life. As you begin to take more and more photos, you'll start to look at life through a photographer's eye and begin to see everyday events, objects, or situations as perfect photo opportunities.

Armed with your digital camera, you can capture more funny and candid moments with your kids or pets or snap photos of beautiful or unusual objects you encounter just walking down the street or through a park. Chances are you'll soon develop the urge to capture and chronicle more aspects of your life (and the lives of those around you) using photography.

Scenes you come upon in your day-to-day life might take on new meaning when you look at them through your photographer's eye—how your backyard or a local park looks right after a snowstorm (shown in Figure 15-1), or something as simple as a leaf floating down a stream on an autumn day (shown in Figure 15-2), or a recently bloomed flower from your garden in the spring (shown in Figure 15-3). All these can be photographed and transformed into works of art that, when printed and framed, will enhance the décor of your home or office or be the inspiration behind a photo gift you create for someone special in your life. Chances are even when you spontaneously e-mail and share a funny or particularly beautiful image you've taken, you'll probably discover it instantly brightens the recipient's mood and improves his or her day.

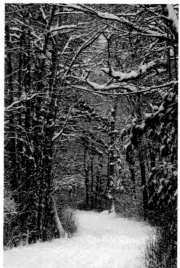

**FIGURE 15-1** A scene you look at every day can take on new beauty after a snowstorm, for example.

**FIGURE 15-2** Objects you encounter in everyday life can be transformed into photographic art.

**FIGURE 15-3** Combine creativity with nature to capture gorgeous photographic images.

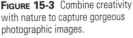

**Tip**   When you begin to look at life through your photographer's eye, always consider how you can frame images and utilize shadows or lighting to create compelling, artistic, or thought-provoking photos of everyday objects, scenes, events, or situations you experience.

**FIGURE 15-4** Using a zoom lens, you can capture exotic animals up close at a zoo.

When you use your photographer's eye in your everyday life, and you're armed with a digital camera (with a zoom lens) that's ready to shoot, a trip to the local zoo can become as exciting as experiencing an African safari (as shown in Figure 15-4). Buildings you see in your hometown or while on vacation transform themselves in your mind into interesting architectural subjects for your photos.

You might have the urge to snap more candid photos of your friends when you're having fun socializing or be more mindful of capturing important celebratory events like birthdays and anniversaries. Even mundane experiences can be captured in pictures—images that, when shot creatively, become keepsakes.

When you begin to take an abundance of photos on an ongoing basis, you'll discover two very important needs. First, properly organizing your digital images so you can find and view them quickly and easily on your computer's hard drive becomes essential. Before you know it, your personal photo archive will probably contain thousands upon thousands of images. If they're not organized, finding a particular image,

say a photo of your child that you shot six months ago at the park, could be like the digital version of looking for a needle in a haystack.

Second, creating a reliable backup of your digital image files is critical. If something ever happens to your primary computer (it gets stolen, damaged, infected with viruses, or crashes), you don't want to lose your photos forever. And, at some point, your computer is going to crash, malfunction, or need to be replaced with more modern technology.

Finally, if disaster does strike, and for some reason your digital images are lost, deleted, or corrupted due to a computer hardware error, software glitch, or user mistake, knowing how to potentially recover your digital images, either by yourself or by hiring a professional data recovery service, is important. As you'll discover at the end of this chapter, if the situation is handled correctly, you can sometimes (but not always) recover lost, corrupted, or deleted image data from a memory card, computer hard drive, or USB thumb drive if a reliable backup of your images isn't available.

 Having to rely on a professional data recovery service to salvage your lost or corrupted digital images is extremely expensive and not 100 percent reliable. A better strategy is to be diligent about maintaining a reliable backup of your images, either on an external USB or FireWire-connected hard drive, or, ideally, on an online remote backup service.

# Organizing Your Digital Images

Without using specialized photo management software, you will need to manually create folders and subfolders for each group of images you import onto your computer. You can opt to import all of your images into the same folder, but once you have hundreds or thousands of images in that one folder, finding individual pictures will be a confusing task.

Instead, create one Pictures folder on your computer's hard drive. (If you're using a Windows-based computer, the folder might be called My Pictures, or on a Mac, the default folder for pictures is called Pictures.) Within that folder, create a series of subfolders for dividing up and storing your images based on categories, like Vacations, Kids' Birthdays, Kids' Sporting Events, Parties, Holidays, Pets, and so on. Within these categories, you can create unlimited subcategories or subfolders. For instance, within the Kids' Birthday folder, you can have separate subfolders for each child and then sub-subfolders for photos taken at each child's birthday party year after year.

What's important is that you keep your folders and subfolders organized, using descriptive names. Creating easy-to-remember category, folder, and filenames will help you instantly recognize them at some point in the future.

Whether you use a PC or Mac-based computer, you can create an unlimited number of subfolders within the master Pictures folder on your computer's hard drive.

## Use Specialized Photo Management Software

The easiest way to organize your photos is to utilize photo management software, such as the latest version of Adobe Photoshop Elements (for PC/Mac), Adobe Photoshop Lightroom (for PC/Mac), Corel PaintShop Photo Pro (PC), Apple iPhoto (Mac), Apple Aperture (Mac), or ACDSee Photo Manager (PC).

These, and many other applications like them, are described in greater detail in the Chapter 12, but they all have features that help you import and organize your images automatically into easy-to-find galleries, folders, or events. You can further categorize and display your images by filename, date, location (using geo-tagging), or a handful of other criteria.

**Note** Depending on which photo management software package you use, groups of photos will be placed into *folders, galleries,* or *events,* which are all basically the same thing; they're just called something different.

These software packages automatically create thumbnails (small-size versions of your images), so you can catalog and view many images on a single screen. You can also rename or rearrange individual images, or manipulate complete galleries, events, or folders quickly and easily.

Upon connecting a digital camera or memory card reader to your computer via a USB cable, the software detects that new images are ready to be imported and then walks you through the process of creating a new folder or subfolder (event or gallery) that you can name. The software will then import your photos to the appropriate destination. You should note, however, that the auto import feature of these programs is easy to use, but not foolproof. Make sure you don't accidently overwrite and erase existing images by having the software import new image files with the same filenames as older images into an existing folder.

Once your images are imported and indexed using one of these software packages, you can crop, edit, enhance, print, rename, or e-mail them from within the application. You can also create slideshows or use pre-created templates to add special effects, such as frames or artistic borders, to your images.

iPhoto, for example, will also utilize geo-tagging data from your digital camera (if your camera has this ability) and will automatically organize your photos based on the location where they were shot. The Faces feature of iPhoto uses facial recognition to automatically scan your images and group them together based on who appears in the photos.

**Note** iPhoto is part of the iLife suite of applications ($79, www.apple.com/ilife), which is available through Apple for all Mac OS–based desktop and laptop computers. Although it is an extremely powerful, yet easy to use, photo management application, more advanced photo management and editing features (for serious hobbyists and professionals) can be found in Apple's Aperture 3 software ($199).

All of the popular photo management applications allow you to add keywords or descriptive tags to your photos so you can sort or search through them later using those terms, words, or phrases. You'll discover that photo management software takes a lot of the confusion and hassle out of organizing all of your digital images into unique files, folders, galleries, or events, so finding and viewing individual images is quick and easy.

## Create Easy-to-Recognize Filenames

Your digital camera will automatically create a generic and numerically sequential filename for every image you shoot, such as IMG_1234.jpg and IMG_1235.jpg. Once you transfer your images to a computer, you can manually rename each image to something more descriptive. If you're importing many photos simultaneously, however, renaming each photo manually isn't the best use of your time.

Instead, group together images based on a specific event or topic, and place similar images into unique and well-categorized folders, galleries, or events. This way, you can gather together dozens or hundreds of images based on an event, person, category, shoot date, or some other criteria.

 **Tip** When naming your folders, galleries, and events, be as descriptive as possible so finding images later is a faster and easier process. For example, consider naming an event "Ryan's 6th Birthday Party – June 2010" or "Summer 2010 Vacation to NYC." This way you know what pictures are stored within each folder and when they were taken based on the folder, gallery, or event name.

## Locating Images Quickly

Both Windows 7 and the latest version of the Mac OS operating system offer users multiple ways to search for a specific file or folder stored on a hard drive (or a data storage device, such as an external hard drive that's connected to the computer). If you need to find the folder containing your Christmas 2009 holiday photos, you can perform a search for the folder named "Christmas 2009 Photos" and then open that directory to see thumbnails of your images.

To find any file on your Mac manually, click the Finder icon (shown in Figure 15-5), located in the lower-left corner of the Mac screen, and then use the search field found in the upper-right corner of the window that opens. (Or you can use the Spotlight icon located in the extreme upper-right-hand corner of the screen. It looks like a magnifying glass.) In the search field (shown in Figure 15-6), enter the folder name, filename,

**FIGURE 15-5** The Finder icon on a Mac

or descriptive words that describe the photo you're looking for. How to utilize the Finder feature on any Mac is described in detail on the Apple website (http://support.apple.com/kb/HT3737).

**FIGURE 15-6** Use the search box to find any folder or file stored on your Mac.

To find any file manually on your PC that's running Windows 7, use the Search Box, which is found by clicking the Start button in the lower-left corner of the screen. You'll also see a Search Box at the top of every folder, or you can press the Windows logo key simultaneously with the F key to make a Search Box appear. If you're looking for a photo, you can click the Pictures search filter button or use the Advanced Search feature built into Windows.

 **Tip** To focus your search on just images, you can have the Search feature look only for files ending with the .jpg or .tiff extension, for example. For additional tips on quickly and manually finding files using Windows 7, visit http://windows.microsoft.com/en-US/windows-vista/Tips-for-finding-files or http://windows.microsoft.com/en-us/windows-vista/Find-a-file-or-folder.

**How to...**

# Use Unique Filenames to Keep Track of Multiple Versions of the Same Image

When you begin to experiment with photo-editing software, you'll quickly become proficient at cropping, enhancing, and adding special effects to your images. Before you do this, however, create a backup of the image in its original form.

You'll also want to create a file-naming system for yourself that takes into account having multiple versions of the same image. For example, in addition to the original image, which may be called IMG_1234.jpg, you might decide to crop the image. In this case, you should use the Save As... feature to save the newly created version of the image as IMG_1234-Cropped.jpg.

Likewise, if you create a smaller-size file version of the original image, so you can more easily post it on a blog or website, share it via e-mail, or publish it on an online social networking site, you might want to name the smaller image IMG_1234-Small.jpg. Yet another variation might be if you transform the full-color original image into black and white. Then you could save the newly created edited image as IMG_1234-BW.jpg, for example.

For images that you edit by fixing the subject's red eye or adjust using color correction, consider renaming that version of the image file IMG_1234-edited.jpg to differentiate it from the original. You can also abbreviate the new filenames using the letter *C* for cropped, *S* for small, *B* for black and white, or *E* for edited, for example. So if a filename is IMG_1234sb.jpg, you would know, based on your file-naming system, that it's a small size, black-and-white version of the original IMG_1234.jpg image.

Develop a file-naming system that's easy to remember and that allows you to identify various edited versions of your image files quickly. Once you start creating multiple edited versions of the same image, you don't want to save over the original image accidently (which results in the original image being deleted and replaced by the newly edited image).

Photo management software also allows you to perform a keyword search to locate specific image folders or images files easily, based on filename, keywords, or other descriptive information you originally provided when importing the images to your computer. Whether you're searching for images directly from your computer's desktop screen or using photo management software, become familiar with the search process so when you need to find specific images quickly, the process won't become a time-consuming hassle.

# Why Backups Are Essential

The importance of maintaining a reliable backup of all of your digital images can't be emphasized enough. Now repeat this sentence out loud: "I need to create a reliable backup of my images, right away, and maintain that backup continuously as I take new photos." What? Can't hear you! Read that sentence again, and this time, say it louder and with conviction! It's important!

As you're about to discover, you have multiple options when it comes to creating a reliable backup of your images. Unfortunately, no single backup solution exists that will protect your files against every possible scenario. For example, you could purchase an external USB hard drive, connect it to your computer, and back up all of your images onto it; if your computer gets stolen, however, or there's a flood or fire where you keep your computer, chances are the external hard drive will be stolen or destroyed as well, as will your backed-up images.

You can back up your images to CD-ROMs or DVDs, but after a while, you'll have a whole stack of CDs or DVDs that you need to store and protect to prevent them from getting scratched.

Using an online backup service (also referred to as a *remote backup service*) is always a good strategy because copies of your images will be stored on a computer somewhere far away from your desktop or laptop computer. However, this backup method is a bit slow and typically requires that you pay a monthly or annual fee.

Many serious hobbyists and professional photographers alike maintain at least two separate backups of their images, using two different methods. The most common and reliable backup methods are described in the sections that follow. Choose one or two backup methods that work well based on your needs.

 Think of maintaining a backup of your images as an insurance policy in case your computer crashes, the data gets corrupted, your computer equipment gets stolen, or you accidently delete or overwrite important image files. Just as with car insurance or home owner's insurance, you can "purchase" different levels of insurance, based on how much peace of mind and protection you desire. The same is true for maintaining reliable backups of your important computer data, including your digital images.

When it comes to backing up your images, you have five main options:

- Create a separate backup folder on your computer's main hard drive and create a second copy of your images in that folder.

- Purchase a high-capacity, external USB hard drive and connect it to your computer, and then use auto backup software that maintains a real-time and constant backup of all files as they're created or modified.

- Save all of your images to CD-ROMs or DVDs and maintain a library of backed-up CDs or DVDs in a safe and secure place.

- Utilize an online-based remote backup service or an online photo service. As you'll discover shortly, there's a difference between these two types of services, yet when it comes to maintaining a remote backup of your images, the end result is basically the same.

- You can also store a smaller number of photos on a thumb drive or portable flash drive.

## Create a Separate Backup Folder on Your Computer's Main Hard Drive

A simple backup solution is to create a Backup Pictures folder on your computer's main hard drive, and then make a second copy of all your digital images and place them within subfolders located in the Backup Pictures folder.

Digital image files can be large if they're shot using a high-resolution camera, however. If you have hundreds or thousands of individual images that are 5MB to 8MB each, that's going to take up a lot of primary hard drive space. If you want to save those images twice on the same hard drive, they will take up even more space and this isn't too efficient. This method is ideal for maintaining a handy backup as you're editing your images. However, it's not a viable option for maintaining a permanent and secure backup of your photos.

**Caution** Although this method will maintain a backup of your images if you accidently overwrite or delete any of the originals, for example, if your computer crashes, winds up with a virus, gets stolen, or has some other mechanical failure, both the original images and the backups will be lost because they were stored on the same hard drive.

## External Hard Drive

For most hobbyists, this is the most inexpensive and reliable method of maintaining a backup of their images. For between $75 and $300, you can purchase an external, one terabyte (1TB) USB

hard drive from any computer or consumer electronics superstore (such as Best Buy, Radio Shack, Wal-Mart, or online), and then either manually copy a backup version of your digital photos to this drive, or utilize specialized backup software to maintain a real-time backup as you add, delete, or modify individual files. If your computer is equipped with a FireWire port, you can purchase an external hard drive that utilizes FireWire to connect the two devices instead of using a USB connection. FireWire offers faster data transfer speeds than USB 2.0.

For PC-based computers running Windows 7, the Norton Ghost software ($69.99, www.symantec.com/norton/ghost) constantly runs in the background when your computer is operational and automatically makes backup copies of all files, including your digital images, saving them onto an external USB hard drive.

For Mac users, the Mac OS operating system has the built-in Time Machine software. When activated, it, too, automatically creates a real-time backup of all files (including your digital images), using an external hard drive or the optional Time Capsule hard drive (Apple, $299–$399, www.apple.com/timecapsule). One benefit to using the Apple Time Capsule as a backup solution is that it can be connected to one or more Macs via Wi-Fi or used with a USB cable.

**Tip**   To be extra safe, you can always disconnect the external hard drive when it's not in use and store it in a fireproof safe or in an area away from your main computer.

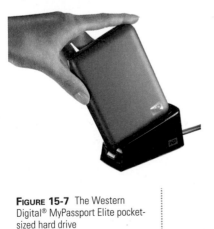

FIGURE **15-7** The Western Digital® MyPassport Elite pocket-sized hard drive

External hard drives are manufactured by many different companies and come in a variety of shapes and sizes. You'll find pocket-size external hard drives, as well as larger units that can be stacked on a desk. If you're constantly on-the-go and store photos on a laptop computer, you'll probably find an small external hard drive convenient.

Figure 15-7 showcases the pocket-sized, 1TB-capacity Western Digital® MyPassport Elite ($159.99), which requires no AC power. The Western Digital® 1TB MyBook 3.0 hard drive, shown in Figure 15-8, is larger, requires AC power, and is designed to sit next to a desktop computer. The MyBook 3.0 comes in a 1TB ($139.99) or 2TB ($239.99) capacity. It is also USB 3.0 compatible, which is 10 times faster than USB 2.0 in terms of transfer speeds.

What's more important than an external USB hard drive's physical size is its capacity. Purchase the largest capacity hard drive you can afford, especially if you'll be using it to back up a lot of large-size digital image files, music files, and/or video files. A 1TB or 2TB capacity hard drive will be adequate for most amateur and hobbyists; however, a smaller capacity 500MB UBS hard drive will be more affordable. If you shop around, you should easily be able to find a 500MB hard drive for under $50 and 1TB hard drive for under $100; however, prices for these storage devices are dropping quickly.

In addition to an external hard drive's physical size and capacity, evaluate its read/write speed. The faster the better. A hard drive's speed is measured in megabits per second (Mbps). Also, make sure the hard drive you choose is USB 2.0 or 3.0 (or later) compatible, and that it works with your Windows or Mac-based computer.

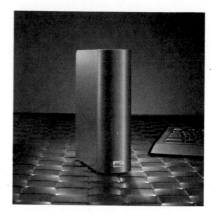

**Figure 15-8** The Western Digital® MyBook 3.0 hard drive

**Tip**  USB 2.0 was the standard on most desktop and laptop computers as of mid-2010. However, USB 3.0, which is ten times faster in terms of transfer speeds, is starting to become the new standard in 2011 and is being incorporated into most newer computers. If your computer is USB 3.0 compatible, choose an external hard drive that is USB 3.0 compatible as well.

Most external hard drives, however, work with either PCs or Macs and offer simple plug-and-play functionality. However, you may need to format the hard drive (using the directions provided with the drive itself) the very first time you use it.

One final thing to consider when evaluating an external hard drive is whether it requires a separate power supply to function. Some external hard drives that are physically small utilize the power from your computer's USB port, and don't need to be plugged into an electrical outlet to function. Some external hard drives, however, do need to be plugged into an AC outlet to function, which makes them more suited for use with desktop computers (as opposed to laptop computers, which are typically used while on-the-go).

## CD-ROMs and DVDs

Available from any office supply superstore, computer store, or consumer electronics store are large spindles of blank CD-ROMs or DVDs, which you can use for backing up your image files.

CD-ROMs have a much smaller storage capacity than DVDs; however, not all computers have built-in multimedia drives capable of writing to DVDs.

Maintaining a library of backup CD-ROMs or DVDs is a more time-consuming process because you have to create each CD or DVD individually, and they only hold between a few hundred and several thousand digital images each (depending on file sizes). However, storing individual digital photo galleries, folders, or events on a CD-ROM or DVD is a method for creating a reliable backup or for distributing large groups of digital images to a small number of friends (one at a time).

As long as you take proper care of the CD or DVD media and don't allow them to get scratched or exposed to high temperatures, for example, they're extremely reliable and can't malfunction like external hard drives.

**Note** Windows 7 features a powerful Backup and Restore feature that works well with CD-ROM or DVD media. To learn more about how to use this functionality to back up your digital images, visit www.microsoft.com/windows/windows-7/features/backup-and-restore.aspx. For Mac users, in addition to using the MobileMe backup service, you can use the Mac OS Disk Utility feature to back up files to CD-ROM or DVD, or you can manually back up files using a drag-and-drop method. The Apple website offers complete directions on how to do this at http://support.apple.com/kb/ht1553.

## Online (Remote) Backup Services

For a monthly or annual fee, you can subscribe to an online (remote) backup service. The service you choose will supply you with software to install on your PC or Mac. The software works in the background and automatically copies all files to a remote server, so at any given time, you have access to a offsite replica of your computer's hard drive. If you need to reinstall your entire computer after a crash, or simply retrieve one lost file, you know all of your important data, including your image files, are safely stored online as part of a secured and encrypted backup.

Depending on how you set up the backup software, your new files (or modified files) may not be sent to the remote backup server in real-time. The computer might wait for a period when you aren't using it before sending the new or modified files to the backup location. You may also discover that having remote backup software constantly running in the background when you're using the computer utilizes system resources, slowing down the overall speed of your PC or Mac.

Four of the more popular online (remote) backup services for consumers are

- **Apple MobileMe** (Mac only)   www.me.com. $99 per year for up to 20GB of online storage space. In addition to offering remote online backup, MobileMe offers an array of other online-based services for Mac users that can be used to sync important data with other computers, iPhones, and iPads, as well as share files (including image files) with other users. The service also allows users to create websites and online-based photo galleries easily.

- **Carbonite** (PC/Mac)   www.carbonite.com. $54.95 per year for unlimited backup storage space. The problem with this service is that if you have an extremely large amount of data to back up, such as thousands of digital images, after a certain point, the service throttles your upload speed, which makes maintaining an up-to-date backup very difficult. Read the fine print for this service carefully, and make sure it meets your needs before signing up.

- **iDrive Pro** (PC/Mac)   www.idrive.com. $4.95 per month for up to 150GB of online storage space.

- **Mozy** (PC/Mac)   www.mozy.com. $4.95 per month for unlimited backup storage space.

## Online Photo Services

While online (remote) backup services are designed specifically for the purpose of backing up important data on a server that's located far away from your primary computer, online photo services also allow you to back up your digital images. However, they also allow you to create online galleries and share your images with others.

As you learned from Chapter 14, you can order prints and photo gifts from these services. Storing your images on any of these online photo services is typically free, although some charge a low monthly or annual fee that gives users access to additional features and functions for backing up, organizing, editing, displaying, and storing digital images.

The most popular online photo services are Flickr.com, a free service from Yahoo!, and Picasa (http://picasa.google.com),

which is a free service from Google. SmugMug.com, Snapfish
.com, Shutterfly.com, RitzPix.com, KodakGallery.com, and
Wal-Mart Photo Center (http://photos.walmart.com/) are other
popular options.

# Recovering Lost, Corrupted, or Accidently Deleted Images

One of the worst things that can happen is that your computer
crashes, your hard disk data becomes corrupted, or one of your
camera's memory cards malfunctions and you lose important
image files. There may also be times when you accidently
delete or overwrite an image file without making a backup first.
You have been warned. It happens to the best of us.

When one or more image files are lost, corrupted, or
accidently deleted, don't panic. Okay, panic a little bit. Next,
if you're comfortable using your computer, you can download
specialized data recovery software, which can often fix
corrupted data on a hard drive, external hard drive, USB thumb
drive, or camera memory card. This same software can also
often recover deleted or overwritten image files.

Data recovery software is not foolproof and doesn't always work. It's a last resort for
recovering lost or corrupted data. A more reliable option is to always maintain a backup of
your digital images.

If you go to a service like Download.com (for PC users)
or the Apple Mac App Store (http://store.apple.com/us/browse/
home/shop_mac/software/utilities), and enter the search phrase
**data recovery software** or **memory card recovery**, you'll find
a handful of useful applications, like CardRescue 4.02 (or later)
for the Mac ($39.95, WinRecovery Software), which rescues
lost pictures from digital camera memory cards.

In many situations, the CardRescue software can recover
accidently deleted pictures, pictures lost due to an entire
drive being (re)formatted, or pictures lost due to memory
card damage or errors. This particular data recovery program
supports SD™ cards, CompactFlash® (CF) cards, Memory
Sticks, xD-Picture cards, or several other memory card formats,
and it is capable of retrieving common image formats, such as
.jpg and .tif, along with Nikon NEF and Canon CR2 raw image
formats. The software is easy to use and can be downloaded at

www.cardrescue.com. For PC Users, WinRecovery Software offers its CardRecovery software ($39.95, www.cardrecovery .com). Its functionality is similar to CardRescue, but it works with Windows 7.

 Some data recovery software is promoted as free for the "shareware" version, but many times this version of the software only identifies data that can be recovered. To actually restore the data, you'll need to purchase the full version of the software.

Another, but more costly, option to using data recovery software on your computer's hard drive or a camera's memory card is to hire a professional data recovery service that specializes in recovering lost data. Using an Internet search engine like Google or Yahoo!, enter the search phrase **data recovery service** or **memory card data recovery**, and you'll see listings for hundreds of companies capable of recovering your lost, corrupted, or deleted image files.

When hiring one of these services, make sure you understand how much you'll be charged, how quickly you can expect to see results, and what the process is for getting the hard drive or memory card to and from the data recovery service. Also determine how much you're responsible for paying if your data can't be recovered or if only a partial recovery is possible.

**Tip** If you live in or near a major city, chances are a data recovery service is located close to your home or office. Being able to drop off your memory card, hard drive, or your entire computer system is typically a lot faster and easier than shipping it somewhere. Check your local Yellow Pages for data recovery services, or seek out a referral from a local photography specialty store.

# A Few Final Thoughts

Digital photography is a fun and exciting hobby that's evolved a lot in the past decade. And with each passing month, new advances are made in digital photography, meaning new cameras are incorporating exciting, innovative, and more powerful features. One current trend is for high-resolution cameras to be incorporated into smartphones and cell phones, and for both point-and-shoot and Digital SLR cameras to shoot not only still images but also high-definition (HD) video.

As technologies like geo-tagging and facial recognition become more advanced, this functionality will be better incorporated into all digital cameras. Existing features, like the

ability to transfer images to a computer or online service from a camera wirelessly (via a Wi-Fi connection), will become easier to use and more widespread with all digital cameras.

Lag times now found in lower-end digital cameras will decrease and disappear, and the photographic capabilities of higher-end Digital SLR cameras will incorporate improved artificial intelligence for automatically capturing crystal-clear images in almost any situation, including poor lighting conditions. Photographic problems like red eye in images when a flash is used will become an issue of the past, and while the features and functionality of digital cameras become more advanced, the equipment will continue to drop in price and become much easier to use.

New and innovative methods for showcasing and sharing digital images will also be introduced in the not-too-distant future. While sharing photos online via Facebook is all the rage today, prior to 2004, this service didn't exist at all. What comes next is anyone's guess, but the possibilities are truly limitless.

In other words, digital photography is still in its infancy in terms of what's possible. However, whether you use a point-and-shoot digital camera, a Digital SLR, or a camera built into your cell phone, you can begin taking amazing shots and developing the skills needed to become a talented photographer right away.

Photography is fun and rewarding and a wonderful way to capture and share memories. As you begin taking pictures using some or all of the photography techniques described in this book, don't forget to also tap your imagination and creativity and incorporate these tools into your photography arsenal. Happy shooting!

# Index